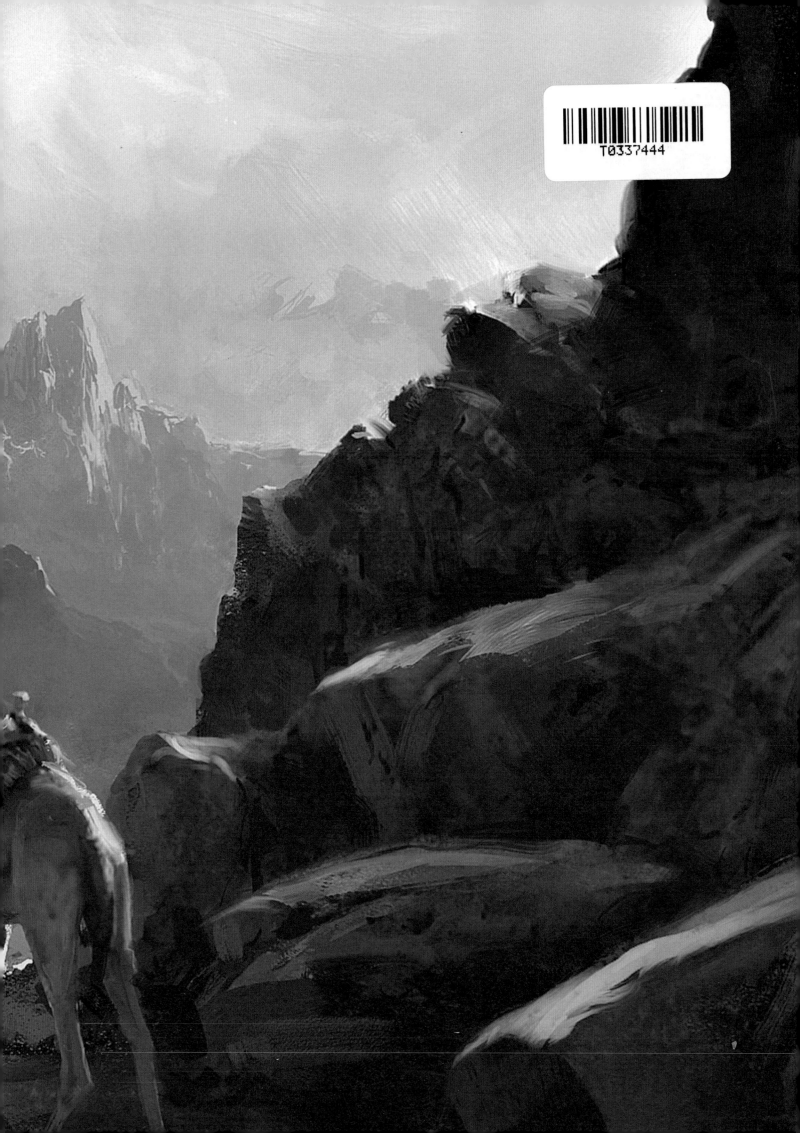

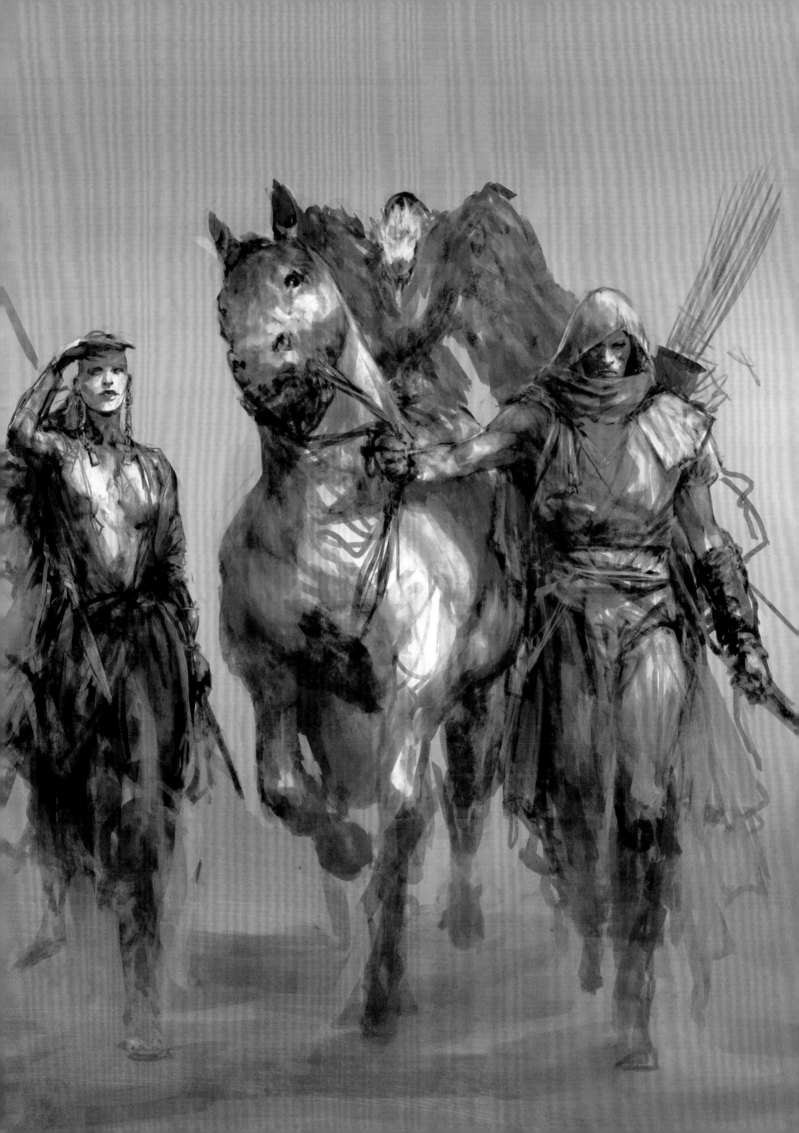

THE ART OF ASSASSIN'S CREED ORIGINS
ISBN: 9781785655166
Limited Edition ISBN: 9781785656552

Published by Titan Books
A division of Titan Publishing Group Ltd.
144 Southwark St.
London
SE1 0UP

First edition: October 2017
10 9 8 7 6 5 4 3

Book design by Amazing15.com

To receive advance information, news,
competitions, and exclusive offers online, please
sign up for the Titan newsletter on our
website: **www.titanbooks.com**

Did you enjoy this book? We love to hear from our
readers. Please e-mail us at: **readerfeedback@
titanemail.com** or write to Reader Feedback at the
above address.

A CIP catalogue record for this title is available from
the British Library.

Printed and bound in China

Artist Credits

Endpapers & this page: Martin Deschambault
Previous page: Vincent Gaigneux
Contents page: Gilles Beloeil

THE ART OF
ASSASSIN'S CREED
ORIGINS

PAUL DAVIES

FOREWORD BY
RAPHAËL LACOSTE

TITAN BOOKS

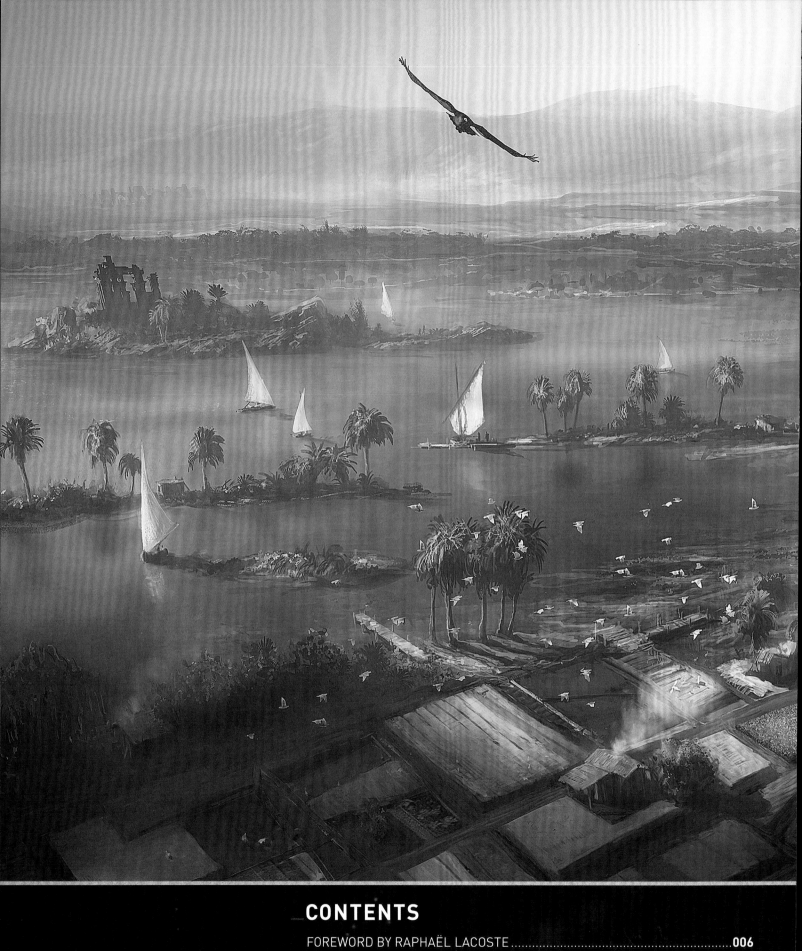

CONTENTS

FOREWORD BY RAPHAËL LACOSTE ...006

CHAPTER I: SIWA ...008

CHAPTER II: DESERTS ..032

CHAPTER III: ALEXANDRIA ..054

CHAPTER IV: NILE DELTA ...096

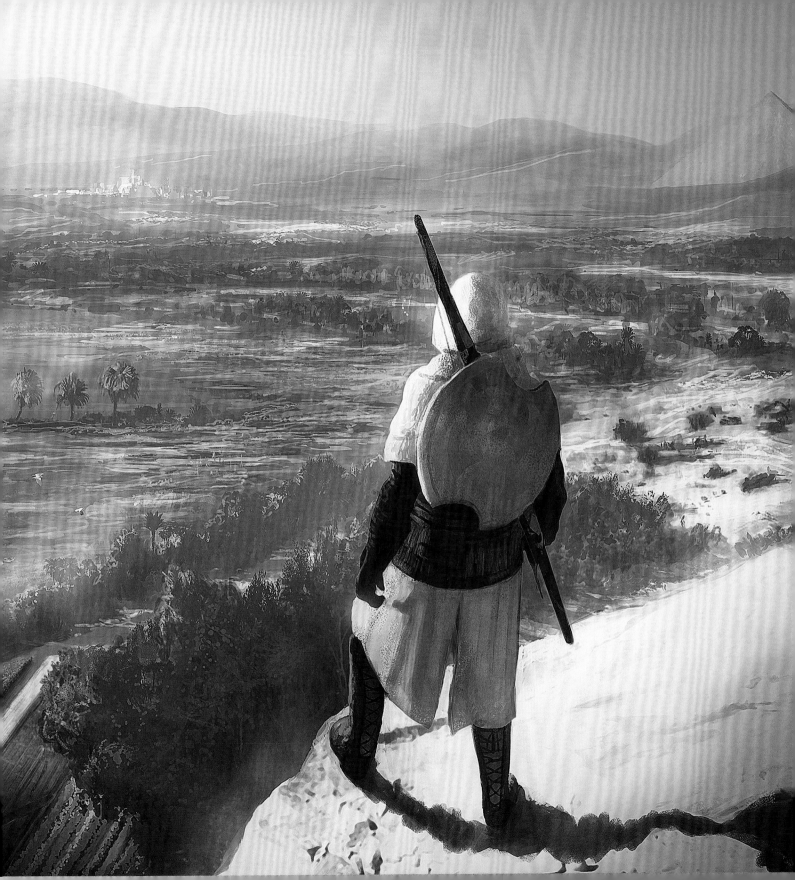

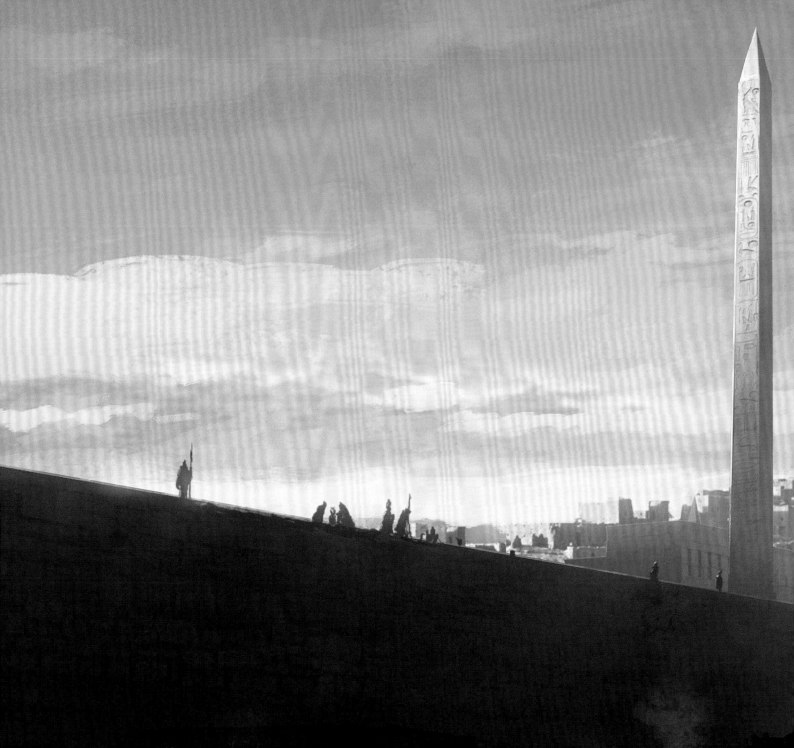

FOREWORD BY RAPHAËL LACOSTE

For over ten years now, *Assassin's Creed* has explored the concept of reliving and reimagining history. Every instalment in the franchise has aimed to offer our fans credible, immersive experiences with the most awe-inspiring moments.

The constant evolution of technology and art direction enables us to continuously develop the unique visual design of our universe. With the distinct style of *Assassin's Creed* we are able to construct powerful, meaningful entertainment that elicits a wide range of emotions. This approach also values the importance of every detail; the stylistic elements that make up the landscapes players traverse, the iconic

architecture they navigate, and the historical characters they encounter in our games.

For the first time in the series, *Assassin's Creed Origins* invites the players to explore a whole country. You will embark on a fantastic adventure across Ancient Egypt; from the lush oasis of Siwa, to the harsh desert sands of the Qattara Depression, through the glorious and multicultural port of Alexandria, and the majestic city of Memphis. The massive and diverse world of *Assassin's Creed Origins* provides the most beautiful journey of the franchise yet.

In the early stages of the game's development we produced hundreds of artworks that aimed to explore a wide range

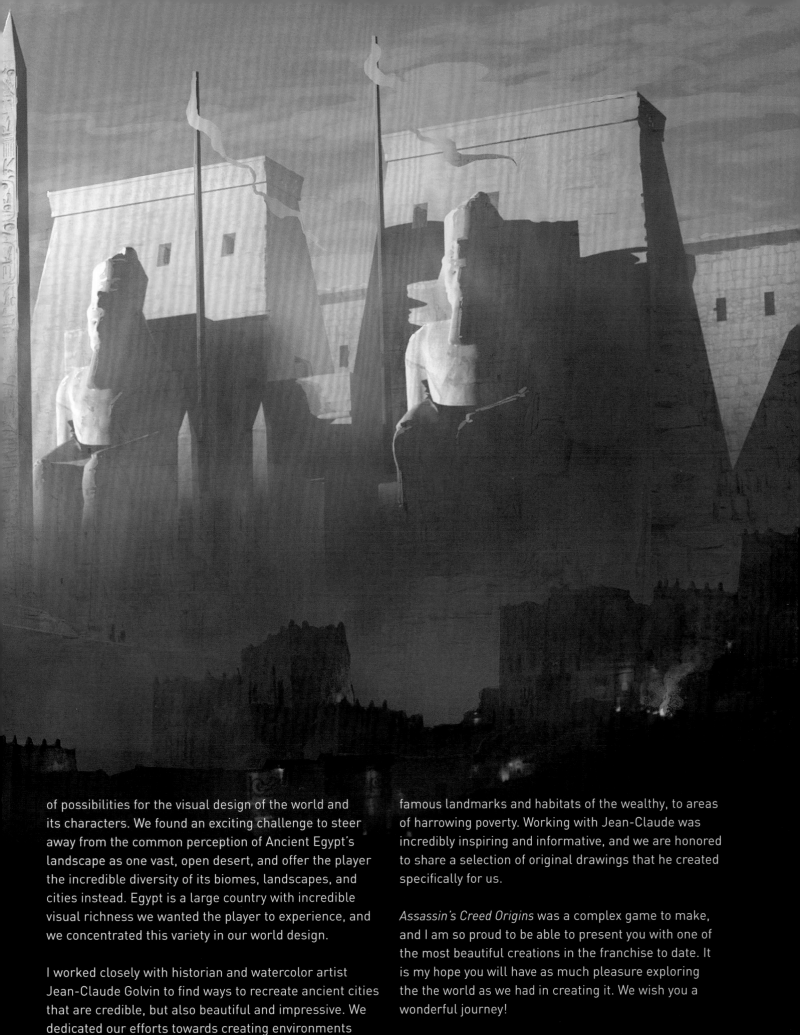

of possibilities for the visual design of the world and its characters. We found an exciting challenge to steer away from the common perception of Ancient Egypt's landscape as one vast, open desert, and offer the player the incredible diversity of its biomes, landscapes, and cities instead. Egypt is a large country with incredible visual richness we wanted the player to experience, and we concentrated this variety in our world design.

I worked closely with historian and watercolor artist Jean-Claude Golvin to find ways to recreate ancient cities that are credible, but also beautiful and impressive. We dedicated our efforts towards creating environments that are rich in contrast: from the epic opulence of

famous landmarks and habitats of the wealthy, to areas of harrowing poverty. Working with Jean-Claude was incredibly inspiring and informative, and we are honored to share a selection of original drawings that he created specifically for us.

Assassin's Creed Origins was a complex game to make, and I am so proud to be able to present you with one of the most beautiful creations in the franchise to date. It is my hope you will have as much pleasure exploring the the world as we had in creating it. We wish you a wonderful journey!

Raphaël Lacoste *Brand Art Director*

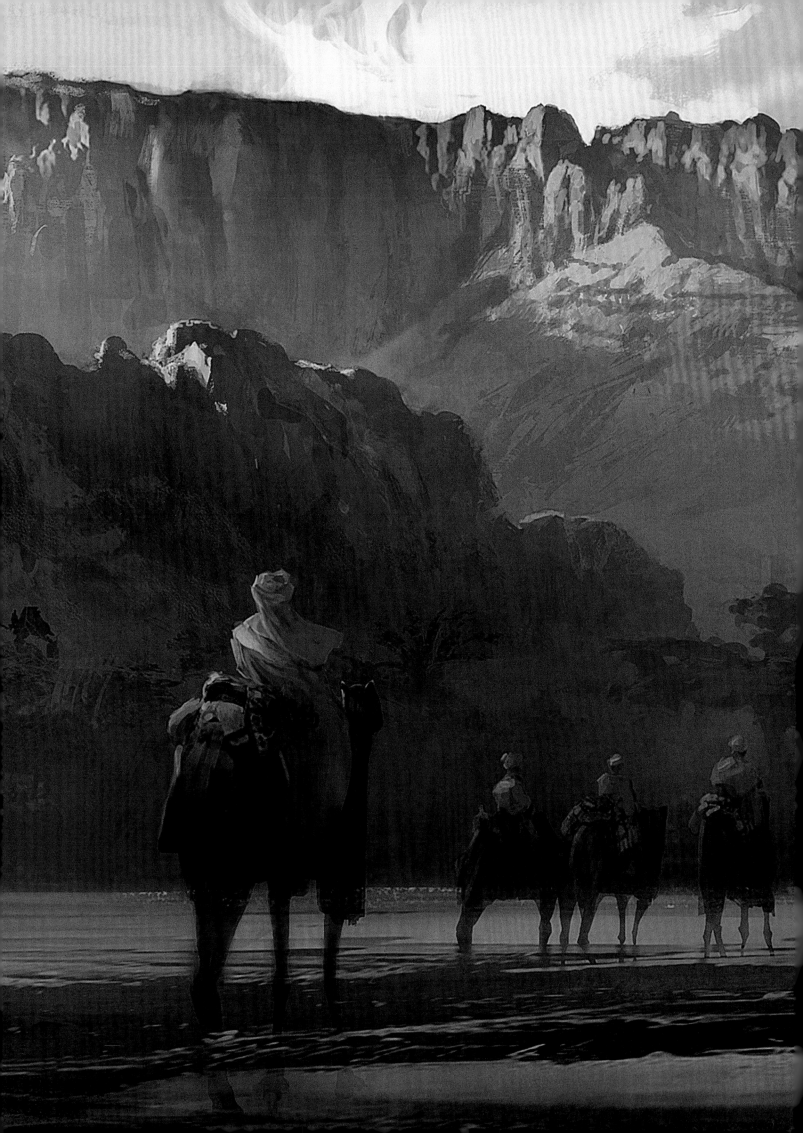

CHAPTER I
SIWA

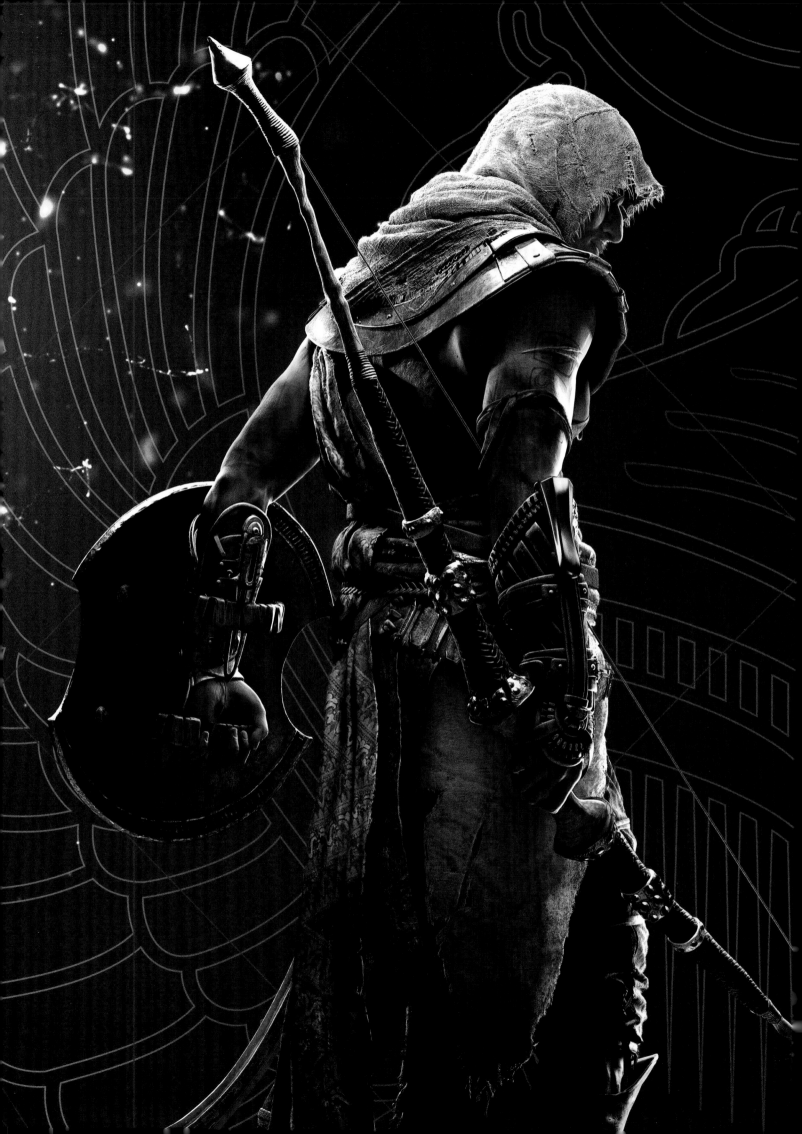

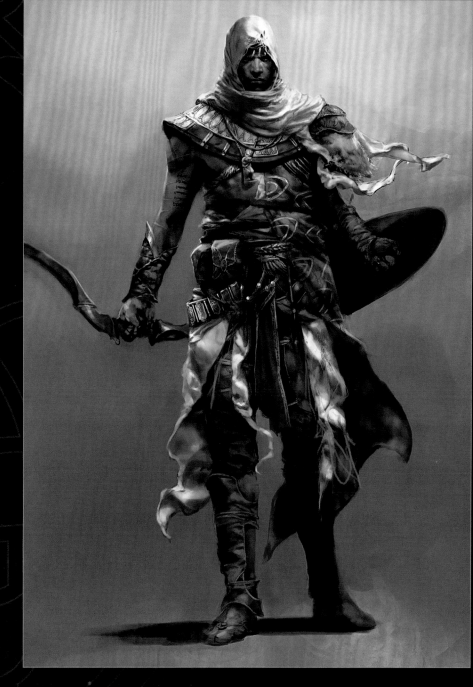

BAYEK

When we first meet Bayek of Siwa he is ragged and disheveled from months of travelling. Our weary wanderer is a Medjay, and ever ready for combat, seeking vengeance for the tragic death of his son at the hands of a murderous gang. Their names are tattooed on his arm, struck through one by one as he kills them.

As the main protagonist for *Assassin's Creed Origins*, Bayek embodies both the purpose and the promise of this new adventure. His playground is Ancient Egypt, caught at the time when Cleopatra and Julius Caesar crossed fated paths and the Ptolemaic Kingdom was on the brink of becoming the Roman province of Egypt. Through this man and his wife, Aya, we experience the struggle of the common people, but also relish the strength to rise above it.

"Giving up are words from a language I do not speak," Bayek says, as he plants the first seeds of what will become the Assassin Brotherhood. His name shall become legend.

[Previous page] landscape by Martin Deschambault
[Left] artwork by Hélix
[Above] a portrait of Bayek by Vincent Gaigneux

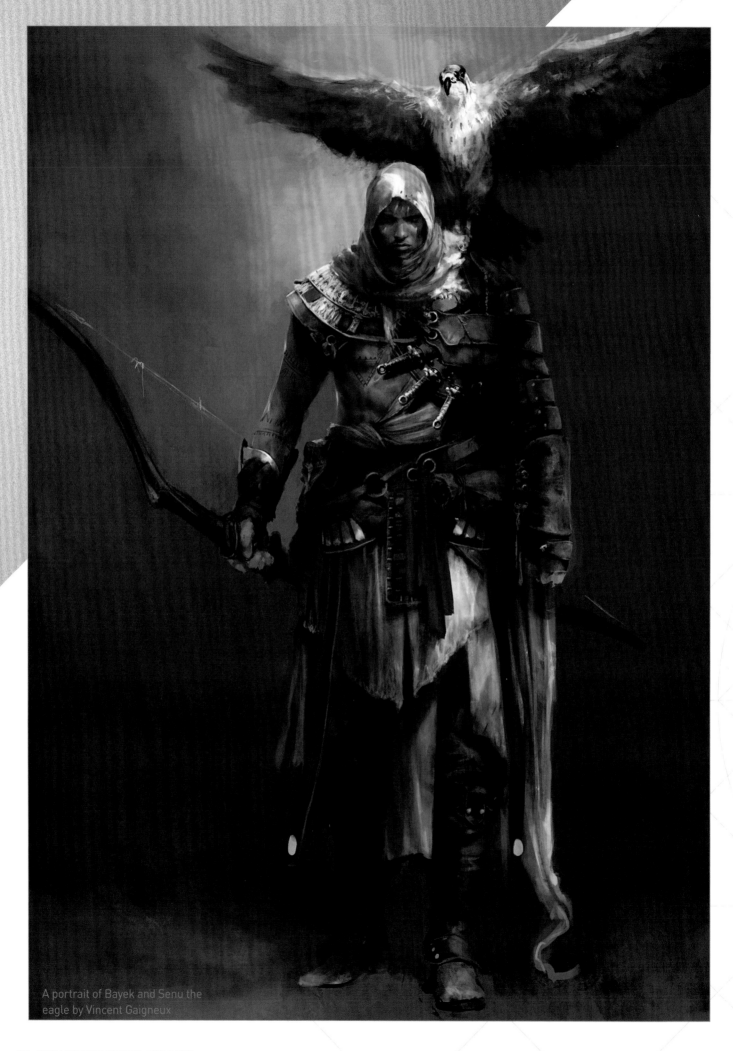

A portrait of Bayek and Senu the eagle by Vincent Gaigneux

The concept art for Bayek explored the many ways that a man who represents certain death might appear. Artist Jeff Simpson says, "I loved doing the mummy stuff. I did not want this to look like your typical beef-jerky wrapped in toilet paper monster-mummy. Playing with the textures and patterns and materials gathered from references of real mummies we have in museums it makes me wonder why our common conception of the 'mummy' in pop culture looks so lame and bland!"

The garments on the right are frightful, almost monstrous, in design, and leave no doubts about this man's deadly intent. The connection between the heroes' appearance and his profession were in the developers' mind right from the start.

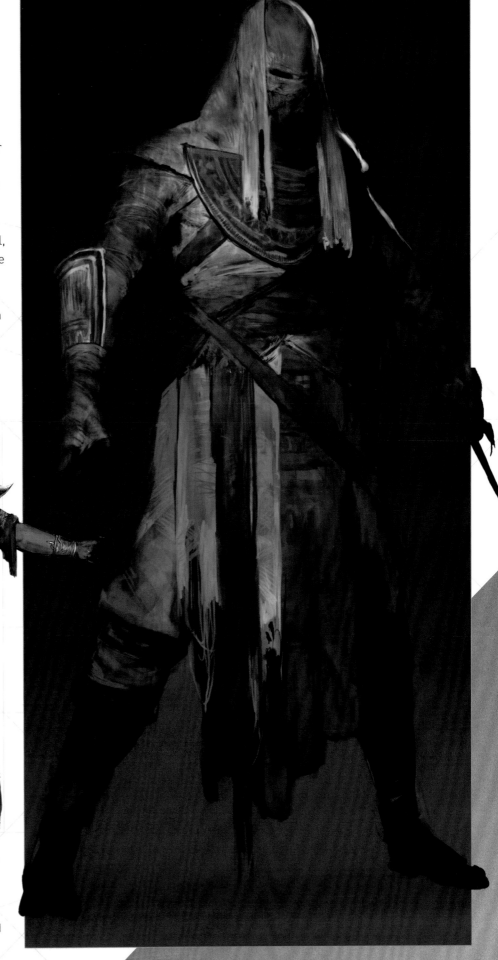

[Above and right] "I tried to incorporate some fun color schemes while keeping the Egyptian motif, inspired by snakes and reptiles of the area." *Jeff Simpson*

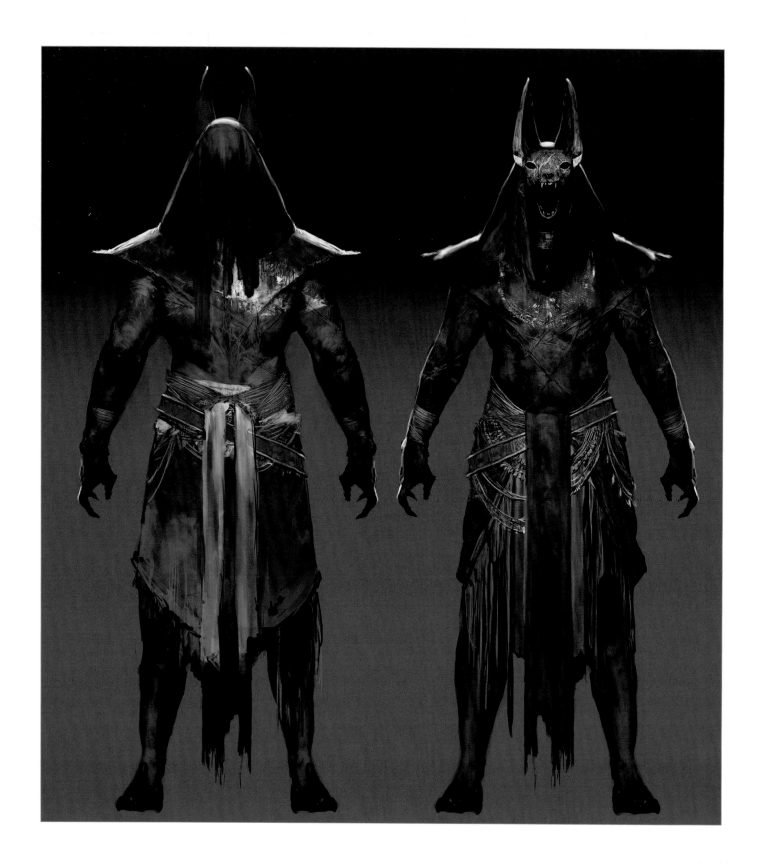

(Above) "A lot of people have designed an Anubis-type creature, but I hoped with this one it would really help push the whole 'death' element. It's always fun when we get to push the fantasy a little bit." *Jeff Simpson*

(Above Right) "The Hercules lion hat was a nightmare for the riggers and animators, I think. They hate me for it, I'm pretty sure." *Jeff Simpson*

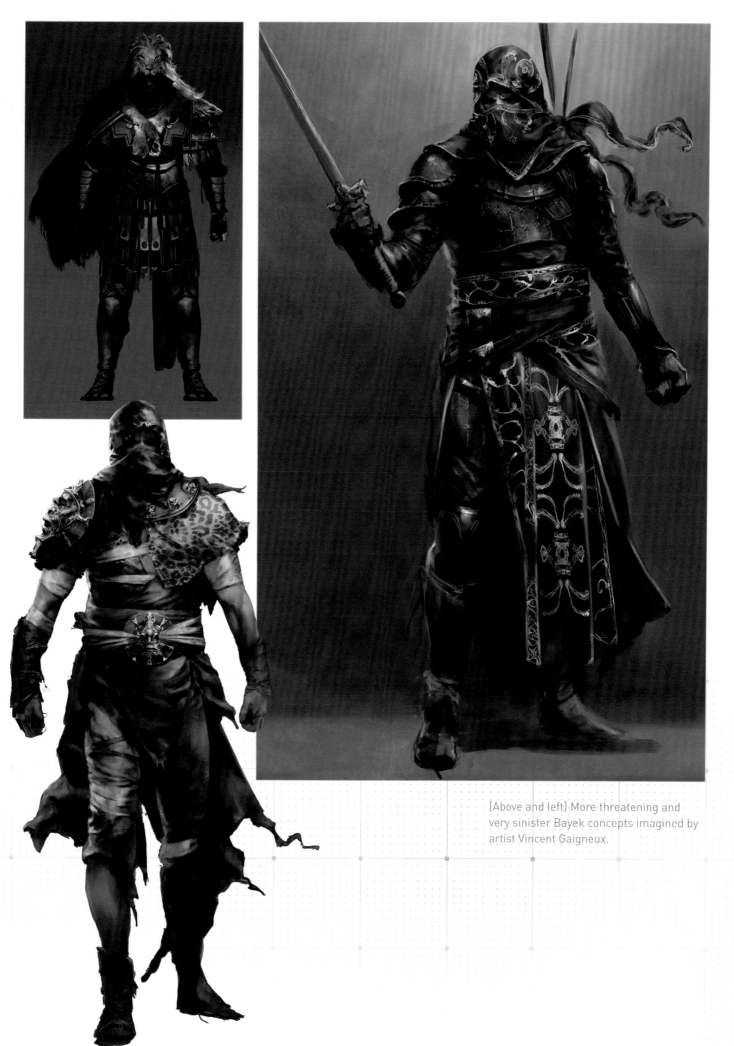

[Above and left] More threatening and very sinister Bayek concepts imagined by artist Vincent Gaigneux.

This remarkable blade [far right] by Martin Deschambault is said to have slain the Persian tyrant Xerxes, who waged war on Greece and despoiled Egypt itself. His assassin, Artabanus (who later took the name Darius), constructed the blade using a clever mechanism that allows it to lay hidden within one's sleeve. The Assassin merely tightens his wrist to provoke the blade to spring forth and deliver a killing blow.

Sketches by Vincent Gaigneux show explorations of Bayek in action.

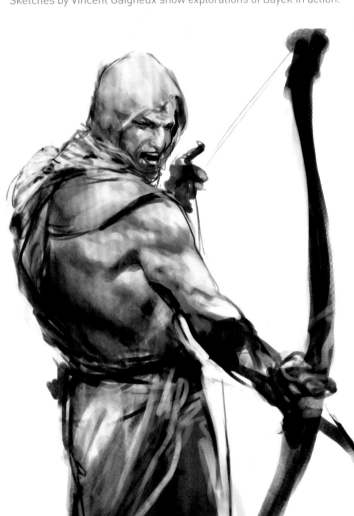

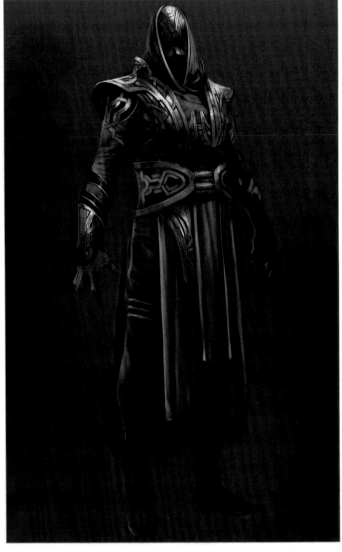

"MONOCHROME SKETCHES EXPLORE THE CHARACTERISTIC MOVEMENT STYLE OF A NEW HERO"

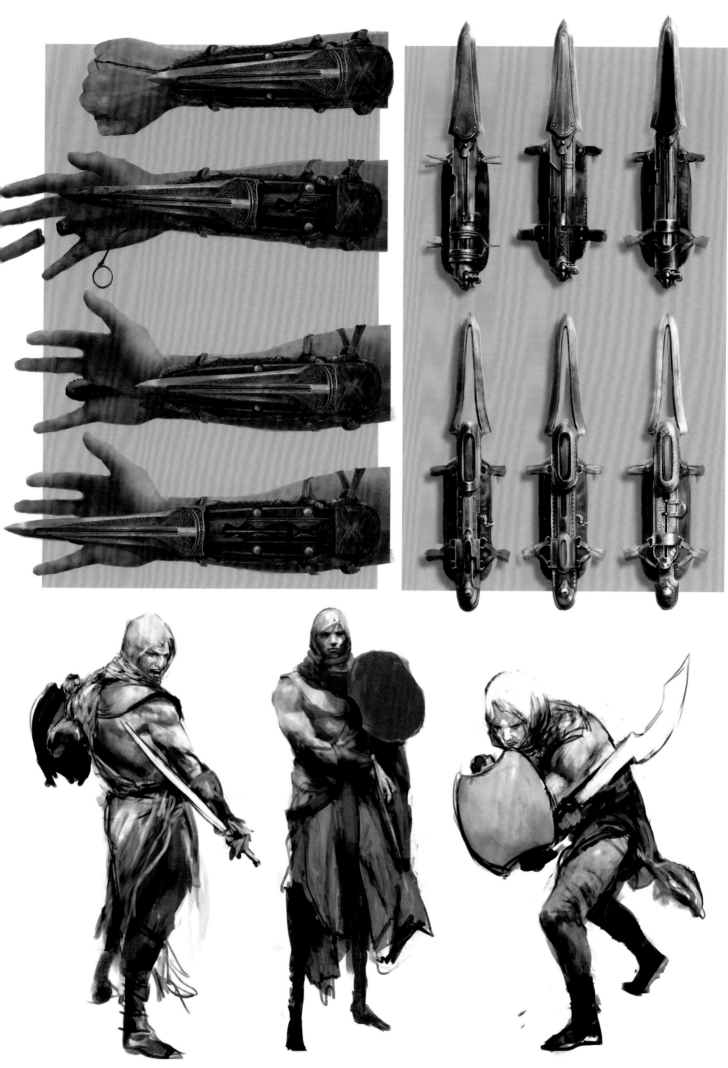

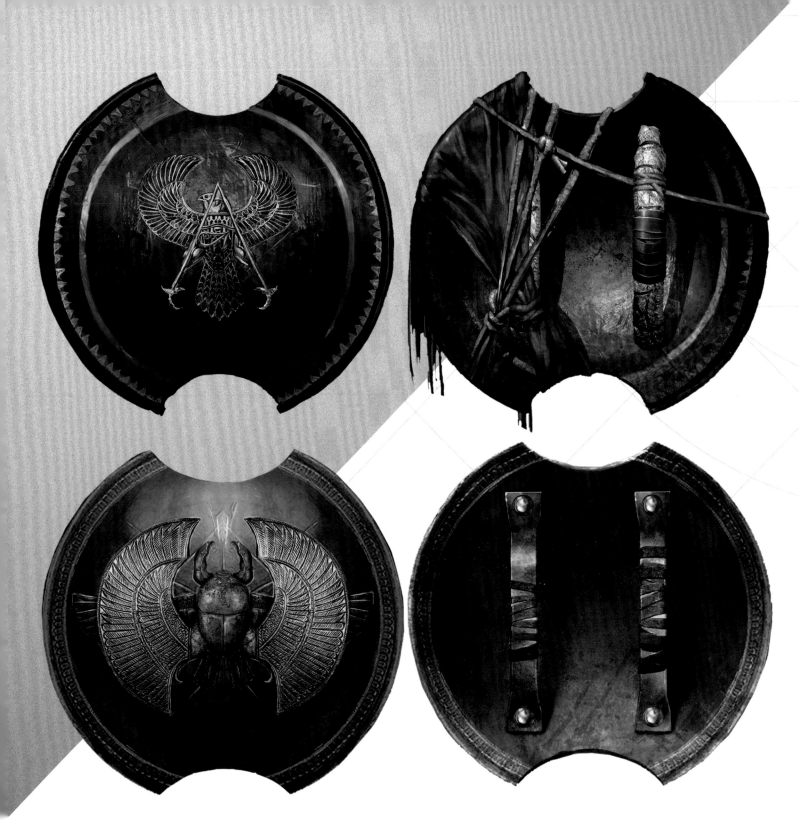

_WEAPONS AND SHIELDS

One of the reasons behind Ubisoft's decision to set *Assassin's Creed Origins* in the Greco-Roman era was because weapons and tools of that time were so elaborately made. Real historical artifacts inspired the concept artists to produce these spectacular designs.

Bayek carries a variation of the Heraklion shield. Note the cutaways that would have allowed the carrier to still see his enemy even with the shield held up. Leather straps wrapped around the handles were there to improve grip – modifications that suggest the owner was an experienced and battle-hardened warrior. Another day, another fight to the death.

These artworks by Jeff Simpson show ancient Egyptian staffs, scimitars and military bows ranging from those of crude construction to those fit for a king, or a king's army. The prosperity of the region where they were made is reflected in the quality of the materials and ornateness of the design, with royal or religious symbols giving clues about their owners.

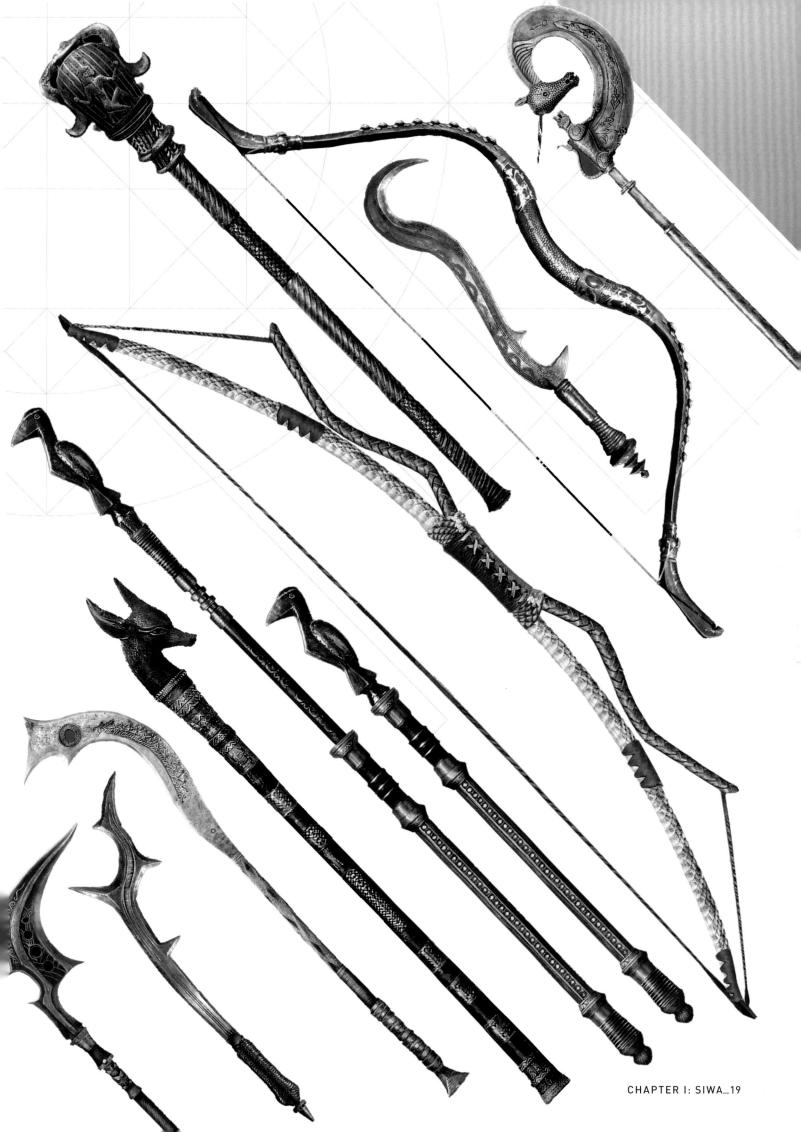

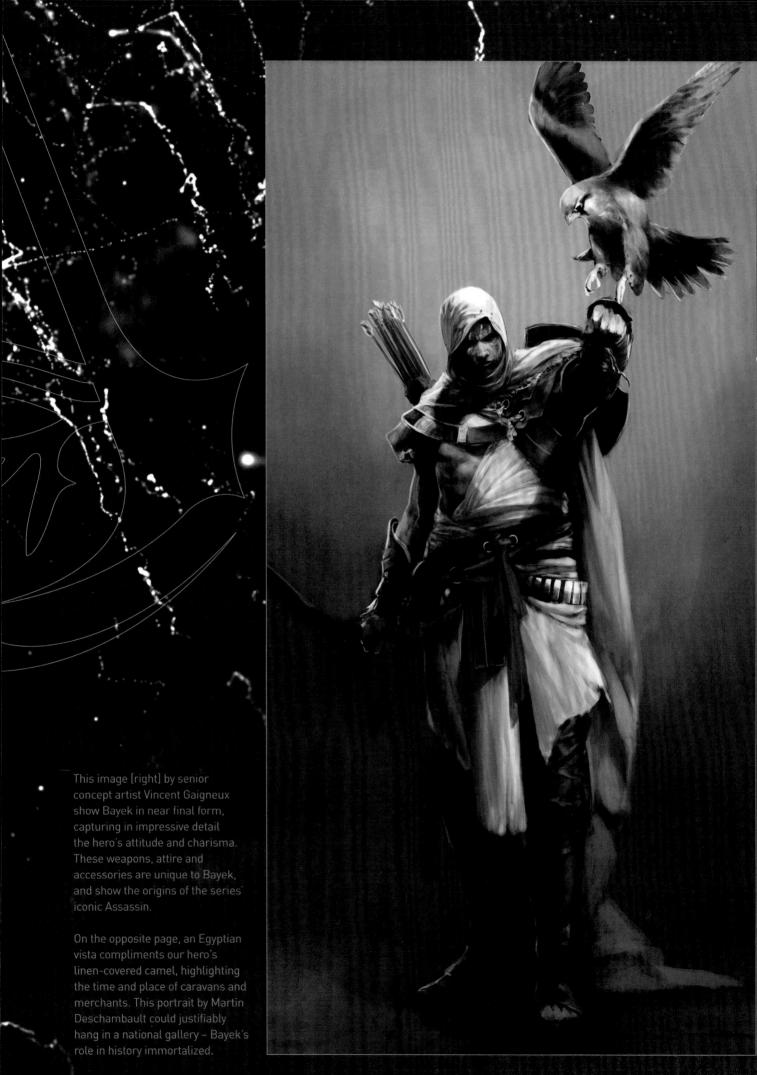

This image [right] by senior concept artist Vincent Gaigneux show Bayek in near final form, capturing in impressive detail the hero's attitude and charisma. These weapons, attire and accessories are unique to Bayek, and show the origins of the series' iconic Assassin.

On the opposite page, an Egyptian vista compliments our hero's linen-covered camel, highlighting the time and place of caravans and merchants. This portrait by Martin Deschambault could justifiably hang in a national gallery – Bayek's role in history immortalized.

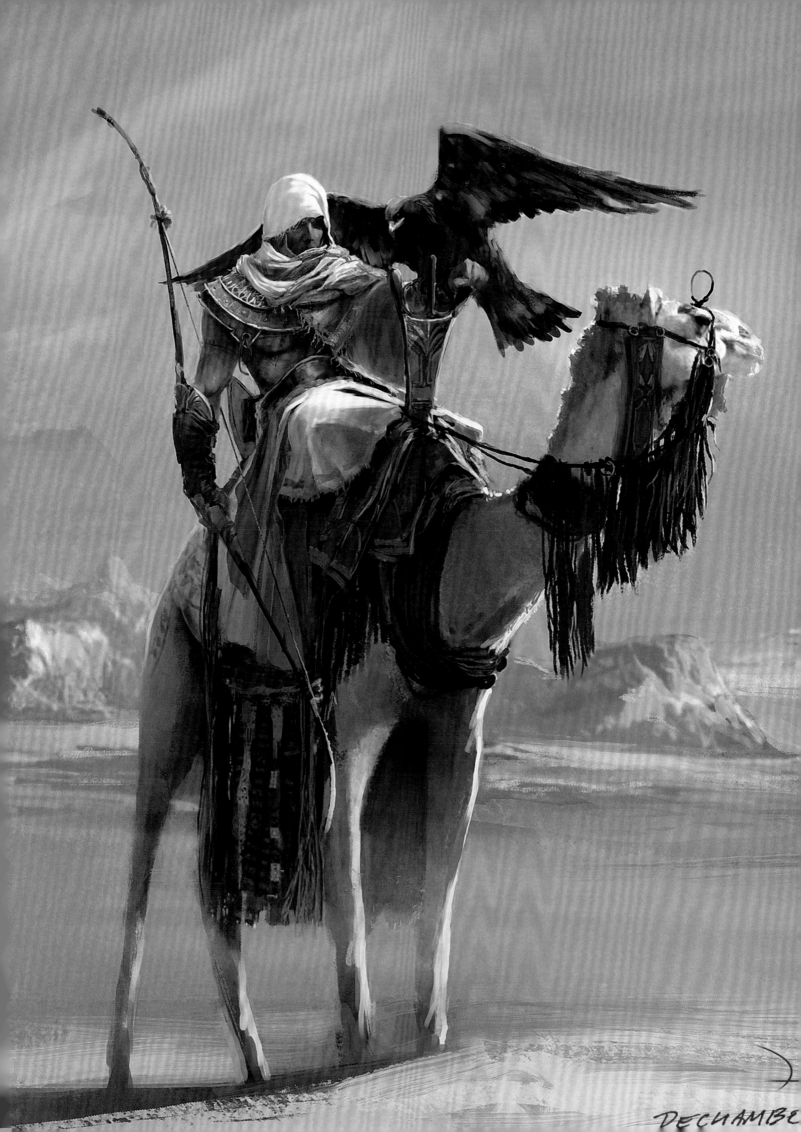

DECHAMBE

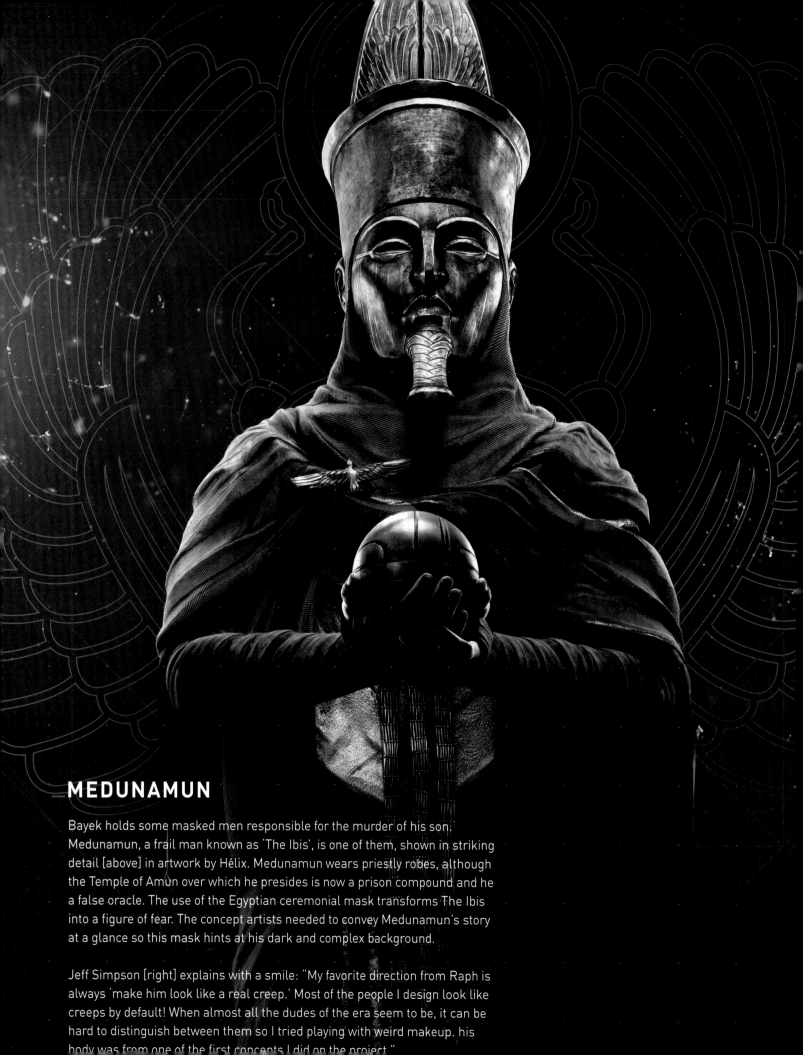

MEDUNAMUN

Bayek holds some masked men responsible for the murder of his son. Medunamun, a frail man known as 'The Ibis', is one of them, shown in striking detail [above] in artwork by Hélix. Medunamun wears priestly robes, although the Temple of Amun over which he presides is now a prison compound and he a false oracle. The use of the Egyptian ceremonial mask transforms The Ibis into a figure of fear. The concept artists needed to convey Medunamun's story at a glance so this mask hints at his dark and complex background.

Jeff Simpson [right] explains with a smile: "My favorite direction from Raph is always 'make him look like a real creep.' Most of the people I design look like creeps by default! When almost all the dudes of the era seem to be, it can be hard to distinguish between them so I tried playing with weird makeup. his body was from one of the first concepts I did on the project."

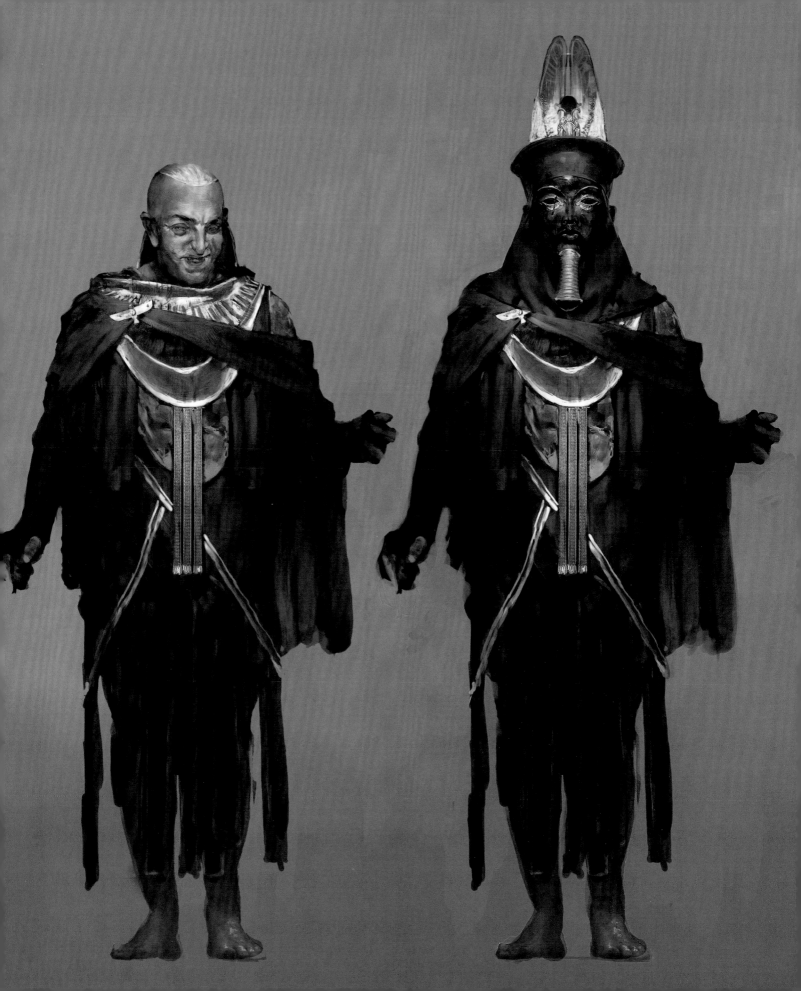

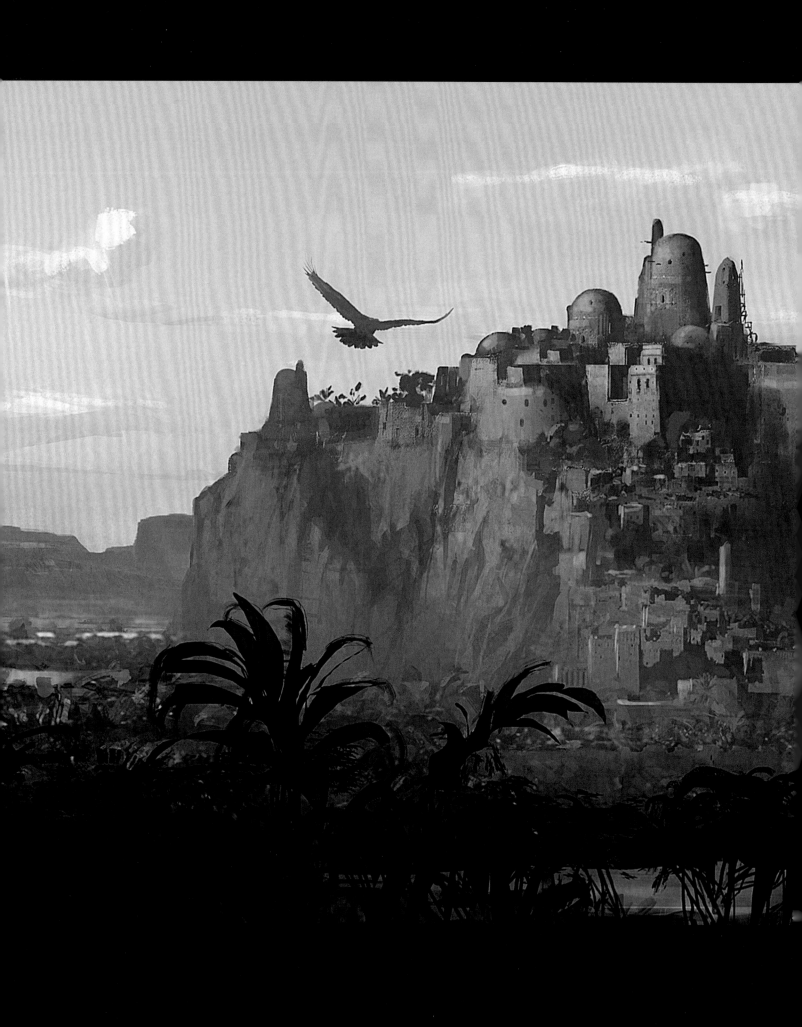

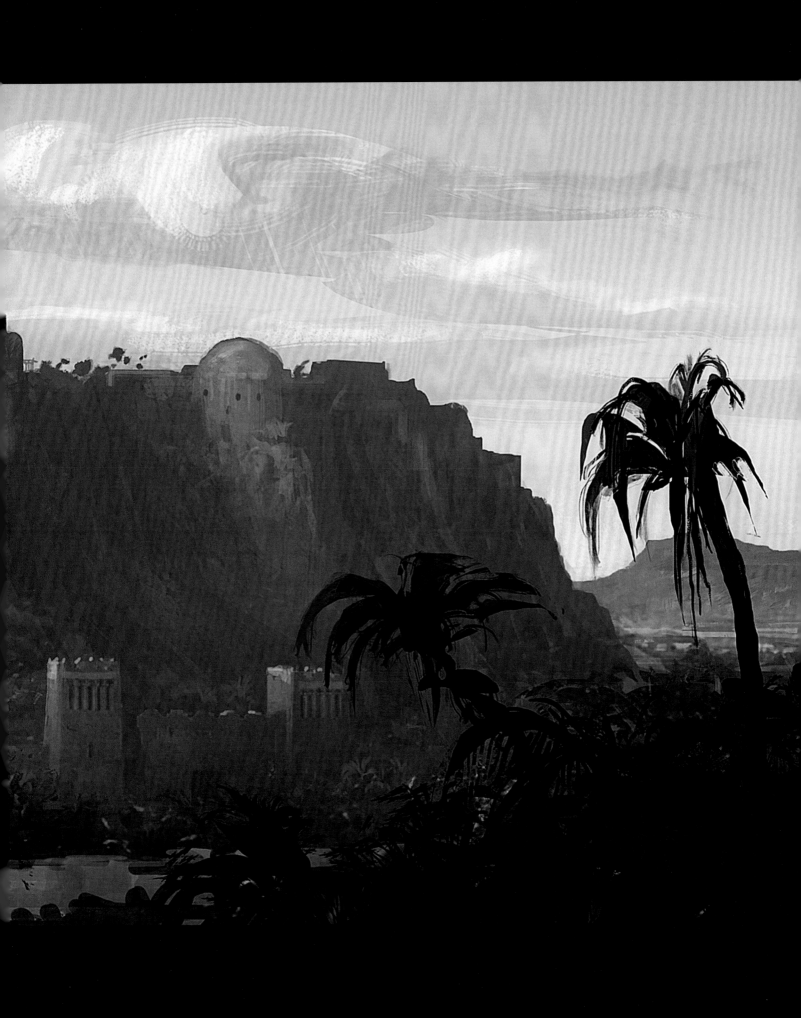

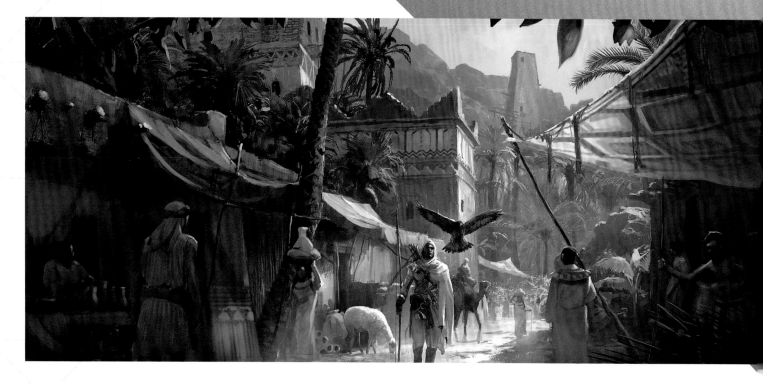

_SIWA, THE SACRED OASIS

"People might imagine that Egypt is only a vast, endless desert, but it's not true. Egypt comprises very diverse landscapes and atmospheres, a richness hidden to the naked eye," explains Brand Art Director Raphaël Lacoste. "Our goal was to unearth the lesser-known beauty, and reach every corner and crevice of it all. Siwa is the perfect example. It is a one-of-a-kind traditional town with small mud brick houses, imposing temples, irrigation canals and a salt lake."

"From inspirational artwork, to 3D and paintover, we found exactly what we wanted," reveals Senior Concept Artist Martin Deschambault. "It is very rare on Assassin's Creed to have a concept exactly like the final game because the locations change a lot during the paintover process."

[This page and previous] all artwork by Martin Deschambault

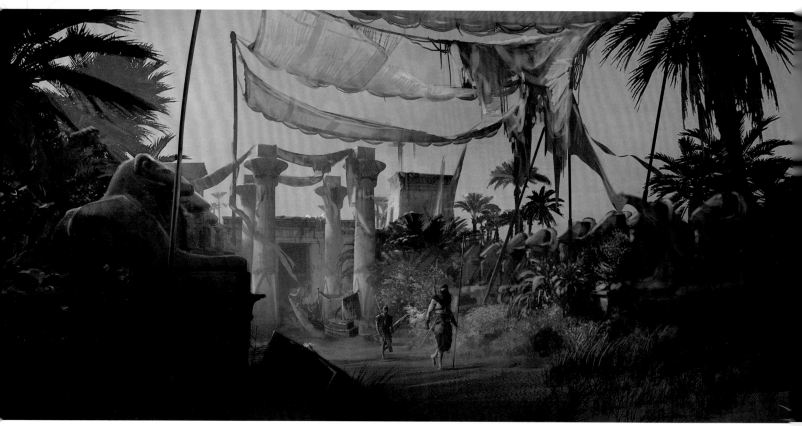

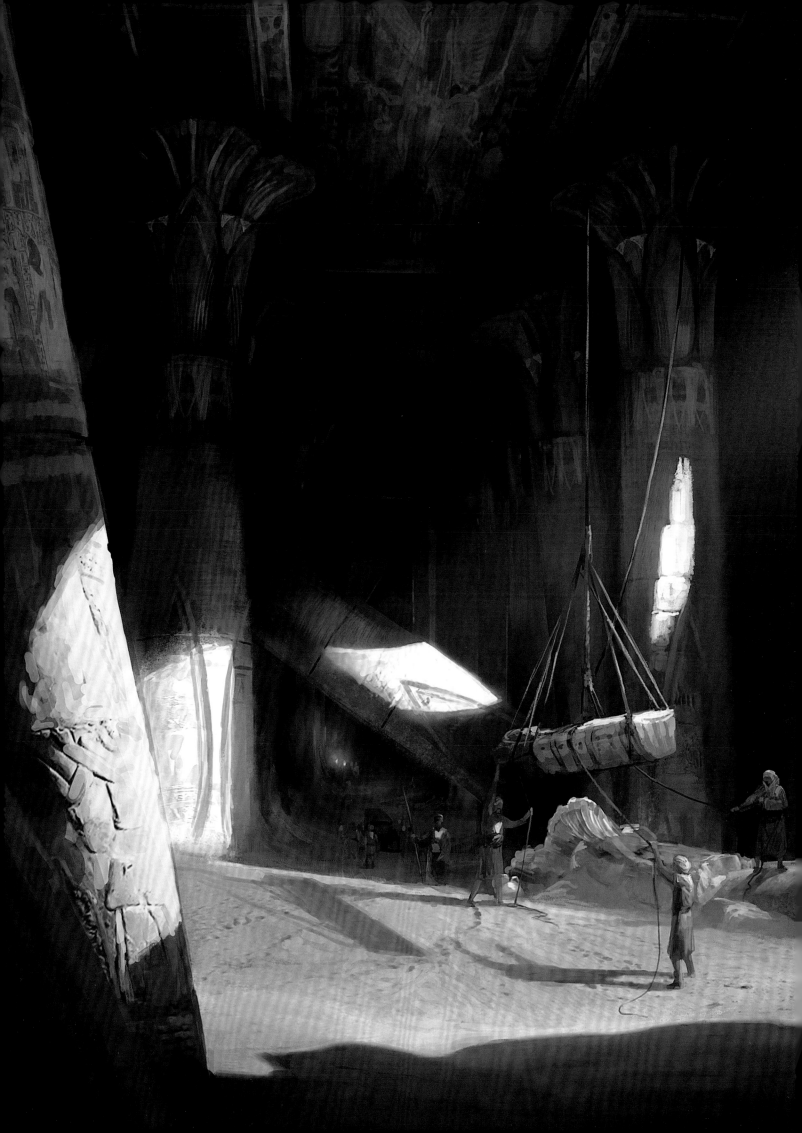

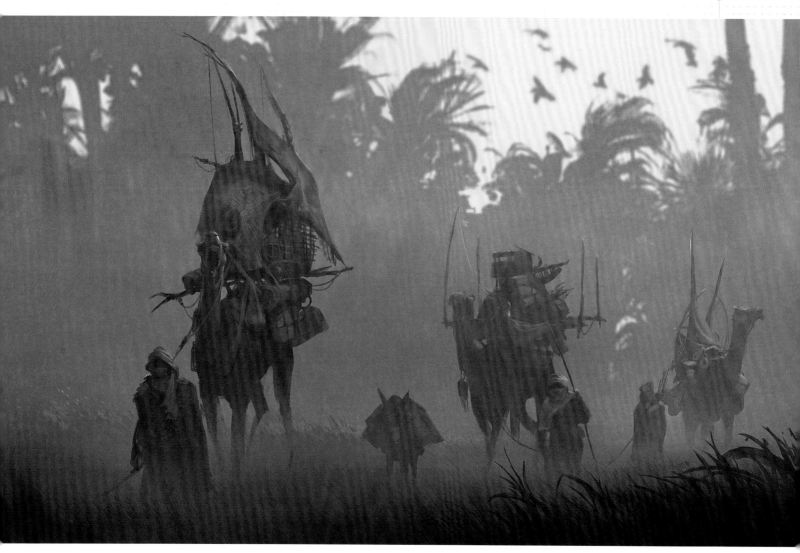

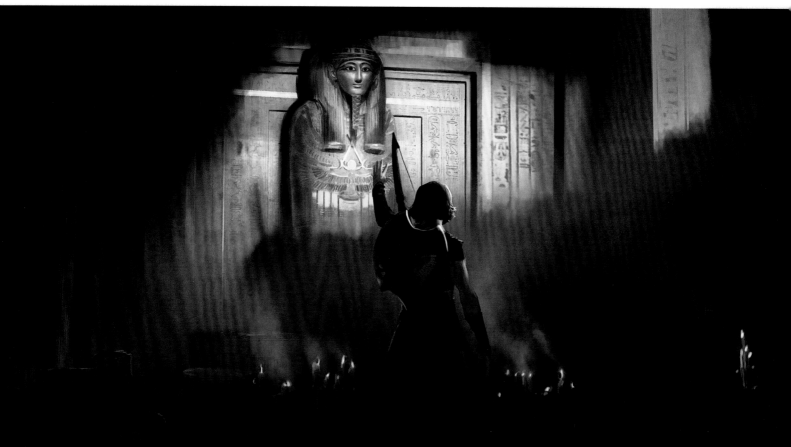

To represent Bayek's world as authentically as possible, the Ubisoft team researched extensively to envision ancient Egypt, explorations of which feature on the left by Martin Deschambault. Says Raphaël Lacoste: "We were inspired by historical documentation, and a wide variety of books on ancient Egyptian society. Our own databases were filled with an endless supply of images and facts that filled our minds with ideas and the desire to properly represent ancient Egypt."

The team ensured they were accurately informed about Egyptian daily life, including popular fashion. "Our greatest inspiration came from books by Jean-Claude Golvin, the French historian and illustrator," Lacoste enthuses. "Jean-Claude produced thousands of images of Ancient Egypt. He's an internationally recognized expert on Antiquity and historical reconstitution. His sense of scale and interpretation of history inspired us a lot. I met with Jean Claude and showed him our progress and illustrations, then proposed that we collaborate on the project. Jean-Claude was overwhelmingly passionate and motivated us with his knowledge and his approach to history."

"Siwa is a big oasis in Western Egypt, located near the Qattara Depression – a large desert valley (and former sea), lined with vertiginous cliffs. The village is prosperous, thriving essentially on its date and olive cultivation. Palm trees cover the valley in green, the water resources are important to the region's soil and prosperity. The oasis is framed by the majestic cliffs of the Qattara in the North, and the black mountains in the South." Raphaël Lacoste

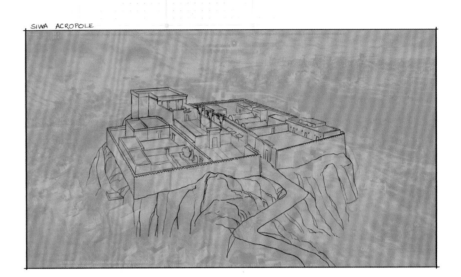

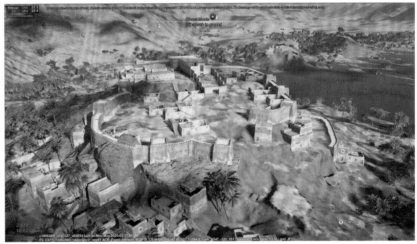

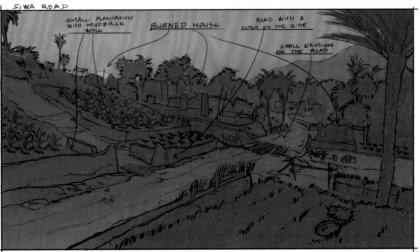

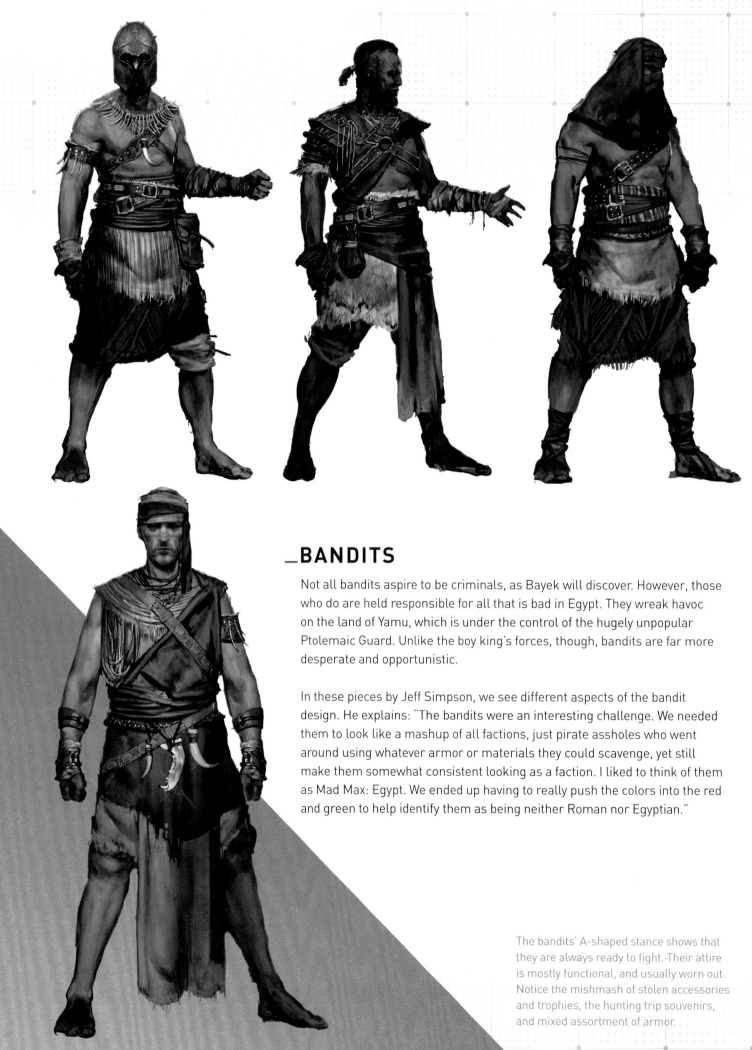

_BANDITS

Not all bandits aspire to be criminals, as Bayek will discover. However, those who do are held responsible for all that is bad in Egypt. They wreak havoc on the land of Yamu, which is under the control of the hugely unpopular Ptolemaic Guard. Unlike the boy king's forces, though, bandits are far more desperate and opportunistic.

In these pieces by Jeff Simpson, we see different aspects of the bandit design. He explains: "The bandits were an interesting challenge. We needed them to look like a mashup of all factions, just pirate assholes who went around using whatever armor or materials they could scavenge, yet still make them somewhat consistent looking as a faction. I liked to think of them as Mad Max: Egypt. We ended up having to really push the colors into the red and green to help identify them as being neither Roman nor Egyptian."

The bandits' A-shaped stance shows that they are always ready to fight. Their attire is mostly functional, and usually worn out. Notice the mishmash of stolen accessories and trophies, the hunting trip souvenirs, and mixed assortment of armor.

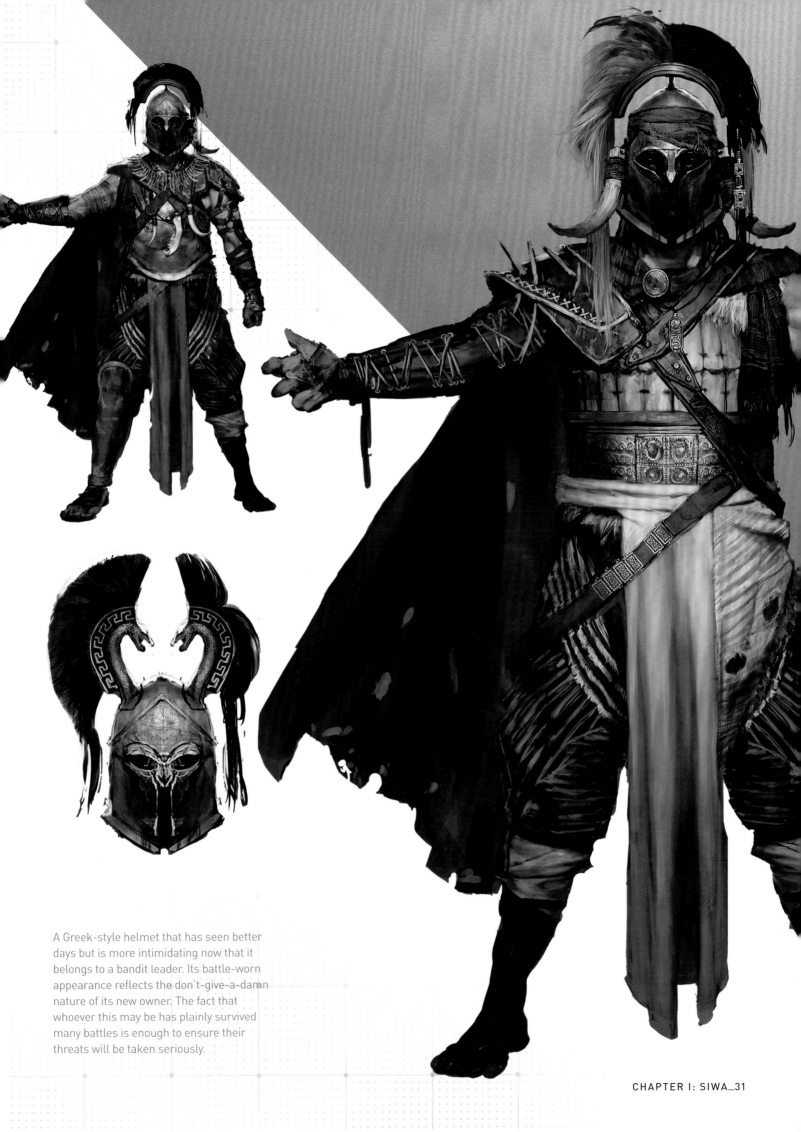

A Greek-style helmet that has seen better days but is more intimidating now that it belongs to a bandit leader. Its battle-worn appearance reflects the don't-give-a-damn nature of its new owner. The fact that whoever this may be has plainly survived many battles is enough to ensure their threats will be taken seriously.

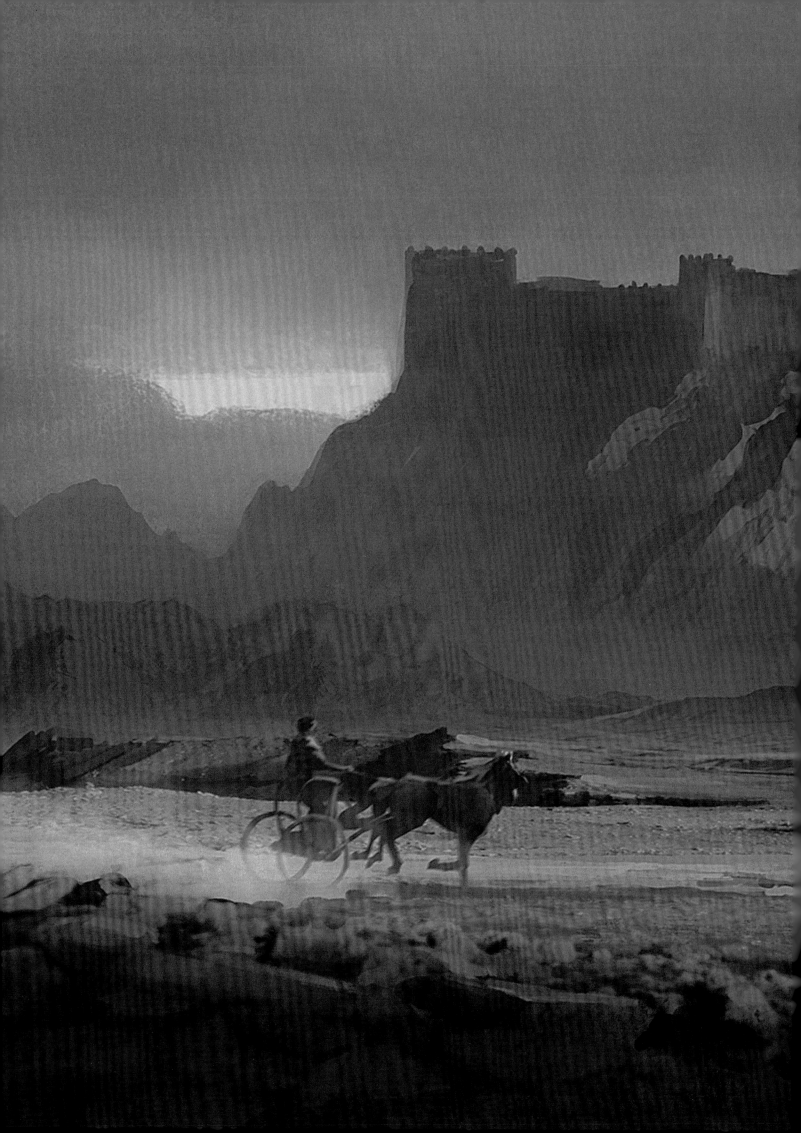

DESERTS

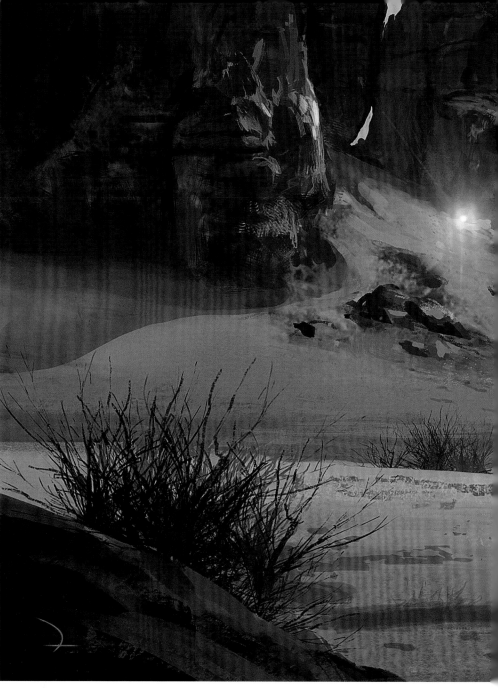

[Above] "High contrast sketches force me to simplify the shape and the storytelling. On the page opposite is a sketch from the same exercise. For this one I decided to add gray value, then I did the color version on the top right. In the final version, I changed the composition of the rock formation to make it more interesting." *Martin Deschambault*

All artwork on this page and previous page by Martin Deschambault

_THE ENDLESS DESERT

Egypt's natural history provided a sumptuous backdrop for *Assassin's Creed Origins*. Raphaël Lacoste says: "We created a unique playground by merging the variety of biomes and locations. Distances had to be massaged in order to give a feeling of emptiness and yet a visual richness that encourages players to explore and rewards their investment in the world."

"Nevertheless," Lacoste continues, "the team's goal wasn't to create a documentary feel, but instead a rich panoply of visual ideas that extracts emotion and feeling from the raw beauty of Egypt. To contrast with the abundant fauna and lush flora of the Nile, we recreated the white deserts, the great Qattara depression, and the black mountains that offers calm lunar landscapes, instances of solitude that can sometimes be dangerous. With the new characters' abilities, scaling gigantic cliffs and mountains offers unique and dizzying views on the biggest playground that the Assassin's Creed franchise has ever seen."

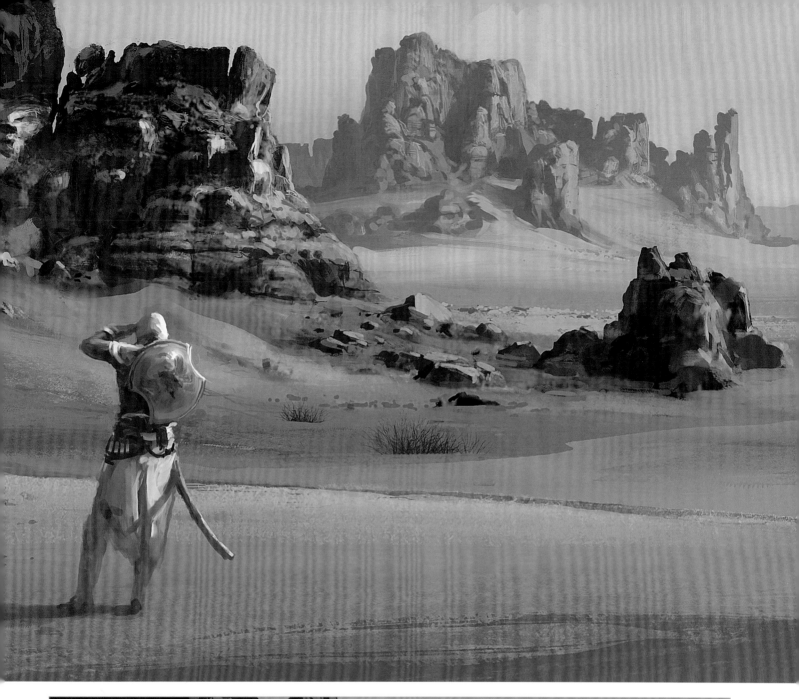

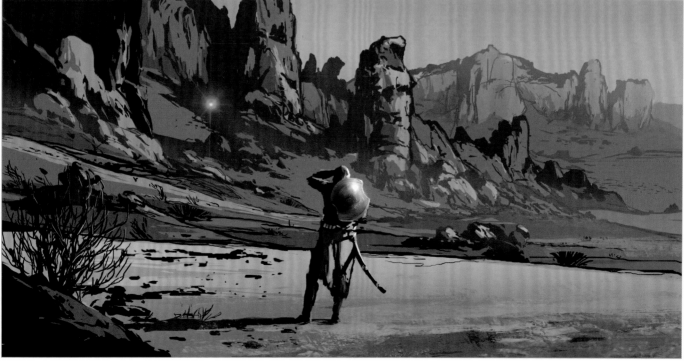

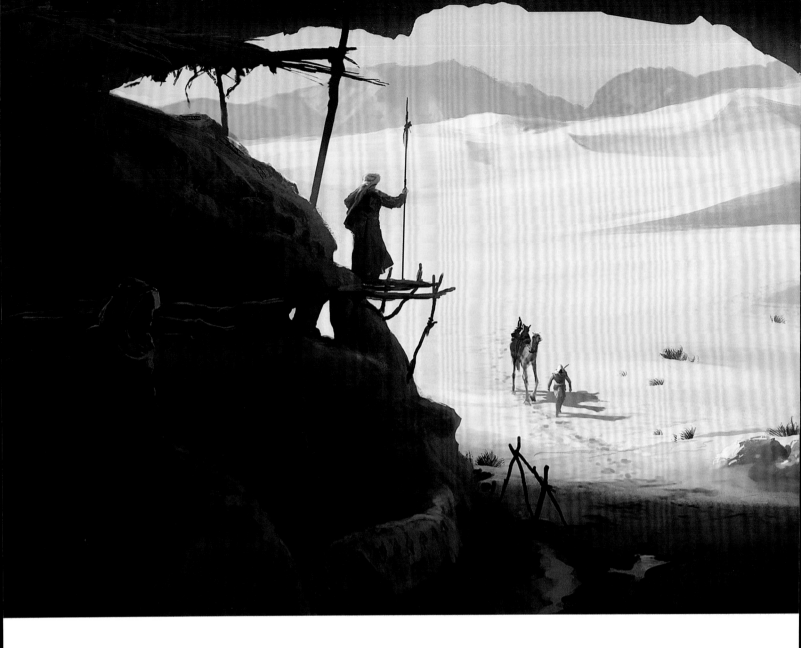

_CAVES AND HIDEOUTS

"Across the page is a proposition for the bandit camp in the mountains. The watchtower blends to stay hidden. I researched real mountain houses and the material used for inspiration and I found a circular house made of rock with a wooden rooftop. It was perfect. The choice of the lighting in this concept reflects the fact they are bandits and they stay hidden in the shadows.

[Right, center] "An exploration sketch of two characters reaching a small oasis in the desert." Martin Deschambault

"We've done multiple 3D iterations, virtually sculpting a landscape running from the Libyan Plateau to the Sinai from west to east, and from the Nile Valley to south of Faiyum from north to south." Raphaël Lacoste

Bayek's journey takes him into remote areas of the desert as he uncovers mysteries, hunts treasure and befriends allies in a personal odyssey, as seen in these pieces by Senior Concept Artist Martin Deschambault [above and above right] and concept artist Gilles Beloeil (right). Deschambault explains how these images came to be. "I created a series of artworks to propose different settings for this bandit camp. The cave concept came from the series of black and white sketches for the point of interest; for example, the water drop shape of the entrance."

Raphaël Lacoste says that "Location choices were informed by historical importance, but also visual and geographical diversity. We couldn't create this game without Alexandria, the pyramids and Memphis for example. We ensured we had different atmospheres and strong themes, like in Siwa or Thonis. The team sought to include known historical locations, but also beautiful artistic renditions of environments and atmospheres to create memorable and unique tones, and invoke specific emotions in the player."

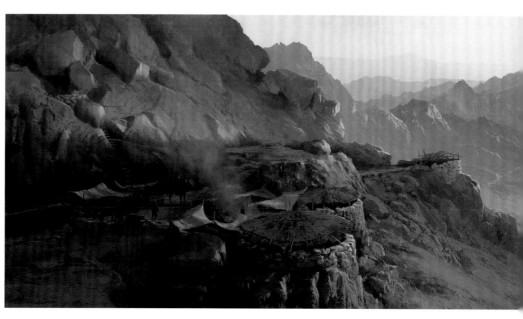
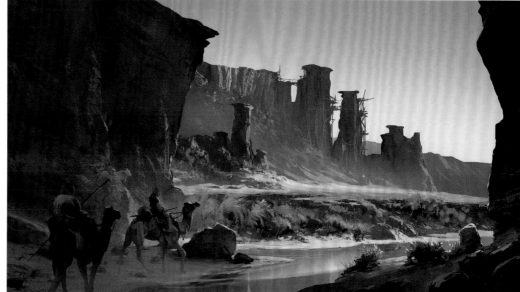
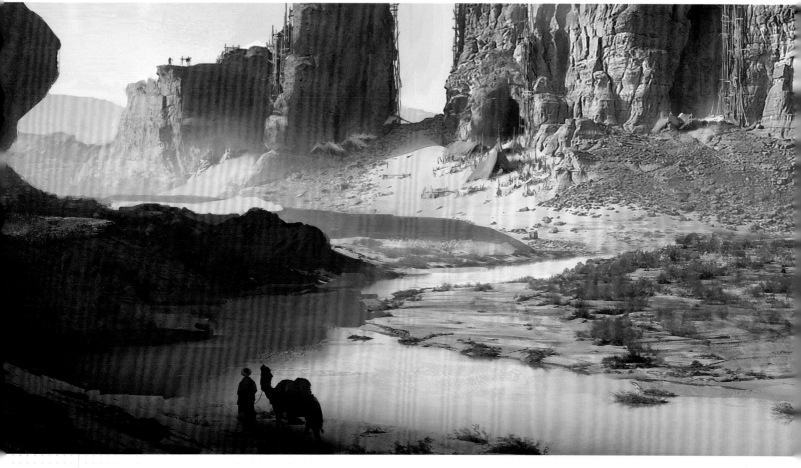

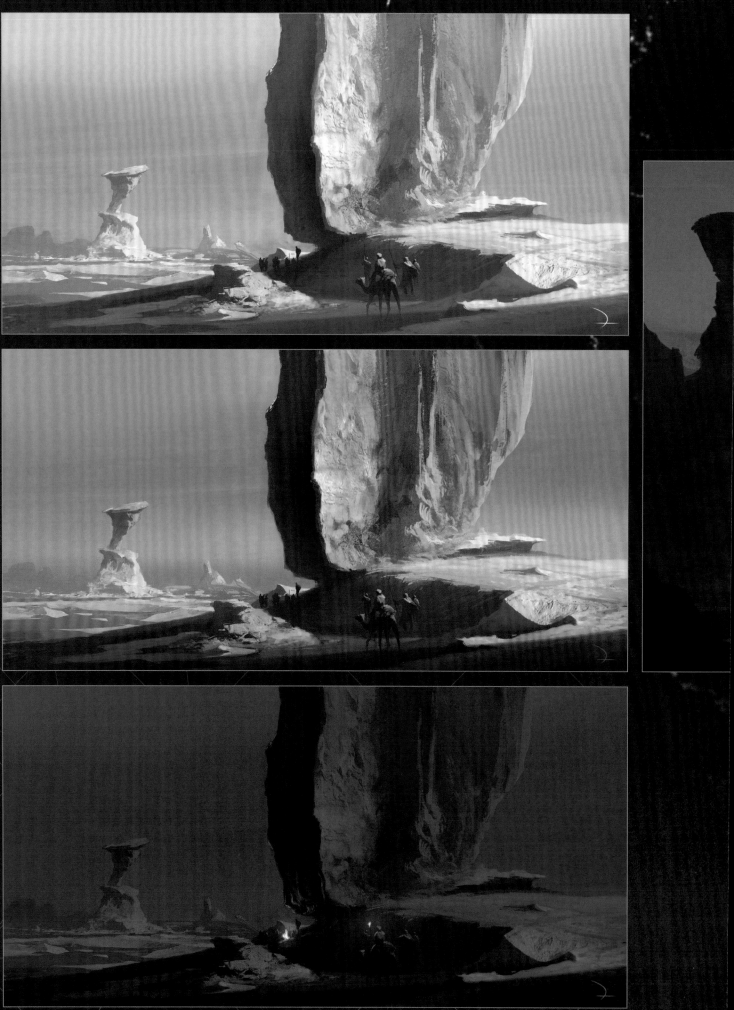

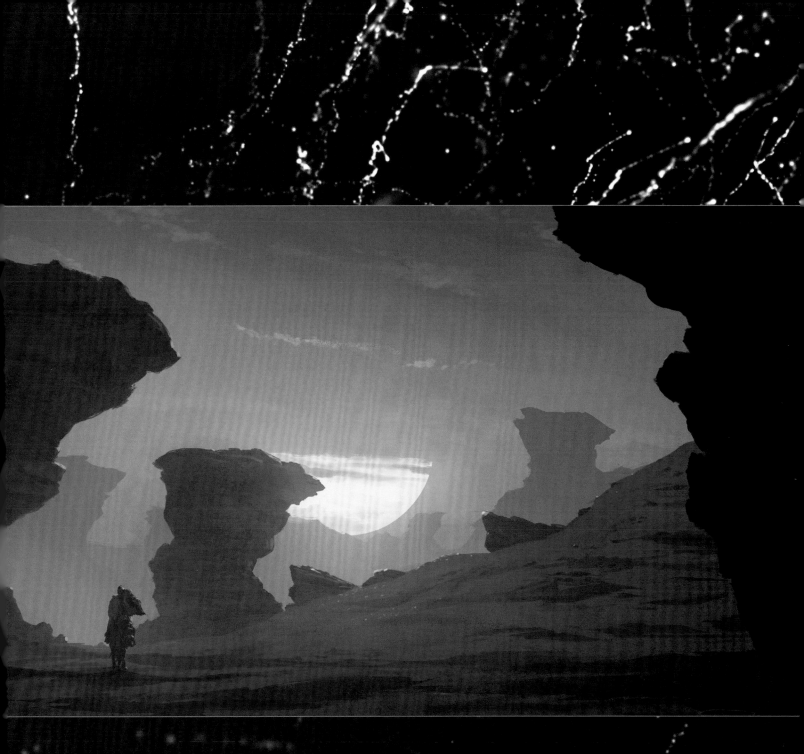

WHITE DESERT

Martin Deschambault explains the inspiration for these four pieces. "The shape of the white desert rock formation are very interesting. With the white desert, it is not only the shape that is interesting, the color also or how the ambient color affect the color of the landscape. I did these three artworks to show how the time of day will change the color of the rock formation, during the sunset they turn orange and the shadow will be blue. It was a great opportunity to play with the shape of the rock and for this one I thought it was a good spot for a temporary camp."

Raphaël Lacoste: "A Sunrise in the White Desert. this is a quite visually stunning place in our deserts, the sky color is almost projected on the white landscape. Ambient atmosphere is fascinating here, and the landscape reacts to light and time of day in a very unique way."

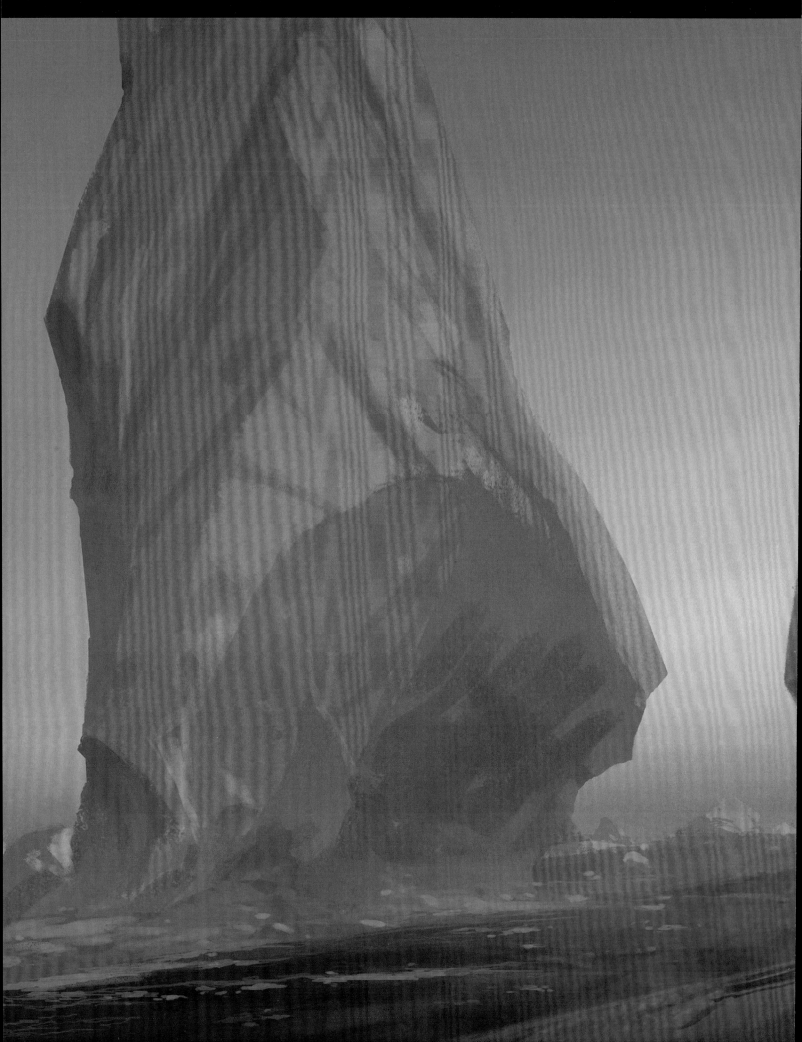

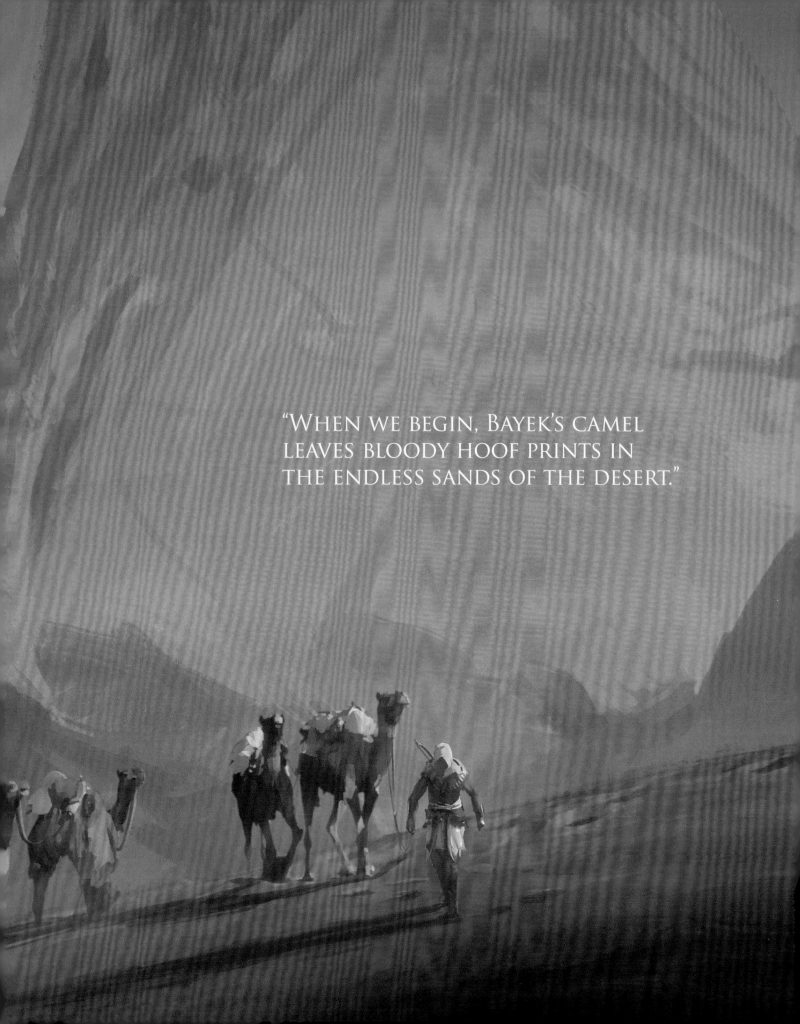

"WHEN WE BEGIN, BAYEK'S CAMEL
LEAVES BLOODY HOOF PRINTS IN
THE ENDLESS SANDS OF THE DESERT."

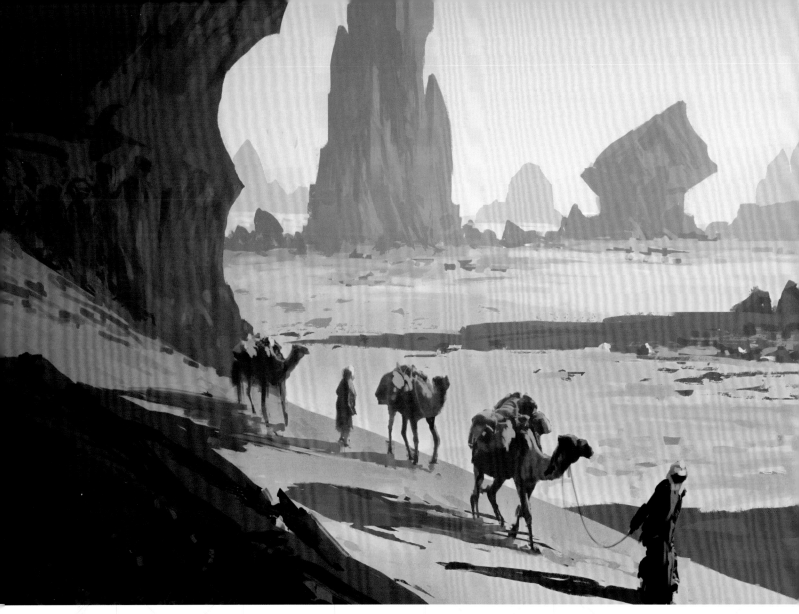

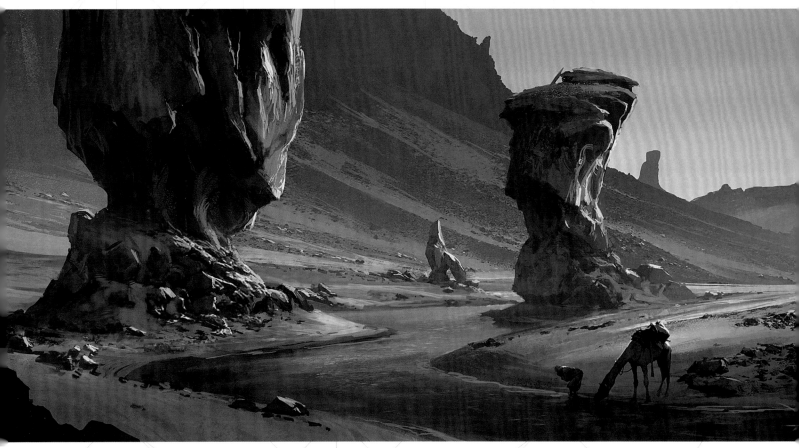

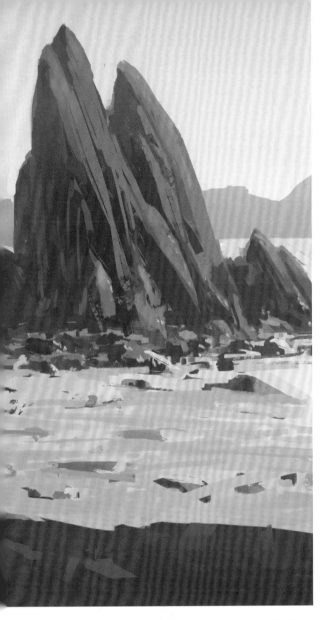

_BLACK DESERT

Concept artists do more than just study and copy photographs and images found in history books. This would be very dull for them and would not lead to the type of depth and creativity needed to make a compelling video game. No, the worlds we explore in Assassin's Creed, and every dramatic scene, are carefully crafted and directed to leave a lasting impression.

Says Raphaël Lacoste, "The beauty of the black desert is in its contrast, between a bright sand and a dark specular obsidian stone. We did a lot of research, wanting to create an interesting distinction with the other deserts we explore in the game, I did some concepts for this biome and wanted this one to be more mysterious, almost lunar – like being on another planet."

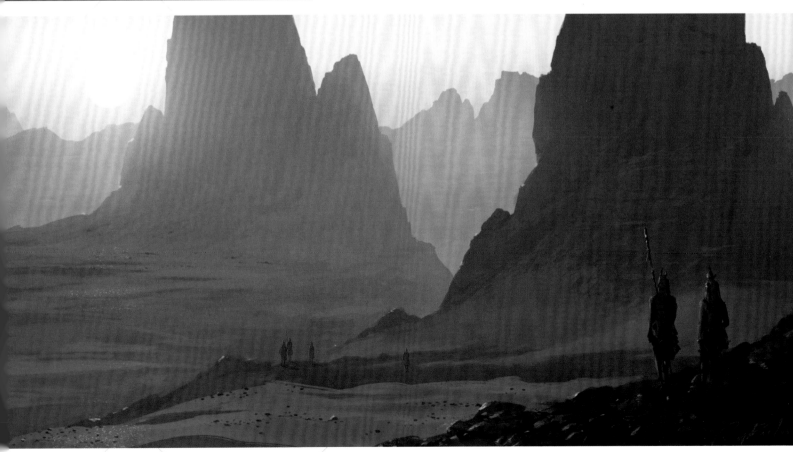

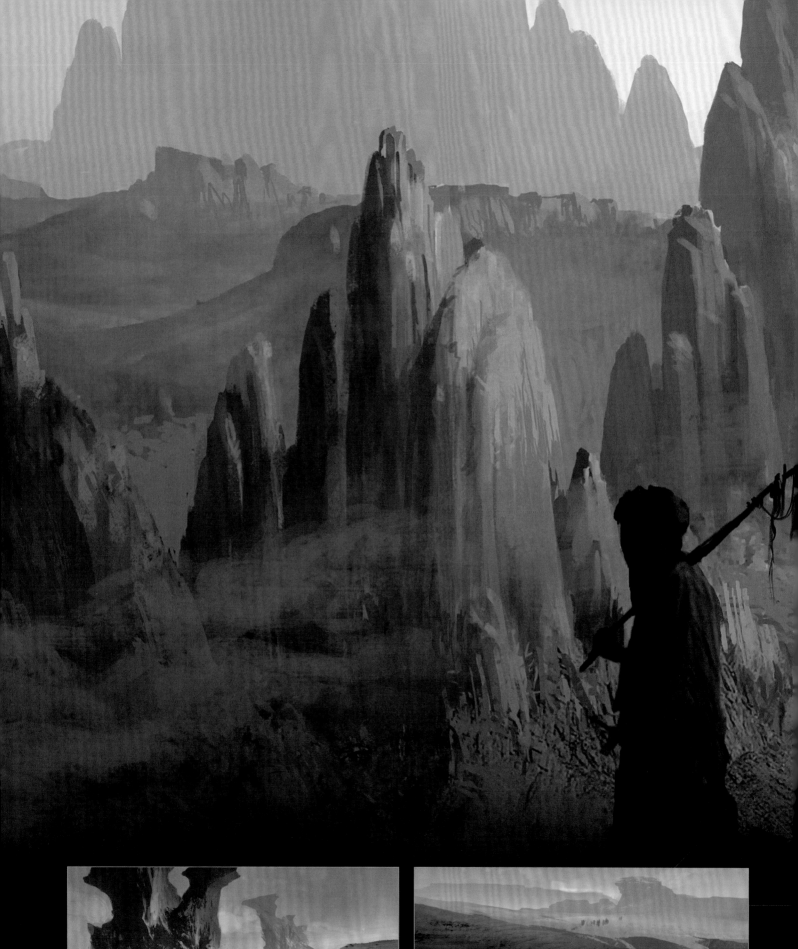

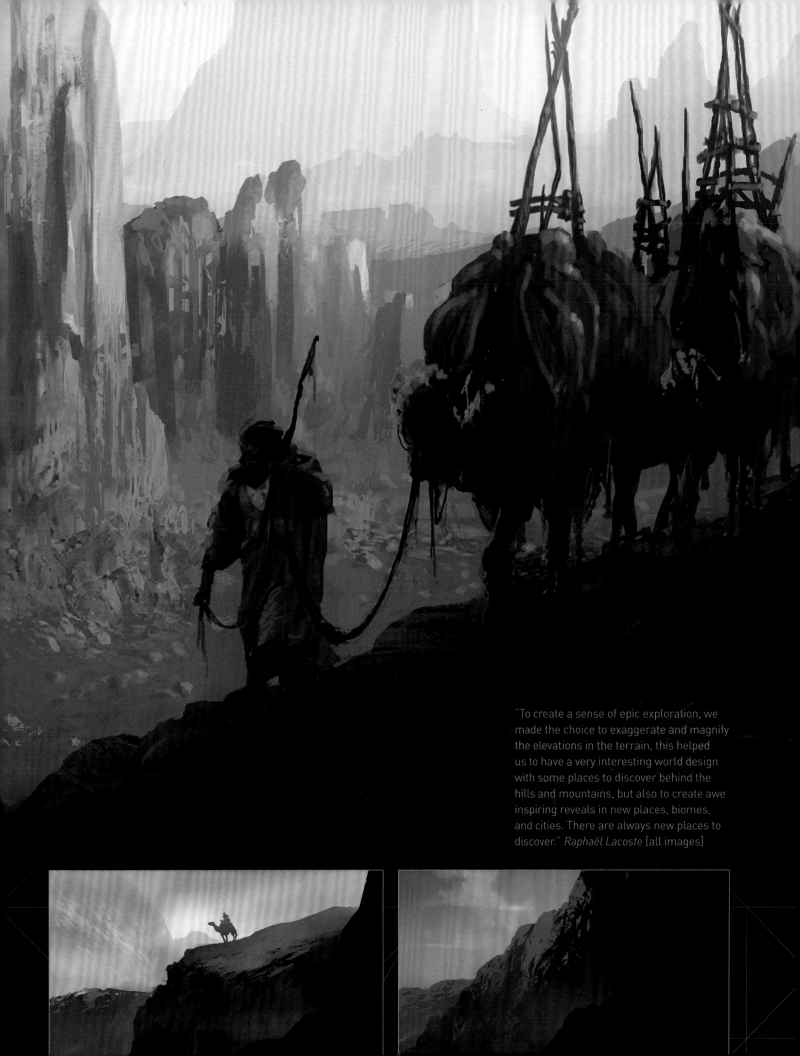

"To create a sense of epic exploration, we made the choice to exaggerate and magnify the elevations in the terrain, this helped us to have a very interesting world design with some places to discover behind the hills and mountains, but also to create awe inspiring reveals in new places, biomes, and cities. There are always new places to discover." *Raphaël Lacoste* [all images]

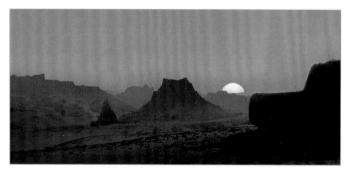
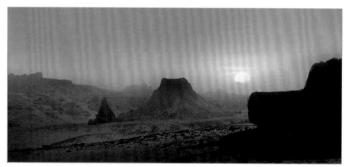

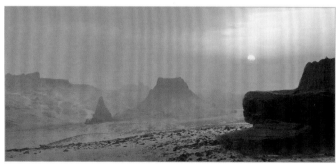
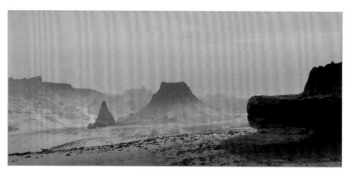

_TIME OF DAY

These pieces by Martin Deschambault explore how the time of day changes through the game: "Time of day is very important; color and lighting are different depending where you are in the world and we wanted to have the best color key for each main time frame. When you look at the references you will find thousands of different sunsets. We chose the ones that worked best for the location and did the cycle of the time of day. We also wanted to give a different ambiance depending on where you are in the game."

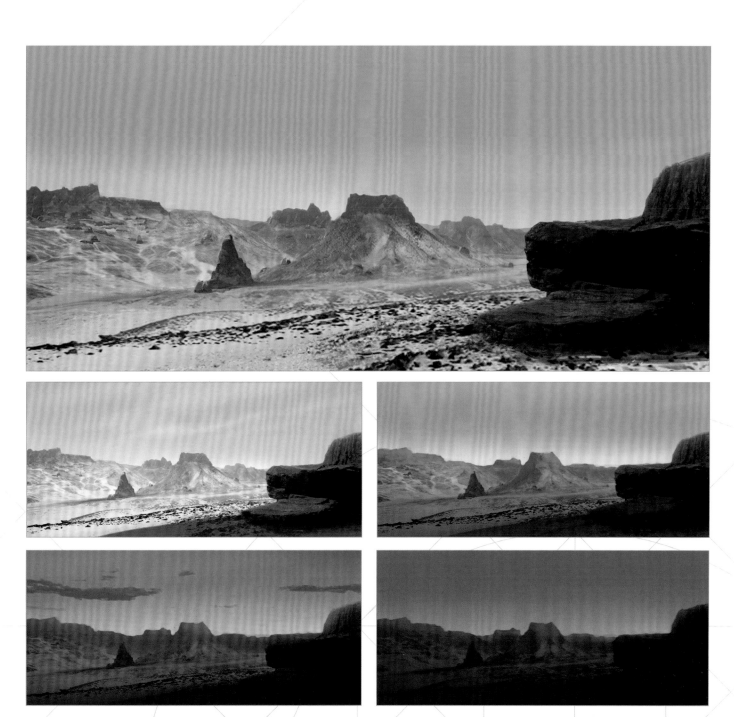

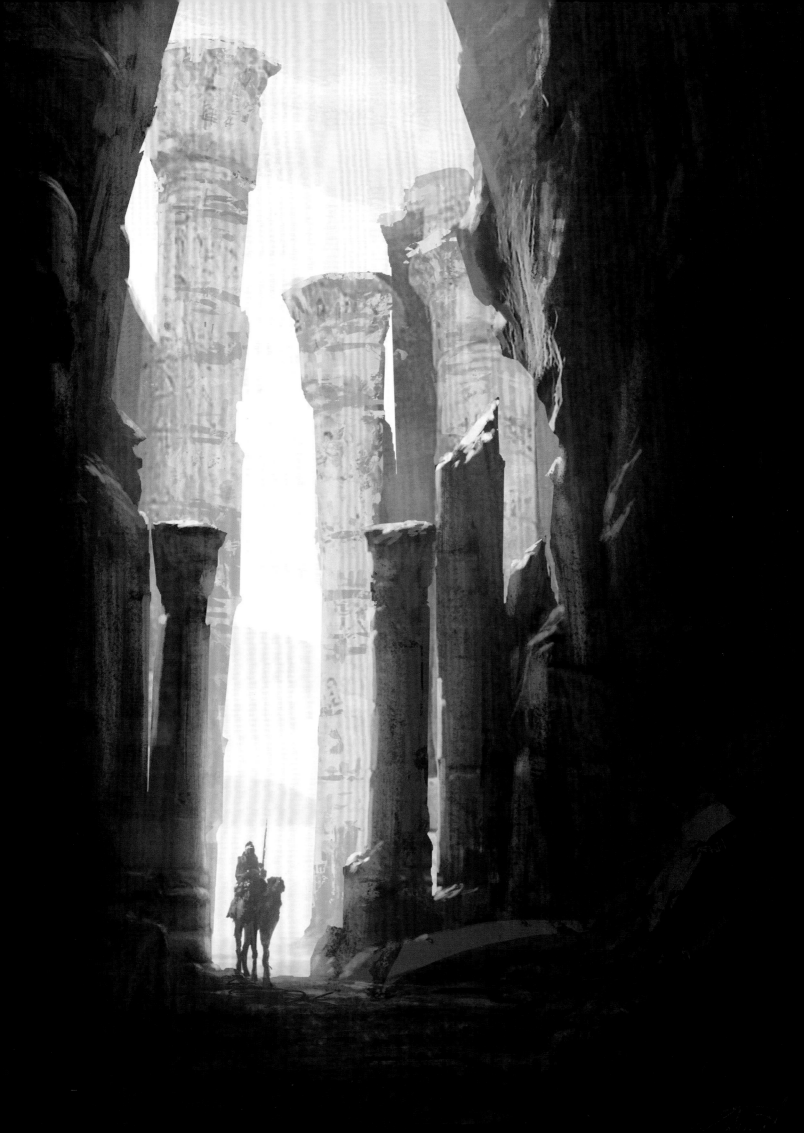

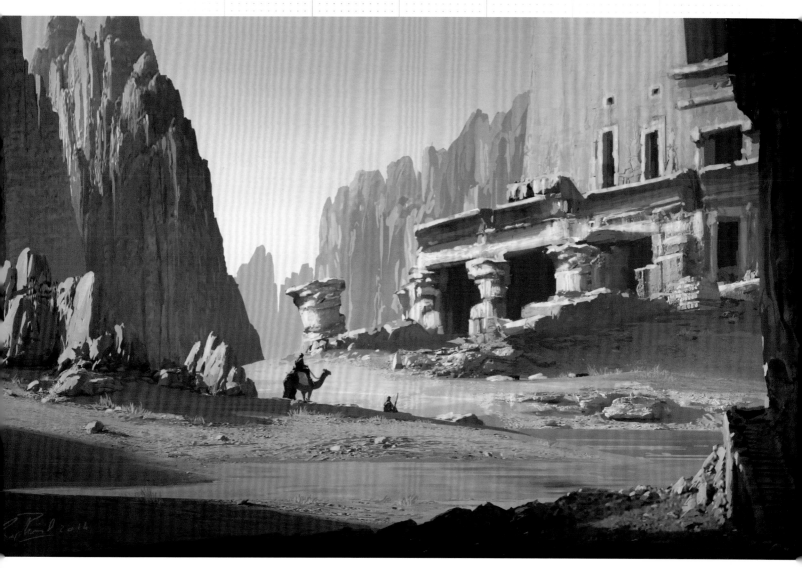

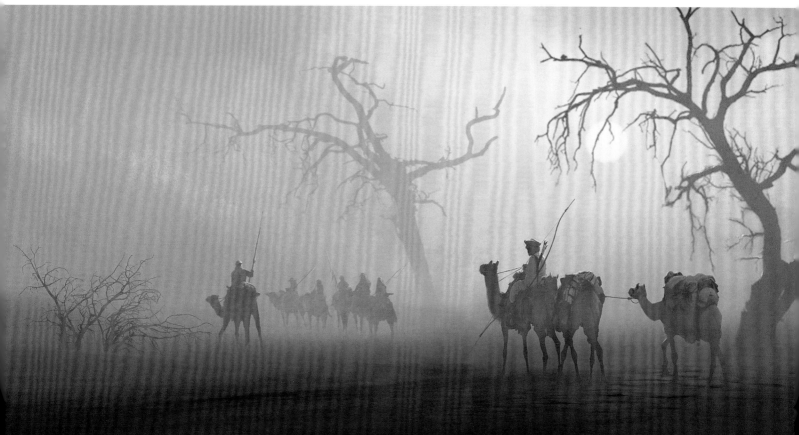

and top] artwork by Raphaël Lacoste

ve and overleaf] artwork by Martin Deschambault

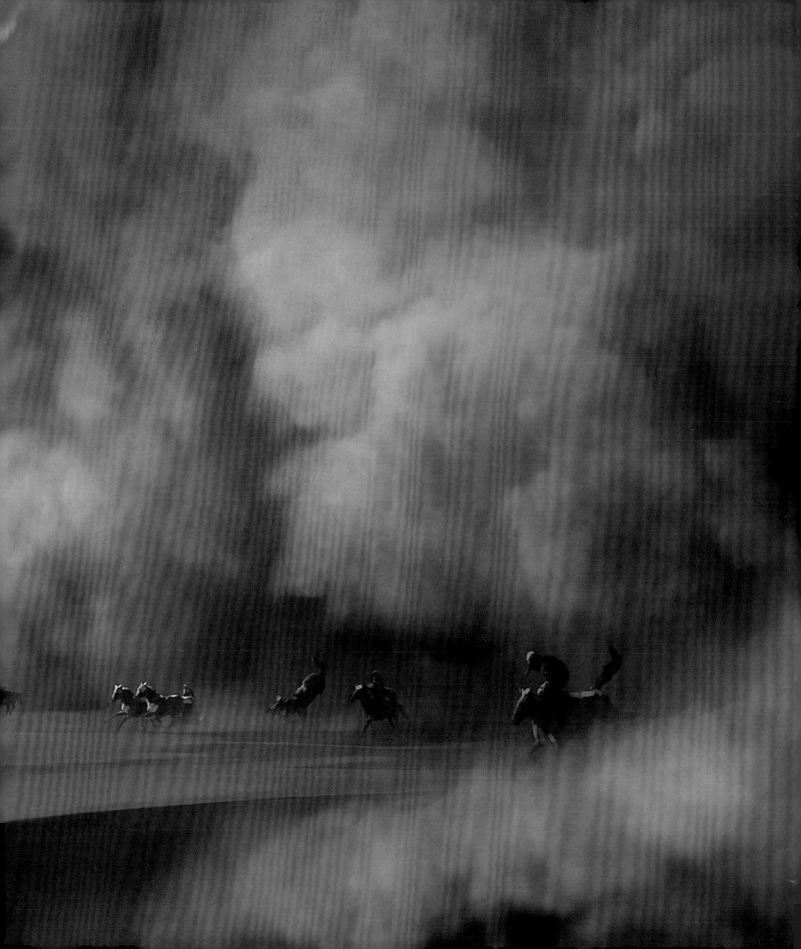

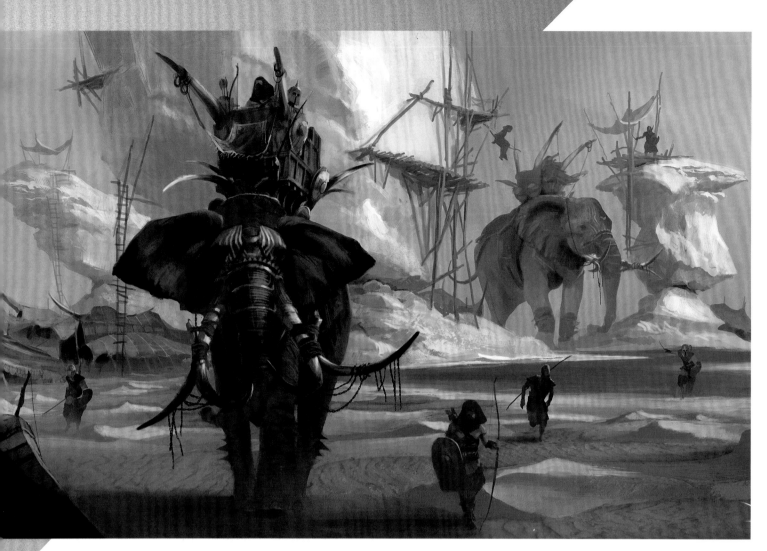

_WAR ELEPHANTS

Martin Deschambault talks about creating these specacatular pieces: "The war elephants are four iconic boss fights placed in different locations in the world. Each one has its own style; one is from the Roman army, set up in an old ruin in the Libyan plateau. Another is from a bandit army situated in the white desert. As you can see in the sketches [below] I did for the style proposition of each one, I tried to find different shapes with an iconic element for each one so you can recognize them from a distance."

(Right) "Key artwork of Bayek fighting a war elephant. Like the other elephant concept art, I did the silhouette of the elephant in black and white to make sure I would have an interesting pose for the final artwork." Martin Deschambault

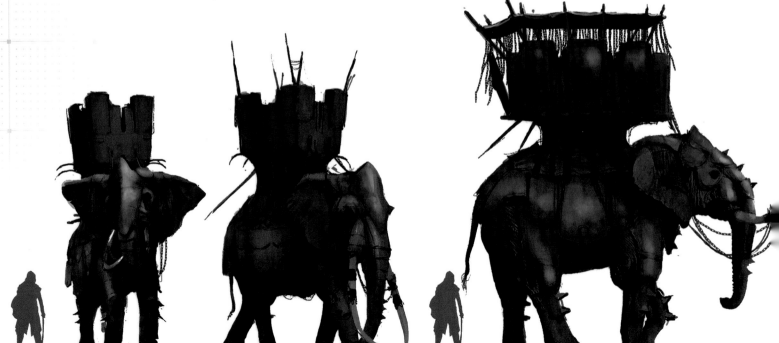

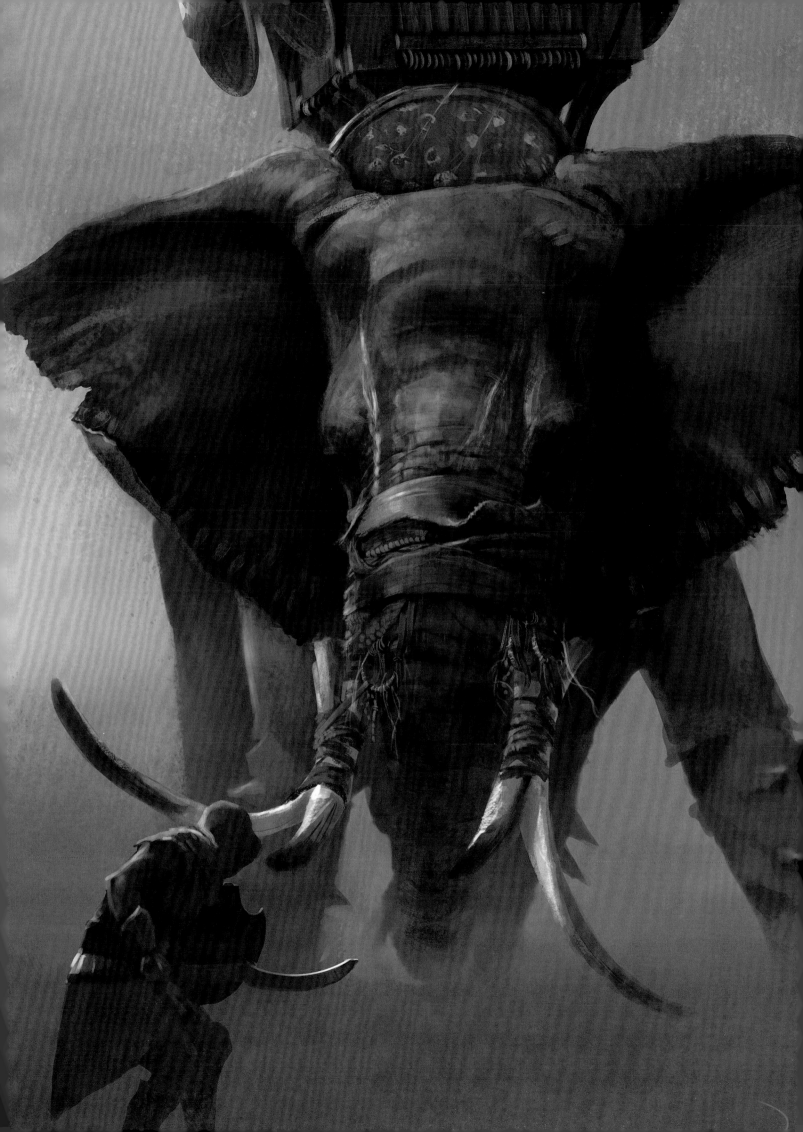

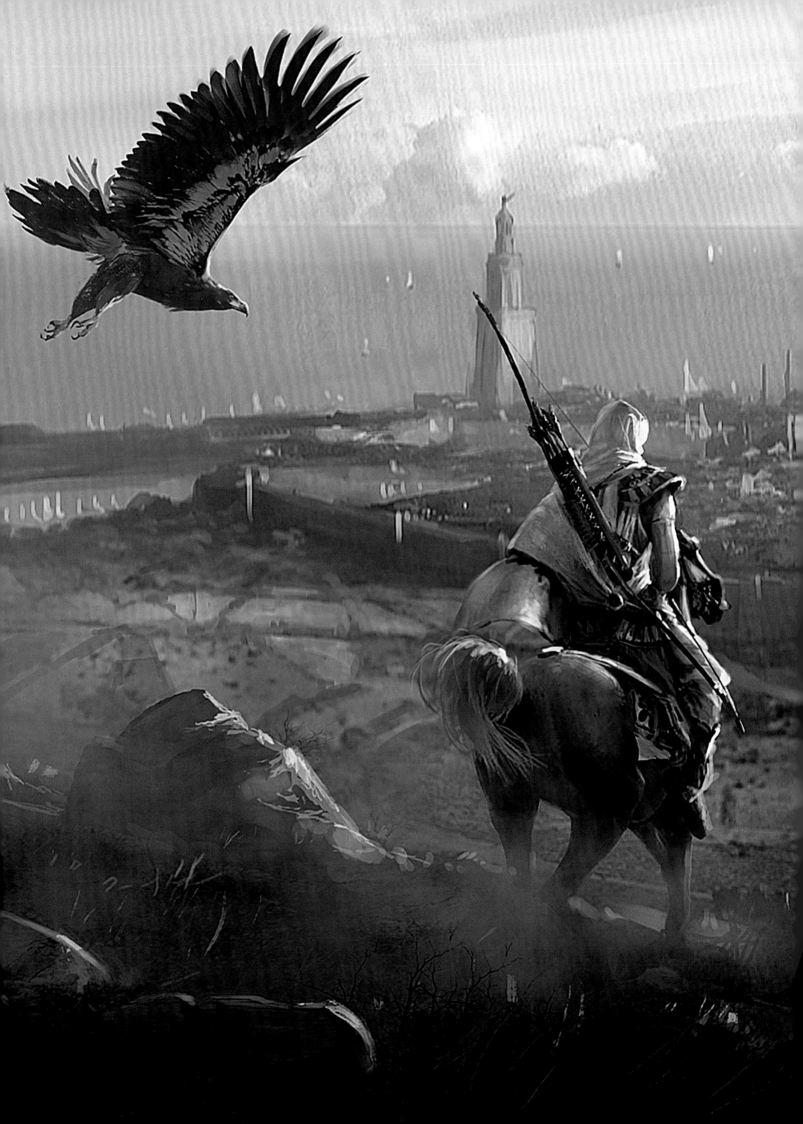

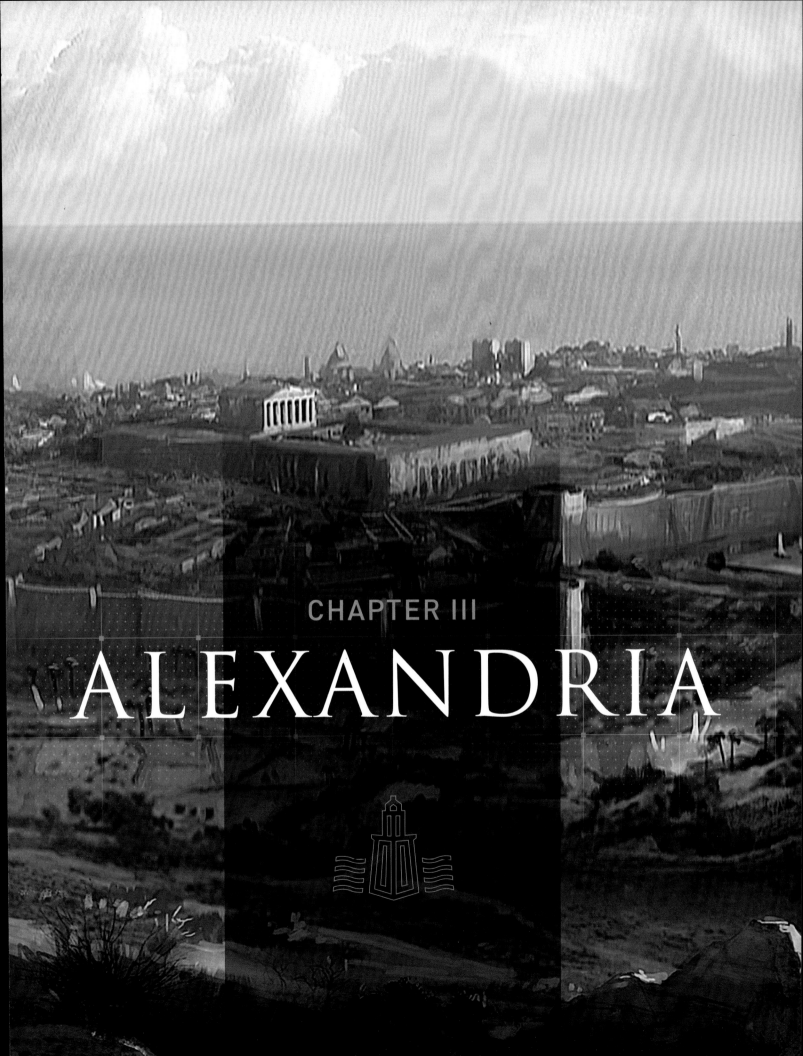

CHAPTER III

ALEXANDRIA

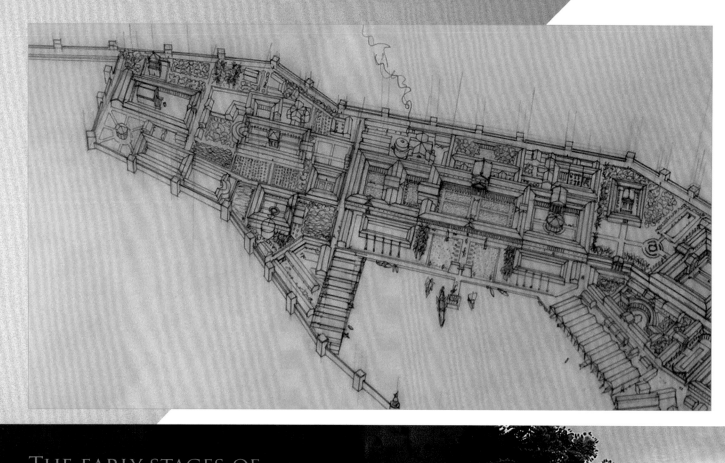

THE EARLY STAGES OF DEVELOPMENT ARE THE MOST EXCITING; THE RAW INSPIRATION OF THE CITY LAYS OUT A MILLION AVENUES FOR CREATIVE EXPLORATION.

_ALEXANDRIA

The *Assassin's Creed Origins* team was spoiled in that not only did they have the endless wild and natural world of Egypt, but also one of the greatest cities in western civilization. As Raphaël Lacoste explains, "Alexandria was a city of power, revolt, and a multiculturalism of unprecedented scale. The Greco-Roman monuments were stunning but also shrouded in mystery."

"Some details really impressed us during our research. For example, there's been more time between the building of the Great Pyramids and Cleopatra, than between Cleopatra and our time," Lacoste says. "As for Alexandria, it was a huge city and the seat of the Ptolemaic royals, such as Cleopatra who lived there in her Palace. The famous lighthouse was a veritable skyscraper for its time, rising 120 meters above the sea and was a beacon of the future and progress with no equivalent at the time. Inside was a helical ramp that allowed horses to bring wood to feed the flames."

A basic, monochrome elevation is sketched before artists set to work constructing the full city. This vision of Alexandria is a colossal effort on the studio's part, based on research in collaboration with historian Jean-Claude Golvin [left]. It was fascinating to see the great city take shape, to give the story a place to exist, imagining potential as a parkour playground for Bayek.

[Below and previous page] artwork by Martin Deschambault

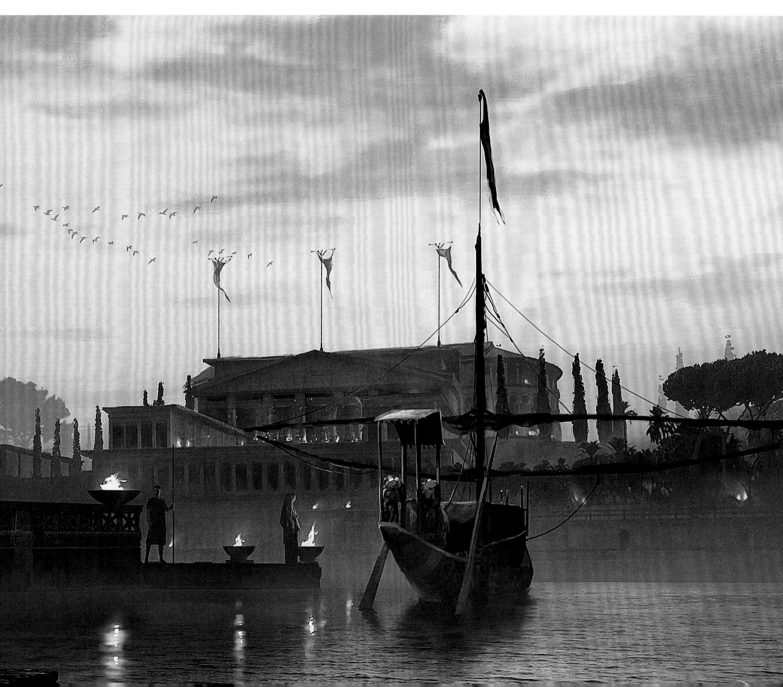

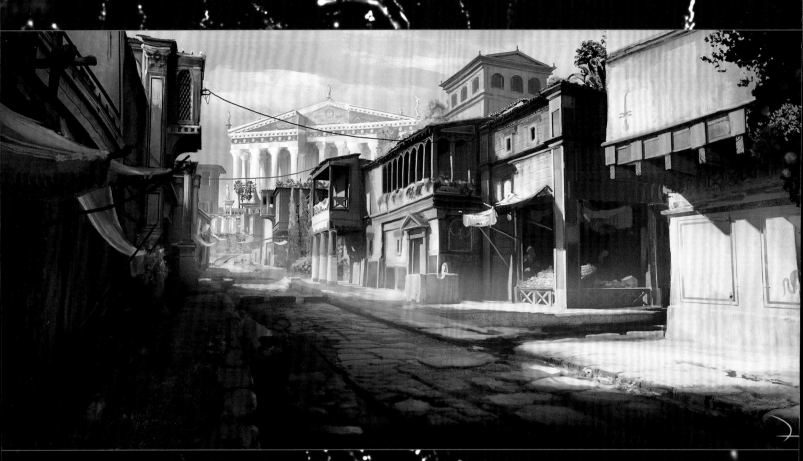

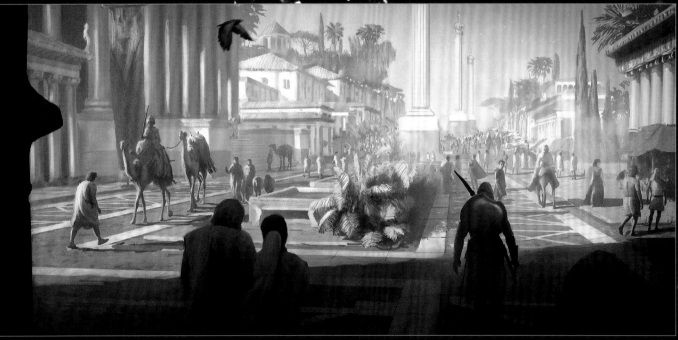

STREETS AND AVENUES OF ALEXANDRIA

"The Great Avenue, the Canopic Way of Alexandria, is populated by the biggest monuments of the Ptolemaic era: Cleopatra's Palace, Alexander's Tomb, the Theater, the Serapeum, the Great Library," explains Raphaël Lacoste, and shown in the artwork [above] by Gilles Beloeil. "It's one of the most beautiful avenues ever created in an Assassin game, with its concentration of such majesty and opulence."

"Our goal was to have players in awe when discovering one of the most magnificent antique cities ever recreated in a videogame, and give a visual contrast to the poor Egyptian villages – which are not without their own charms – that they visit on their journey." Raphaël Lacoste

"The look of Alexandria's architecture was a challenge," explains Senior Concept Artist Martin Deschambault [right & top]. "We had references and information about real houses, but decided to push the richness and the color to make it even more epic and beautiful.

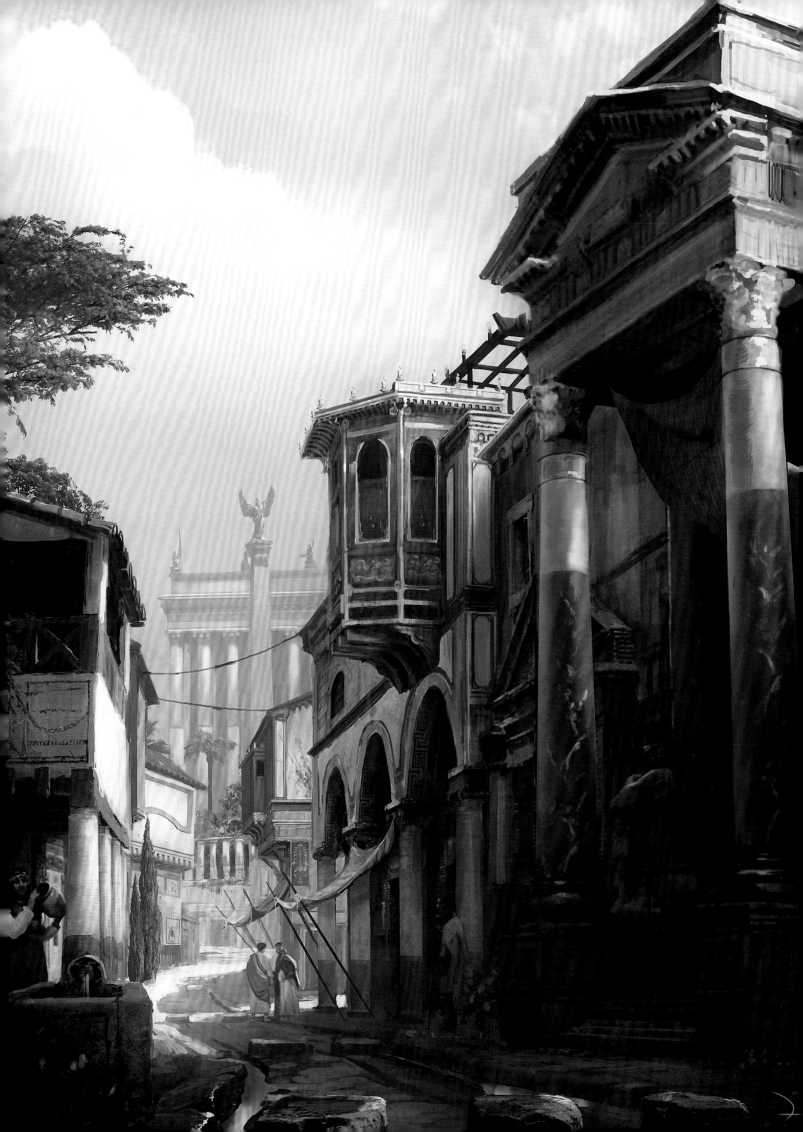

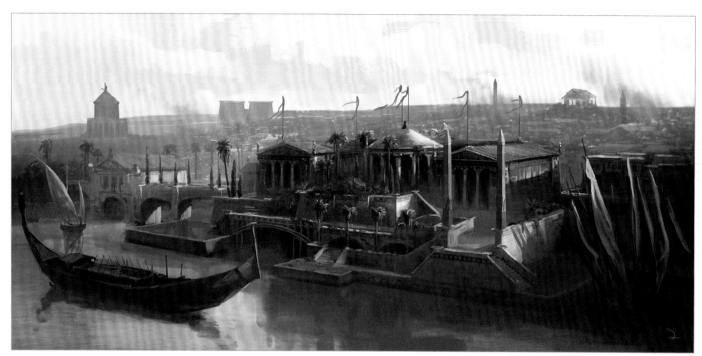

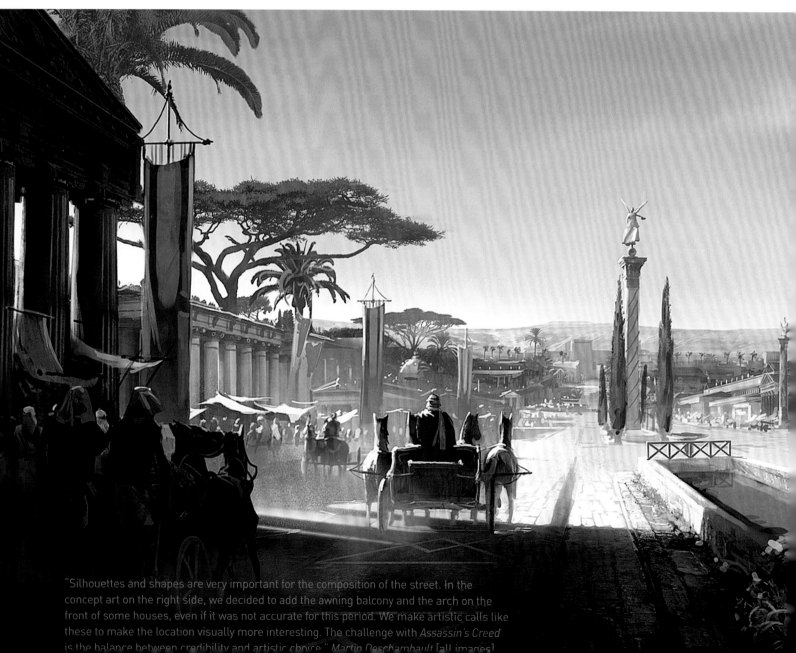

"Silhouettes and shapes are very important for the composition of the street. In the concept art on the right side, we decided to add the awning balcony and the arch on the front of some houses, even if it was not accurate for this period. We make artistic calls like these to make the location visually more interesting. The challenge with *Assassin's Creed* is the balance between credibility and artistic choice." *Martin Deschambault* [all images]

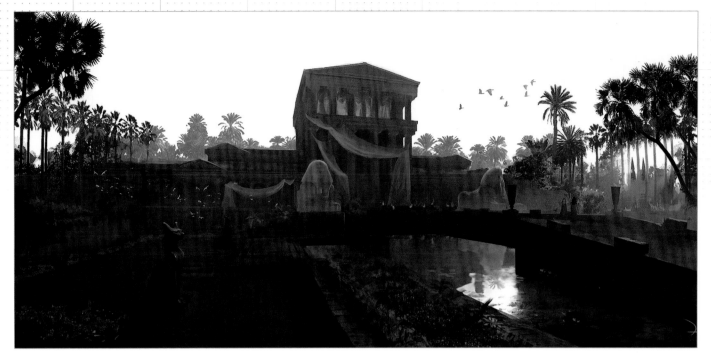

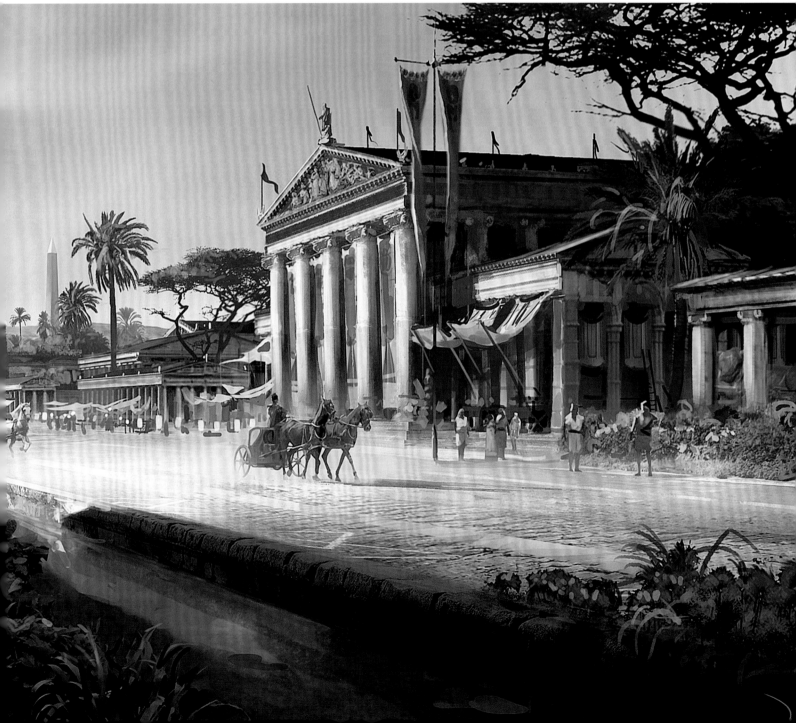

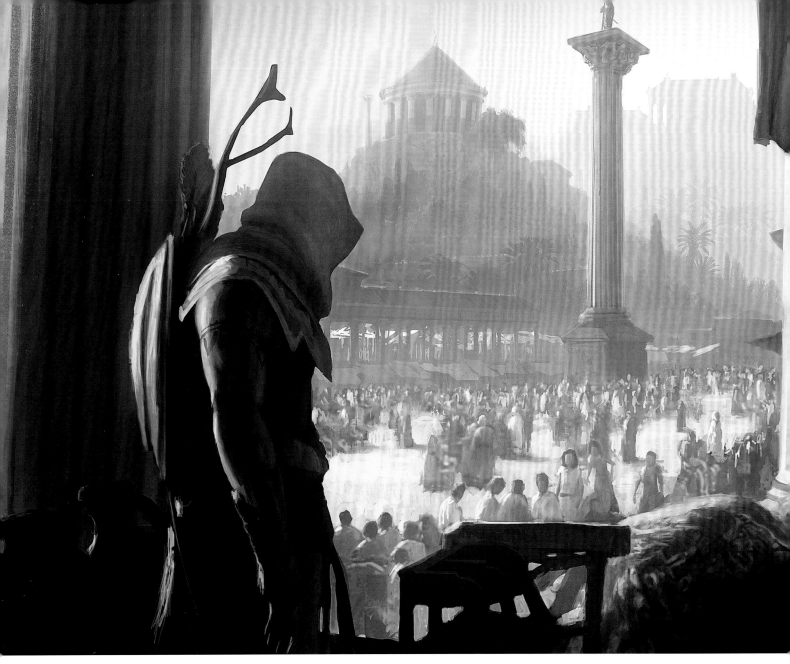

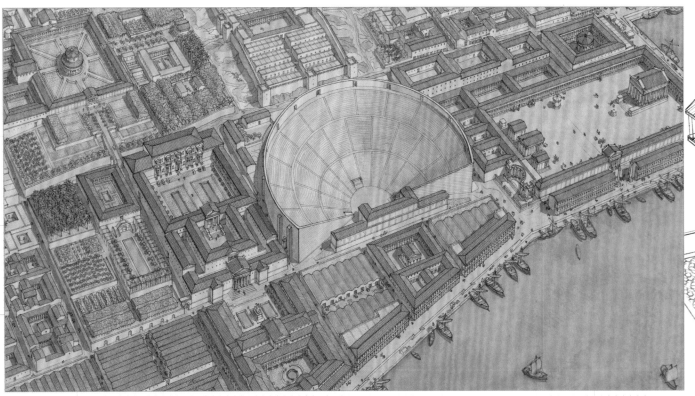

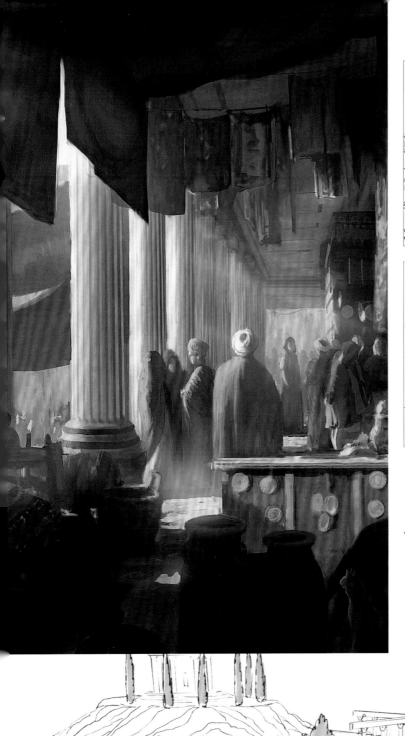

_STREET LIFE

"The magnificent drawings of Jean-Claude Golvin [below left] inspired us to do some line art of our own [below & above]. It turned out to be very useful for the 3D team because you don't have all the information of lighting, texture, props and characters that can hide the architectural information," Martin Deschambault explains.

[Top left] artwork by Gilles Beloeil

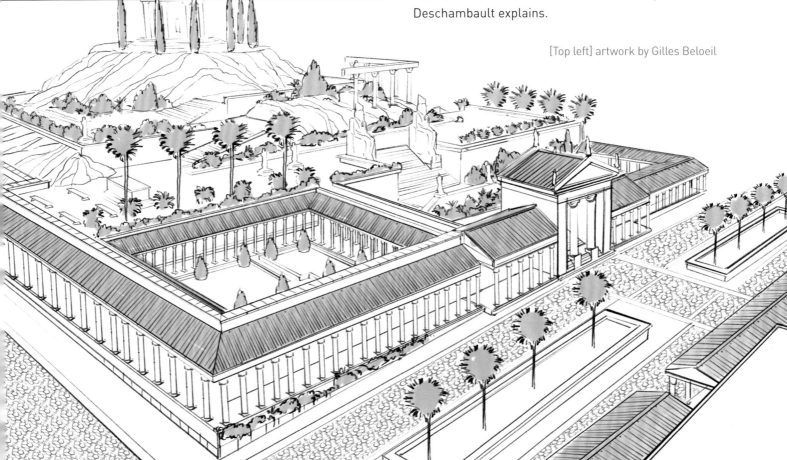

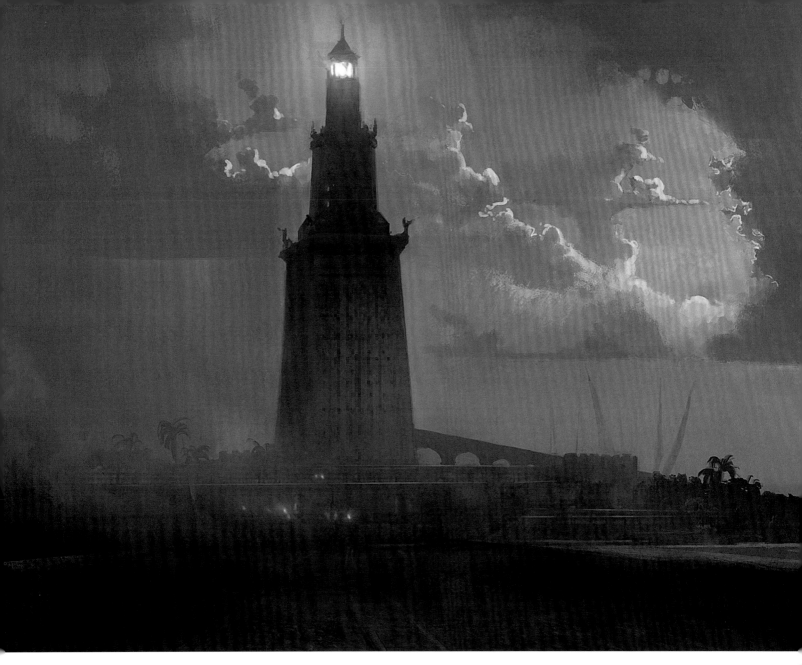

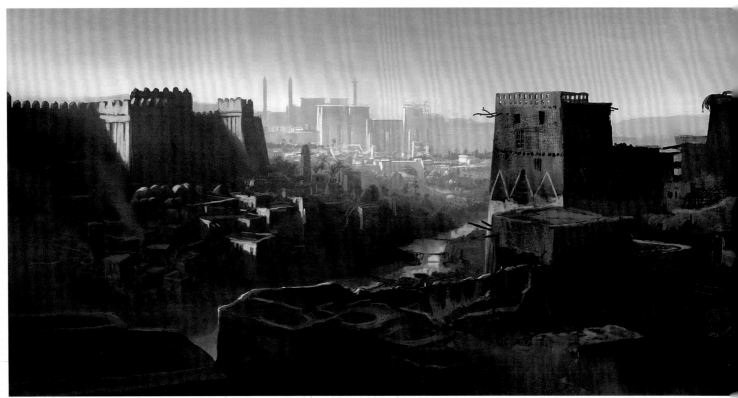

The Alexandrian skyline has been lost for hundreds of years, making the *Assassin's Creed Origins* project of rebuilding the legendary city so thrilling. Senior Concept Artist Martin Deschambault chose to highlight the most famous landmarks of the time in these pieces.

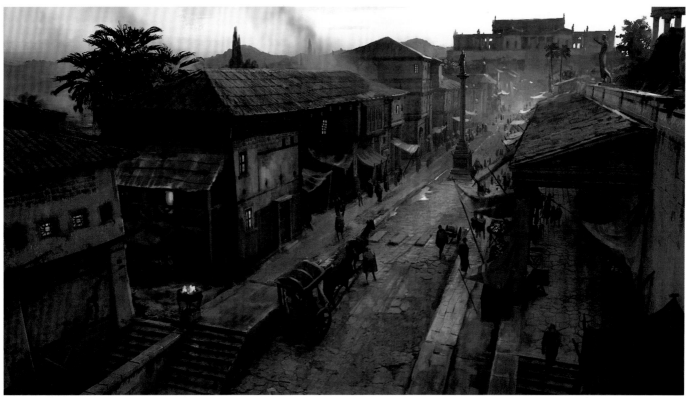

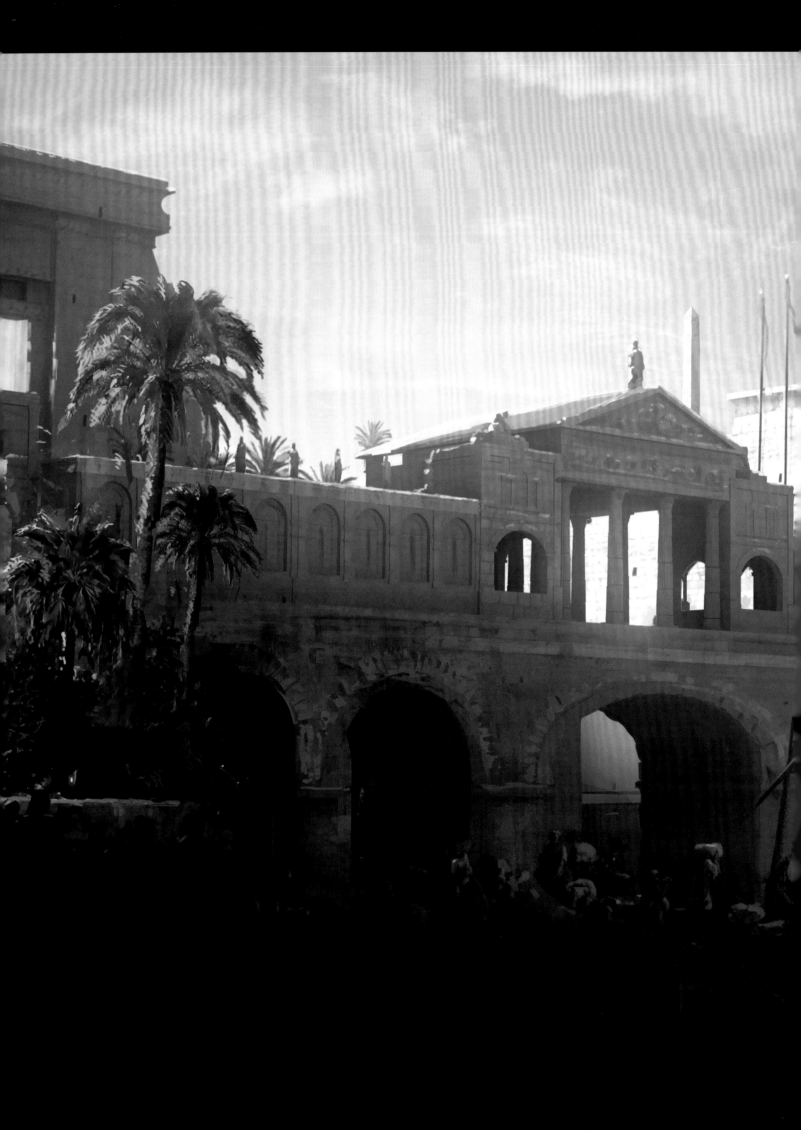

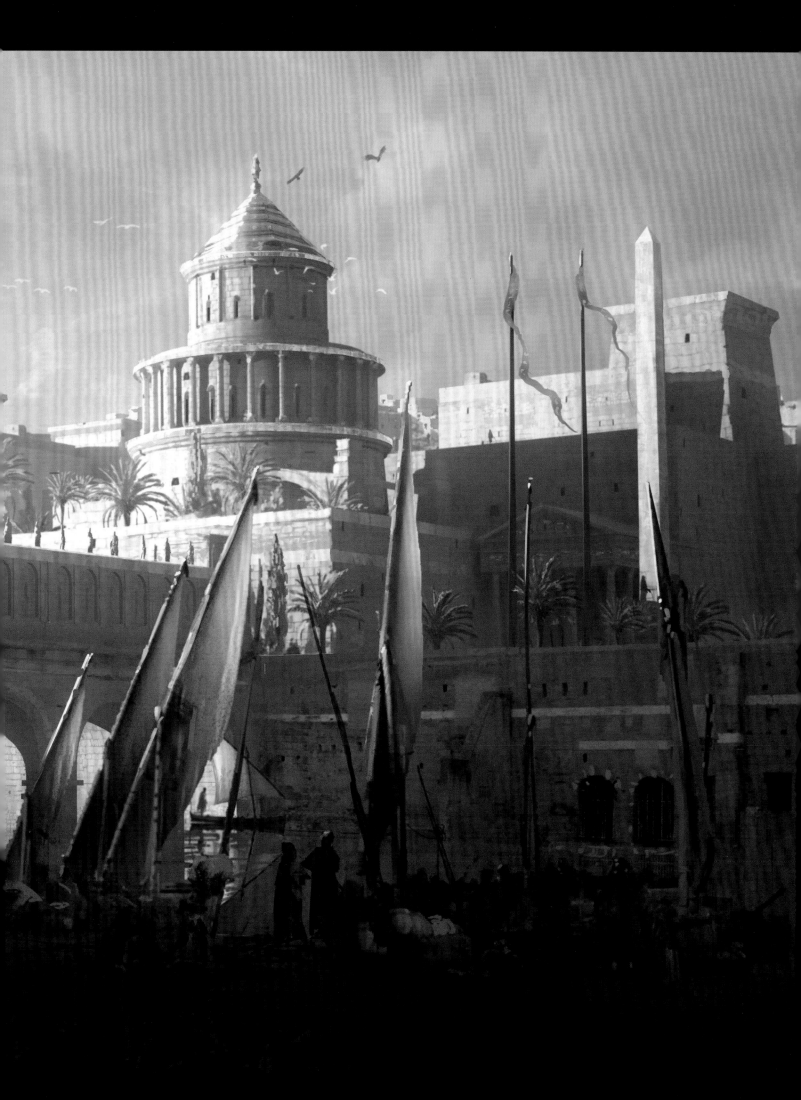

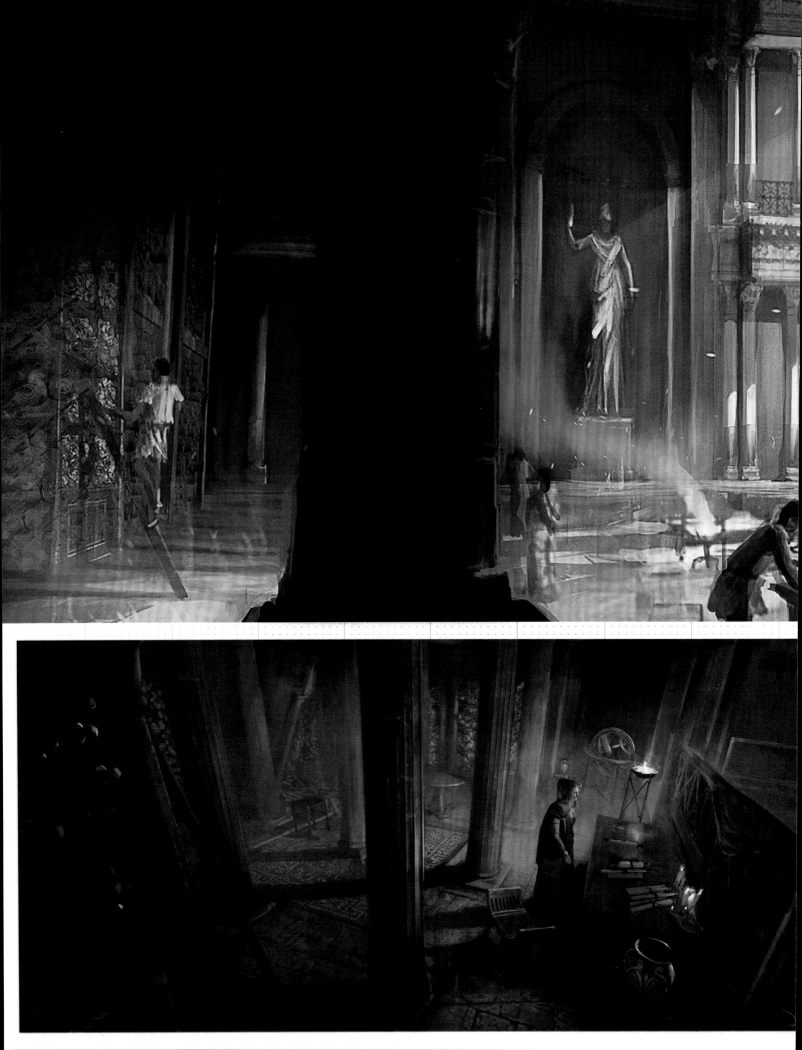

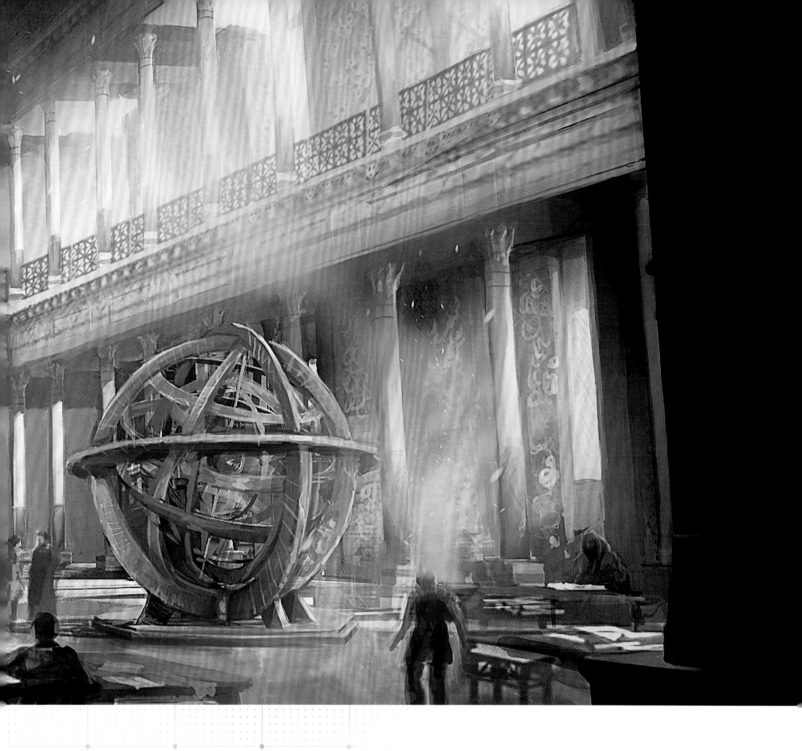

_GREAT LIBRARY

Raphaël Lacoste: "We decided to give the player access to hidden locations in the city's foundations, to show both the majesty and opulence, and the mysteries of ancient Egypt. We seek to create links between history and our game, balancing the rhythm of player discovery with gameplay aspects in compelling new ways."

The Great Library of Alexandria is the location of one of the puzzle-oriented set pieces in the game. Hidden below its floor is a sacred den that Bayek seeks access to by solving a cryptic poem. Very few people know of the den's existence. It is a place of knowledge, where scholars have covered the walls with documents and sketches, left bottles of wine on the ground, and piled weaponry on top of papyri, maps and plans. According to one description among the concept notes, this is where wild fantasies of conspiracy and hidden truths flourish, in other words, "It resonates with an ancient vibe".

Little do the learned people of Alexandria know that beneath them lies knowledge that would challenge their concepts of order and existence.

[Previous page] artwork by Raphaël Lacoste
[Left] artwork by Martin Deschambault
[Top] artwork by Raphaëlle Deslandes

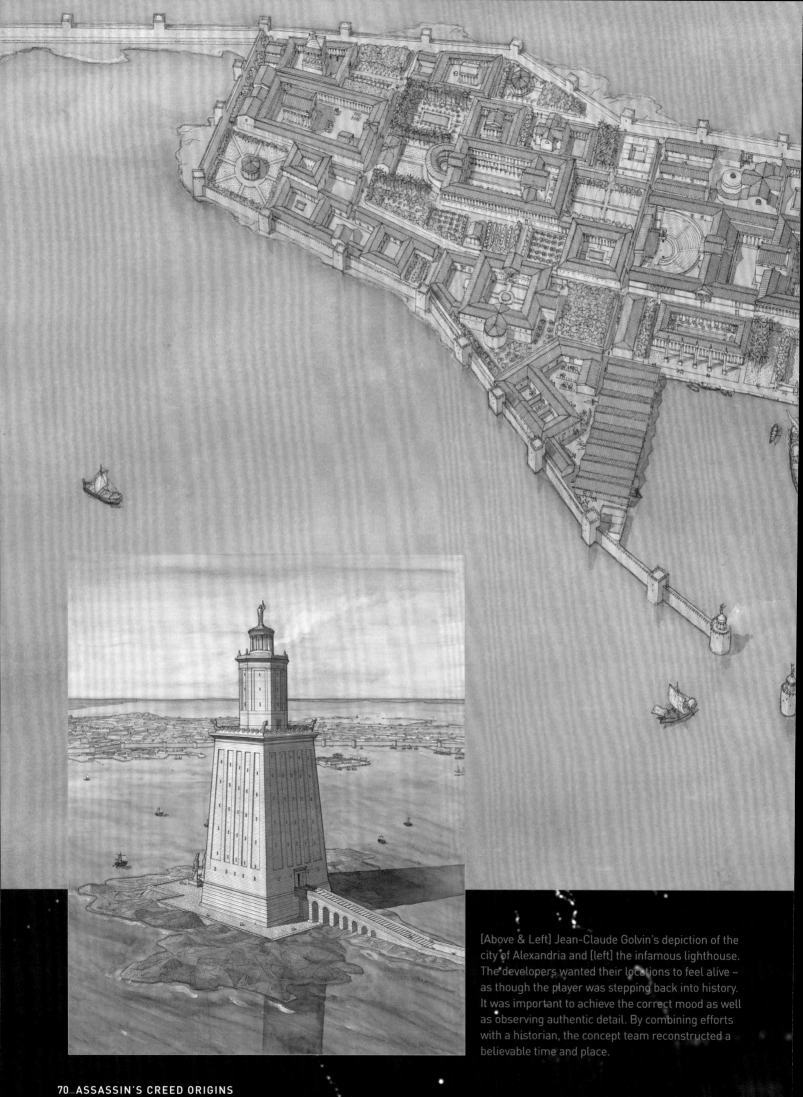

[Above & Left] Jean-Claude Golvin's depiction of the city of Alexandria and [left] the infamous lighthouse. The developers wanted their locations to feel alive – as though the player was stepping back into history. It was important to achieve the correct mood as well as observing authentic detail. By combining efforts with a historian, the concept team reconstructed a believable time and place.

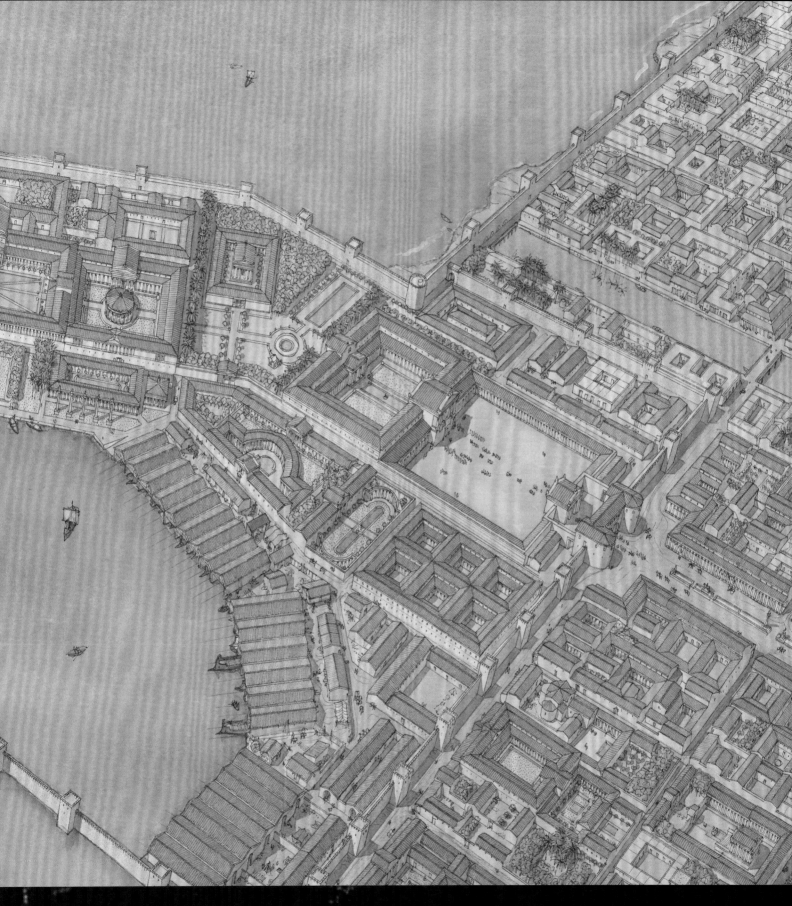

Jean-Claude Golvin's extensive research into the period has guided Ubisoft's artists on the types of items to include, and what their purpose was. The vivid color and atmosphere brings the scene to life.

"Jean-Claude created more than fifty drawings and watercolors during our preproduction," Raphaël Lacoste says. "This series of unique images helped us create Alexandria, Letopolis, Siwa, Krocodilopolis, and Heraklion. He also gave detailed written descriptions of locations, and the citizens' lifestyle and activities. Jean-Claude knows history, but he is also able to provide an artistic interpretation and soul to the recreation of a place."

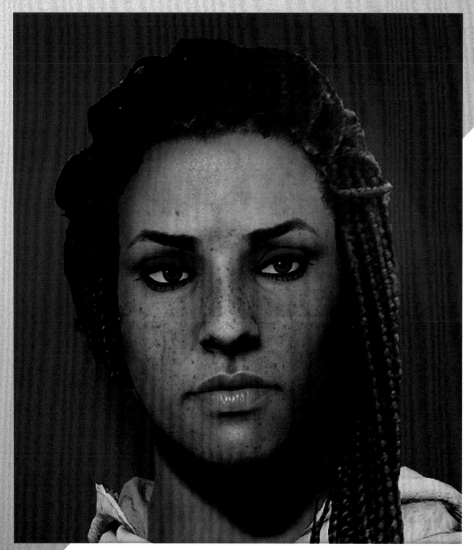

_AYA

Aya is as determined as Bayek to avenge their son's death and assure freedom for her people. Aya favors a do or die philosophy, contrasting with Bayek.

Aya is tough and has an impulsive nature, but her cool head and intelligence have enabled her to befriend Cleopatra. They talk directly about the threats they face, and Aya displays a shrewd in-your-face attitude while serving as a vigilante on the royal payroll. In return for handling Cleopatra's dirty work, Aya receives help breaking down the network of scoundrels working for Ptolemy XIII, as well as closing in on her son's killers.

Her role as bereaved mother is written behind her eyes, where we see sadness as well as determination. Raphaël Lacoste: "As a Heroic Woman, we wanted Aya to be memorable, bringing to life her reckless temper and charismatic beauty. We worked on several options for her haircuts, face and outfit to explore the best fit for her unique personality."

[Above] paintovers by Jeff Simpson & Raphaël Lacoste
[Right] artwork by Vincent Gaigneux

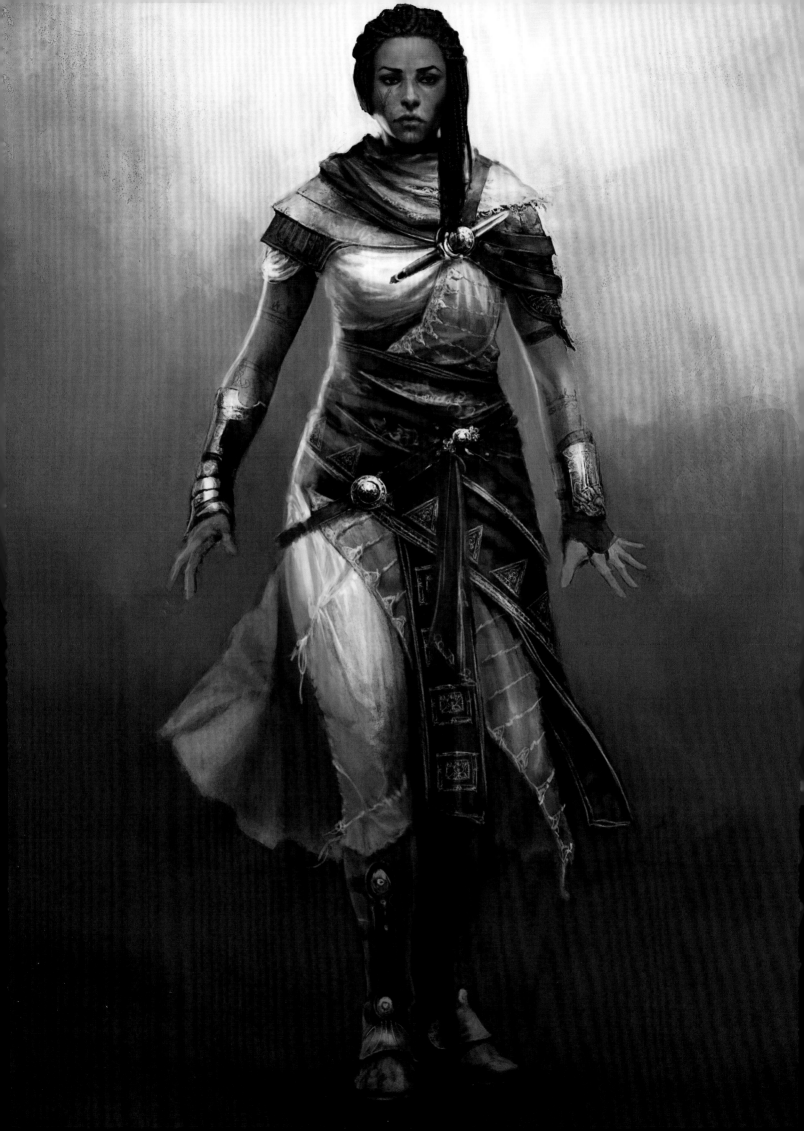

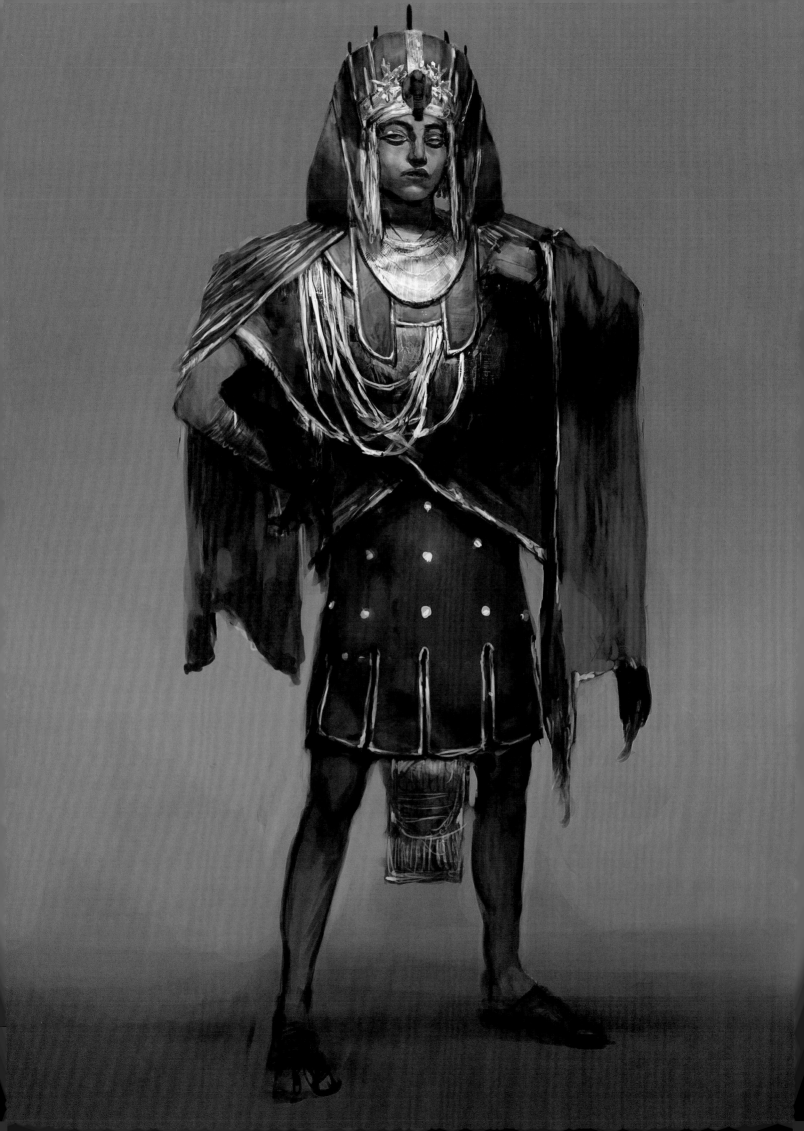

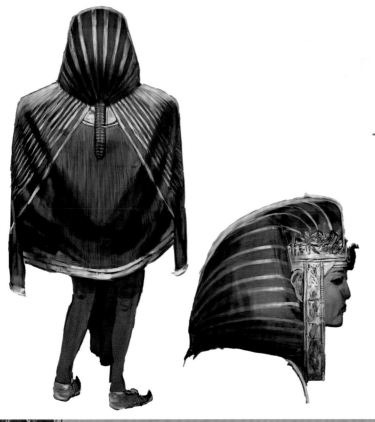

_PTOLEMY XIII

Theos Philopator Ptolemy XIII is a boy-king of Egypt and does not have the strength or charisma to preside over an empire. History informs us that a regent called Pothinus was appointed for him and the narrative team further supposes that a secretive Order, driven by a desire for arcane knowledge, became the driving force behind many of Ptolemy's actions.

Jeff Simpson [left]: "He's a kid who thinks he's a king, wearing ridiculously oversized clothes; you pretty much know this guy isn't going to survive very long. It's always more fun to design villains than heroes. Really hard to make the Egyptian royalty stuff not look TOO kitschy..."

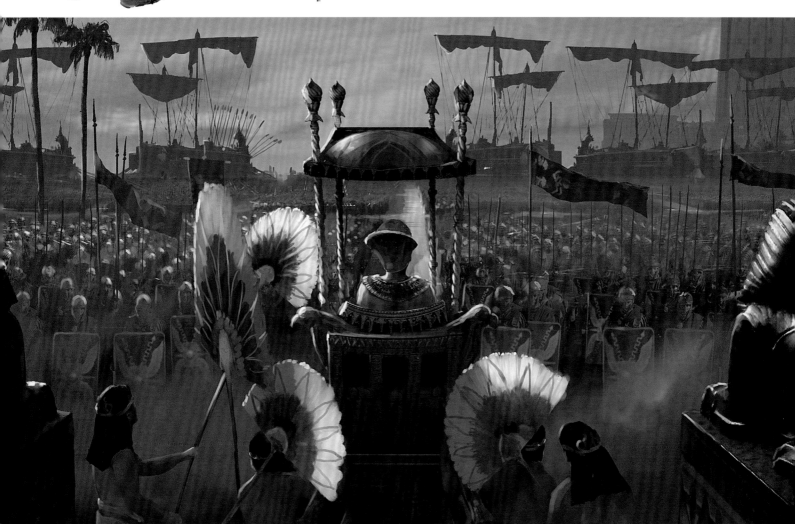

[Above] artwork by Martin Deschambault

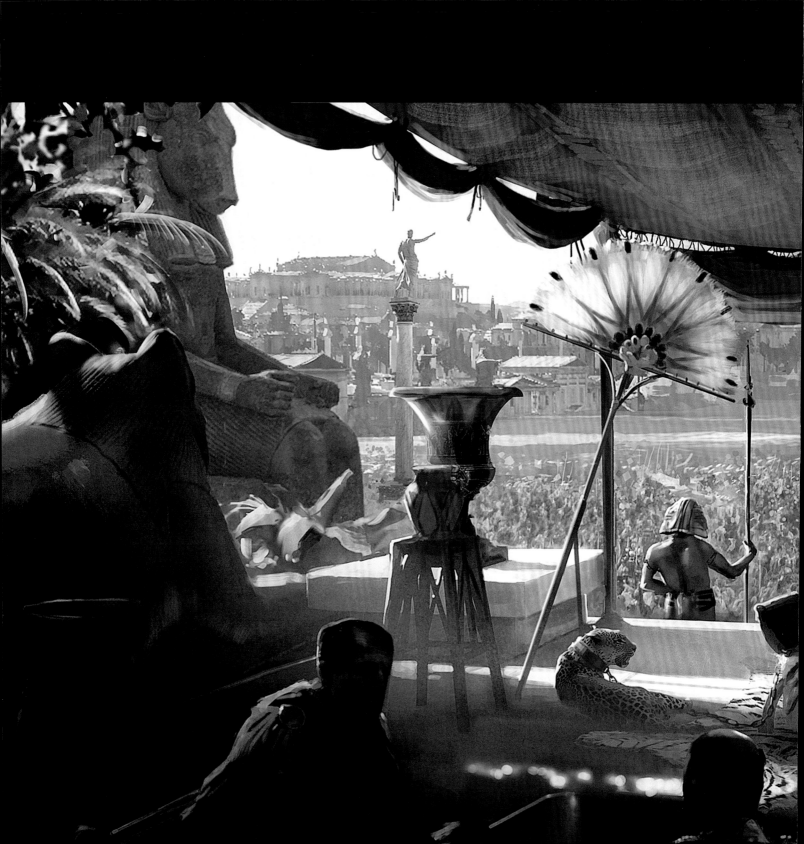

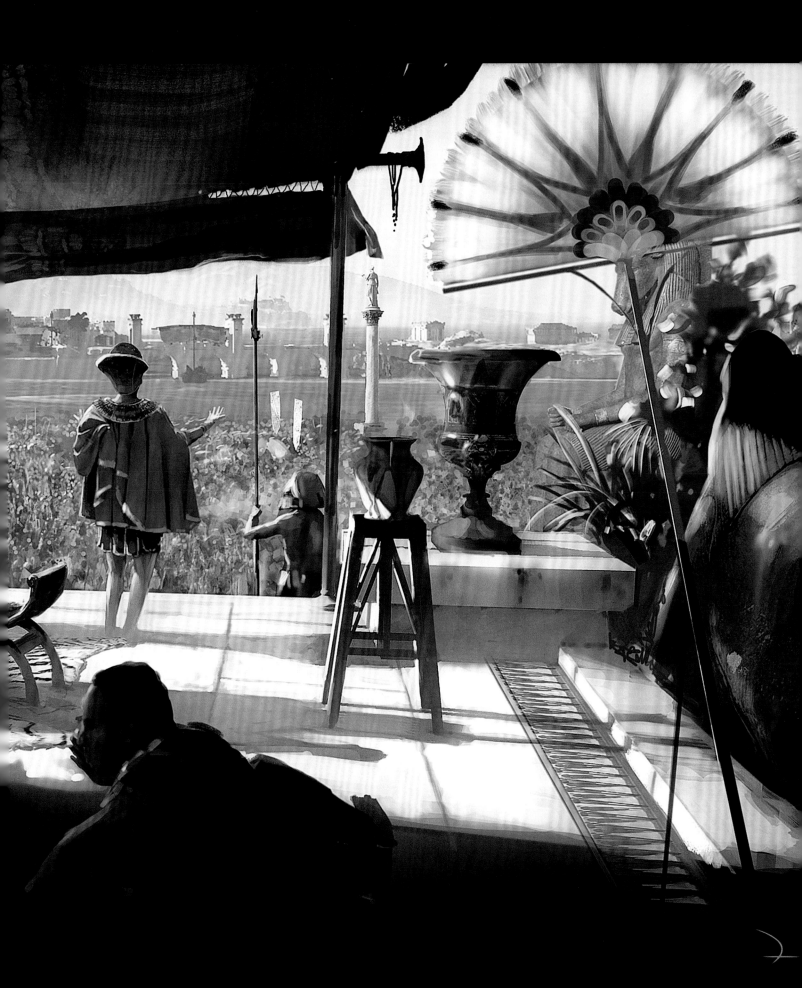

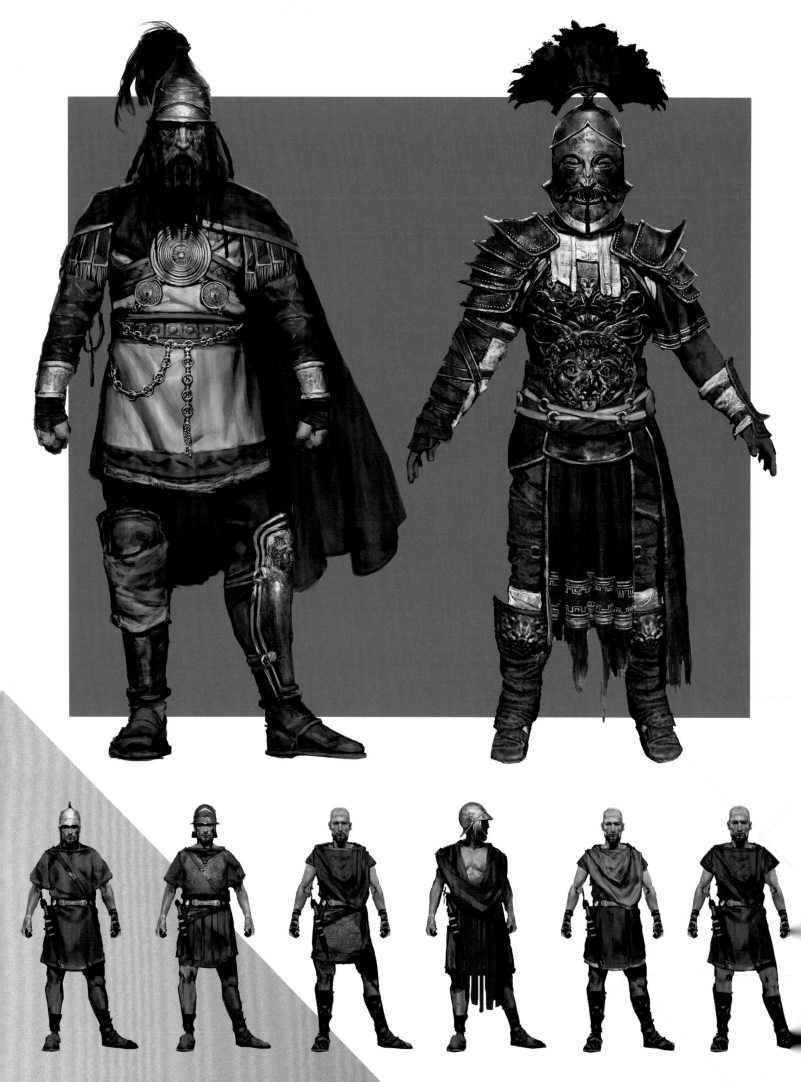

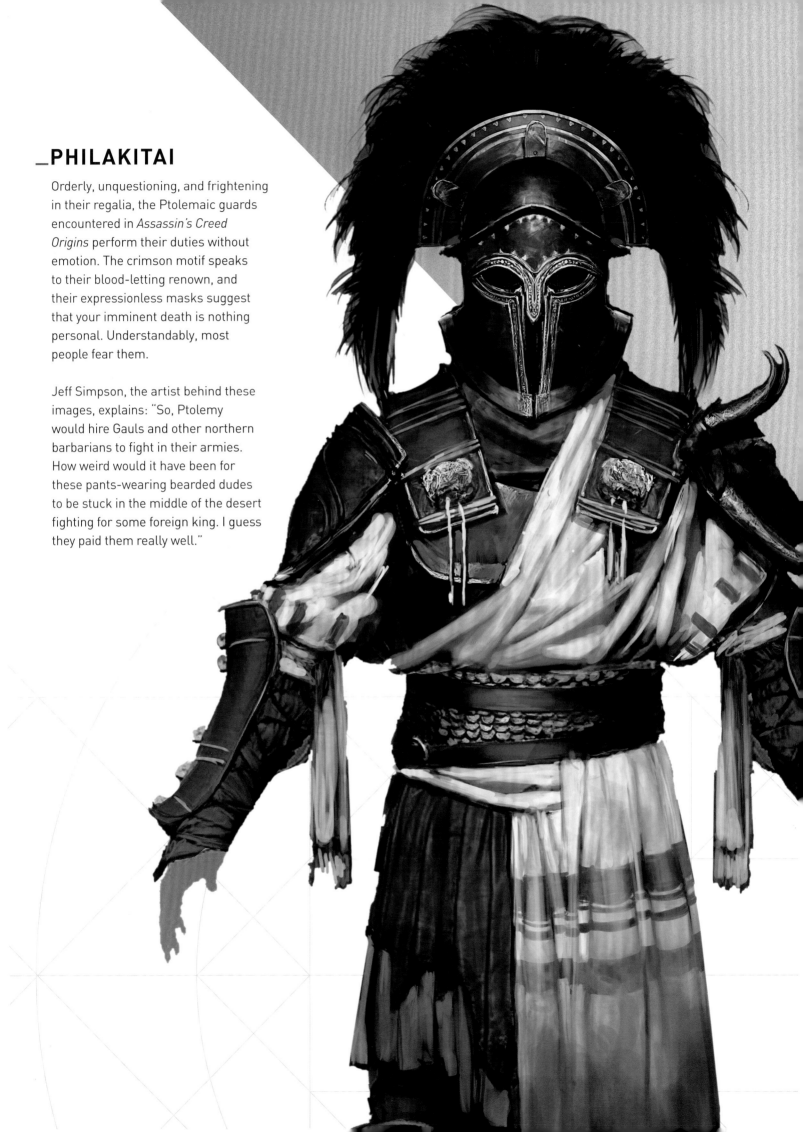

_PHILAKITAI

Orderly, unquestioning, and frightening in their regalia, the Ptolemaic guards encountered in *Assassin's Creed Origins* perform their duties without emotion. The crimson motif speaks to their blood-letting renown, and their expressionless masks suggest that your imminent death is nothing personal. Understandably, most people fear them.

Jeff Simpson, the artist behind these images, explains: "So, Ptolemy would hire Gauls and other northern barbarians to fight in their armies. How weird would it have been for these pants-wearing bearded dudes to be stuck in the middle of the desert fighting for some foreign king. I guess they paid them really well."

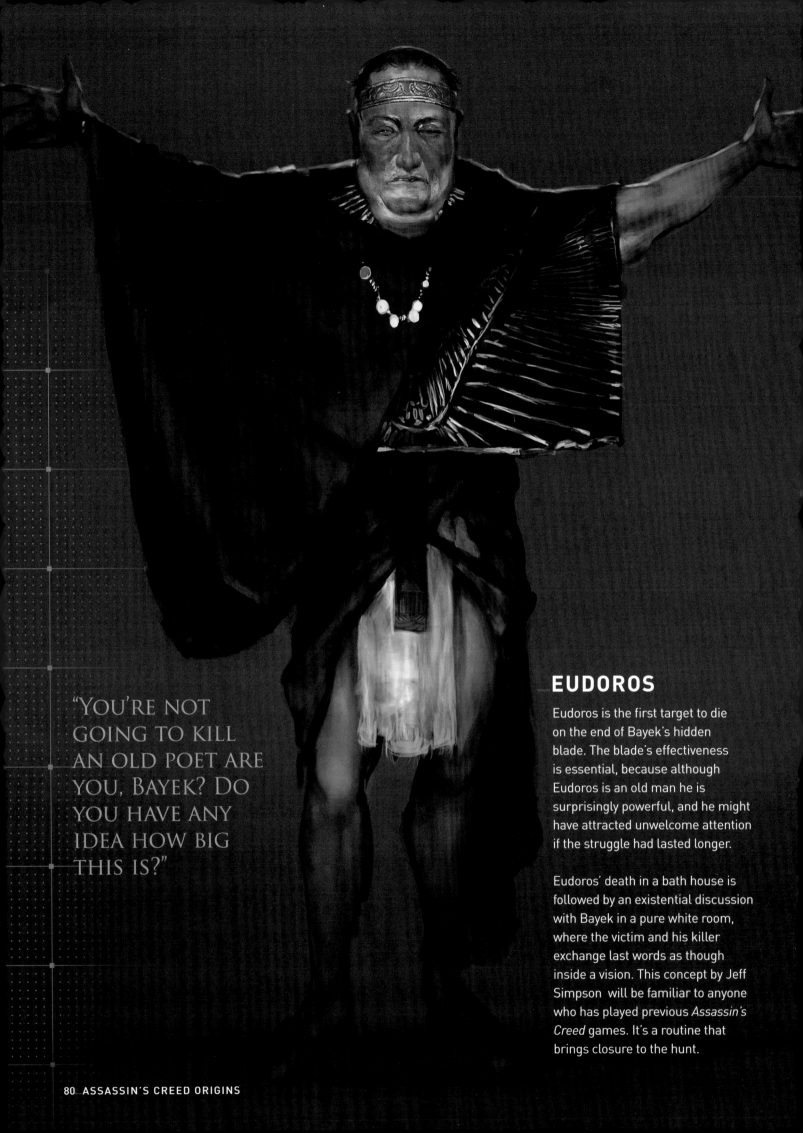

"YOU'RE NOT GOING TO KILL AN OLD POET ARE YOU, BAYEK? DO YOU HAVE ANY IDEA HOW BIG THIS IS?"

EUDOROS

Eudoros is the first target to die on the end of Bayek's hidden blade. The blade's effectiveness is essential, because although Eudoros is an old man he is surprisingly powerful, and he might have attracted unwelcome attention if the struggle had lasted longer.

Eudoros' death in a bath house is followed by an existential discussion with Bayek in a pure white room, where the victim and his killer exchange last words as though inside a vision. This concept by Jeff Simpson will be familiar to anyone who has played previous *Assassin's Creed* games. It's a routine that brings closure to the hunt.

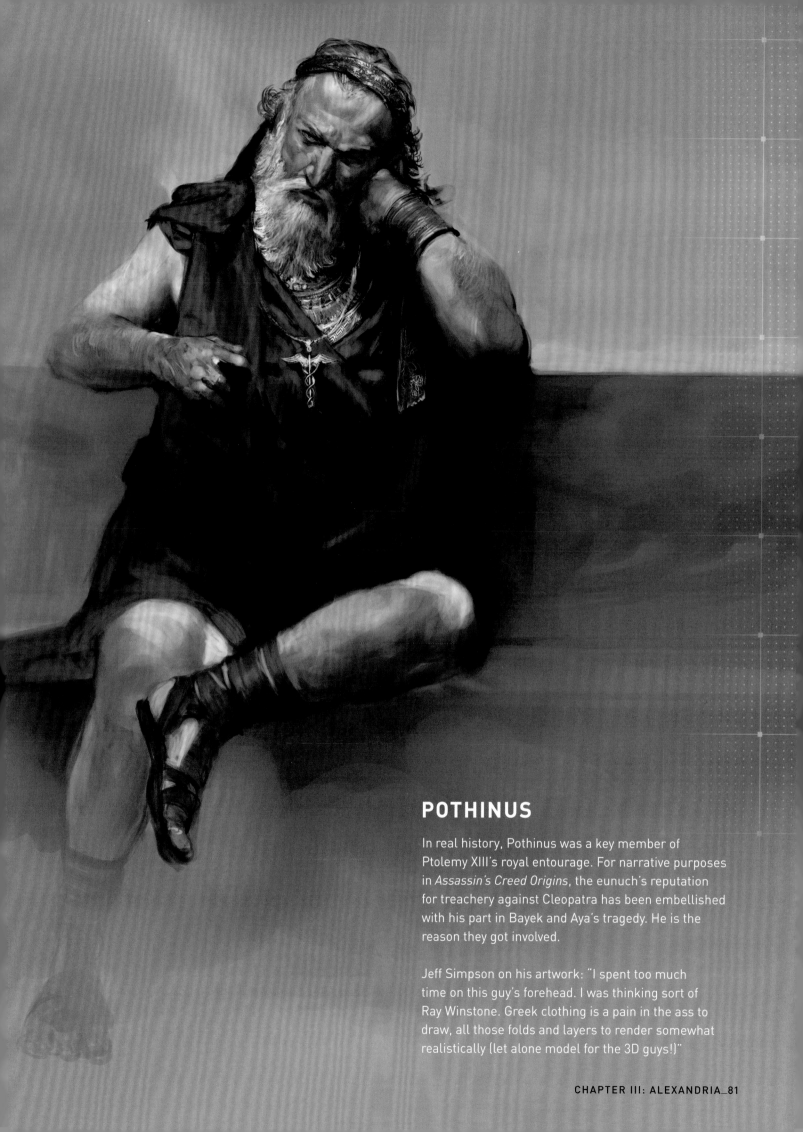

POTHINUS

In real history, Pothinus was a key member of Ptolemy XIII's royal entourage. For narrative purposes in *Assassin's Creed Origins*, the eunuch's reputation for treachery against Cleopatra has been embellished with his part in Bayek and Aya's tragedy. He is the reason they got involved.

Jeff Simpson on his artwork: "I spent too much time on this guy's forehead. I was thinking sort of Ray Winstone. Greek clothing is a pain in the ass to draw, all those folds and layers to render somewhat realistically (let alone model for the 3D guys!)"

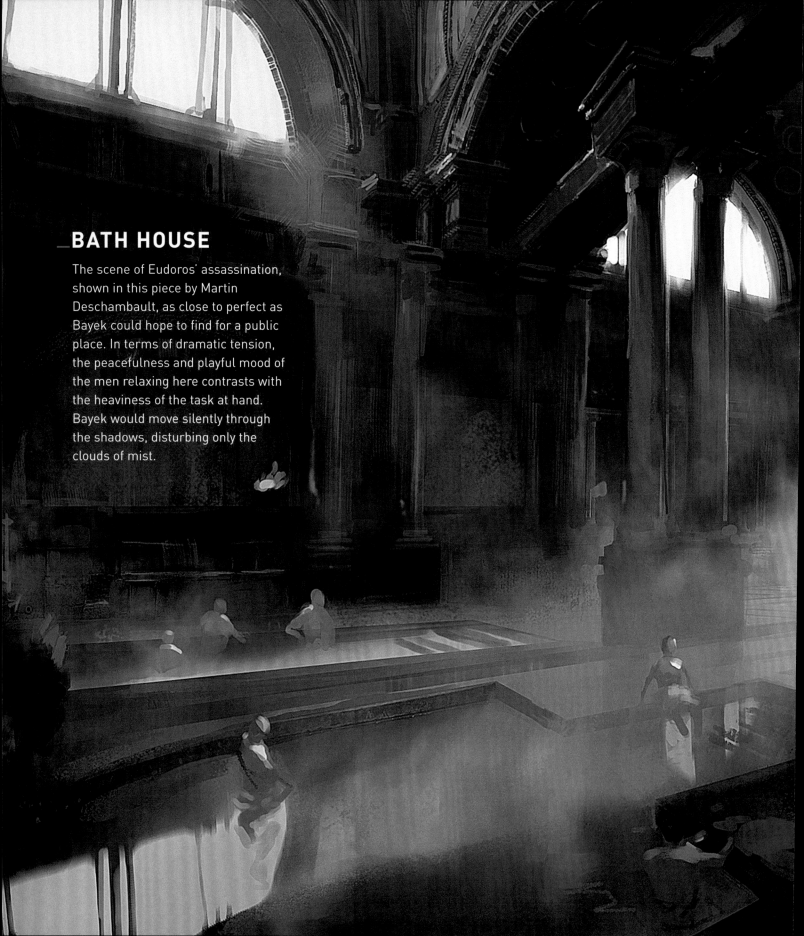

BATH HOUSE

The scene of Eudoros' assassination, shown in this piece by Martin Deschambault, as close to perfect as Bayek could hope to find for a public place. In terms of dramatic tension, the peacefulness and playful mood of the men relaxing here contrasts with the heaviness of the task at hand. Bayek would move silently through the shadows, disturbing only the clouds of mist.

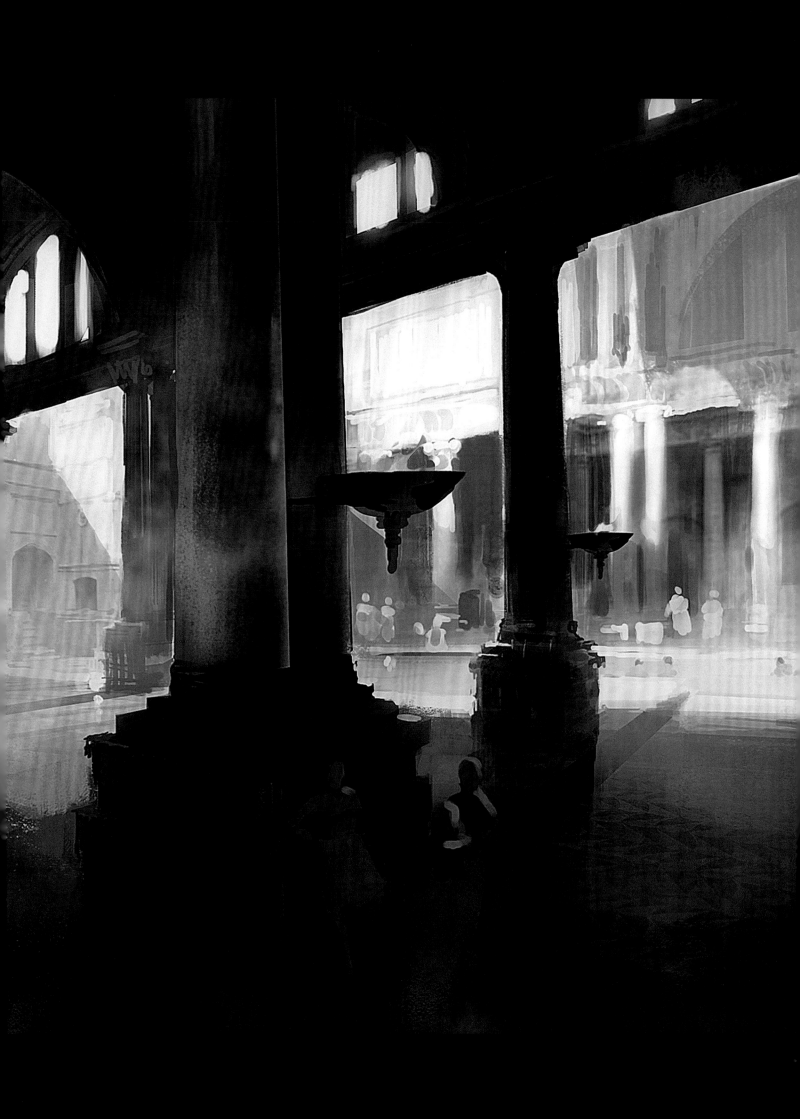

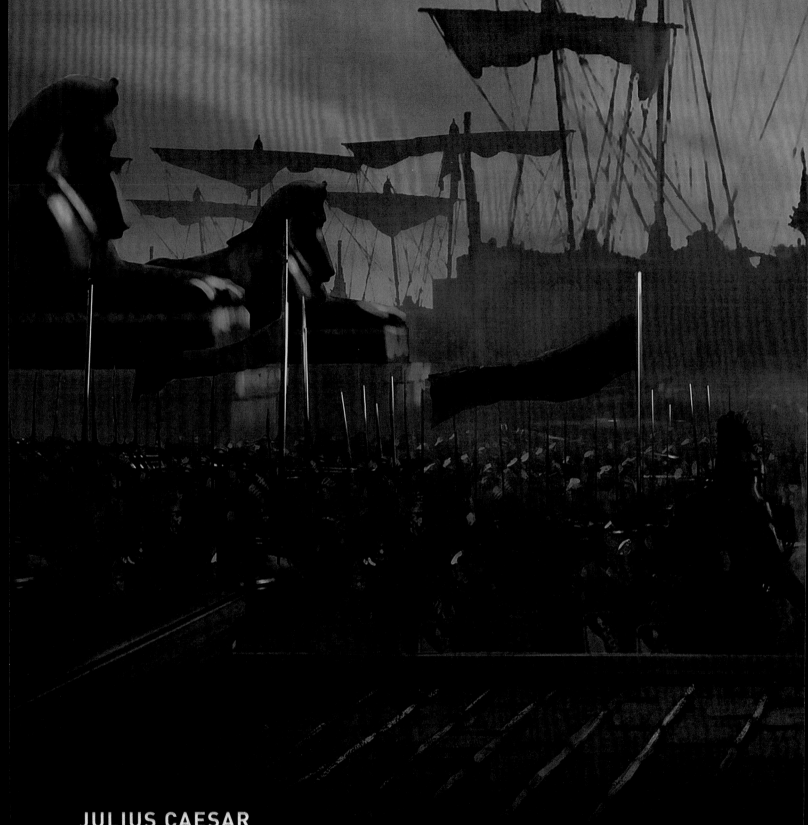

JULIUS CAESAR

The most famous Roman emporer is shown above in artwork by Martin Deschambault. Cleopatra and Caesar are famous for their love affair, recognized briefly in *Assassin's Creed Origins*. Caesar is so impressed with their duties on behalf of his queen that he helps them track down their common enemy, Pothinus. Caesar is also intrigued by the tomb of Alexander.

This is the charm that Ubisoft Montréal carefully works into the plot, shifting Caesar's military focus to something more mystical. He urges Bayek and Aya to tell him more about Siwa, the place Alexander chose as his first

place to visit in Egypt. He is portrayed as charming and inquisitive, yet coldly calculating – always with an end game in mind.

Alexander's tomb leaves Caesar spiritually excited, although he decides not to disturb what he discovers there. He also cautiously releases Ptolemy back to his people instead of having him killed. With the Battle of the Nile brewing, every step Caesar takes is made carefully and with respect. Even his greatest enemy, Septimius, is spared a brutal assassination and is instead ordered back to Rome to face trial.

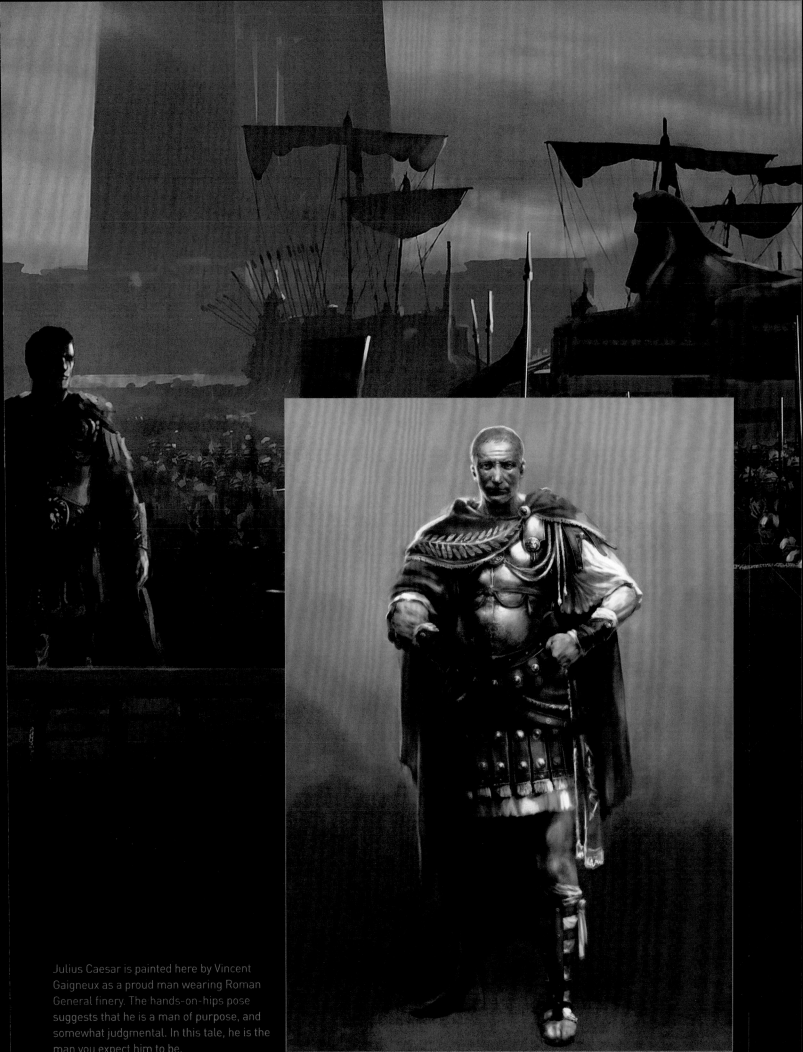

Julius Caesar is painted here by Vincent Gaigneux as a proud man wearing Roman General finery. The hands-on-hips pose suggests that he is a man of purpose, and somewhat judgmental. In this tale, he is the man you expect him to be.

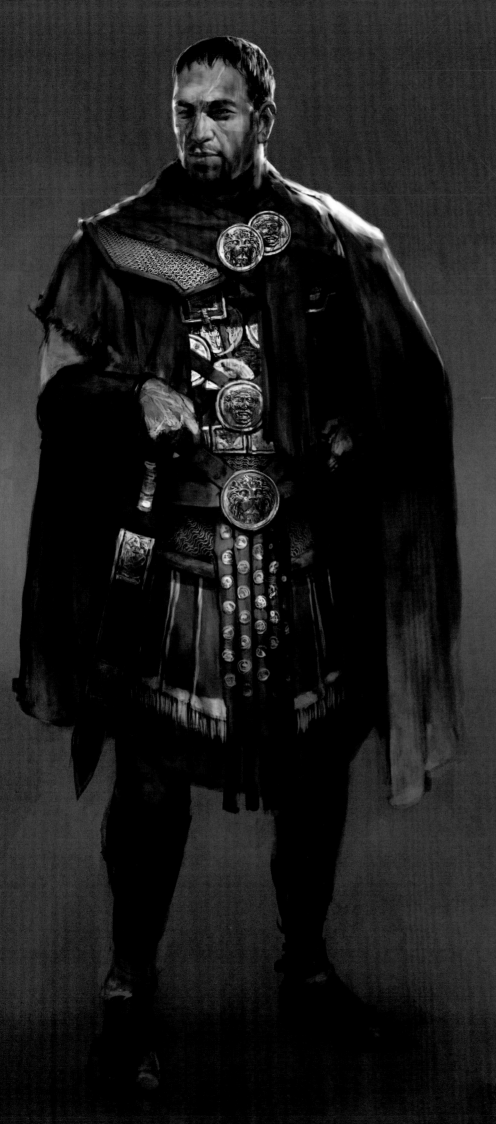

FLAVIUS METELLUS

In the game, Flavius is more than just a conspirator against Julius Caesar. He is motivated by what he believes is in the best interests of Rome. Flavius is a man at home in the shadows and is purely a creation for the game, not tied to history. He is a man who speaks in a banal and stately tone and who sees no wrong in his actions. He separates death and decency from the needs of rule and order. He despises the state of Egypt, doing what he thinks must be done. He is an emissary of Rome incarnate, comfortable in his armor, with its lion-embossed broaches and impressive gilded scabbard. Yet he also represents Rome's failure to crush the spirit of Egypt's people, and allows us to see this struggle up close in the story of Bayek and Aya.

"Brief was to show an experienced Roman soldier, has been around for a while and gotten dirty out in the desert. Fun fact: We don't know for sure if Romans always wore red, it's just the color most artists over the years have chosen to depict them in! I guess we did too though, so... whatever! It looks good." *Jeff Simpson*

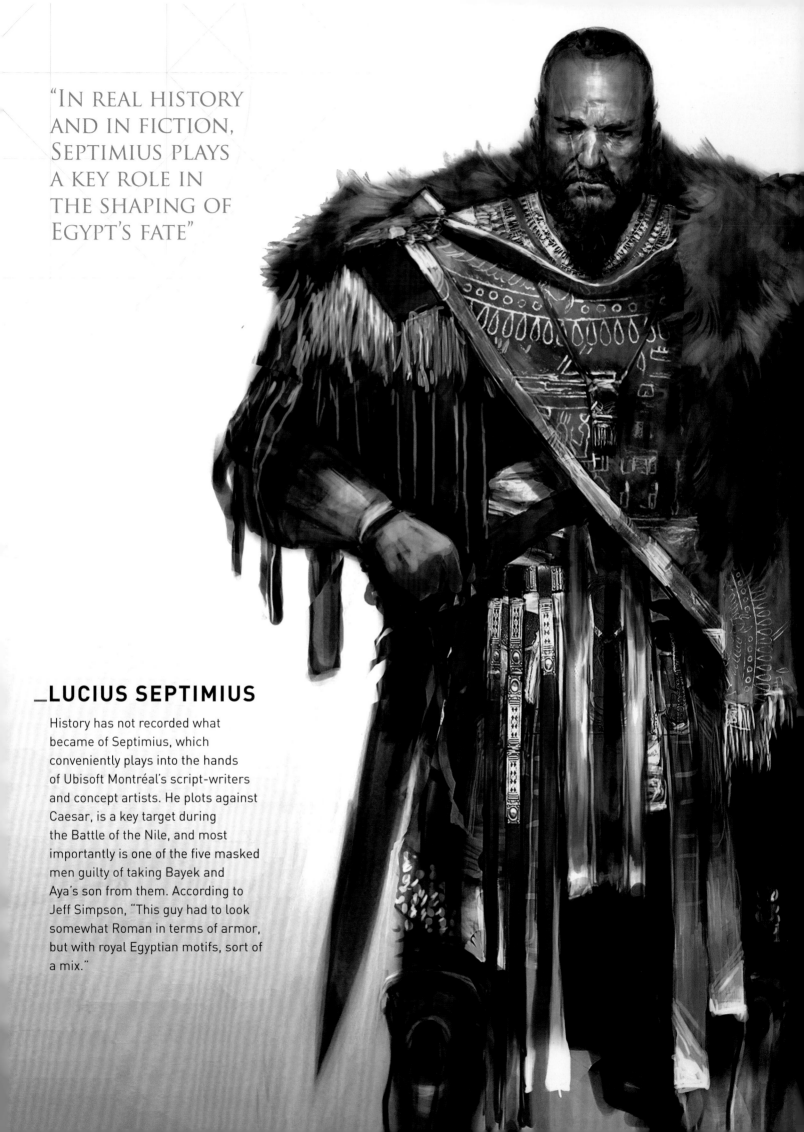

> "IN REAL HISTORY
> AND IN FICTION,
> SEPTIMIUS PLAYS
> A KEY ROLE IN
> THE SHAPING OF
> EGYPT'S FATE"

_LUCIUS SEPTIMIUS

History has not recorded what became of Septimius, which conveniently plays into the hands of Ubisoft Montréal's script-writers and concept artists. He plots against Caesar, is a key target during the Battle of the Nile, and most importantly is one of the five masked men guilty of taking Bayek and Aya's son from them. According to Jeff Simpson, "This guy had to look somewhat Roman in terms of armor, but with royal Egyptian motifs, sort of a mix."

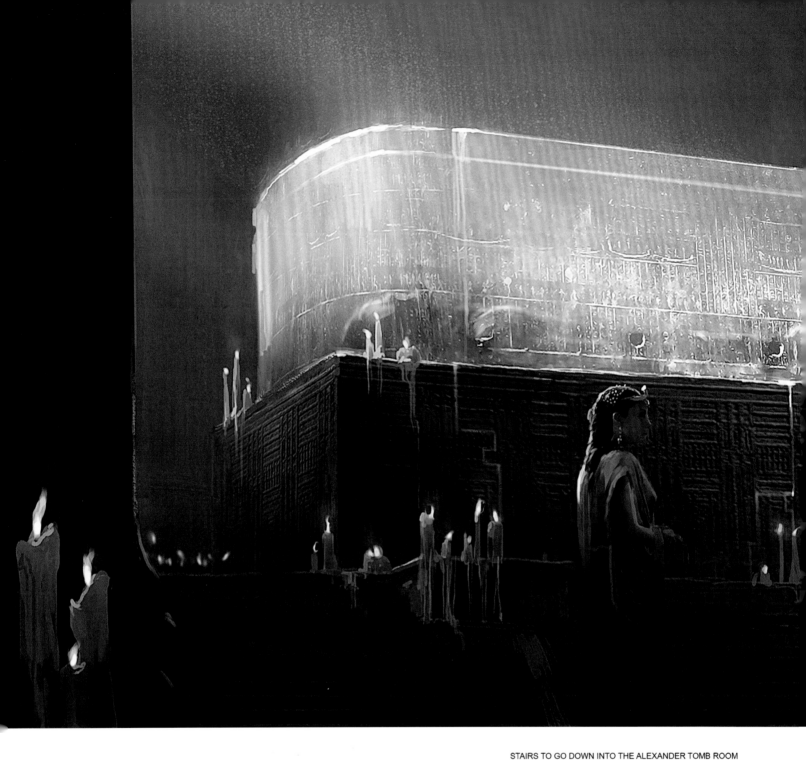

_TOMB OF ALEXANDER THE GREAT

The location of Alexander the Great's Tomb remains a mystery, although its existence is confirmed in historical sources. Martin Deschambault's imagining of it [above] shows an artifact of great magnificence, a huge sarcophagus of sculpted gold, gleaming in candle light. And for the final twist, a connection to the fictitious First Civilization.

For the purposes of the game's story, Alexander the Great's Tomb fulfills every dream we might have had about such an elaborate final resting place. When we gaze upon the mask of Tutankhamun, then combine it with the legend of Alexander the Great, it is fun to wonder what manner of grandeur might have greeted the eyes of Cleopatra and Caesar when they visited the location.

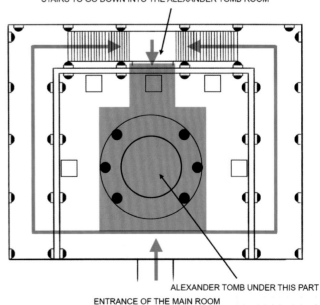

STAIRS TO GO DOWN INTO THE ALEXANDER TOMB ROOM

ALEXANDER TOMB UNDER THIS PART

ENTRANCE OF THE MAIN ROOM

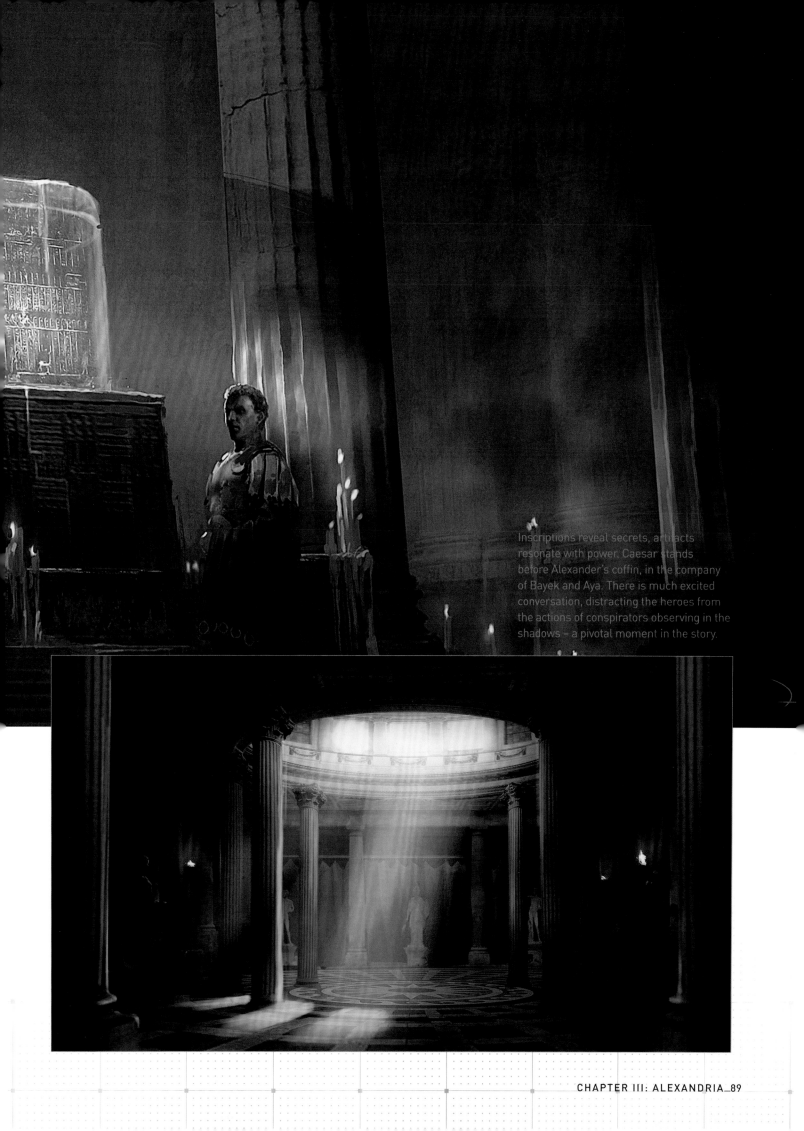

Inscriptions reveal secrets, artifacts resonate with power. Caesar stands before Alexander's coffin, in the company of Bayek and Aya. There is much excited conversation, distracting the heroes from the actions of conspirators observing in the shadows – a pivotal moment in the story.

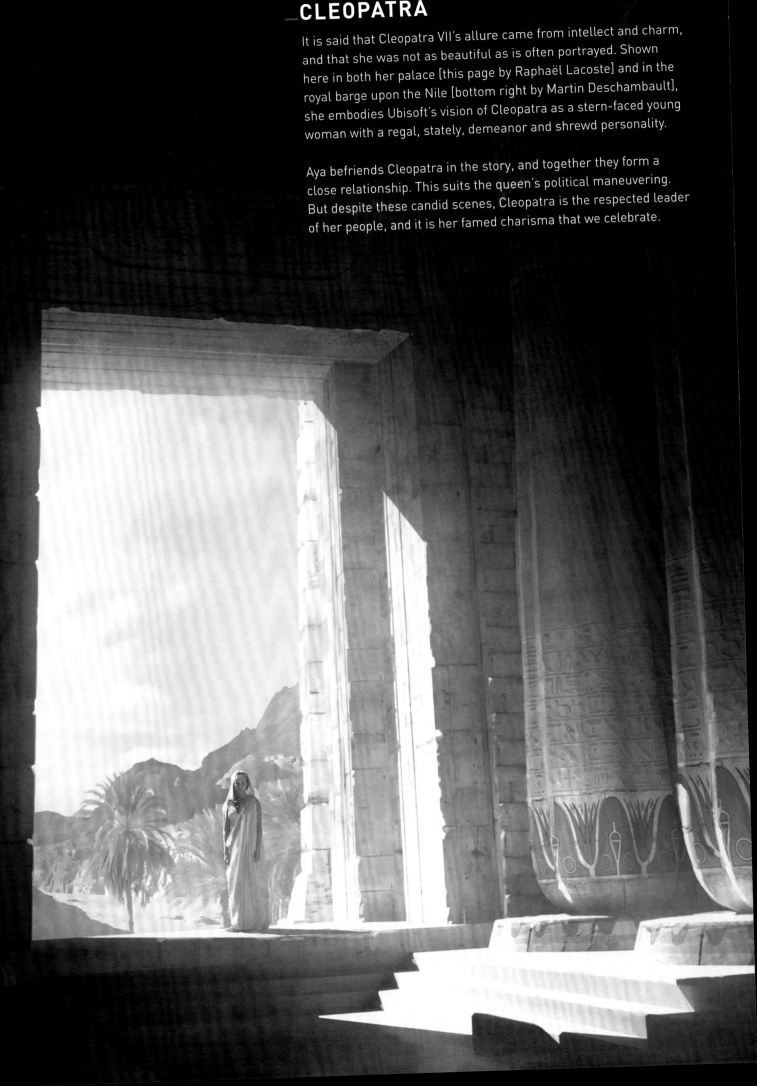

CLEOPATRA

It is said that Cleopatra VII's allure came from intellect and charm, and that she was not as beautiful as is often portrayed. Shown here in both her palace [this page by Raphaël Lacoste] and in the royal barge upon the Nile [bottom right by Martin Deschambault], she embodies Ubisoft's vision of Cleopatra as a stern-faced young woman with a regal, stately, demeanor and shrewd personality.

Aya befriends Cleopatra in the story, and together they form a close relationship. This suits the queen's political maneuvering. But despite these candid scenes, Cleopatra is the respected leader of her people, and it is her famed charisma that we celebrate.

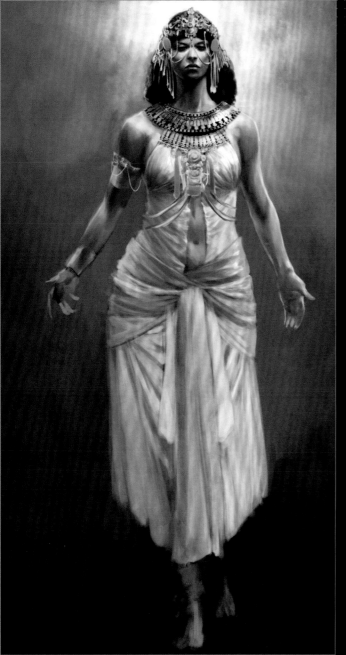

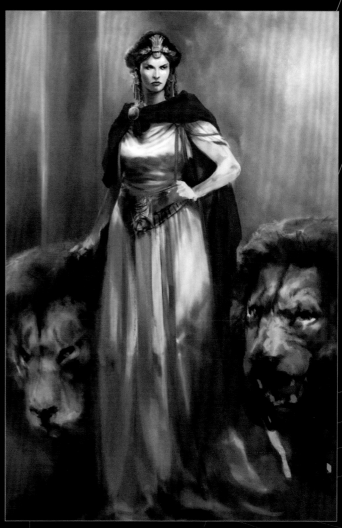

Portraits of the young queen [left and below by Vincent Gaigneux] assign to her an otherworldly appearance, akin to a goddess, which is how she would have been worshipped. It is believed that she played up this association, staging elaborate entrances to woo her audience and strengthen her position of power.

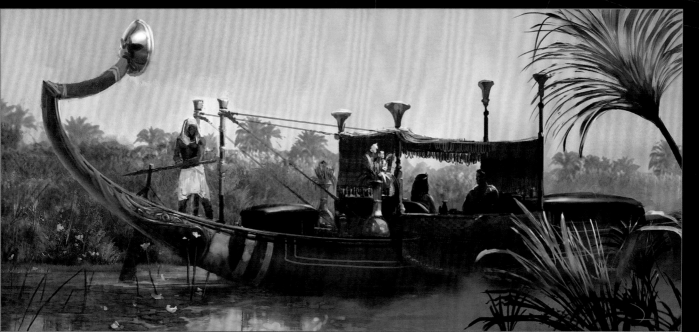

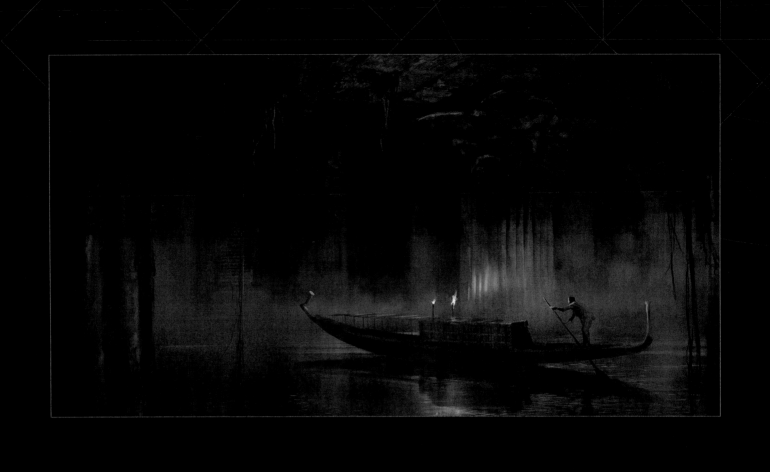

CANAL WAYS

Ancient Egyptian ingenuity has few equals, and it is easy to appreciate the people's belief in their leaders' godlike powers when feats like this freshwater canal are considered. The canal, which ran forty-five miles from the Nile to Alexandria, is said to have been built while Ptolemy I (c. 367 BCE – 283/2 BCE) was in power.

For the purposes of *Assassin's Creed Origins*, the canal provides an alternative pathway into areas that would otherwise be off-limits. Its murky waters allow designers to experiment with mood and pacing, catching players off-guard with a different challenge. A journey along the canal can feel almost processional, building up to an important confrontation. Exploration beneath the surface is unnerving, again taking players out of their comfort zone.

"I created this first cistern canal concept with the arch, but we realized later the arch was not used at this period. So, we had to find another solution. I did a big 3D scene for this location and I took different points of view for my concept art. It is easier when you have arch in your architecture. But I like to paint over the 3D as much as possible to break the rigidity of the 3D and make it more organic."
Martin Deschambault [both pieces[

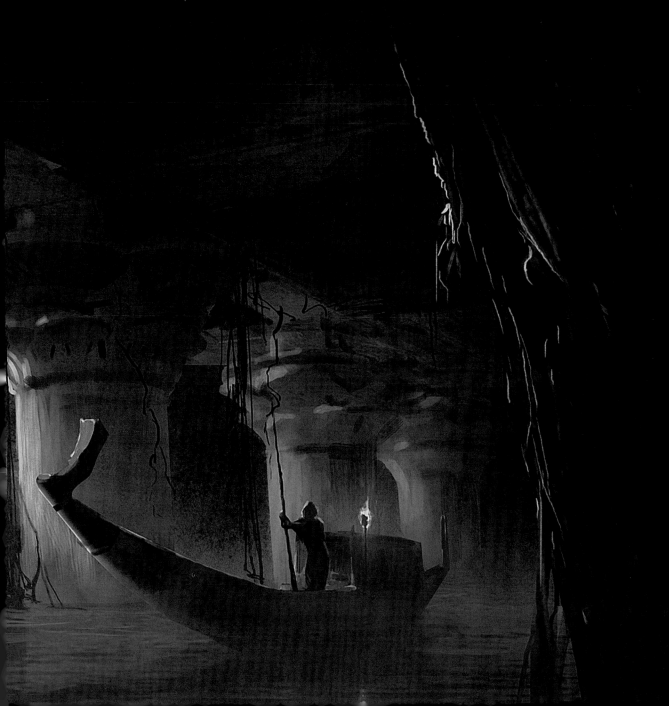

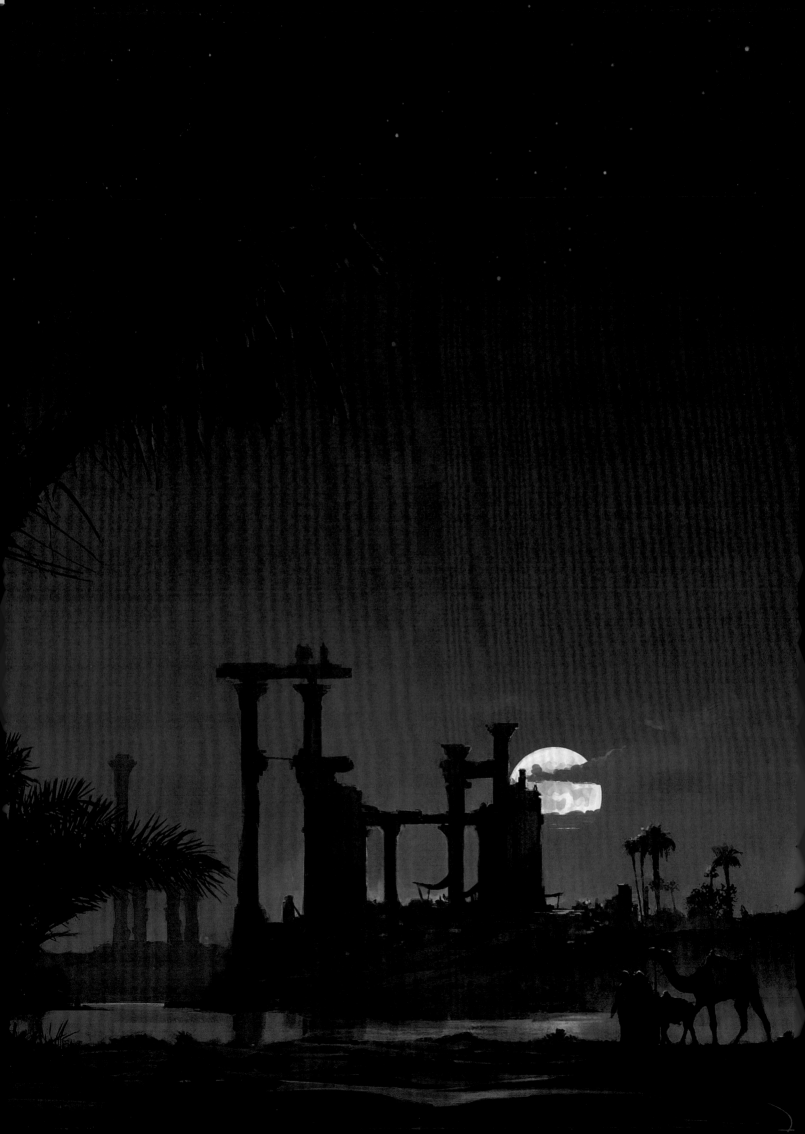

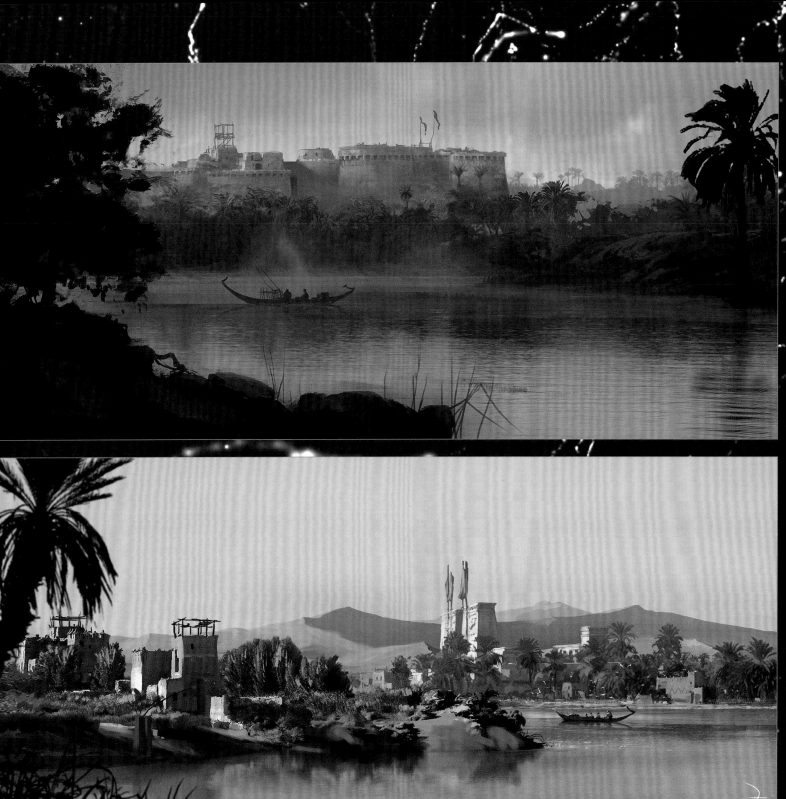

MAREOTIS LAKE

Mareotis Lake, a brackish body of water, sits just to
the south of Alexandria. A thin spit of land separates
the lake from the ocean and it's upon this strip, one
of the greatest cities of the ancient world was built. In
these concept pieces by Martin Deschambault, we see

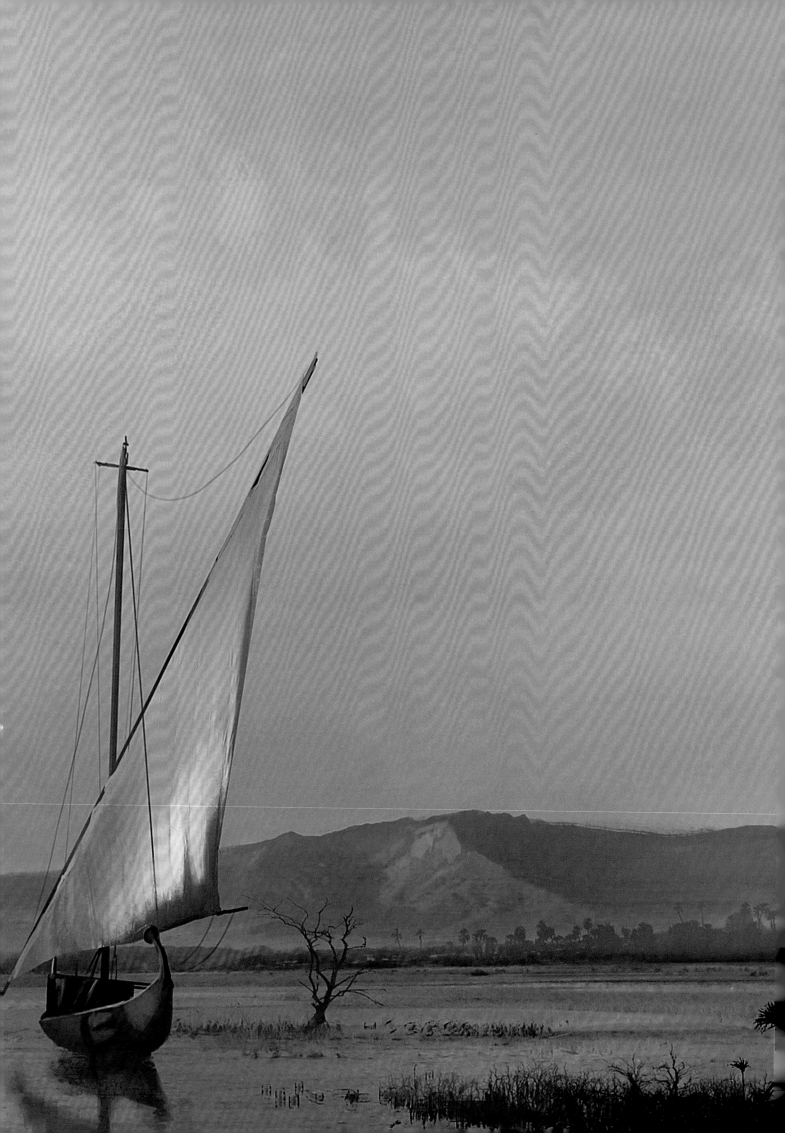

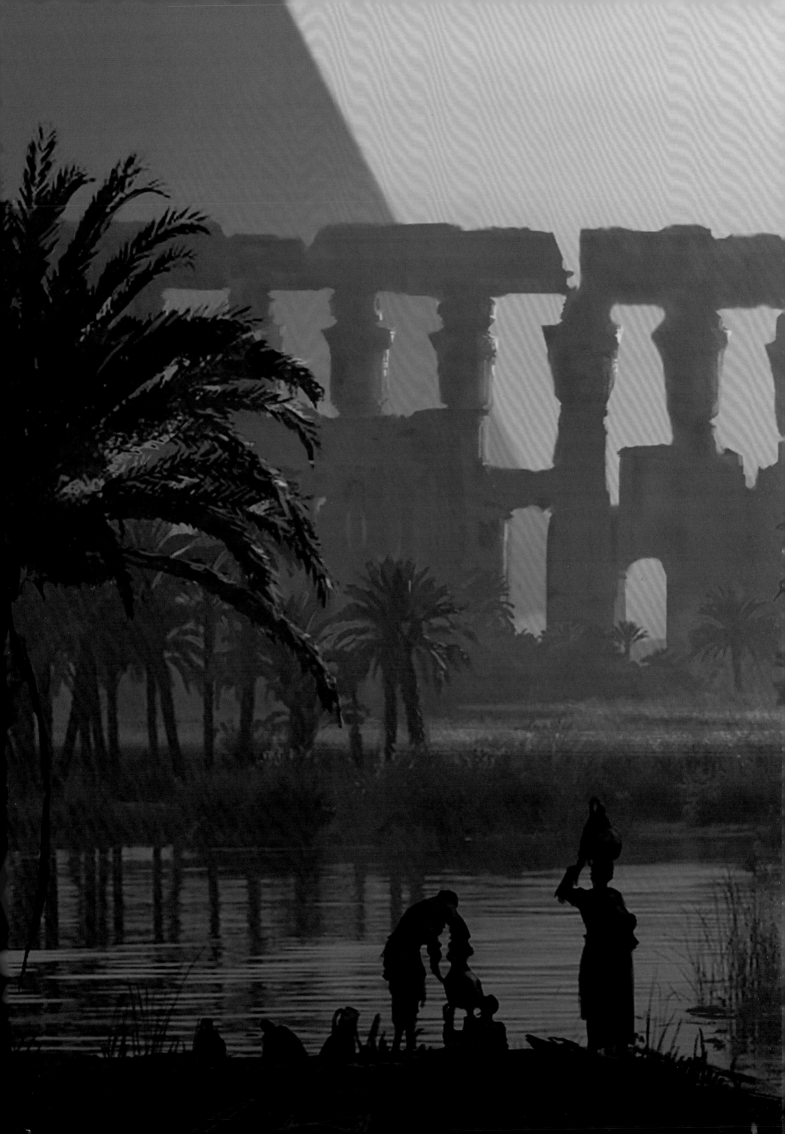

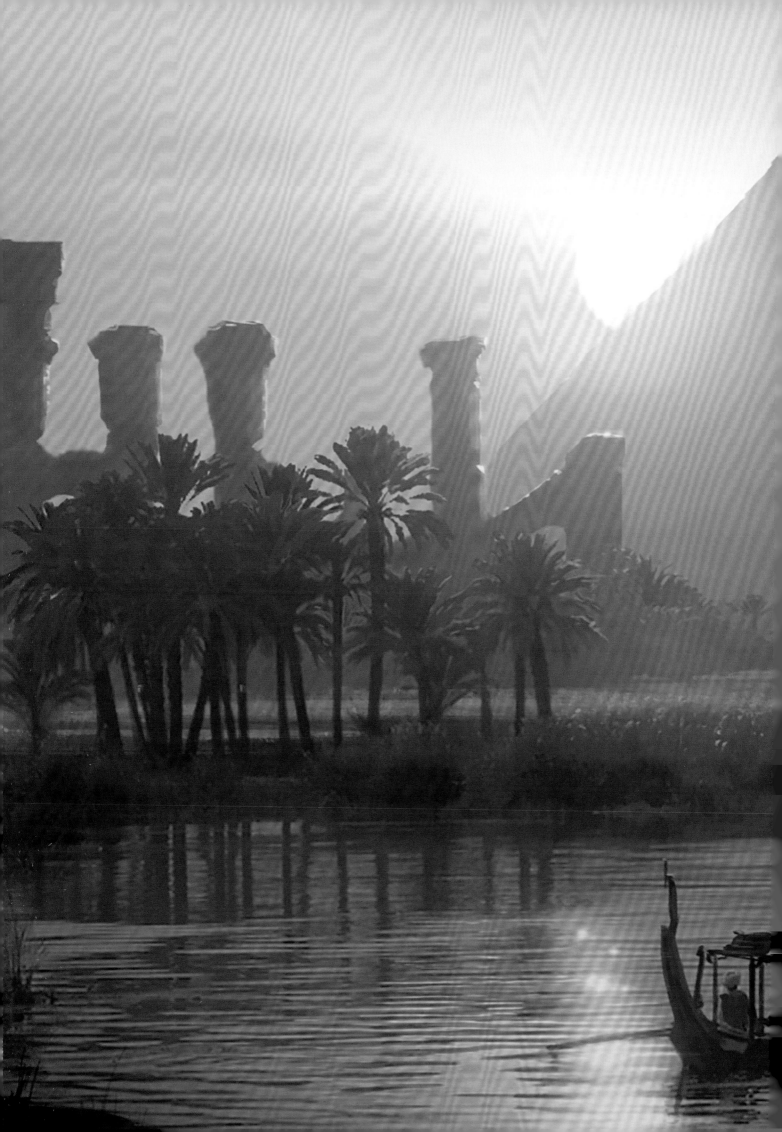

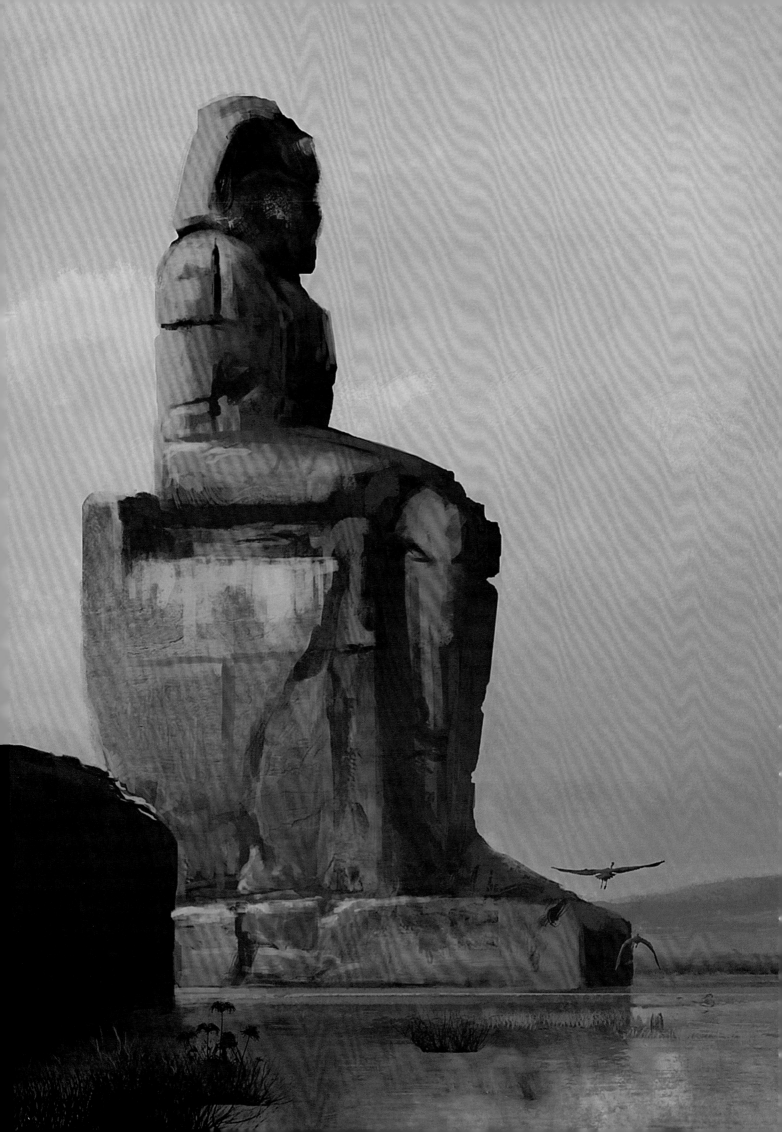

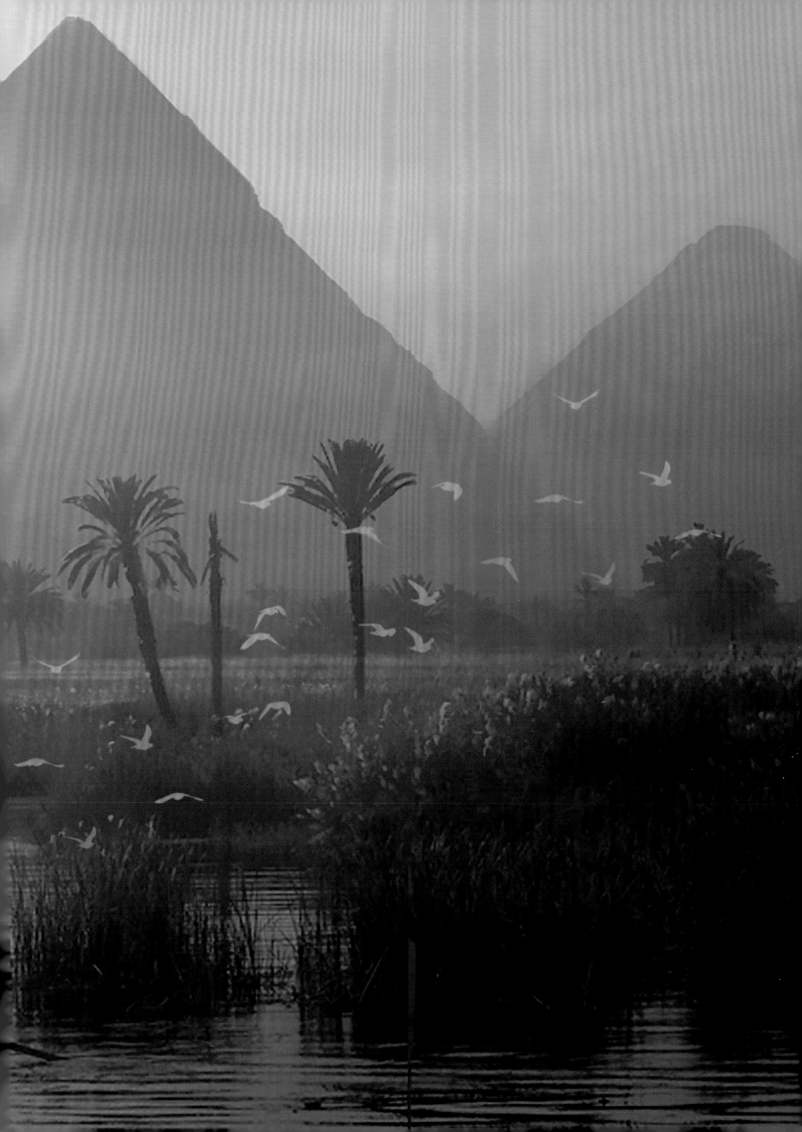

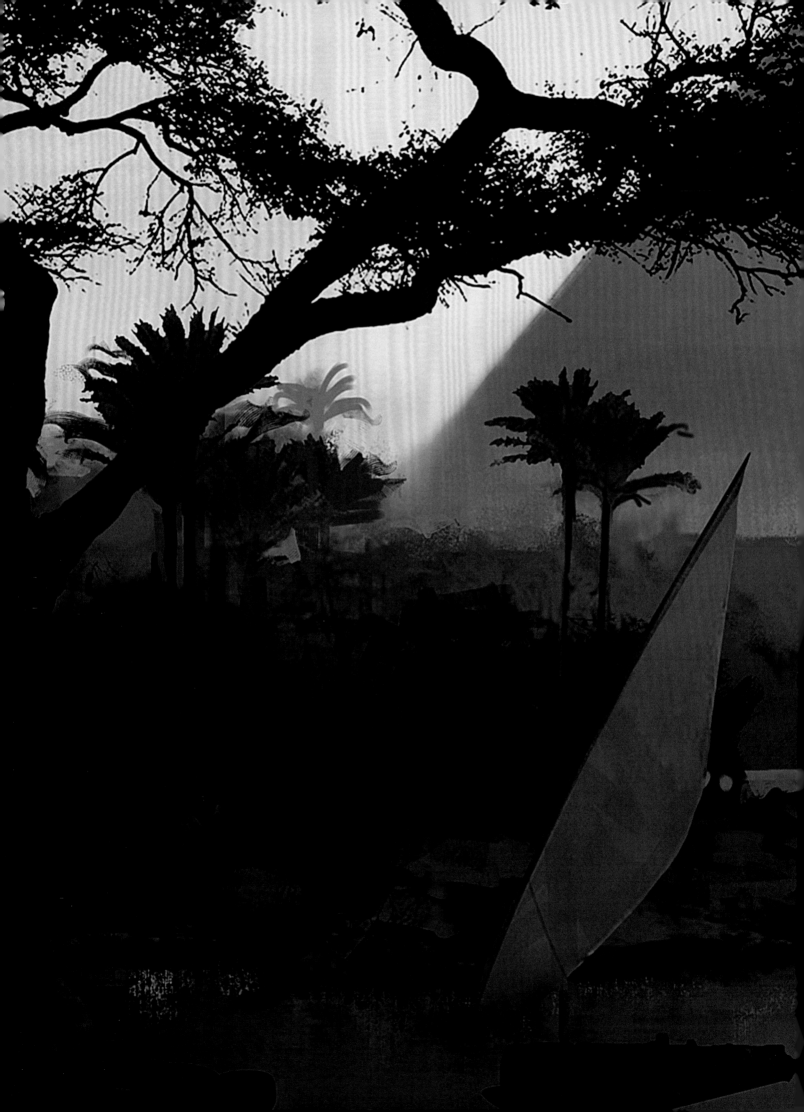

NILE DELTA

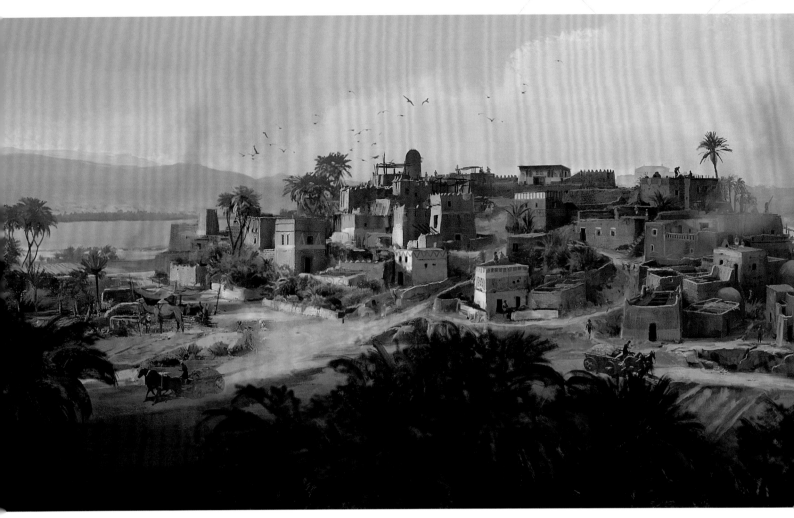

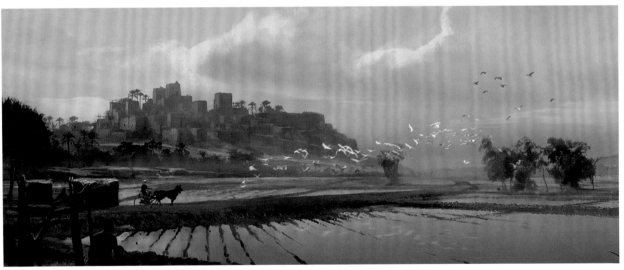

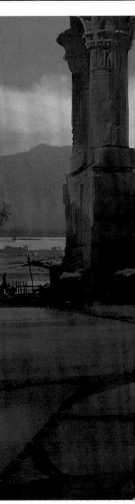

_WORLD RE-BUILDING

One of the most beguiling aspects of the Assassin's Creed series is how
the team uses a combination of historical remains, fragments of ancient
ruins, and descriptions from books to create convincing reproductions
of time and place. "To create a world for a game is very complex," says
Raphaël Lacoste. "It requires a lot of knowhow and is a challenge renewed
at each project, even for a very experienced team. We make choices: design
choices, artistic choices, historical choices, scenario choices... There's no
good game without making these choices! Even once these elements are
integrated there's still a lot of validation to be done so that everything works
as a consistent, beautiful and fascinating world."

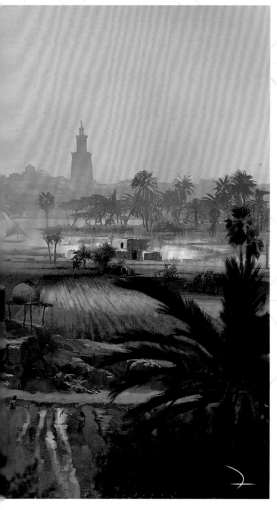

"The player has the opportunity to discover in the morning mist the Nile Delta's dangerous marshes, populated by crocodiles and hippopotamuses, and can also appreciate the majesty of the flocks of herons and ibises." *Raphaël Lacoste*

[Fold-out and previous page] artwork by Martin Deschambault
[Fold-out] artwork by Raphaël Lacoste
[Below] artwork by Gilles Beloeil
[All other images on this page] artwork by Martin Deschambault

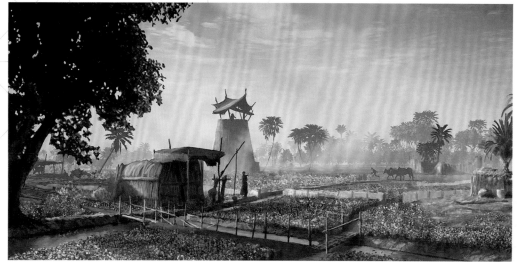

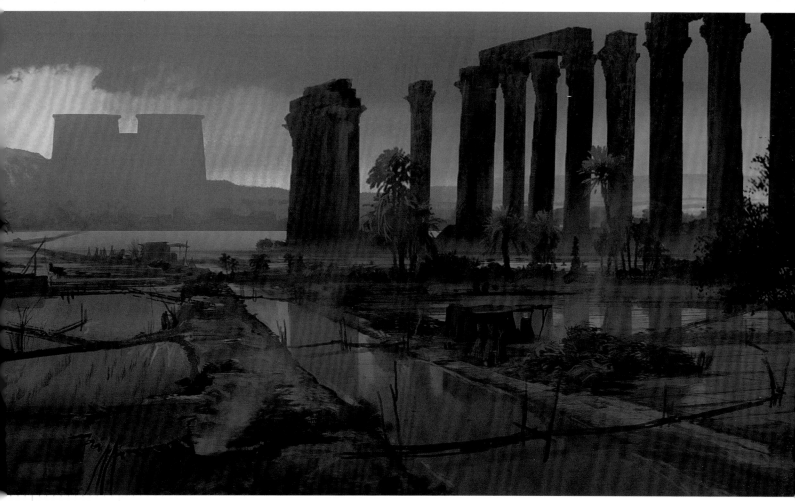

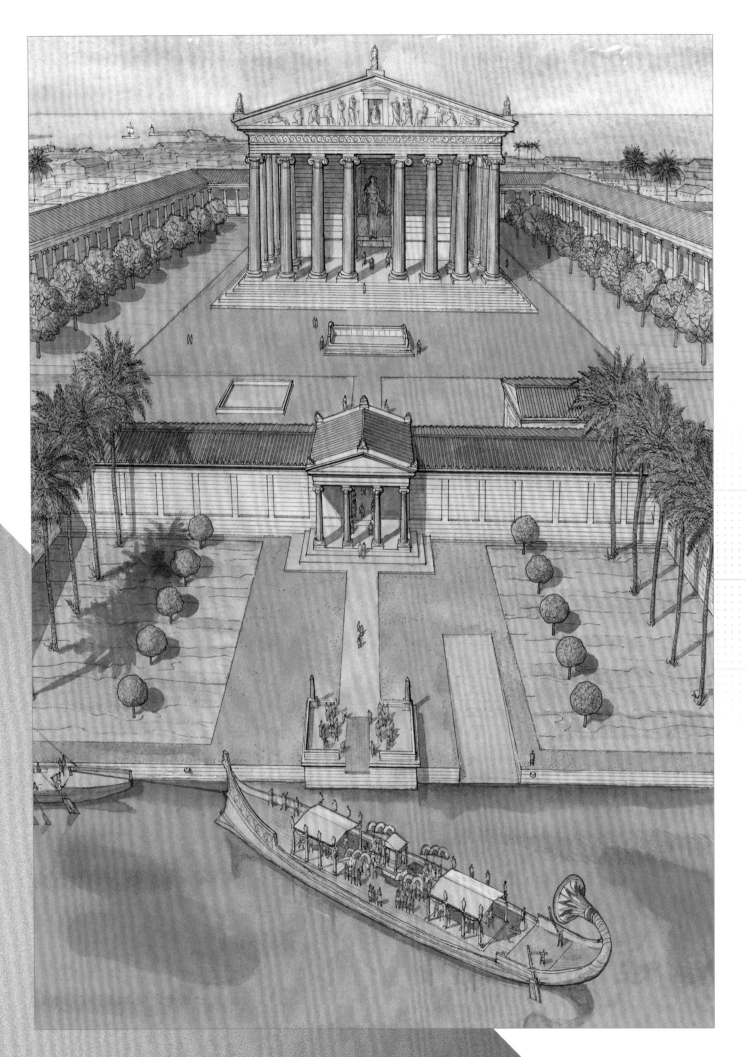

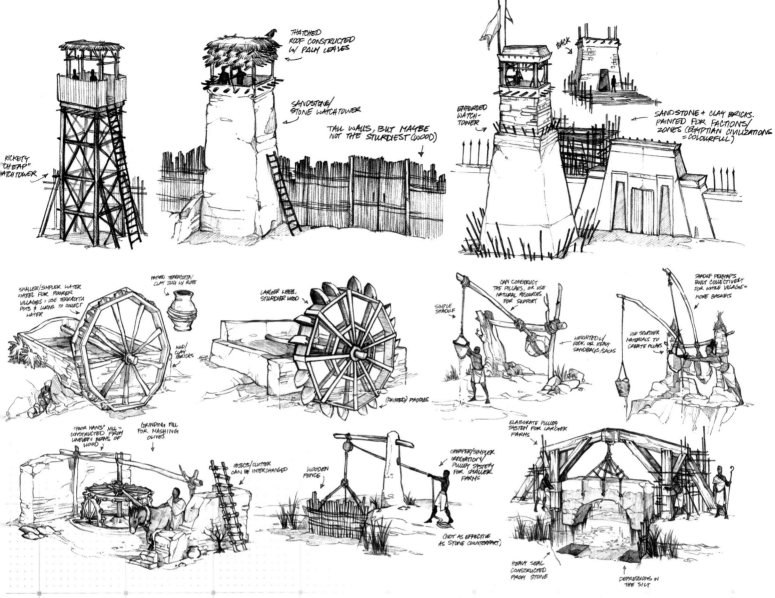

"THE PORT AT KANOPOS WAS ESTABLISHED
LONG BEFORE THE RISE OF ALEXANDRIA
AND REMAINED ACTIVE FOR MANY YEARS"

_KANOPOS

As the principal port for trade, Kanopos is a center for gossip, and it is here that Bayek meets with Apollodorus to shed light on Eudoros' cryptic dying remarks. He also encounters Phoxidas, a jovial ship's captain, otherwise known as a pirate. This brief Kanopos excursion brings a very different flavor to proceedings.

"When we created our main protagonists we ensured their characteristics were informed by the places they were from, so that they had a unique flavor," says Raphaël Lacoste. "We've followed the same thinking when creating our secondary characters and our crowds – peasants in the fields, residents of cities and villages. For instance, in the countryside, poor Egyptians grew flax that they wove into linen, and then made into clothes. Whereas wealthy residents of Memphis or Alexandria could afford to pay for expensive imported fabrics and materials of many colors."

(Above) Meticulously detailed sketches of daily life in Kanopos informed the concept team's virtual reconstruction of the area. These functions, their historical accuracy, and the people carrying out the work, bring life to locations that would otherwise feel empty and false.
[Left page] a detailed depiction of the city by Jean-Claude Golvin.

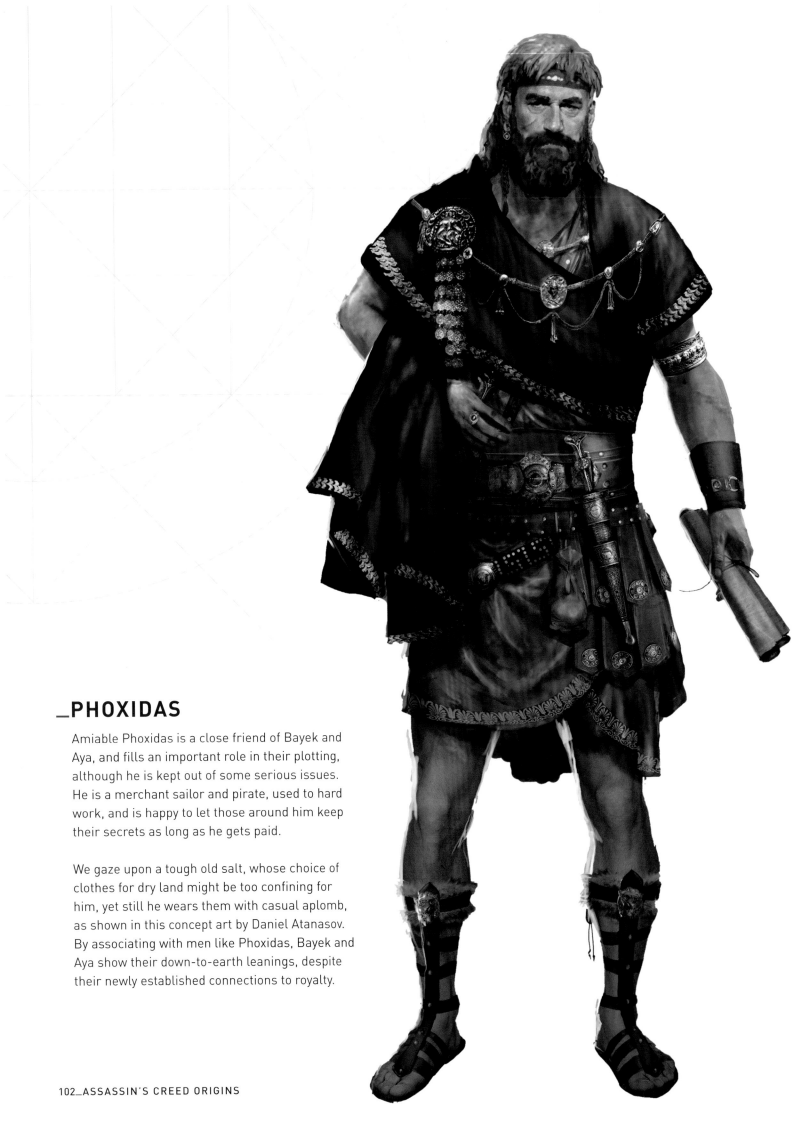

_PHOXIDAS

Amiable Phoxidas is a close friend of Bayek and
Aya, and fills an important role in their plotting,
although he is kept out of some serious issues.
He is a merchant sailor and pirate, used to hard
work, and is happy to let those around him keep
their secrets as long as he gets paid.

We gaze upon a tough old salt, whose choice of
clothes for dry land might be too confining for
him, yet still he wears them with casual aplomb,
as shown in this concept art by Daniel Atanasov.
By associating with men like Phoxidas, Bayek and
Aya show their down-to-earth leanings, despite
their newly established connections to royalty.

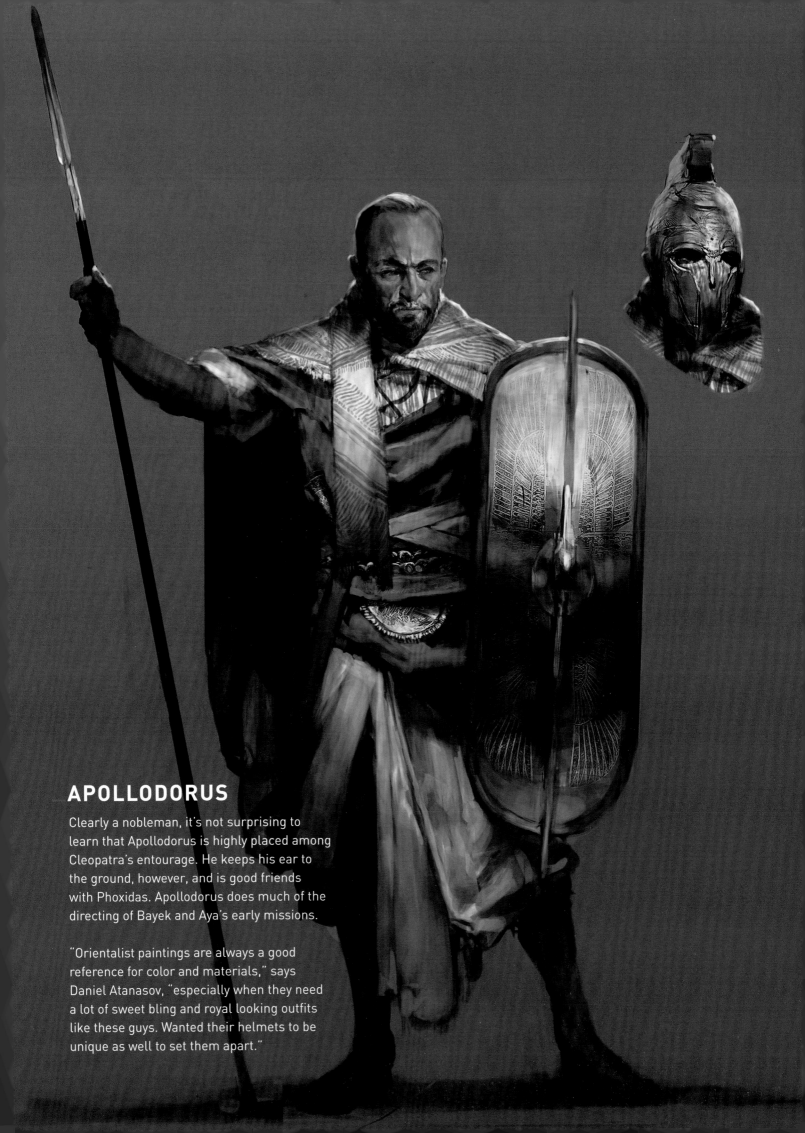

APOLLODORUS

Clearly a nobleman, it's not surprising to learn that Apollodorus is highly placed among Cleopatra's entourage. He keeps his ear to the ground, however, and is good friends with Phoxidas. Apollodorus does much of the directing of Bayek and Aya's early missions.

"Orientalist paintings are always a good reference for color and materials," says Daniel Atanasov, "especially when they need a lot of sweet bling and royal looking outfits like these guys. Wanted their helmets to be unique as well to set them apart."

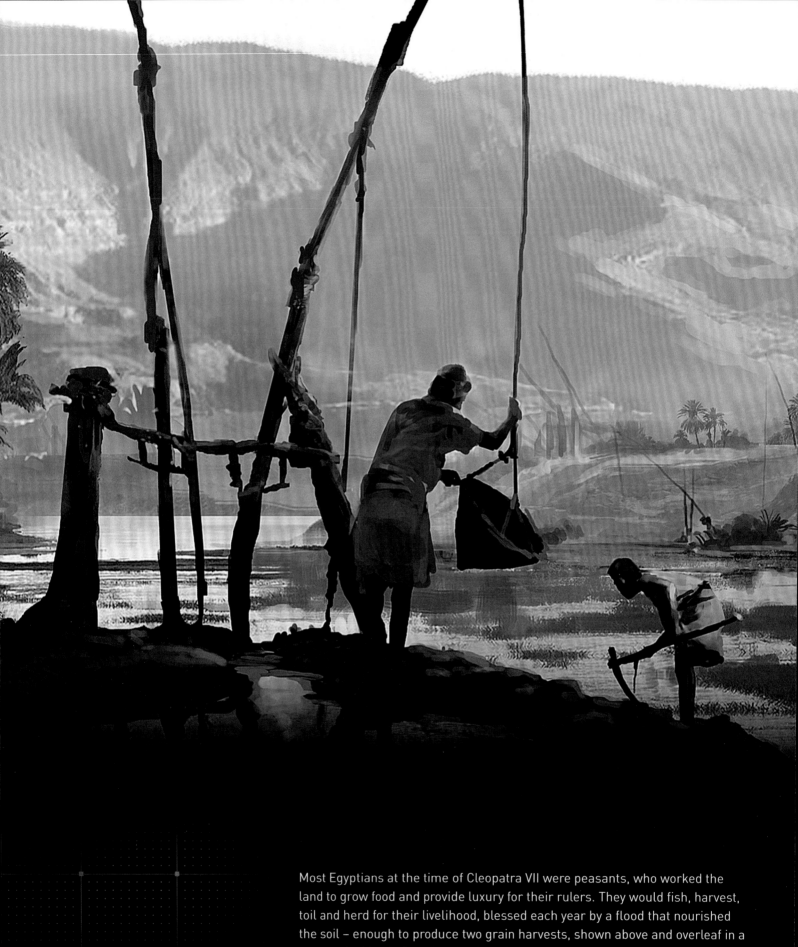

Most Egyptians at the time of Cleopatra VII were peasants, who worked the land to grow food and provide luxury for their rulers. They would fish, harvest, toil and herd for their livelihood, blessed each year by a flood that nourished the soil – enough to produce two grain harvests, shown above and overleaf in a concept by Martin Deschambault and right by Raphaël Lacoste. Consequently, many Egyptians worshipped the Nile as a life-giving source. Their existence was far removed from the political subterfuge of their rulers, let alone the cultural changes coming from further afield, specifically Rome. These are the people that Bayek and Aya fight to represent, so that they may be valued and not cruelly treated.

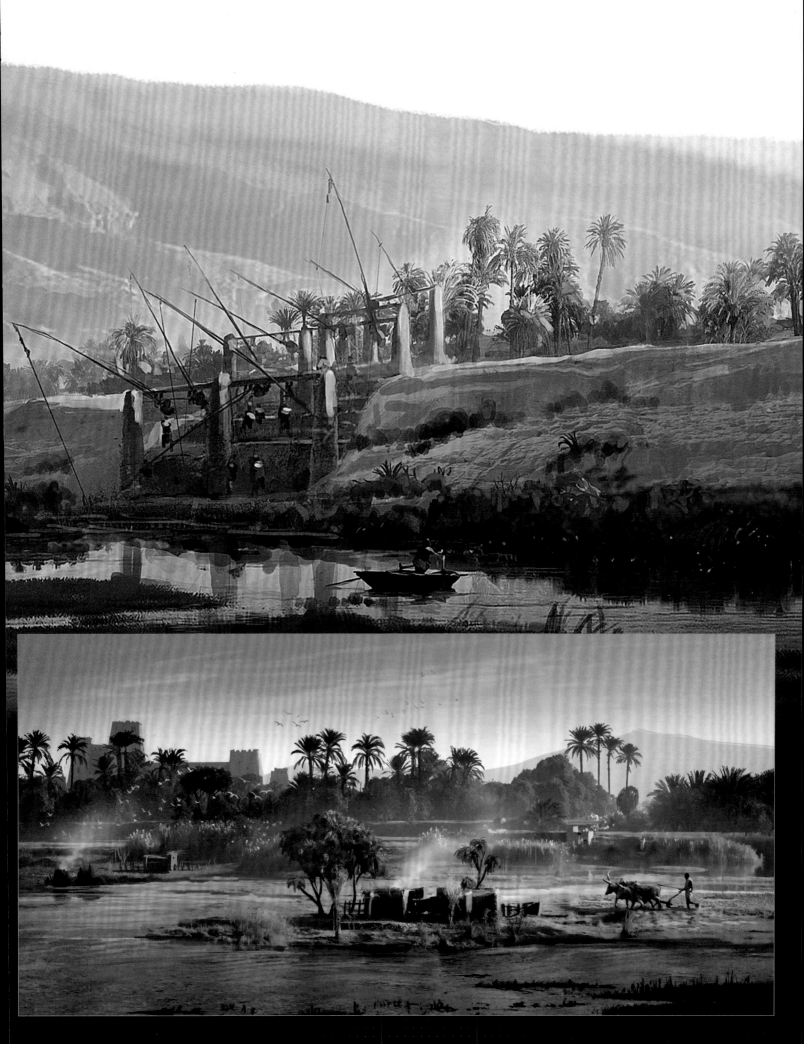

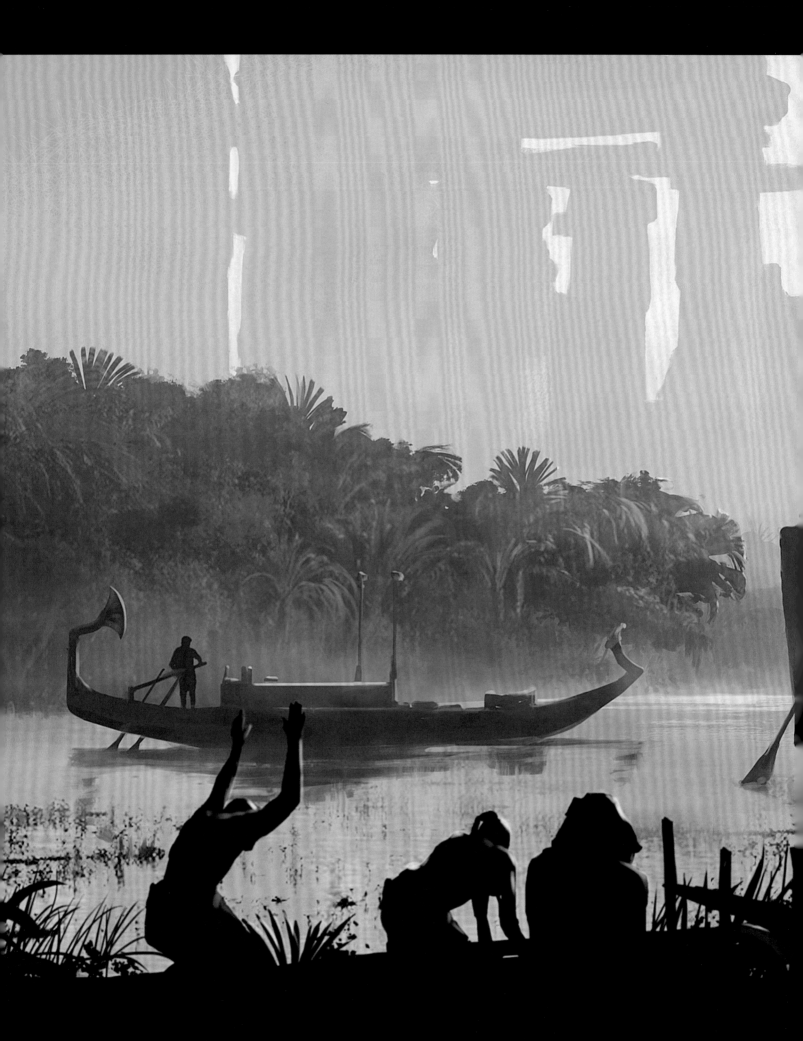

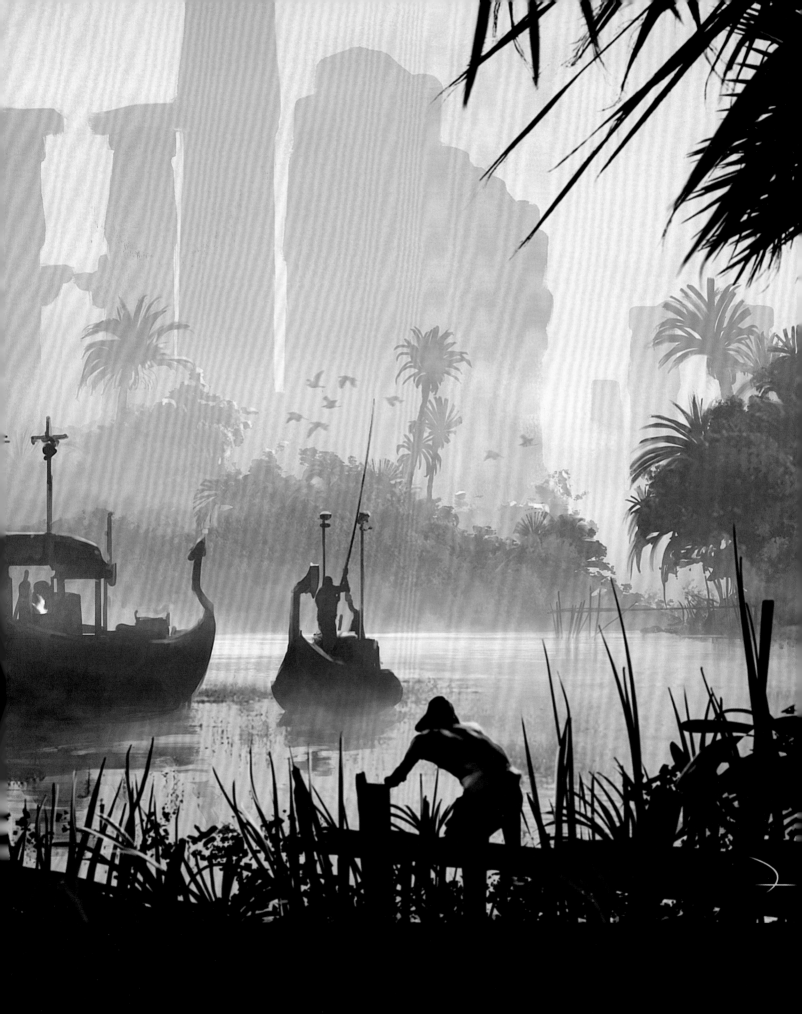

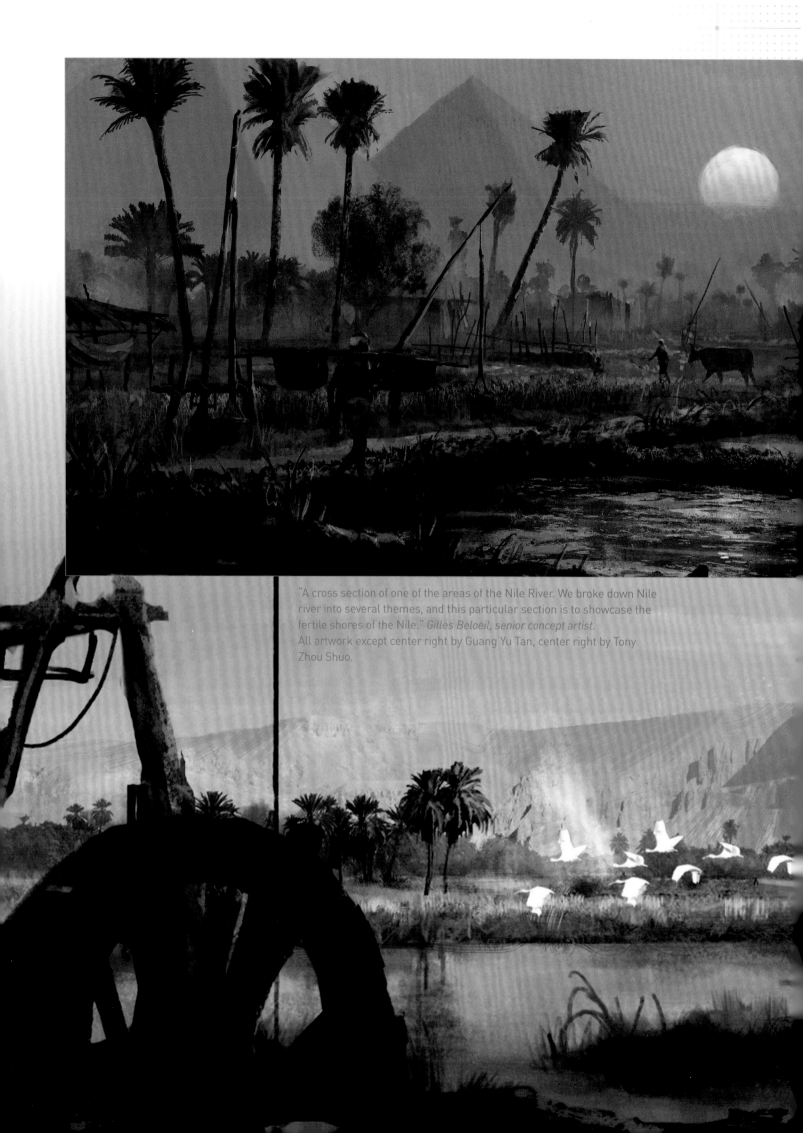

"A cross section of one of the areas of the Nile River. We broke down Nile river into several themes, and this particular section is to showcase the fertile shores of the Nile." *Gilles Beloeil, senior concept artist.*
All artwork except center right by Guang Yu Tan, center right by Tony Zhou Shuo.

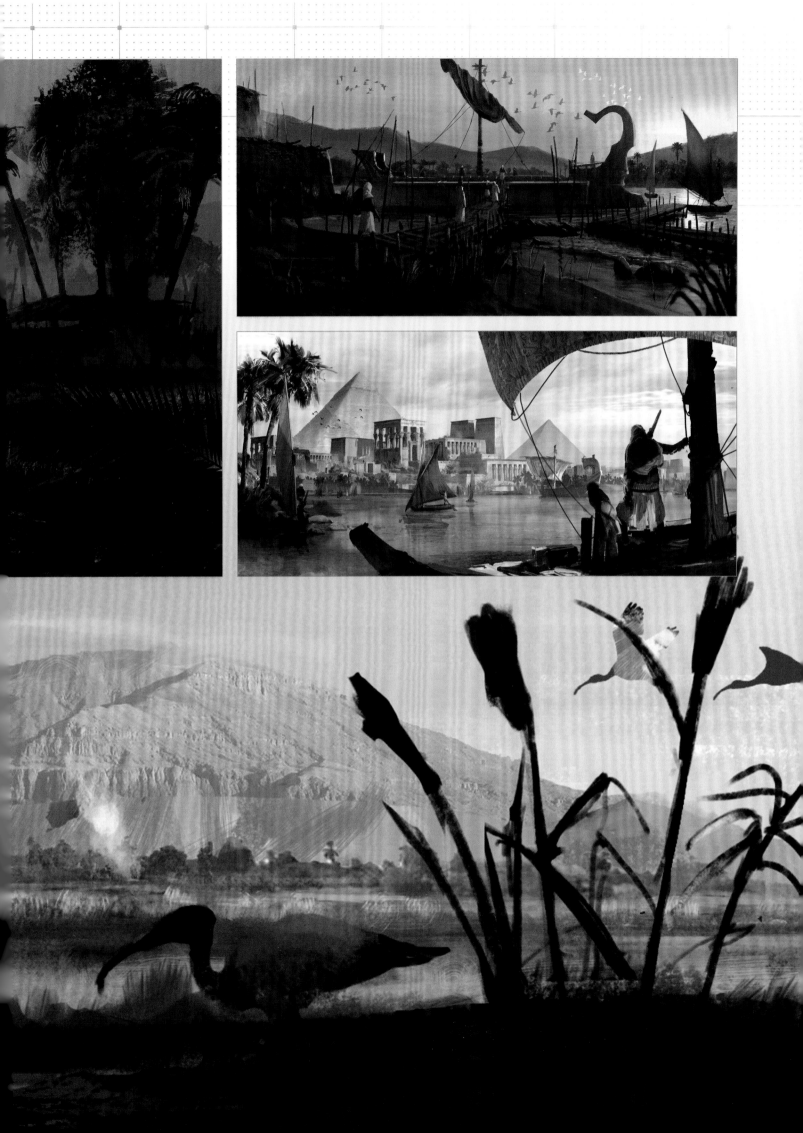

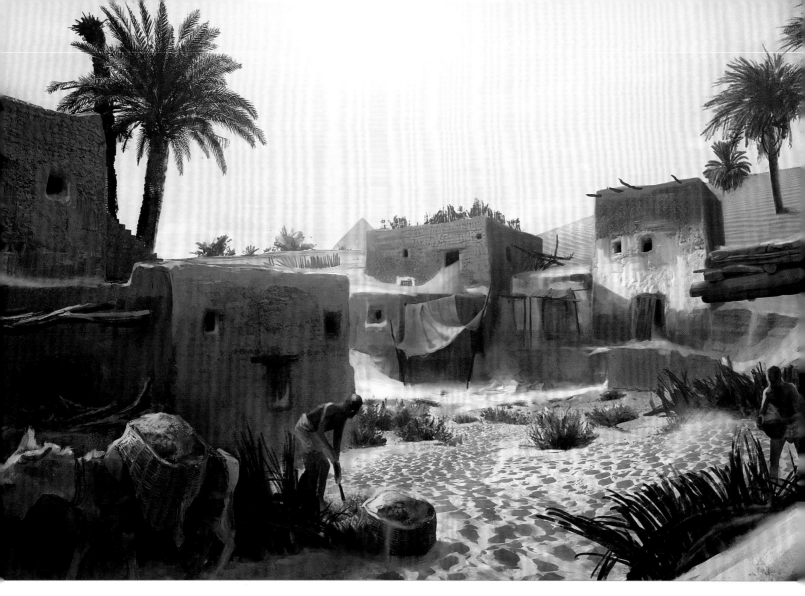

_LETOPOLIS

Contrasting with the flooded plains of the Nile Delta, the arid climate of Letopolis constantly threatens to reclaim the city for the desert, shown here in concepts by Martin Deschambault. At the time of our story, this area is conscientiously preserved through the work of bounty hunter Taharqa, which may be connected to the ancient beliefs linked to the neighboring lands of Giza and Saqqara.

"The population of Letopolis is working hard to fight against the sand invasion," explains Martin Deschambault. "I wanted to show the crowd life and the props setting for this thematic. We already had the design of the mudbrick houses, I had to help the 3D team to visualize how the sand will invade the village. Some houses are already gone, there is too much sand inside the house. We see the villager trying to save what is left."

(Left) *Assassin's Creed Origins* uses many contrasting images of Egypt to fuel the imagination and ensure we never tire of exploration. This fertile oasis off the beaten path appears to be a refuge, but the carrion birds tell a different story. What would such a remote location hide for Bayek and Aya?

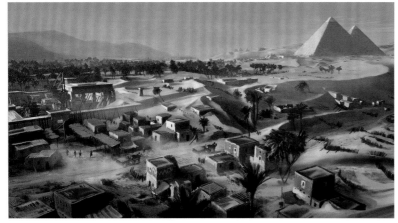

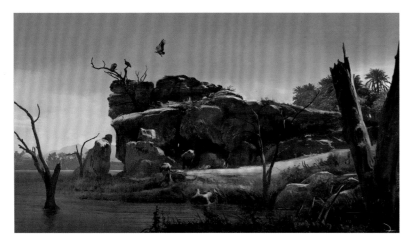

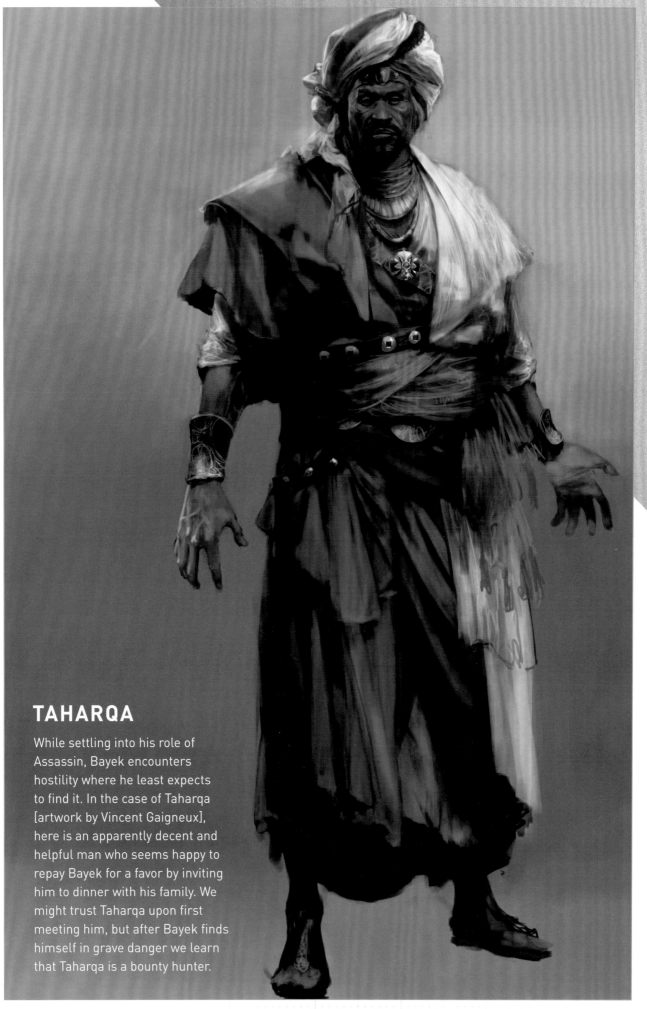

TAHARQA

While settling into his role of Assassin, Bayek encounters hostility where he least expects to find it. In the case of Taharqa [artwork by Vincent Gaigneux], here is an apparently decent and helpful man who seems happy to repay Bayek for a favor by inviting him to dinner with his family. We might trust Taharqa upon first meeting him, but after Bayek finds himself in grave danger we learn that Taharqa is a bounty hunter.

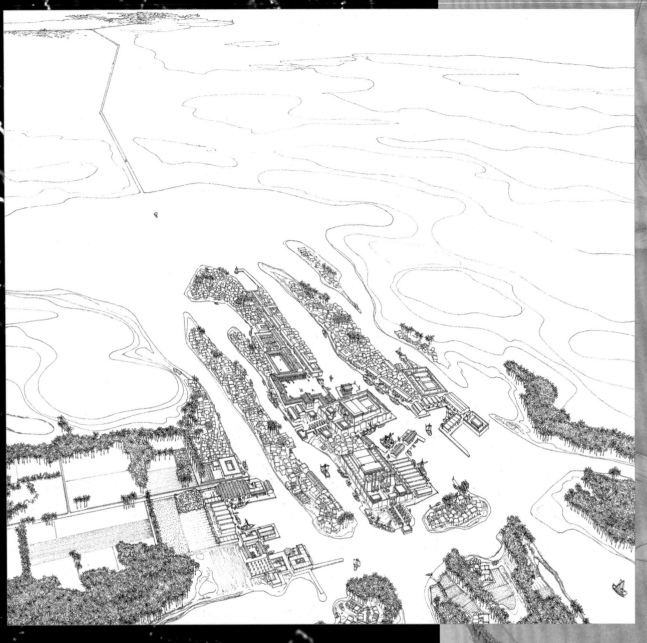

> "ACCURATE ISOMETRIC VIEWS OF THE LOST CITY WERE USED AS A REFERENCE GUIDE FOR THE DESIGN TEAM."

THONIS

Known as Thonis to the ancient Egyptians, the lost city of Herakleion was rediscovered by researchers in 2013. The city is believed to have been swallowed beneath the Mediterranean approximately 1200 years ago. Traces of the city were found in 2000 and investigated by a team from the European Institute for Underwater Archeology (IEASM).

The findings were such a goldmine of information they inspired Ubisoft Montréal and artist and historian Jean-Claude Golvin [above and right], to fully recreate Herakleion in *Assassin's Creed Origins*. It is believed that Herakleion served as a major hub for trade between Egypt and the rest of the known world. The location features a giant red granite statue of the Nile god Hapi, a monolithic chapel and a fleet of ships.

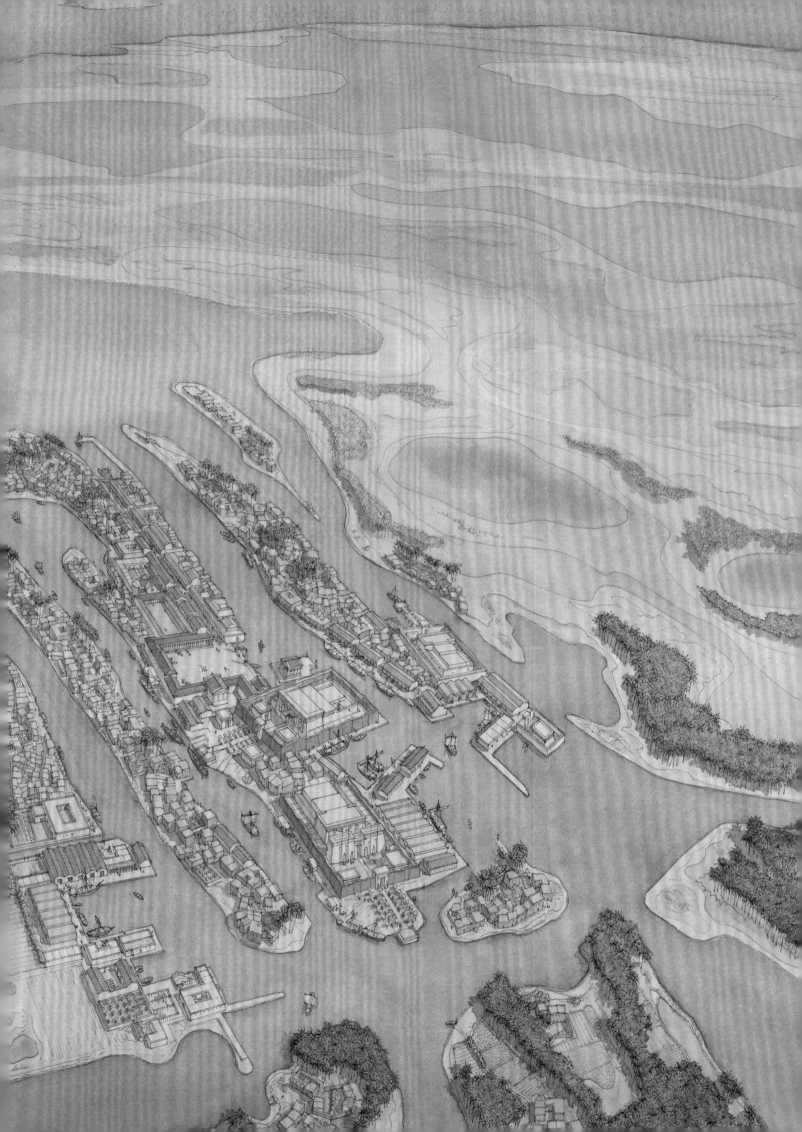

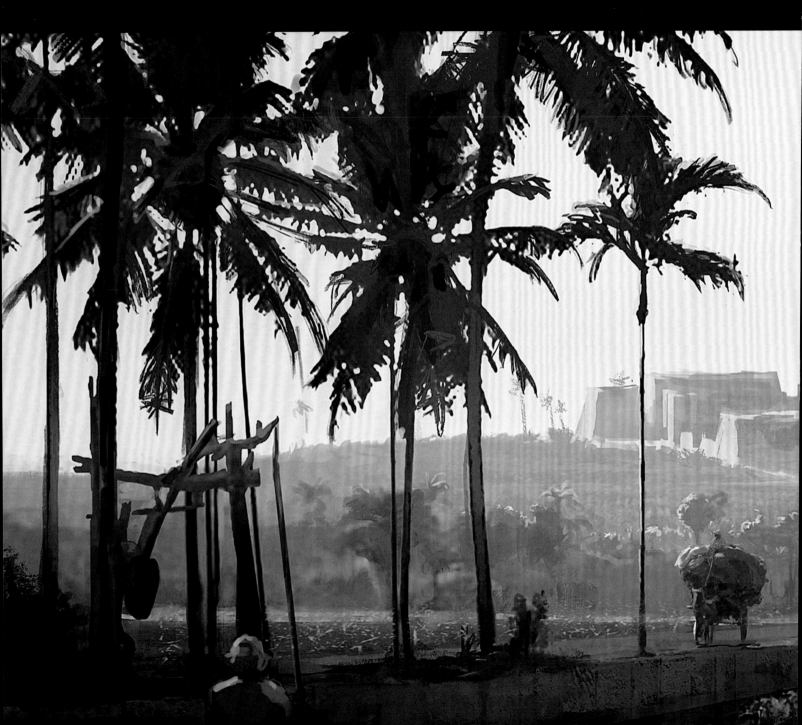

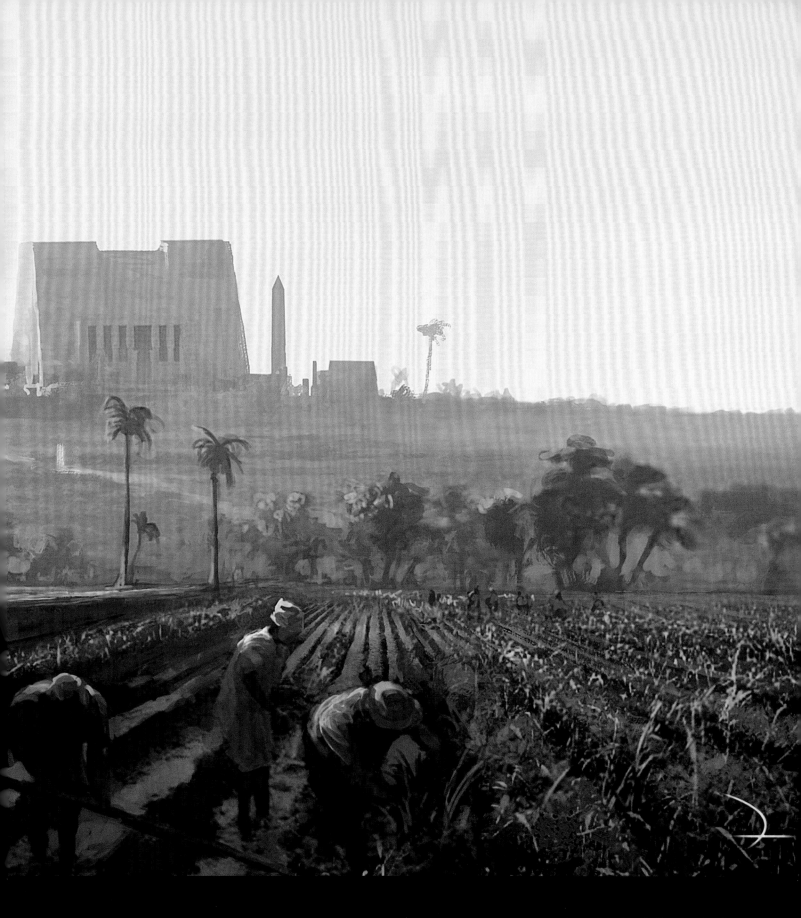

Artwork by Martin Deschambault
[Overleaf] artwork by Raphaël Lacoste

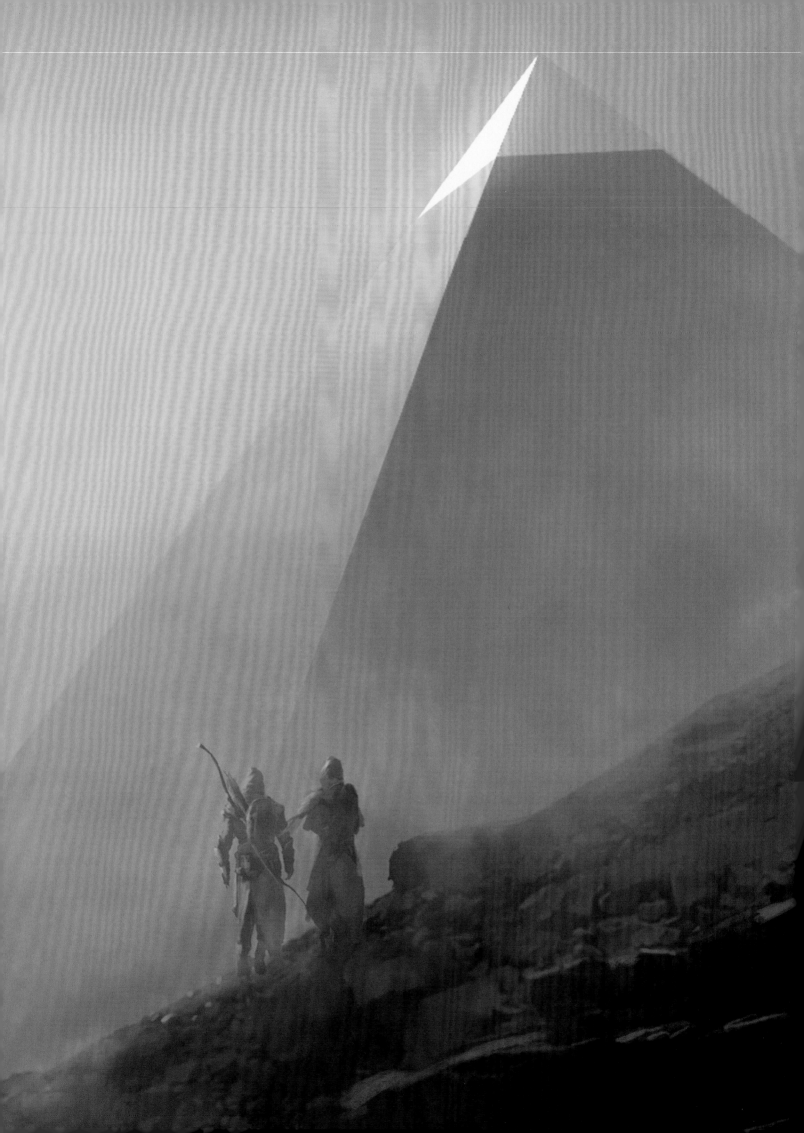

GIZA
AND
MEMPHIS

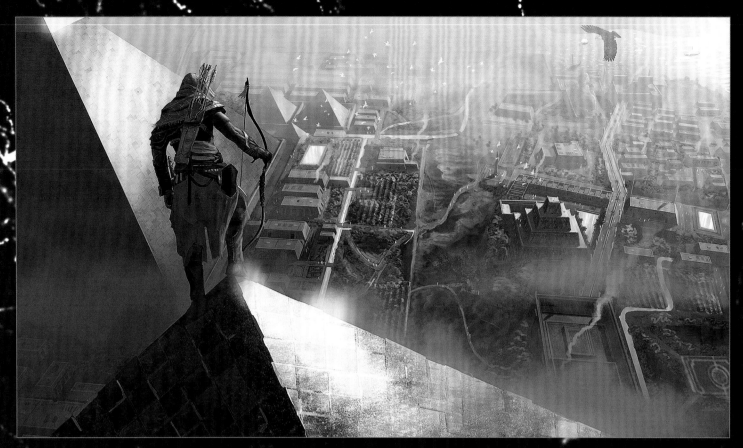

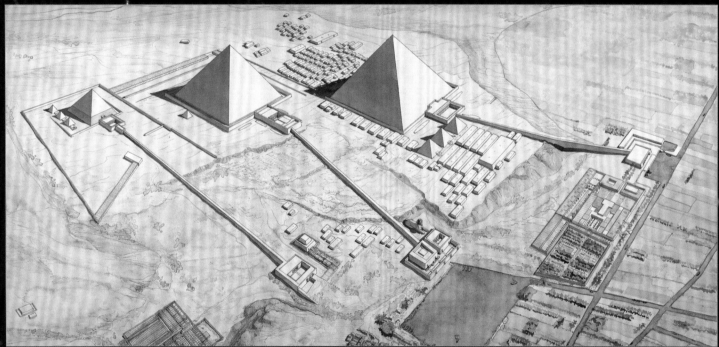

_THE PYRAMIDS

The Great Pyramid of Giza is one of the Seven Wonders of the World, revered from the moment it was completed until now. It is a marvel of engineering that took decades to complete. The Biblical epics of Hollywood have implanted the notion that thousands of slaves toiled miserably to quarry, cut and drag vast stone slabs to build it but this is not true. The workers were mostly peasants, employed by the pharaohs, and who would otherwise have been left without means to earn a living during the Nile's annual flood.

"This artwork [right] was not made for a specific moment in the game, I just wanted to draw a simple and moody composition of Bayek walking to the Pyramids. Sometimes it is nice to take a break of the constraints of production. It is always useful for inspiration and it can lead to some ideas for future concept art." *Martin Deschambault*

[Above] the Giza plateau by Jean-Claude Golvin
[Top] artwork by Art Director & Senior Concept artist Eddie Bennun

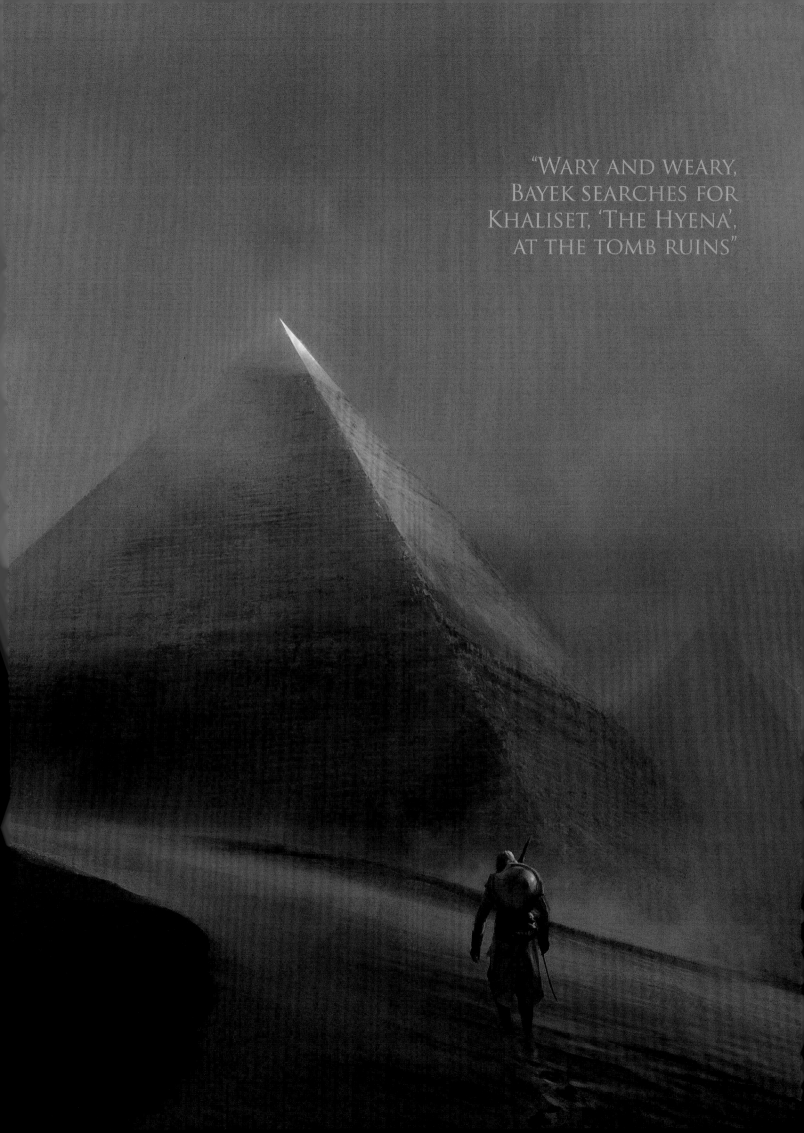

"WARY AND WEARY,
BAYEK SEARCHES FOR
KHALISET, 'THE HYENA',
AT THE TOMB RUINS"

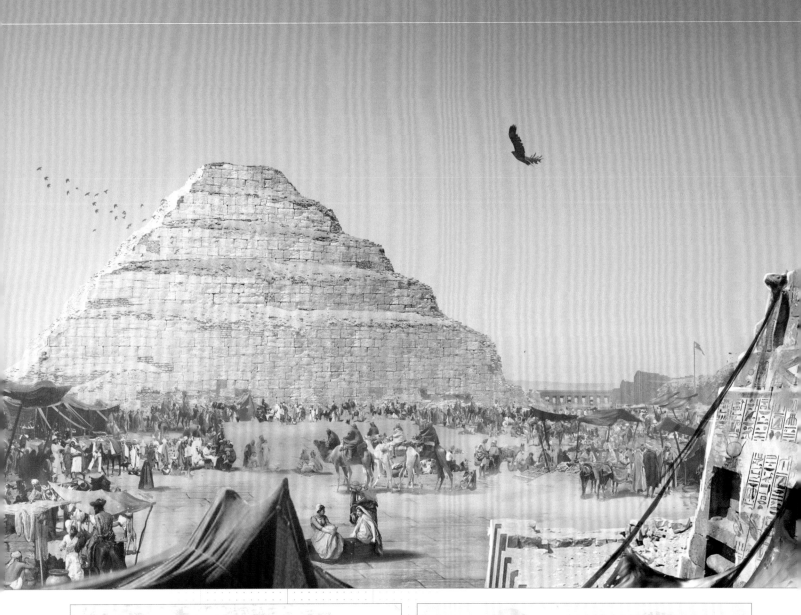

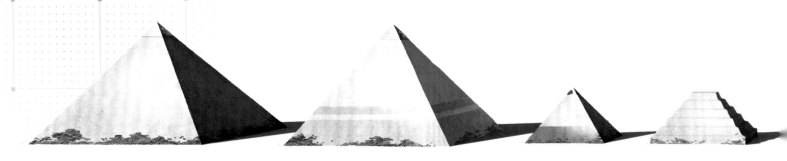

Khufu Pyramid Khafre Pyramid Menkaure Pyramid Djoser Pyramid

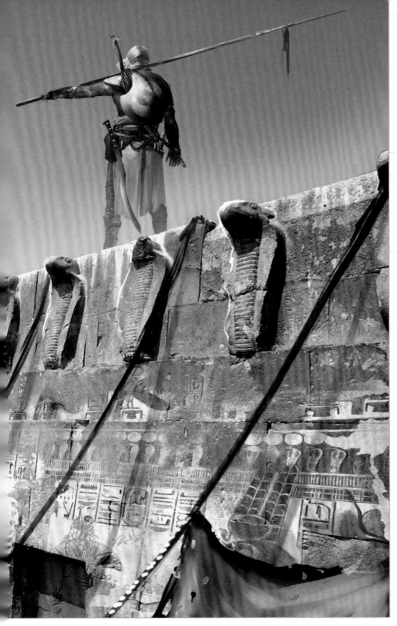

[Left] The Djoser Step Pyramind by Daniel Atanasov

No Egyptian odyssey would be complete without visiting the famous pyramids. Naturally, Ubisoft's concept artists invested some serious time in research. The images below by Diana Kalugina show examples stretching back to the fourth-dynasty king, Sneferu (2686-2667 BCE), whose most successful design pioneered the look we now associate with 'pyramid'.

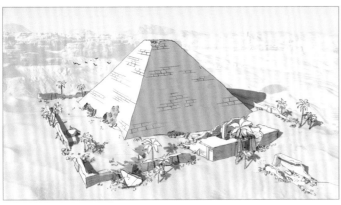

Sneferu's Red Pyramid, built from red limestone, was a template for all that came after. His son Khufu (2575-2566 BCE) built the Great Pyramid of Giza, using approximately 2,300,000 limestone blocks. Khufu's son, Khafre (2558–2532 BCE), followed suit with a building that's thirty-four feet lower, and still has some of its limestone casing intact. It was Khafre who built the Great Sphinx in honor of the sun god Ra-Harakhte, although its face is a portrait of Khafre.

Red Pyramid

Bent Pyramid

Medium Pyramid

Hawara Pyramid

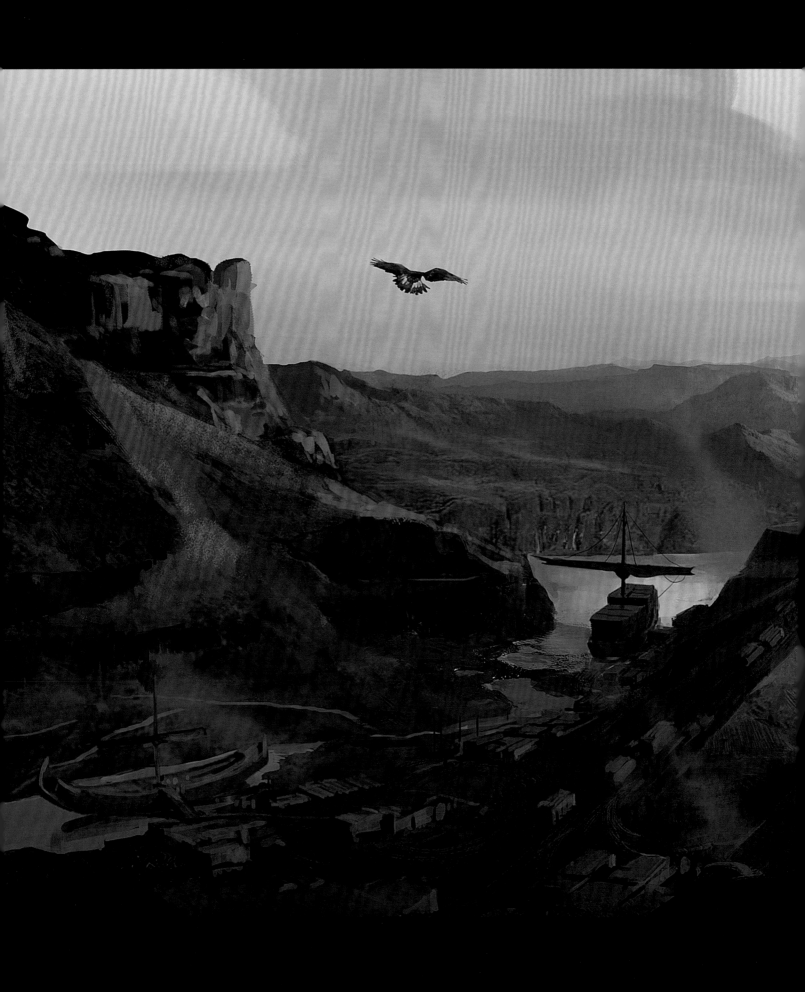

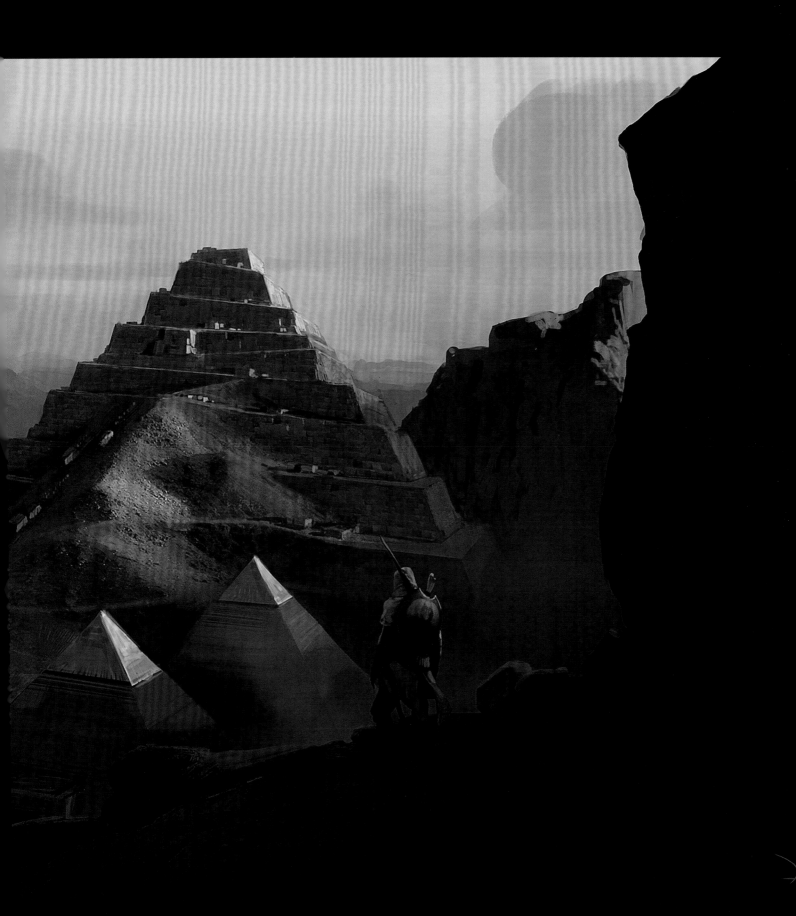

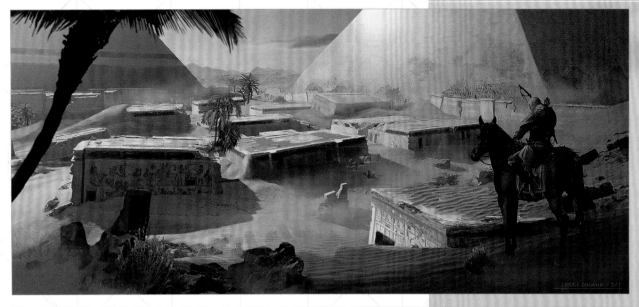

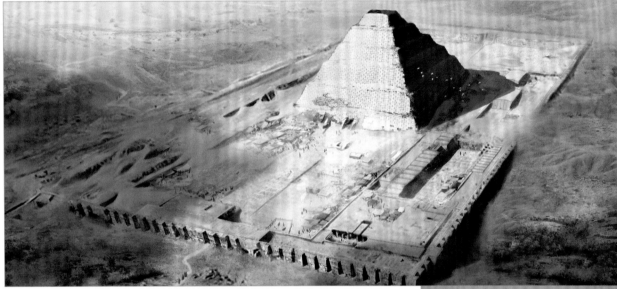

The pyramids of Giza are huge, with the Great Pyramid standing 480 feet at the time when it was built. As with all the pyramids, the Great Pyramid's 2.5 ton blocks (with some as heavy as 16 tons) would have been encased in limestone, giving the sides a smooth appearance quite unlike the staggered look we see today.

Through Bayek, we can explore the causeways, temples and burial chambers as they would have appeared more than 2000 years ago. However, it is staggering to think that they were built more than 2500 years before that. There might also have been archeologists in Bayek's era, some frightened of curses, other more unscrupulous types stealing treasure and religious artifacts to trade. Bayek hopes to secure something of personal value.

[Top] Art Director Eddie Bennun explores the human-level view of the pyramids and surrounding buildings.
[Previous spread] "The construction of the pyramid is an epic moment. This one is not part of the Giza pyramid, but the setting of the pyramid in the canyon is very interesting. This pyramid was located in the red mountain, and I saw some beautiful references with this kind of lighting which I used for inspiration." Martin Deschambault, senior concept artist.
[Right] artwork by Ivan T Koritarev. [Above] artwork by Daniel Atanasov.

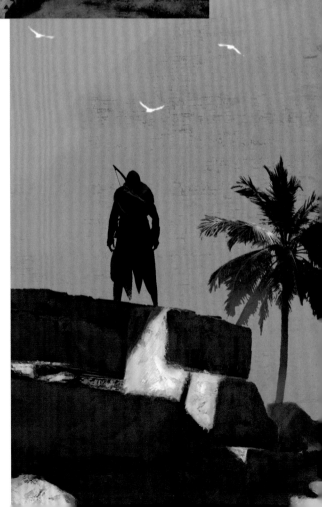

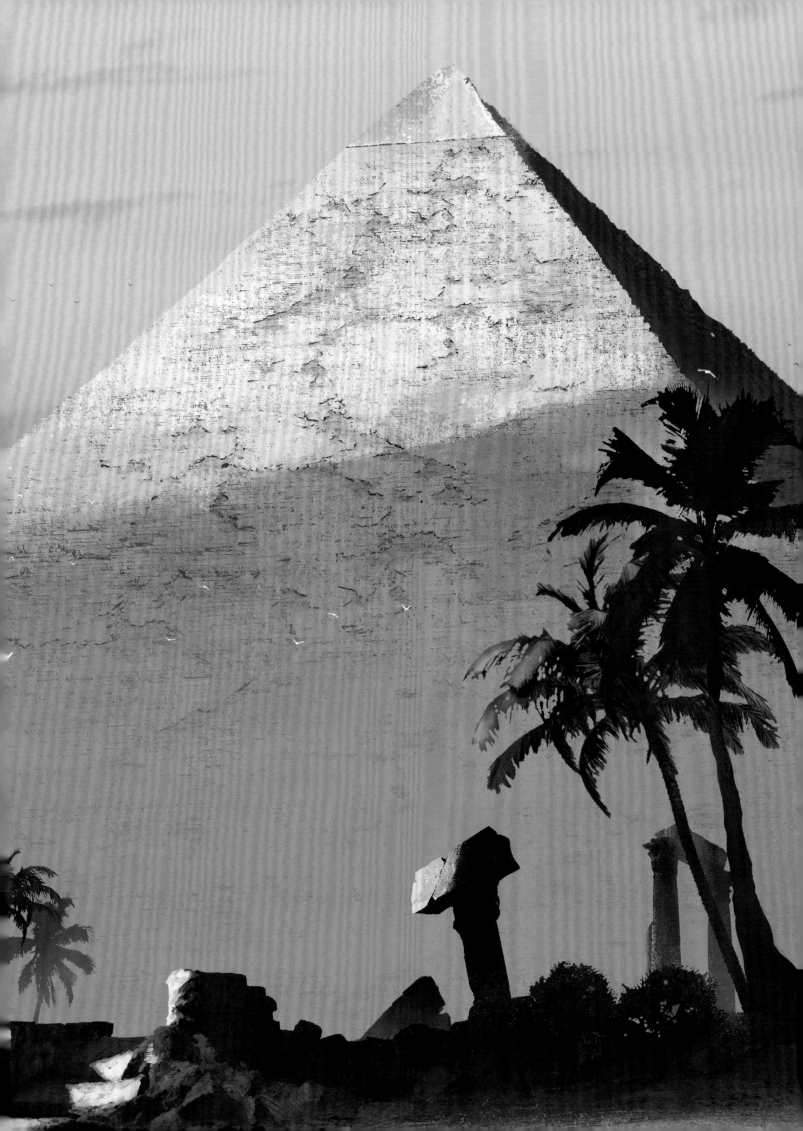

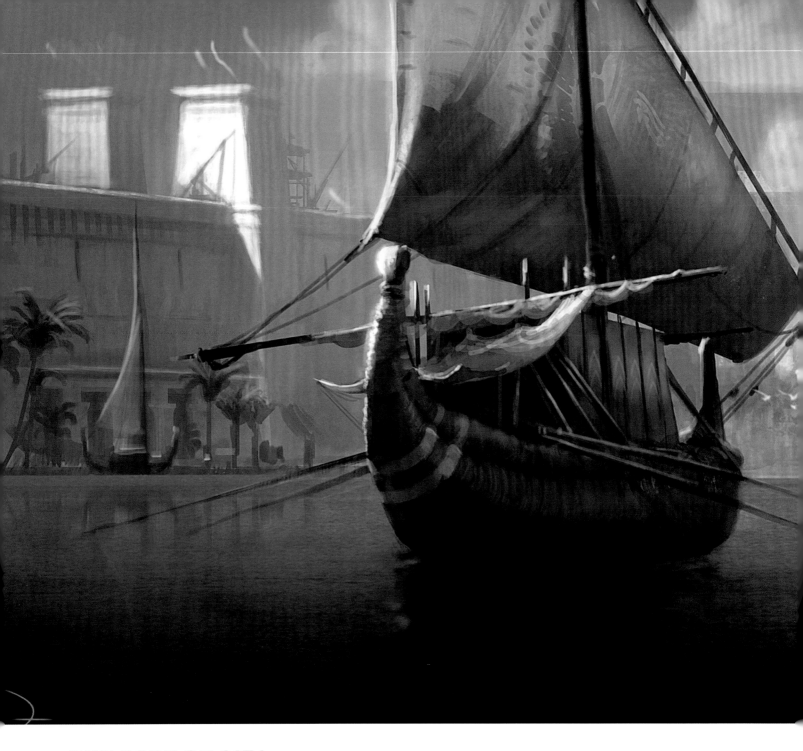

_THE PORT OF GIZA

Access to the funerary temples of the Pharaohs was gained via landing stages along the Nile as depicted by Gilles Beloeil [right]. These temples were built close to the royal tombs, and served as a place of worship for the various Pharaoh cults, or as places to commemorate their lives. As senior concept artist Gilles Boleil explains, "We had to design this access keeping in mind that it was sacred, solemn. We had to play with the proportions of the structures to make the player feel this importance."

In the game, this tranquil setting is disrupted by carnage. Bayek is in pursuit of the bandit leader Khaliset, The Hyena, whose loyal 'pets' savage a small team of men while they prepare to ambush Bayek. As introductions go, the setting and circumstances are unexpected and therefore memorable. The location's focus on death and remembrance draws us painfully back to the central theme of Bayek's quest: the loss of his child. At the scene's climax, Bayek must choose whether to take a life or spare it, and live with the consequences.

[Above] "This is one of the first concept pieces I did for the project. This is not a real location but it is a good inspiration for the Egyptian city. We were at the beginning of our research about the architecture and the layout of this period, very inspired by the animation movie 'The Prince of Egypt'." Martin Deschambault

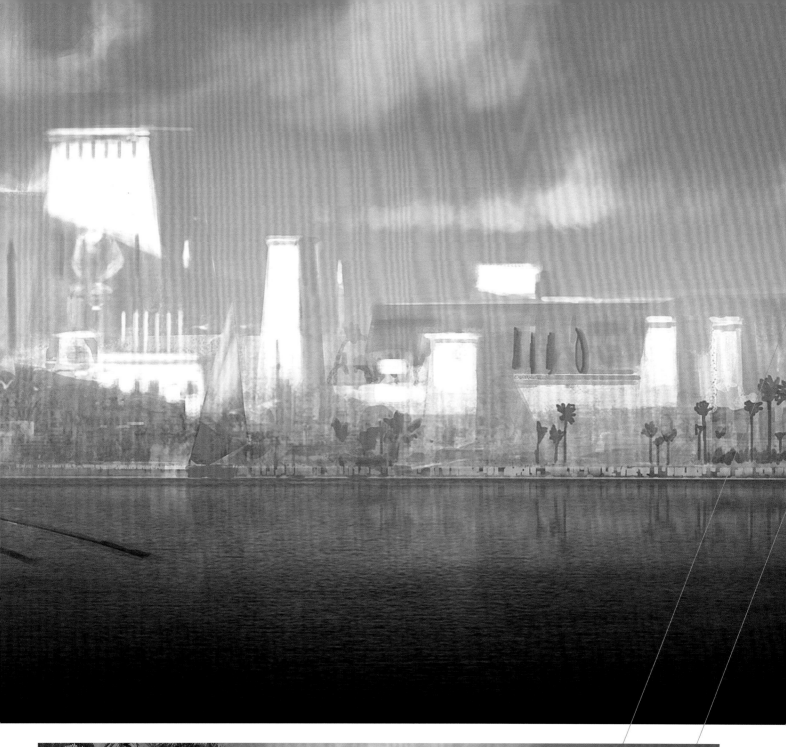

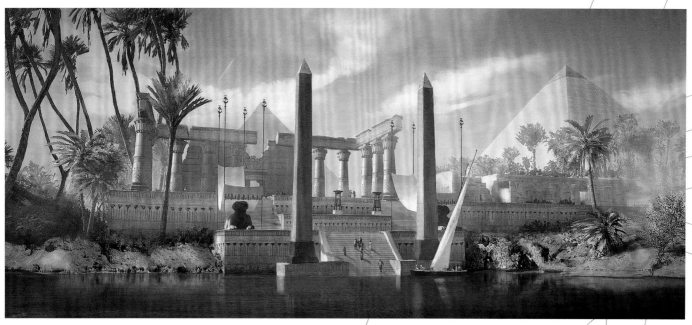

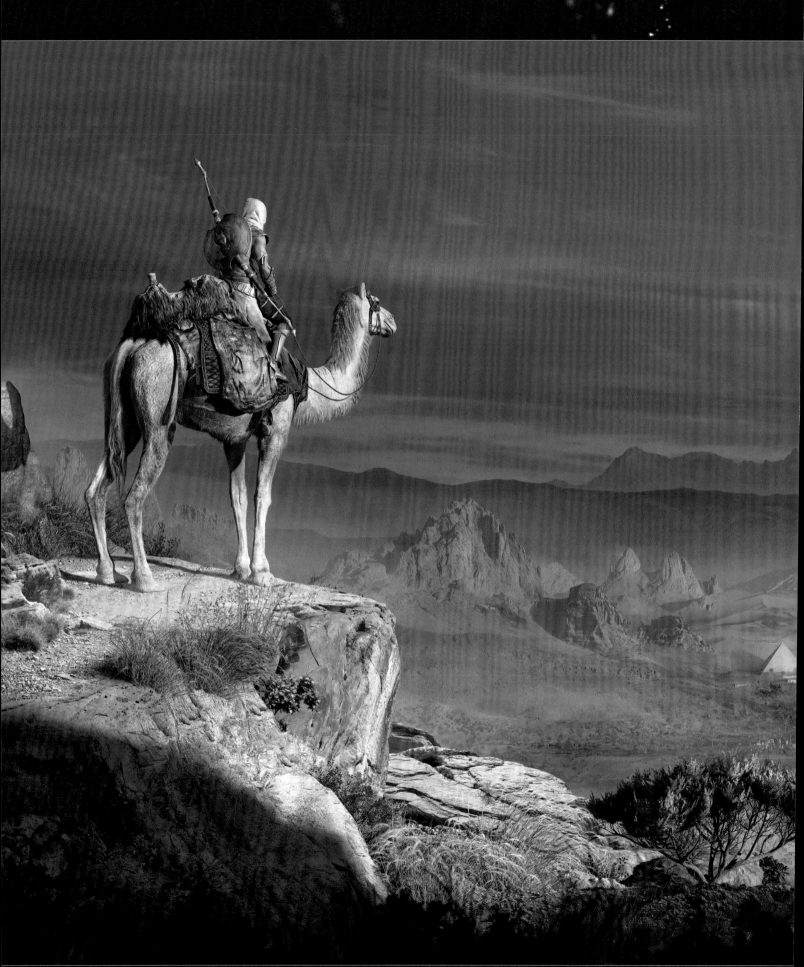

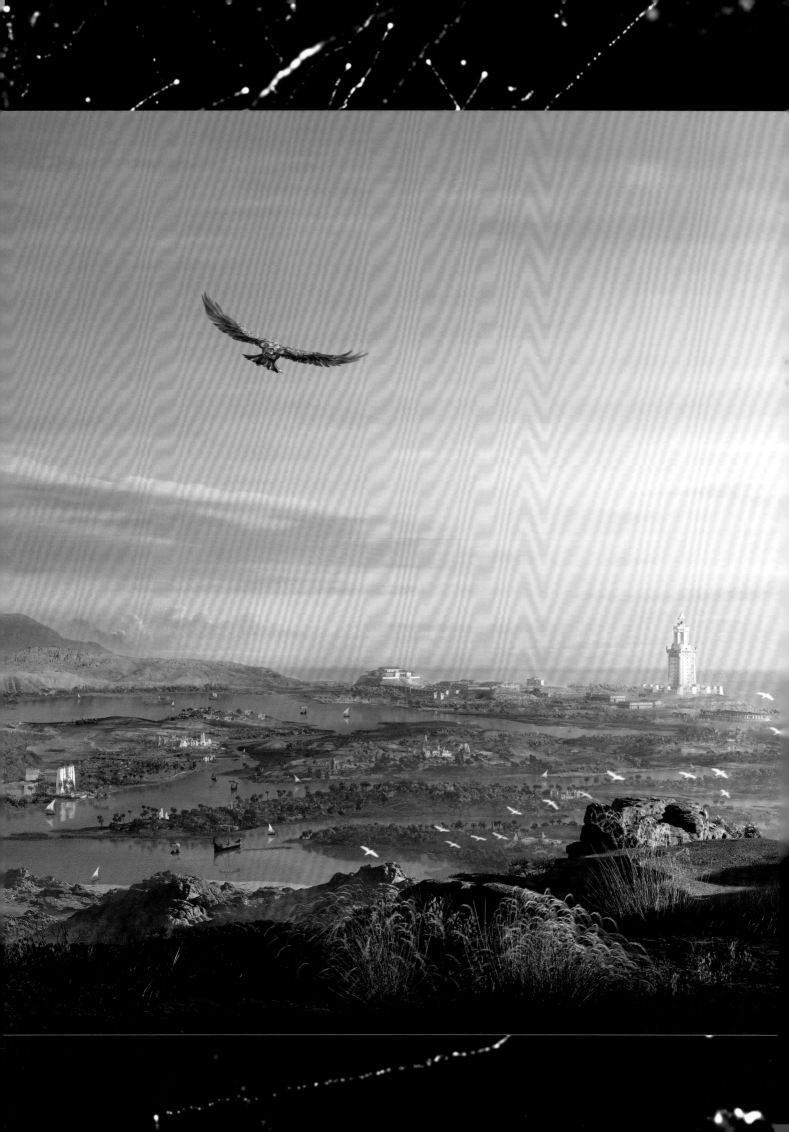

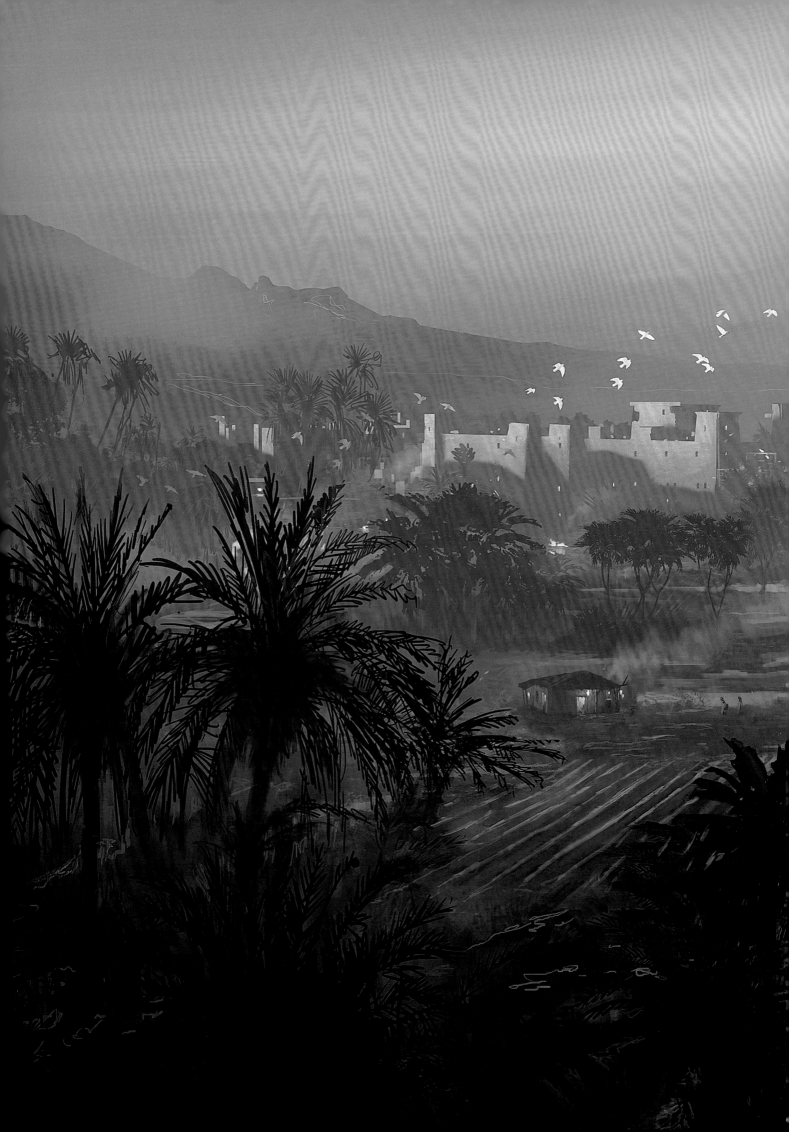

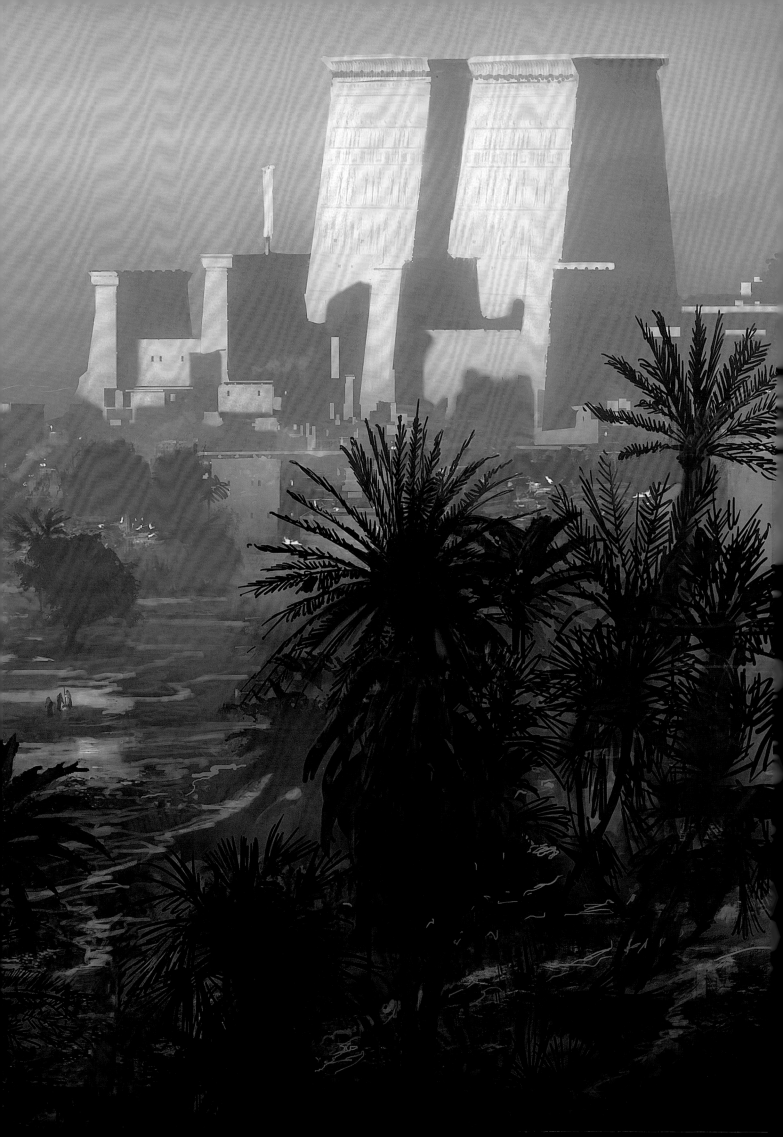

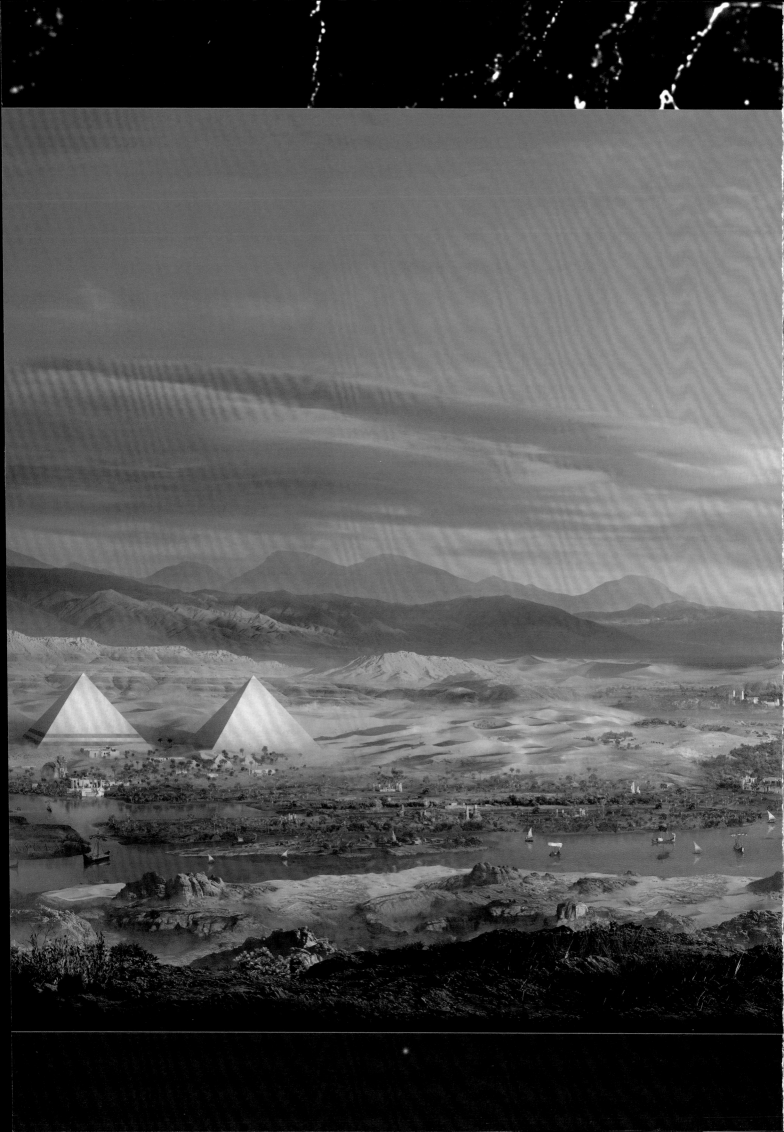

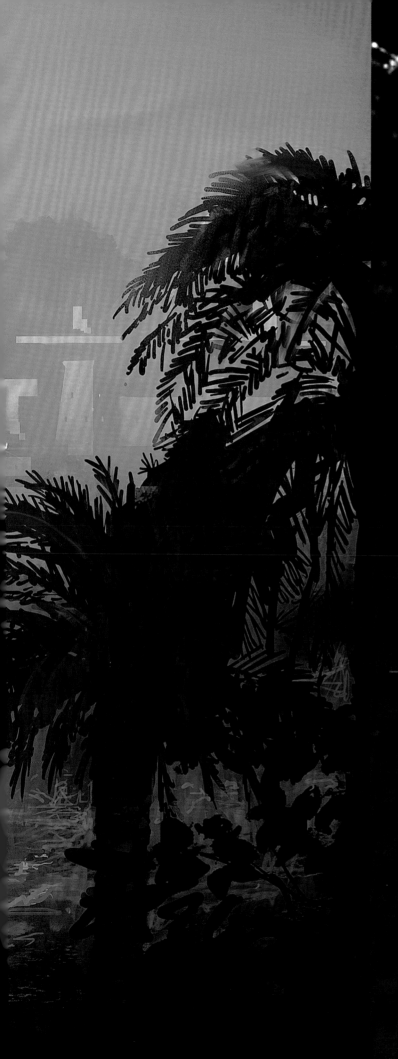

"BAYEK INVESTIGATES THE ORIGIN OF CURSES AFFECTING THE WELLBEING OF BOTH PEOPLE AND ANIMALS"

MEMPHIS

"Memphis is the heart of Egypt," proclaims Cleopatra. "If Memphis won't treat me as its Queen, how can I be expected to be treated like a goddess?" This is how we learn the importance of Memphis to Egypt. But when Bayek arrives he finds that the city has apparently been cursed on the eve of the Apis Bull Festival.

"Memphis is an epic Egyptian city," says Martin Deschambault. "The scale is exaggerated but it was to increase the monumental feel. It was a great exercise to study how they stylized the architecture and very useful when it came time to create more realistic artwork. Because you can always have some level of stylization even if it is realistic."

Citizens of Memphis worshipped the god Ptah, patron of craftsmen, to ensure the success of their trade industry. Workshops lined the principal port, and warehouses distributed food throughout the region.
[This page] artwork by Gilles Beloeil.

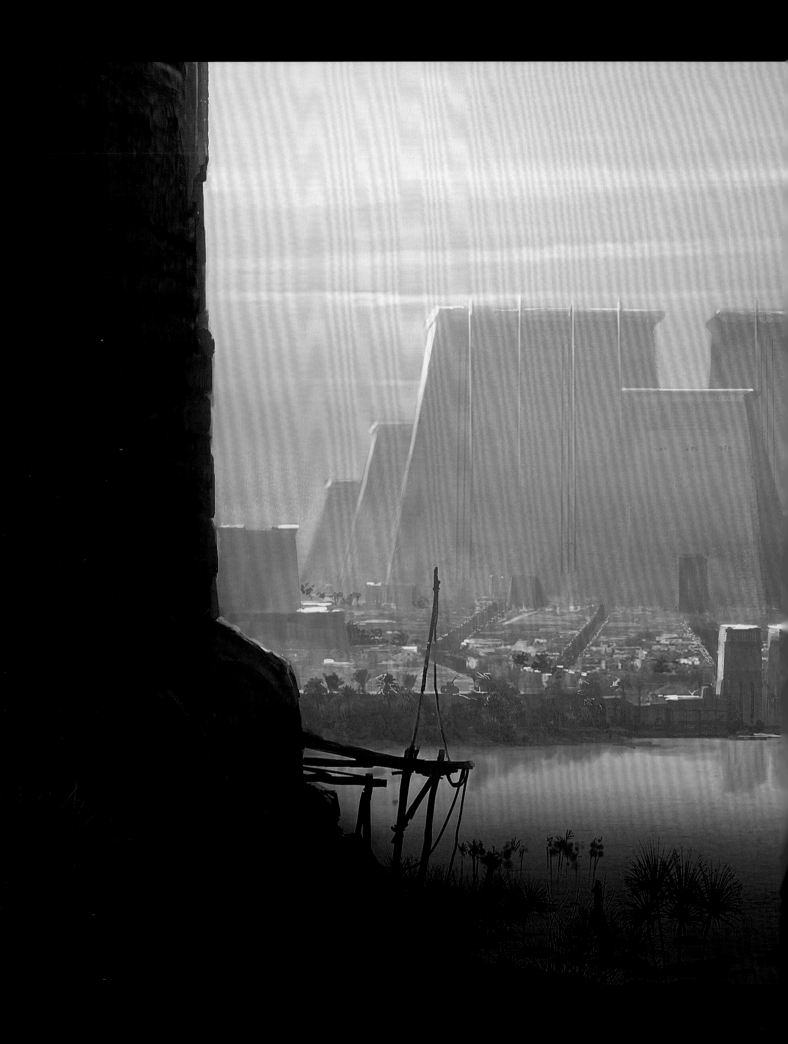

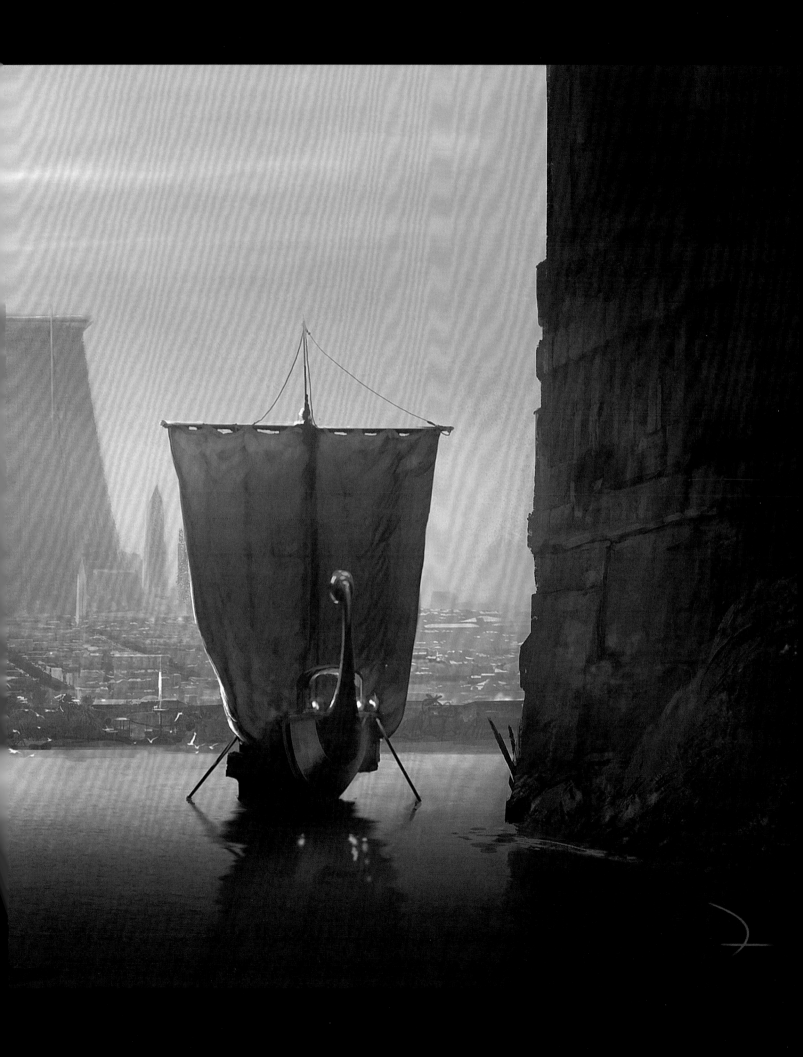

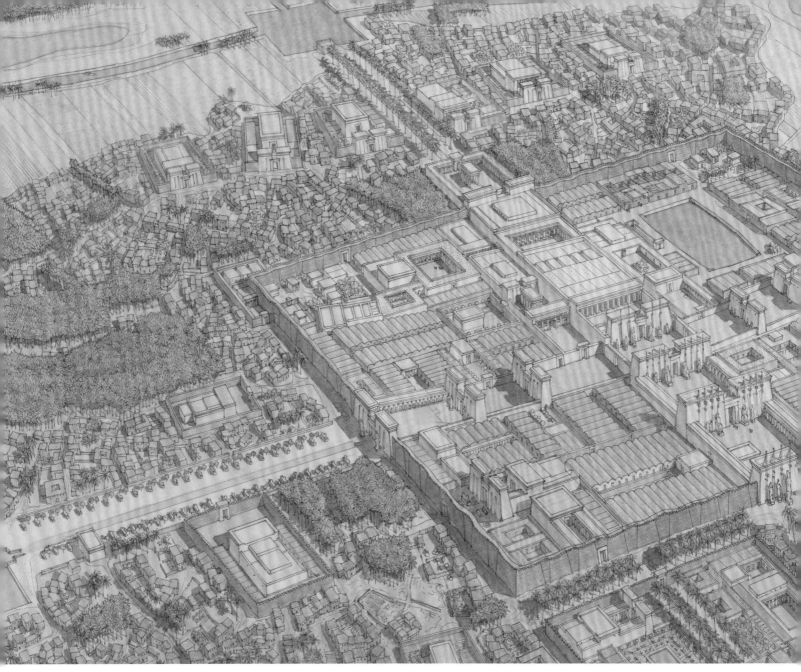

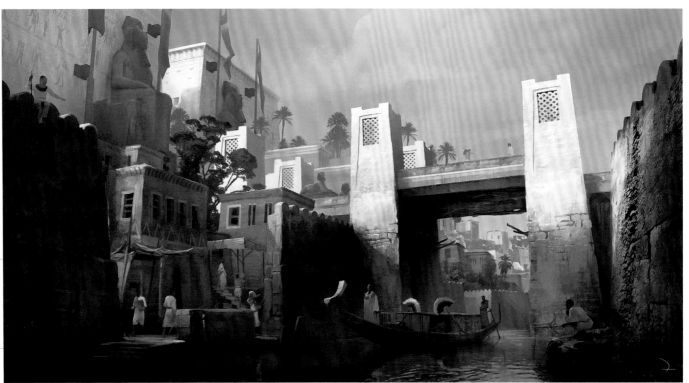

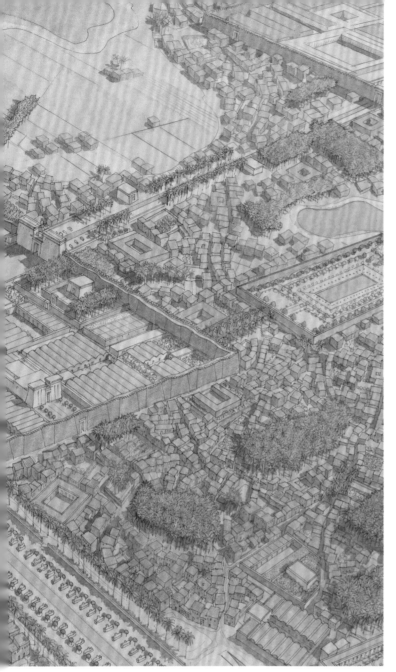

Founded in 3100 BCE, Memphis was originally called The White Wall ('Ineb-Hedj'). With its command of trade routes within Egypt and across the Mediterranean it's no wonder Cleopatra coveted the location so much. It was also home to the legendary King Tutankhamun, around 1000 years before Bayek's story takes place.

Below and on the previous page, depictions of the city show an exaggerated architecture with a more stylized feel. Artist Martin Deschambault talks about creating this early on. "You can see the scale is more realistic but there is still some stylization in the shape and composition. This is why we like to exaggerate the scale and proportion at the beginning of the conception. When we start to make the location more realistic, we will lose some stylization but still keep some level of it. If we were already too realistic at the beginning, it will be hard to give style and personality to the art direction after."

[Left] A birds-eye view of the city by Jean-Claude Golvin.
[Below Left] Sometimes playability and fun trumps historical accuracy as Martin Deschambault explains, "Memphis had a lot of canals in the city and we wanted to have a bridge. Unfortunately, the Egyptians didn't use bridges during this time period, so I had to find new references that would work as a base for the design of the bridge. It is probably not historically accurate, but it looks plausible and works perfectly in the game."
[Below] artwork by Raphaël Lacoste.

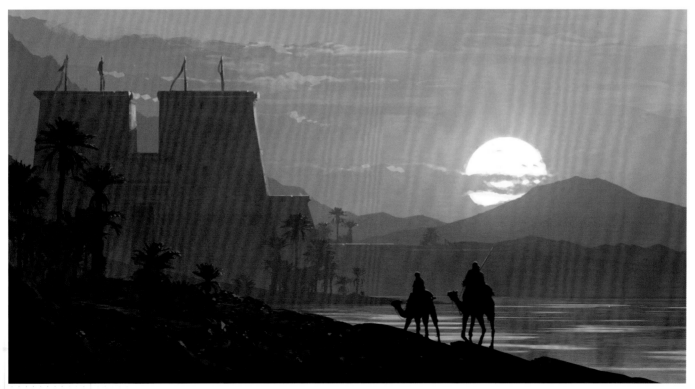

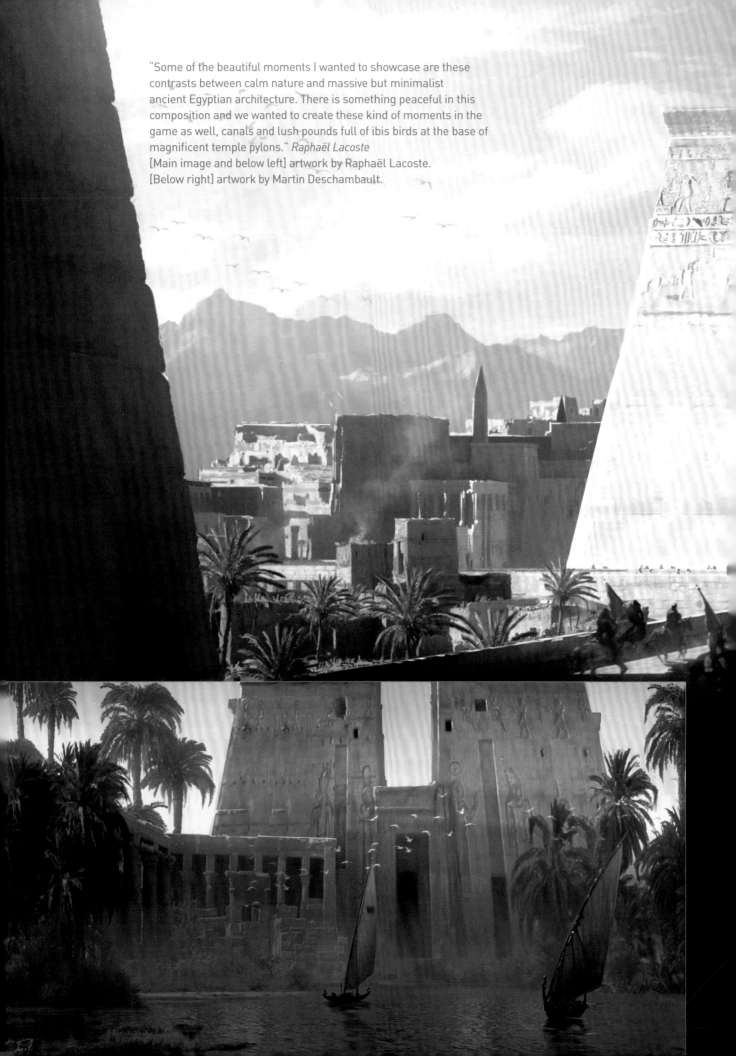

"Some of the beautiful moments I wanted to showcase are these contrasts between calm nature and massive but minimalist ancient Egyptian architecture. There is something peaceful in this composition and we wanted to create these kind of moments in the game as well, canals and lush pounds full of ibis birds at the base of magnificent temple pylons." *Raphaël Lacoste*
[Main image and below left] artwork by Raphaël Lacoste.
[Below right] artwork by Martin Deschambault.

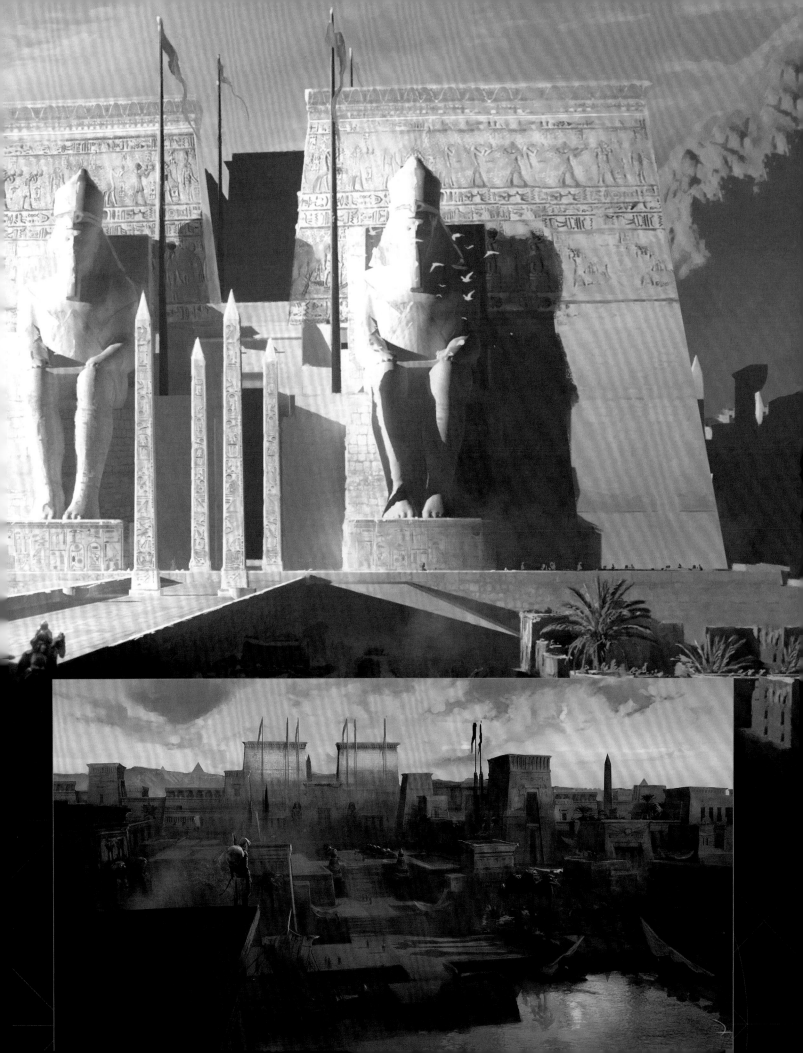

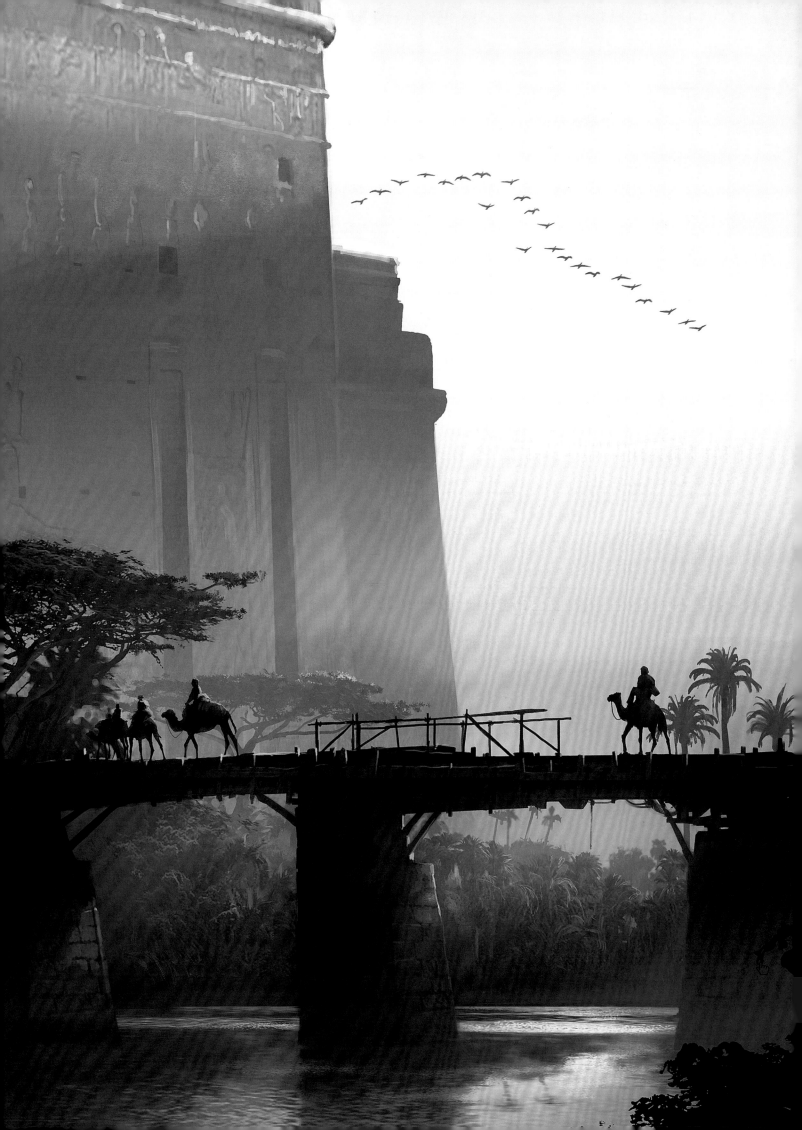

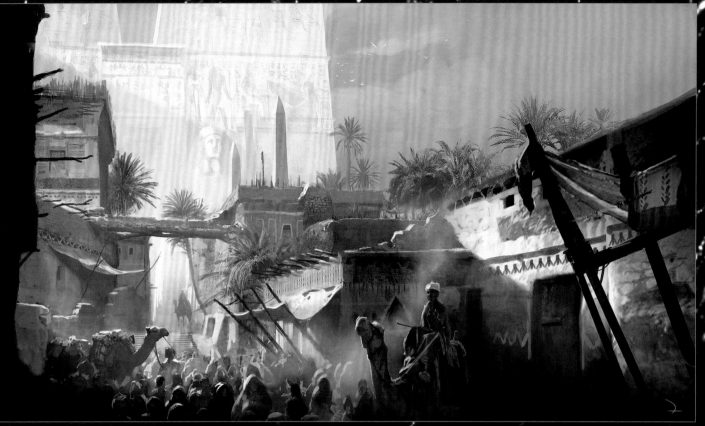

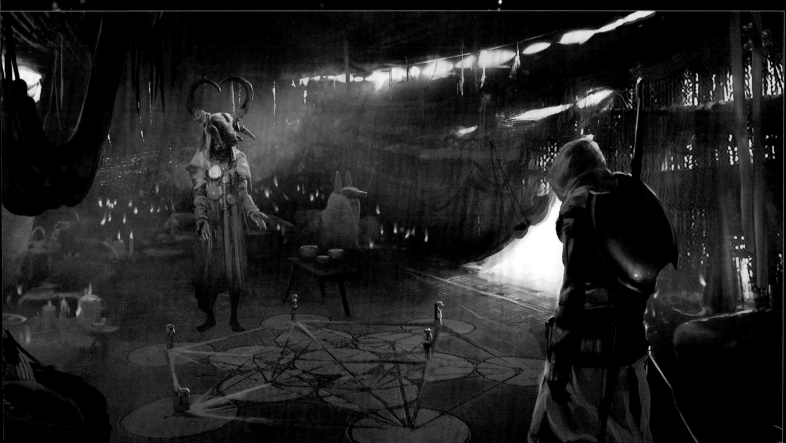

[Top] "I wanted to show the density of population and the organic look, contrasted with the monumental temple in the background. This kind of concept is very useful for an Assassin's Creed game. It is not about designing every detail, every house or prop, it is all about finding the right feel and mood for the city street." *Martin Deschambault.*

[Left] "The scale of the temple is monumental. I like the contrast of the small wooden bridge with the epic temple in the background. It is a fancy way to design a simple wooden bridge." *Martin Deschambault*

[Above] artwork by Martin Deschambault

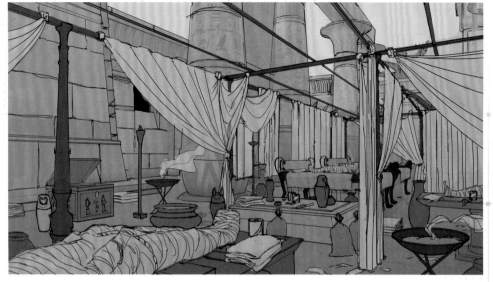

"In this drawing, I needed to try and organize this large space for mummification and make it interesting to explore. This is where the idea of segmenting the space with drapes came from. This divides the space and also visually evokes a hospital setting. Then I only had to add objects that were used at that time for mummification such as canopic jars." *Gilles Beloeil*

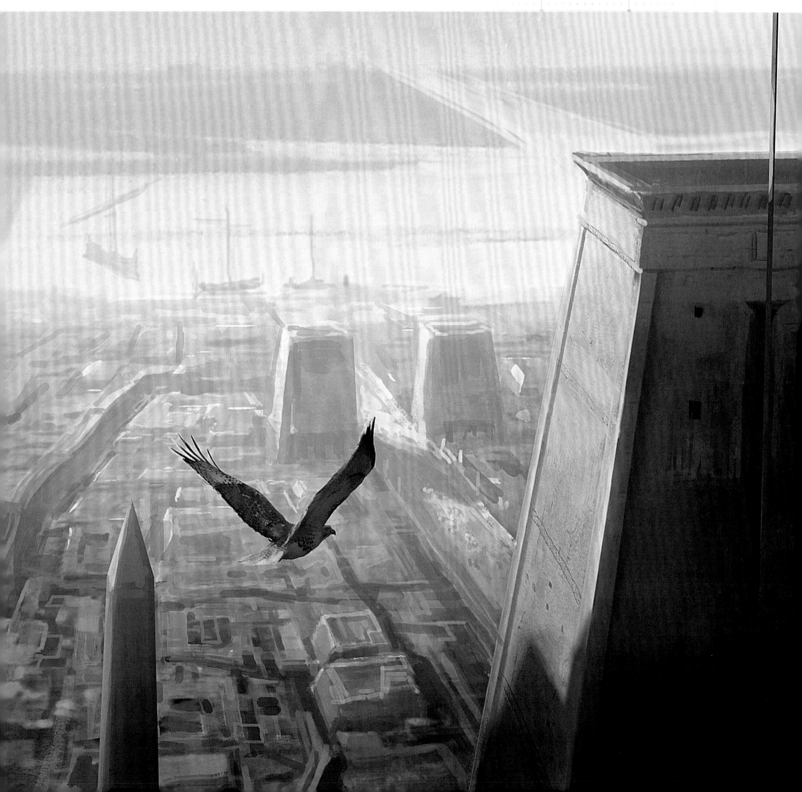

An eagle's eye-view of Memphis with an exaggerated scale. Below is an early
concept art by Martin Deschambault used primarily to inspire the team. An
untrained eye can admire the impressive vista, but an assassin seeks routes to
his target around, over and through the mega structures. The thrill of climbing
and exploring history's most famous monuments to power, from the Galata
Tower in old Constantinople to Notre Dame in Paris, is one of the Assassin's
Creed series' unrivalled experiences. We discover the whereabouts of every open
window, every secret passage, every unlocked door in order to gain entrance.
More importantly, we devise spectacular escapes and perform Leaps of Faith
from the highest points. Where the eagle flies, we dare to follow.

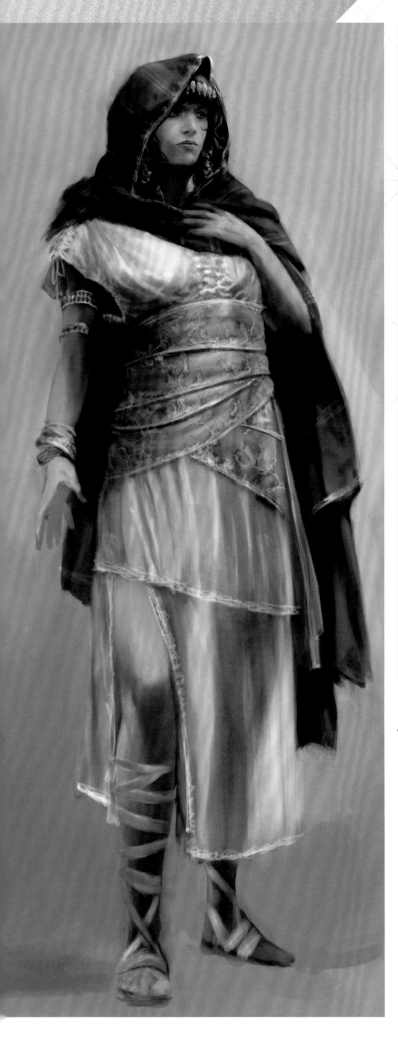

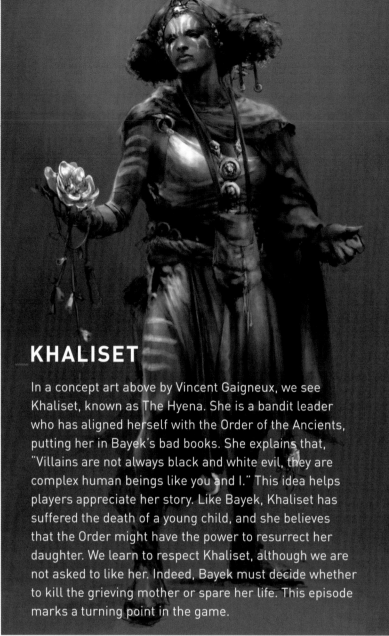

_KHALISET

In a concept art above by Vincent Gaigneux, we see Khaliset, known as The Hyena. She is a bandit leader who has aligned herself with the Order of the Ancients, putting her in Bayek's bad books. She explains that, "Villains are not always black and white evil, they are complex human beings like you and I." This idea helps players appreciate her story. Like Bayek, Khaliset has suffered the death of a young child, and she believes that the Order might have the power to resurrect her daughter. We learn to respect Khaliset, although we are not asked to like her. Indeed, Bayek must decide whether to kill the grieving mother or spare her life. This episode marks a turning point in the game.

_TAIMHOTEP

The concept on the left by Vincent Gaigneux shows Taimhotep, the wife of the High Priest of Ptah. Her desperate need to produce a male heir is agonizing. After consulting with a seer, clues to the cure appear in a dream and Bayek eventually resolves her plight.

Cleopatra insists that Bayek and Aya uncover the cause of the Apis Bull's illness, so that the festival can proceed. There is a logical explanation for the whole mess, although it is solved in part by the mystical revelations experienced by Taimhotep in the seer's tent. "We tried to show elegance and power, without the cheesy 1960s kitsch some of us associate with these designs thanks to the old movies," Jeff Simpson says. "We had to tone down the colors a bit, work in some 1980s fashion in there a bit too!"

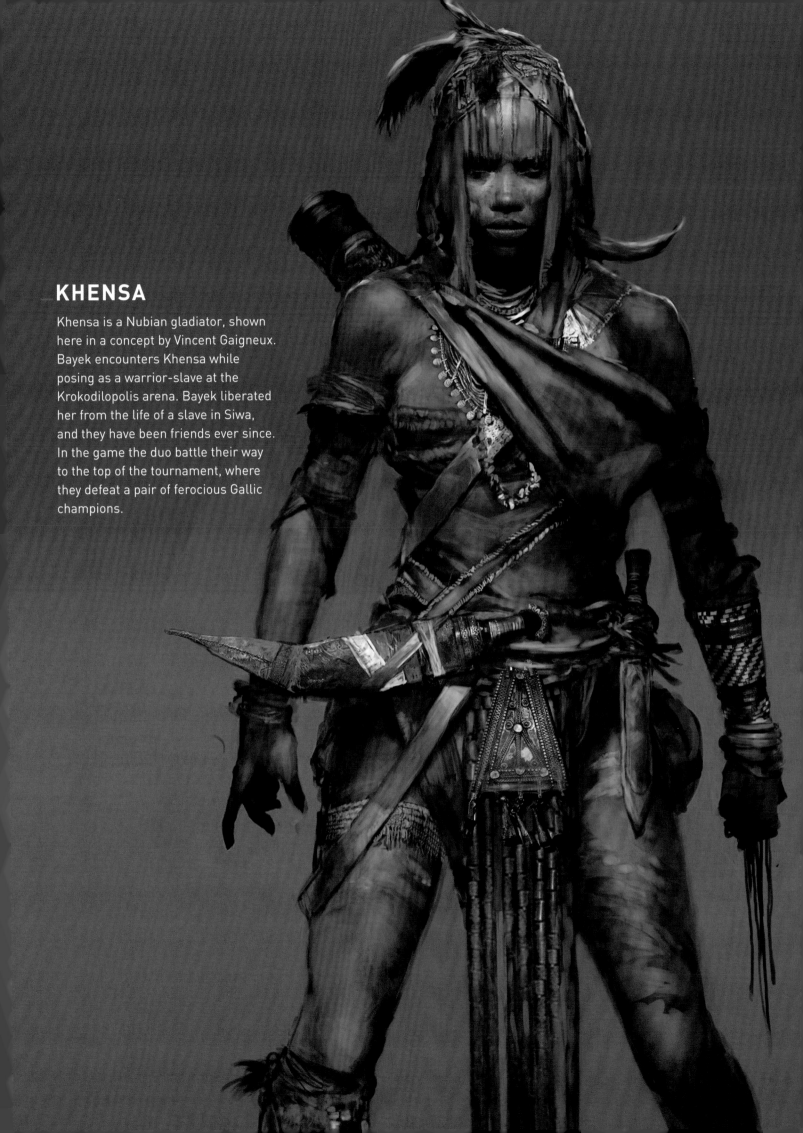

KHENSA

Khensa is a Nubian gladiator, shown here in a concept by Vincent Gaigneux. Bayek encounters Khensa while posing as a warrior-slave at the Krokodilopolis arena. Bayek liberated her from the life of a slave in Siwa, and they have been friends ever since. In the game the duo battle their way to the top of the tournament, where they defeat a pair of ferocious Gallic champions.

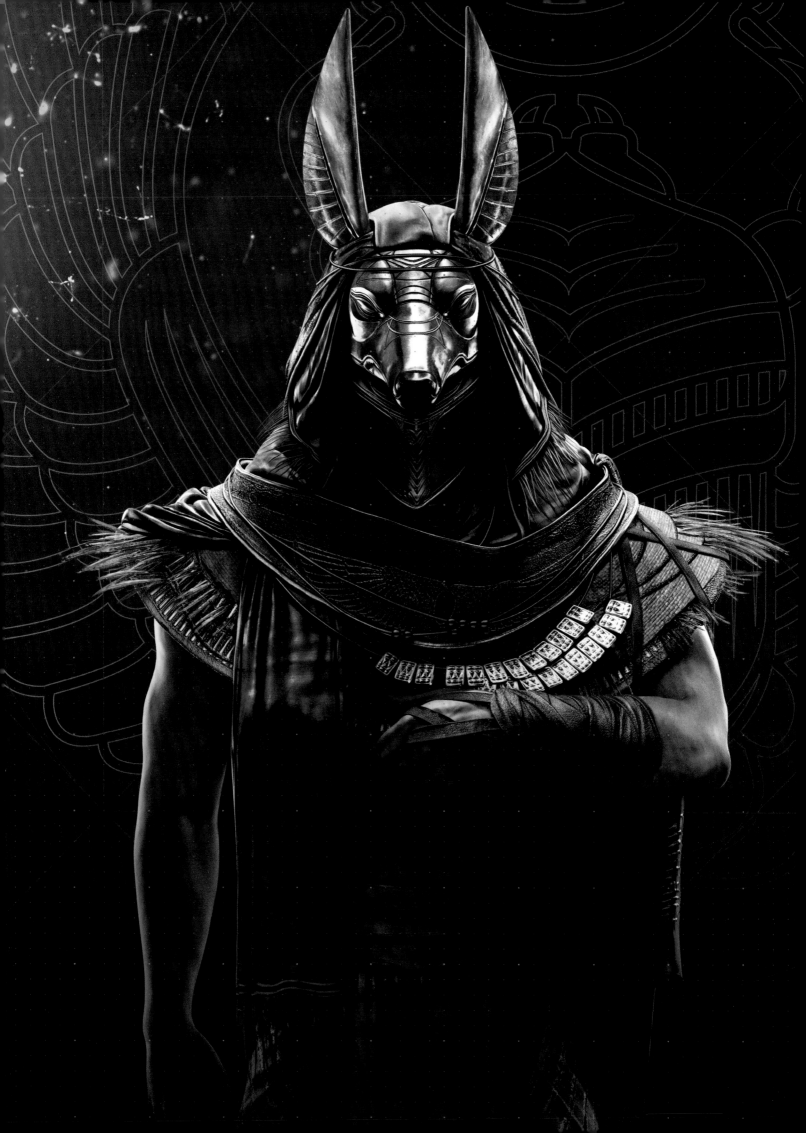

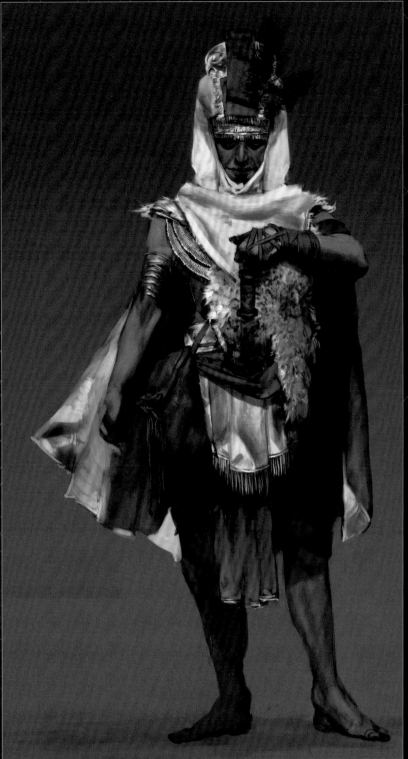
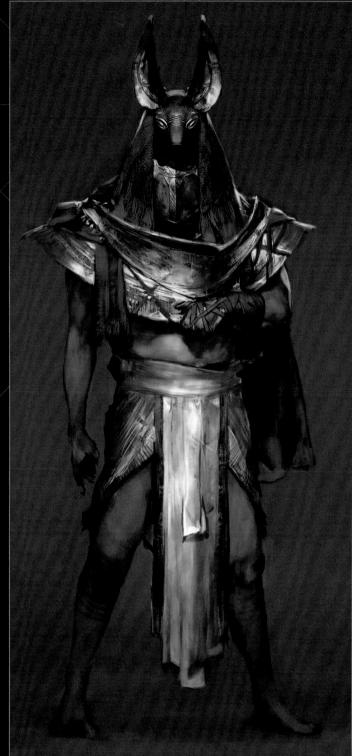

HETEPI

Hetepi, known as The Lizard, is the priest behind the supposed curse of the Apis Bull Festival in Memphis. He is identified as a "man wearing a mask", shown here in artwork by Hélix. Further investigation involving distraught priestesses and their kidnapped brother reveals his true station and possible location. This villainous priest is more than willing to be a pawn in The Order's plans for Egypt. It is fun to track him down, and an even greater pleasure to end his life.

"This guy knows how to dress, he should be the real star of the franchise. Who needs shoes when you have a cool hat? One of the earliest designs I did, had to find a good balance between 'wacky' and 'scary' and 'almost credible'." *Jeff Simpson* [above]

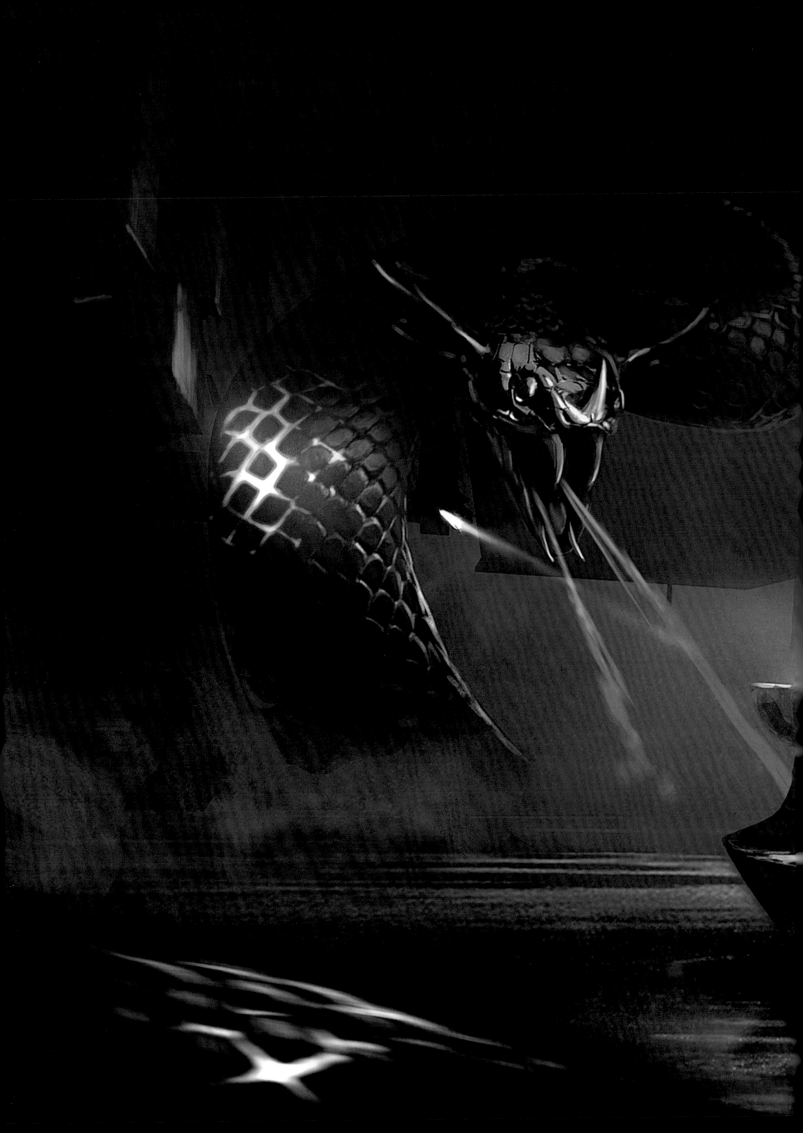

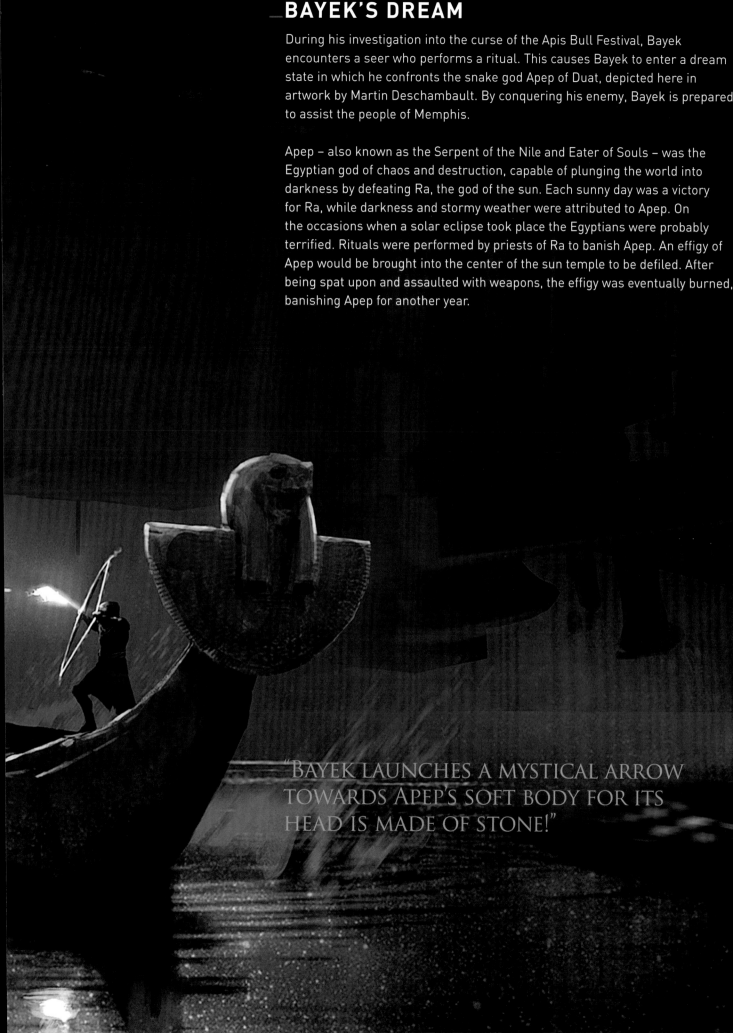

BAYEK'S DREAM

During his investigation into the curse of the Apis Bull Festival, Bayek encounters a seer who performs a ritual. This causes Bayek to enter a dream state in which he confronts the snake god Apep of Duat, depicted here in artwork by Martin Deschambault. By conquering his enemy, Bayek is prepared to assist the people of Memphis.

Apep – also known as the Serpent of the Nile and Eater of Souls – was the Egyptian god of chaos and destruction, capable of plunging the world into darkness by defeating Ra, the god of the sun. Each sunny day was a victory for Ra, while darkness and stormy weather were attributed to Apep. On the occasions when a solar eclipse took place the Egyptians were probably terrified. Rituals were performed by priests of Ra to banish Apep. An effigy of Apep would be brought into the center of the sun temple to be defiled. After being spat upon and assaulted with weapons, the effigy was eventually burned, banishing Apep for another year.

"BAYEK LAUNCHES A MYSTICAL ARROW TOWARDS APEP'S SOFT BODY FOR ITS HEAD IS MADE OF STONE!"

"This is a fun moment to illustrate. We had to imagine Bayek's dream. It was a mixture of real elements but in a weird context. Like this giant statue floating above the ground, the bottom of the statue broken into pieces also floating in midair. The aurora borealis in the sky would be very mysterious for Bayek." *Martin Deschambault* [all images]

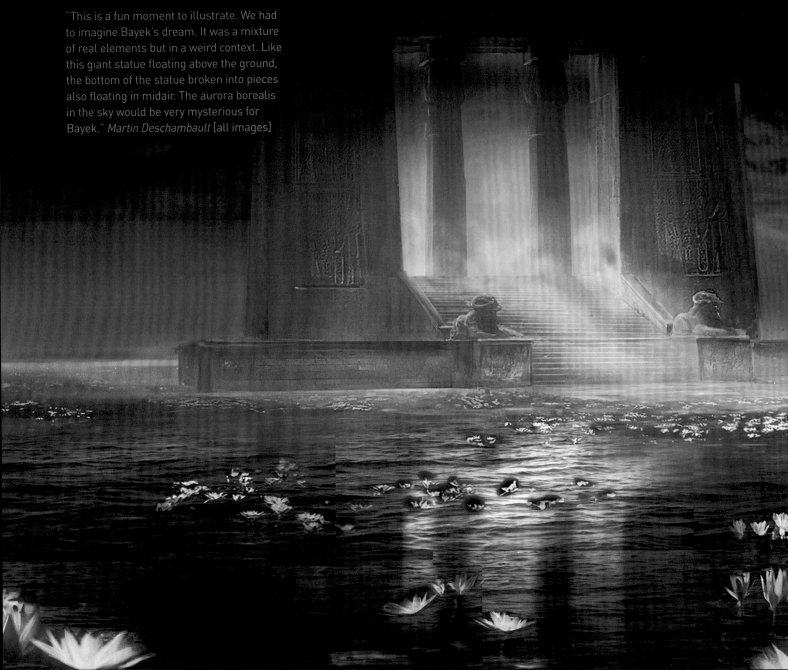

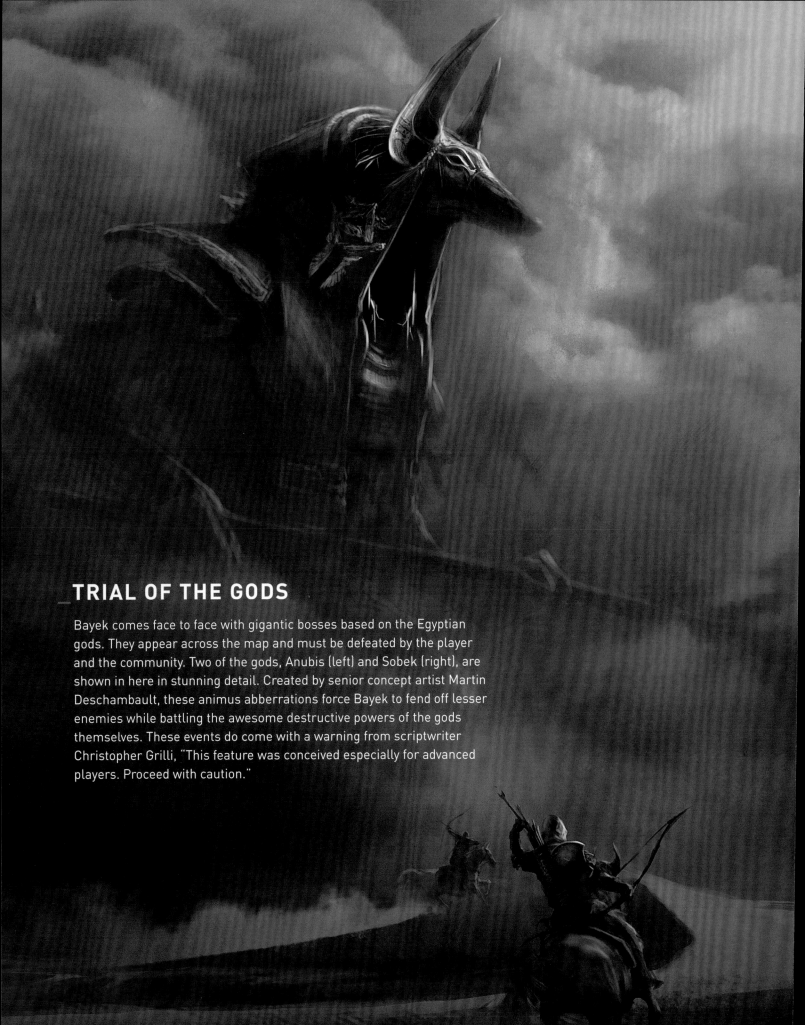

TRIAL OF THE GODS

Bayek comes face to face with gigantic bosses based on the Egyptian gods. They appear across the map and must be defeated by the player and the community. Two of the gods, Anubis (left) and Sobek (right), are shown in here in stunning detail. Created by senior concept artist Martin Deschambault, these animus abberrations force Bayek to fend off lesser enemies while battling the awesome destructive powers of the gods themselves. These events do come with a warning from scriptwriter Christopher Grilli, "This feature was conceived especially for advanced players. Proceed with caution."

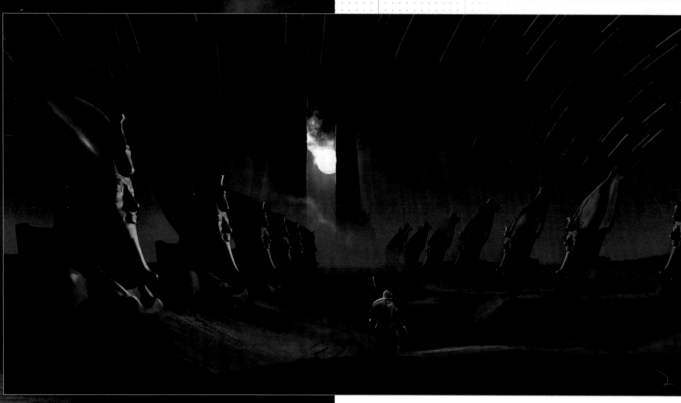

[Top] "We had this idea of a floating statue, with debris falling very slowly," says Martin Deschambault, who created all the images on these pages. "We wanted to play with the gravity, the different speeds and some reverse actions. We had some great brainstorm sessions talking about how to design the dream. On the right, this was an early idea to illustrate the symbolism of Bayek's dream, showing a real animal instead of the Egyptian gods wearing masks."

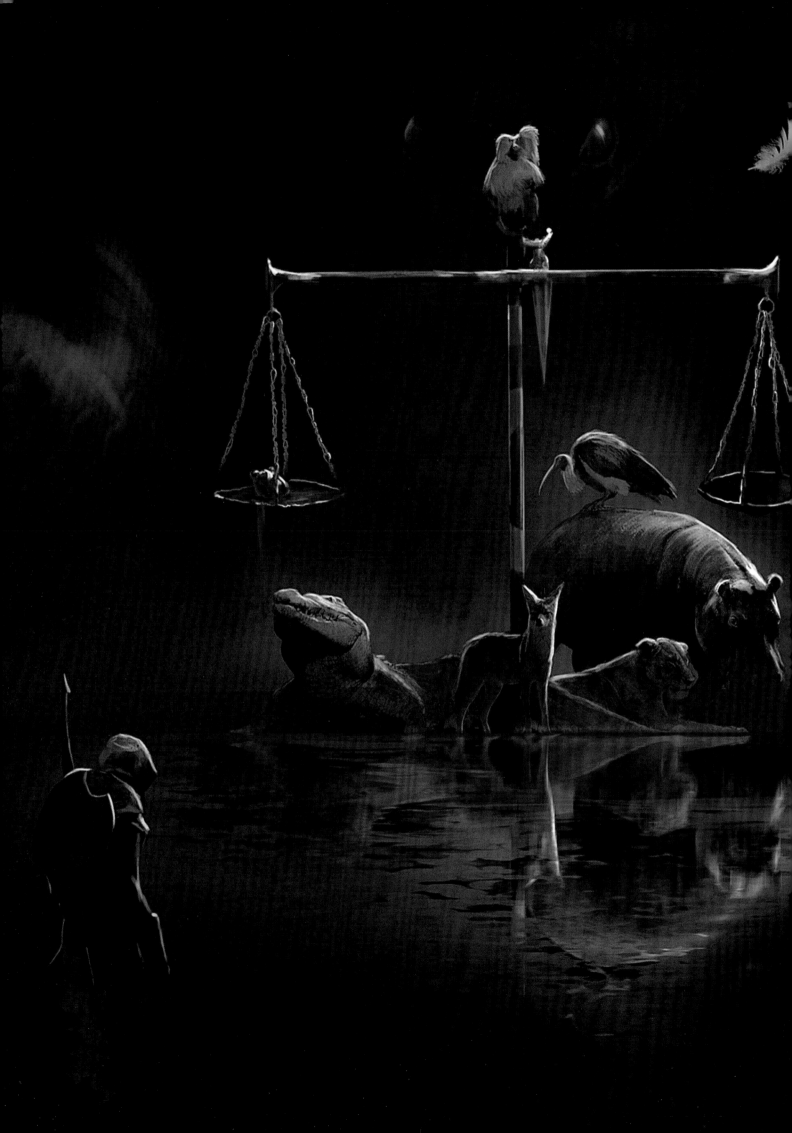

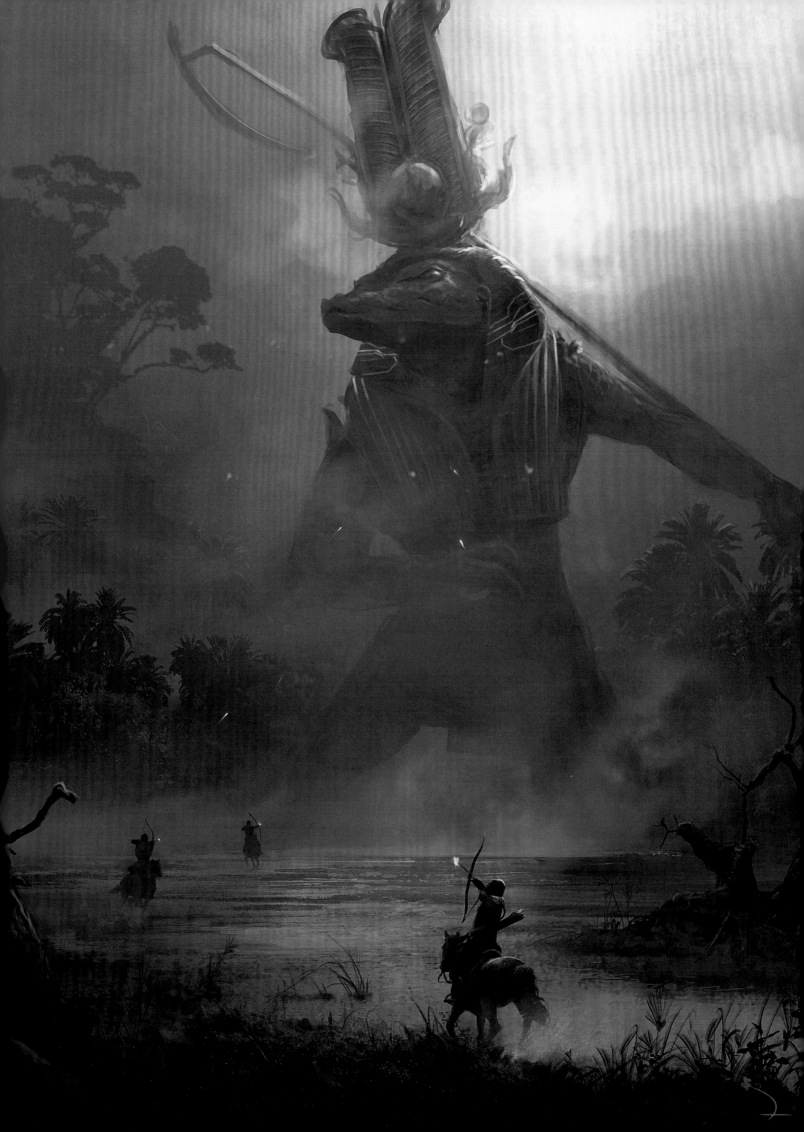

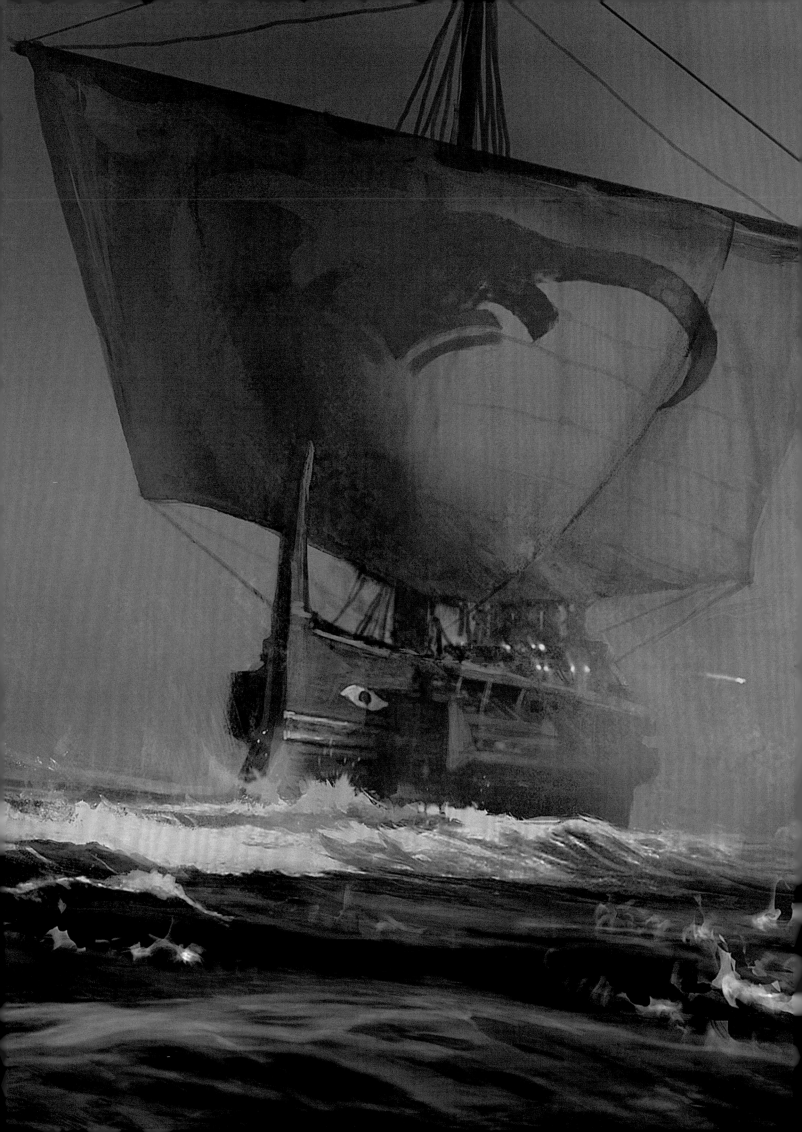

NAVAL BATTLES

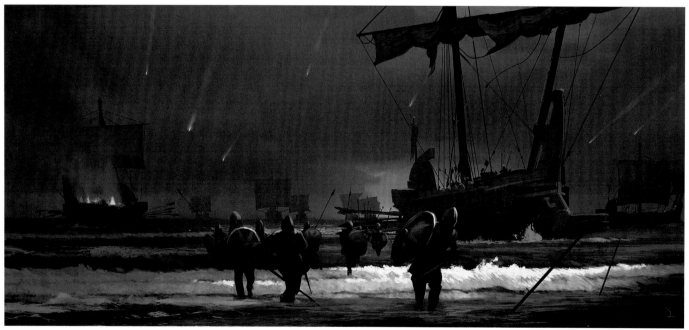

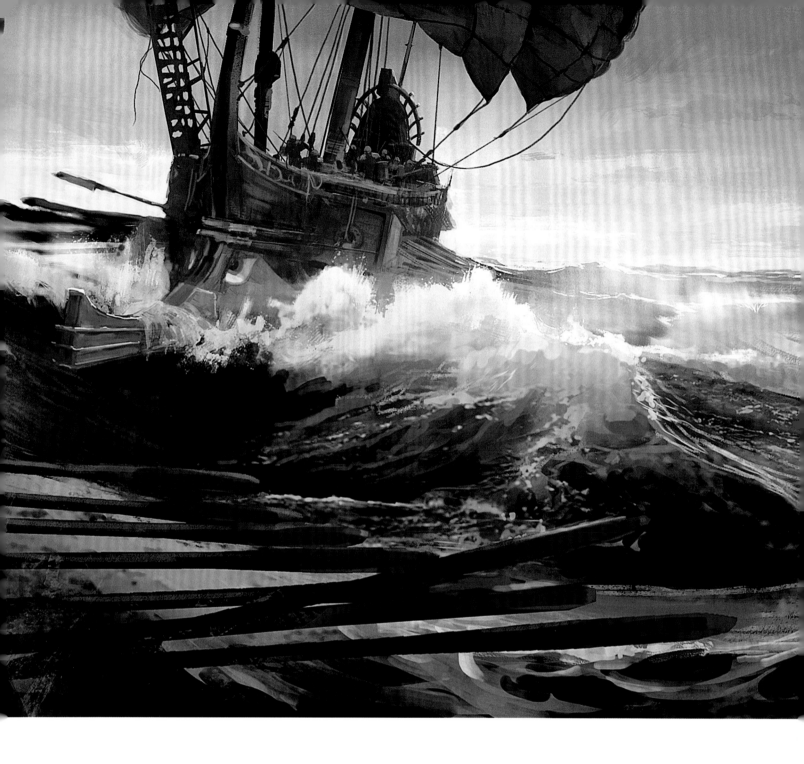

_MEETING POMPEY

The pursuit of the Order of the Ancients brings Aya to the Aegean Sea with the hope of allying with Pompey. A naval battle ensues, with Aya – now Cleopatra's protector – in command of her own crew. Ahead of the battle we gain insight into Aya's strong will. She says she will "burn the entire sea between us if it means we are closer to our goal."

The naval battles with Greek triremes and Egyptian galleys proved quite different to the brigs and galleons of *Assassin's Creed IV: Black Flag*. Aside from the mechanics, what mattered most was the visual impact of a skirmish taking place on the turbulent Aegean Sea. When gameplay dynamics are combined with the desired aesthetics and the latest technology, the effect can be spectacular.

Thrashing seas, clashing oars and the smoking arc of burning arrows add to the drama of ancient naval warfare. Concept artists let their imagination run free, with the expectation that the technical teams could keep up. Says Martin Deschambault, the artist who created these images and the one on the previous spread: "These scenes are always epic and you can feel the tension of the naval battle with all the waves and angry water."

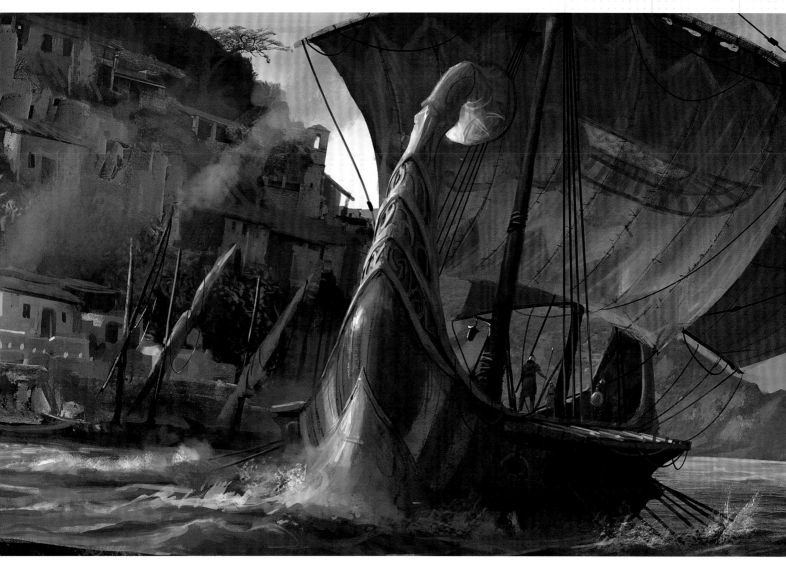

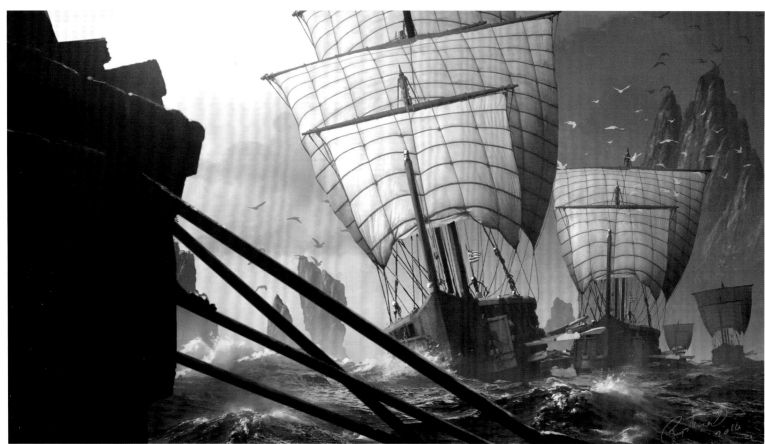

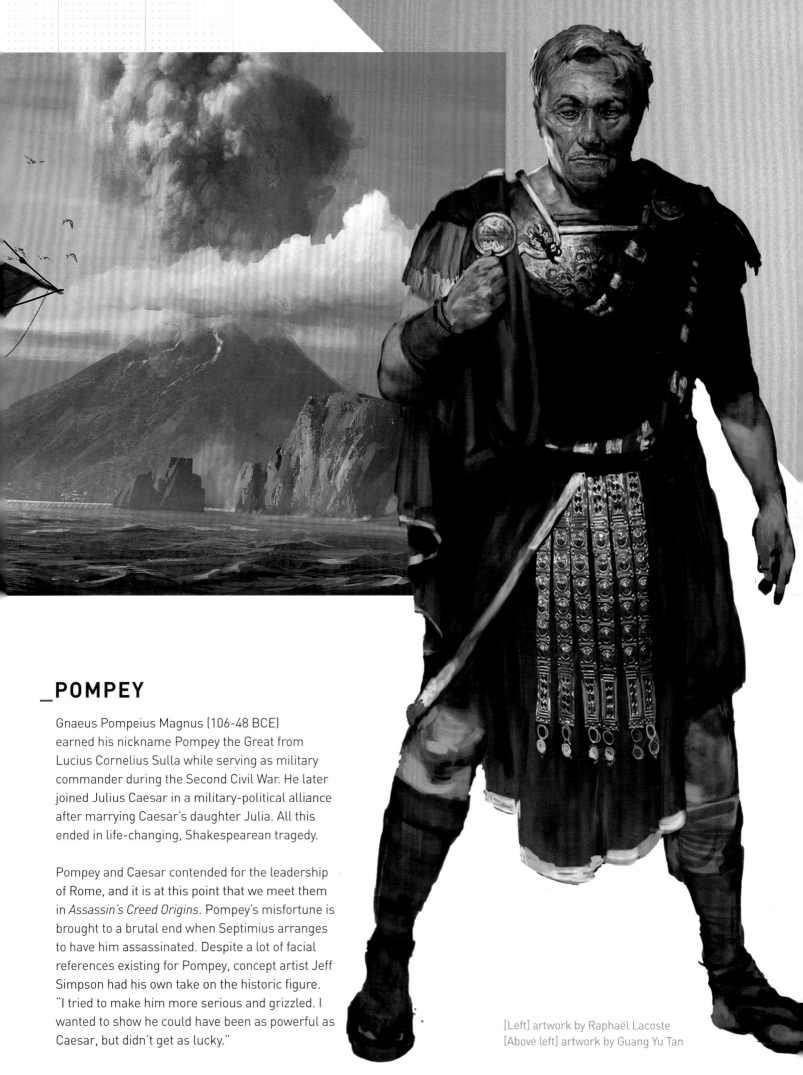

_POMPEY

Gnaeus Pompeius Magnus (106-48 BCE)
earned his nickname Pompey the Great from
Lucius Cornelius Sulla while serving as military
commander during the Second Civil War. He later
joined Julius Caesar in a military-political alliance
after marrying Caesar's daughter Julia. All this
ended in life-changing, Shakespearean tragedy.

Pompey and Caesar contended for the leadership
of Rome, and it is at this point that we meet them
in *Assassin's Creed Origins*. Pompey's misfortune is
brought to a brutal end when Septimius arranges
to have him assassinated. Despite a lot of facial
references existing for Pompey, concept artist Jeff
Simpson had his own take on the historic figure.
"I tried to make him more serious and grizzled. I
wanted to show he could have been as powerful as
Caesar, but didn't get as lucky."

[Left] artwork by Raphaël Lacoste
[Above left] artwork by Guang Yu Tan

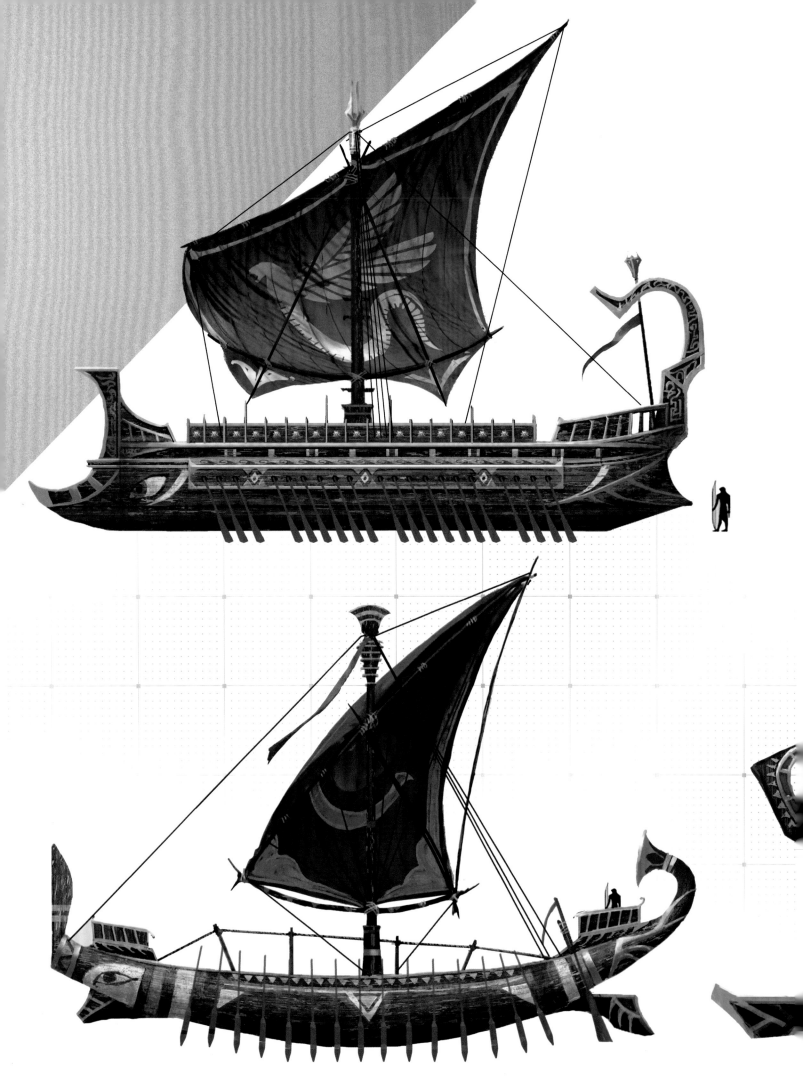

_BOATS

The importance of the Nile to Egyptian society cannot be overstated and as such, boats were an essential part of daily life, from humble fishing vessels to the Pharaoh's lavish ship, shown here in astonishing detail by Guang Yu Tan. Scriptwriter Christopher Grilli explains, "The Nile was rife with fishing boats, transportation barges, military ships and leisure vessels. While smaller boats could be built from bundled papyrus reeds, [bottom left] barges and fleets required stronger materials. Wood could support the weight of quarried stone and obelisks that would travel along the Nile to Giza and Heliopolis for the construction of pyramids and temples. It was also strong in defending against attacking ships and sturdy enough to be shaped into a battering ram. Navigation methods also changed over time, from two large oars held by helmsmen to several oars along the boat's sides connected to tillers. A Pharaoh's boat was their pride and joy, and often boasted multiple decks with cabins, dining rooms and lounges."

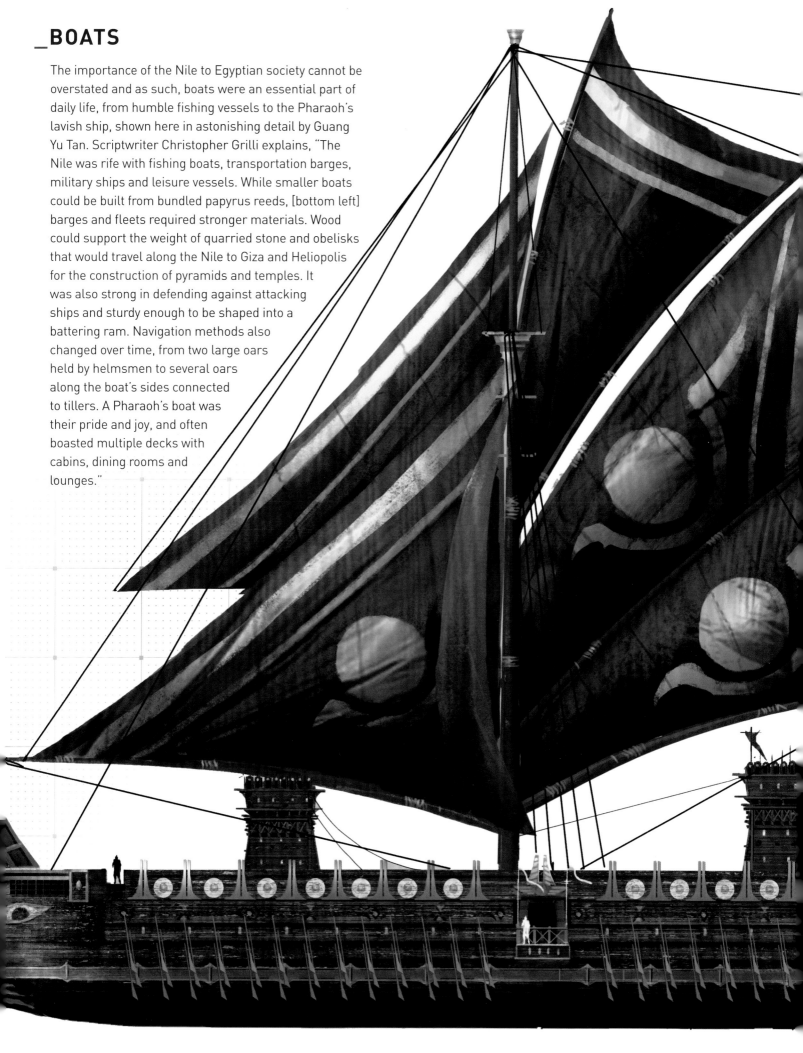

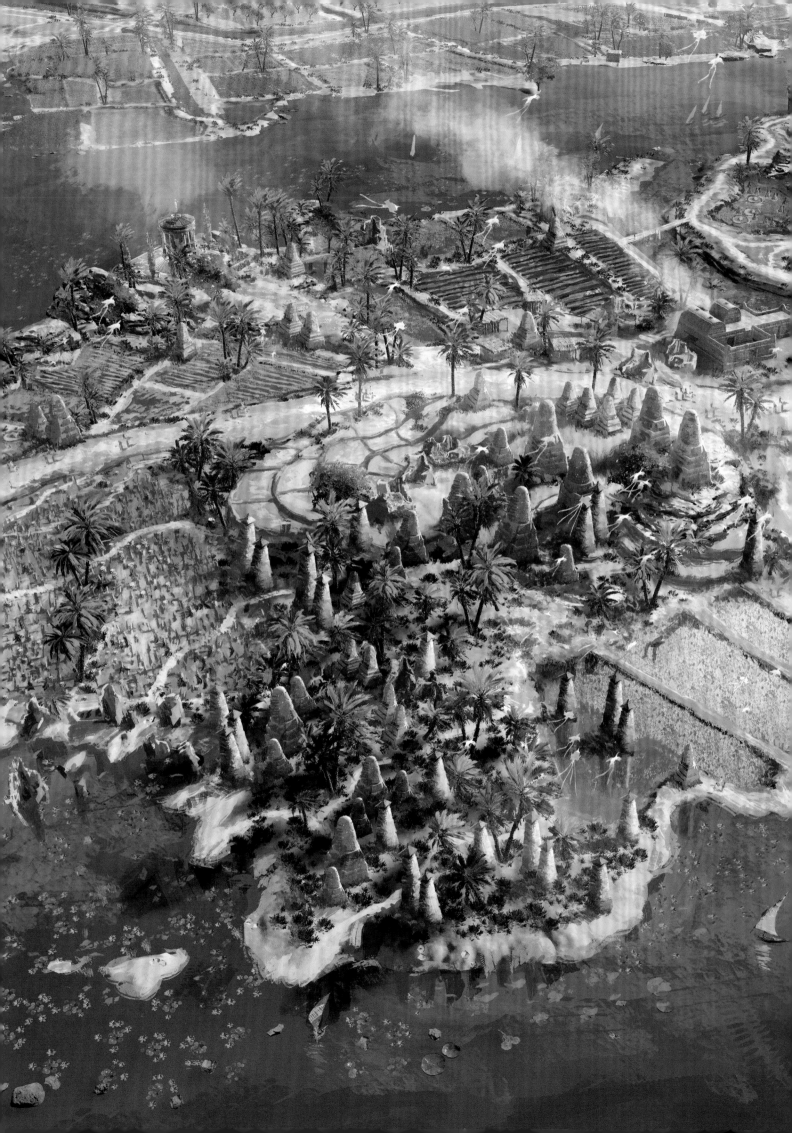

CHAPTER VII

FAIYUM

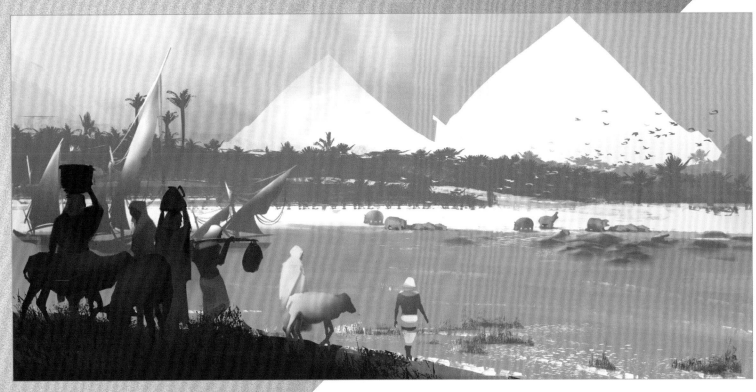

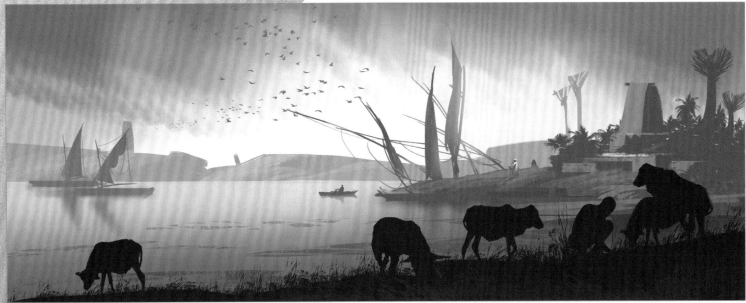

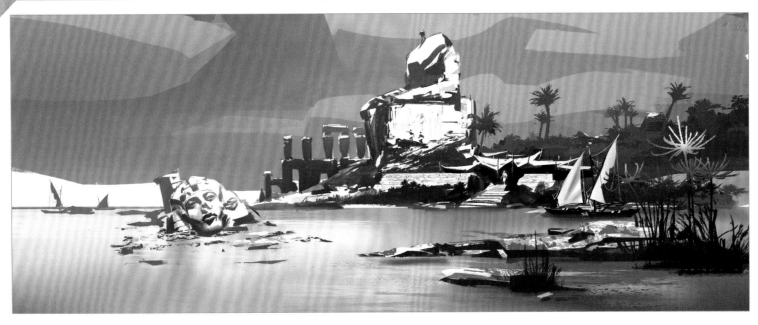

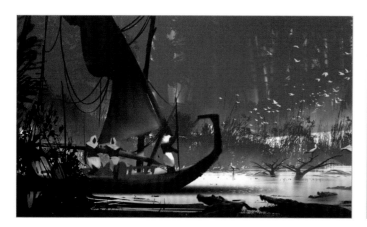
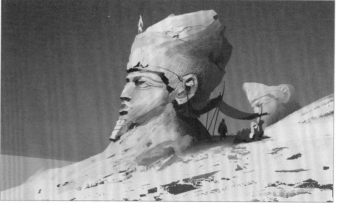
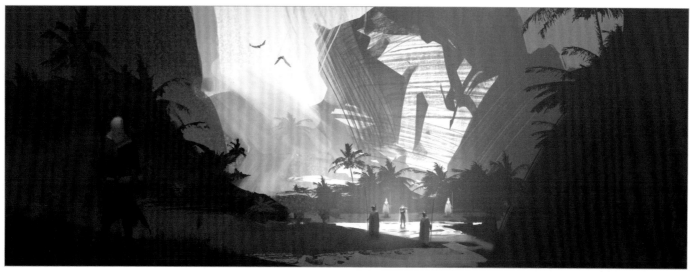
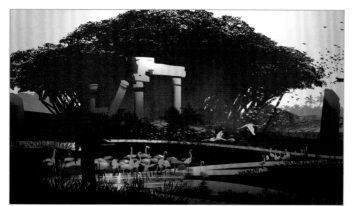
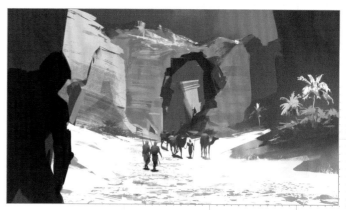

_FAIYUM

Faiyum is an area of southern Egypt that sits on the shores of a vast lake, making it a highly fertile region. Kerkesoucha, depicted in the previous spread, is one of many outposts in Faiyum. The area is rich with granary crops like rice and corn but the diversity of the landscape also gives rise to terraced crops. High-rise pigeon coops are one of the distinct structures that give this area its uniqueness and one that players can identify while exploring from all angles.

These early sketches by Li Ke Yi are used to explore day-to-day life in Egypt in various different landscapes of the Faiyum Oasis.

[Previous page] artwork by Jing Cherng-Wong

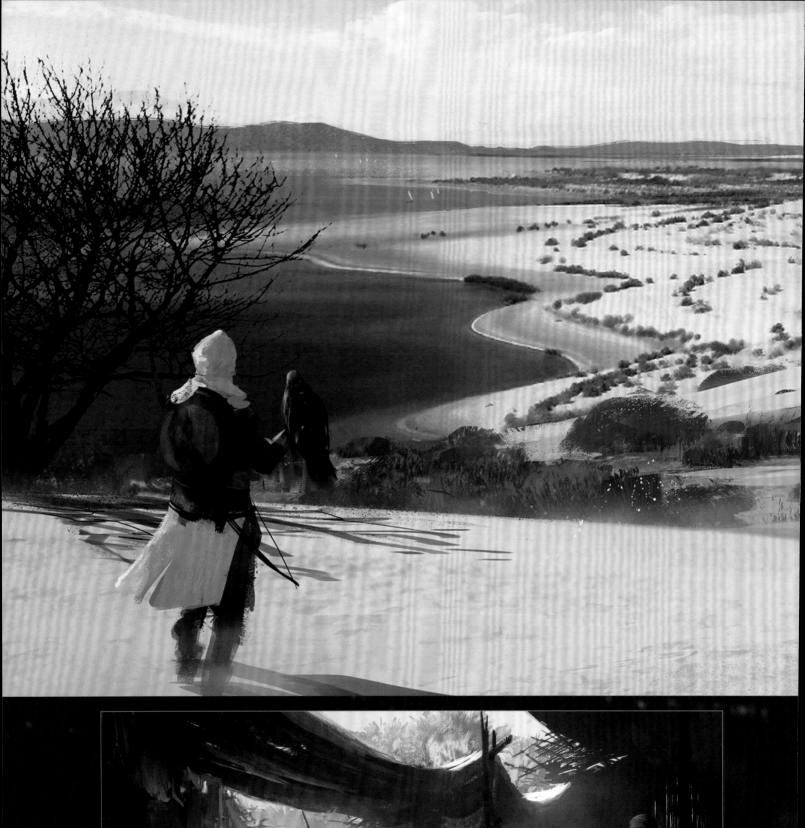
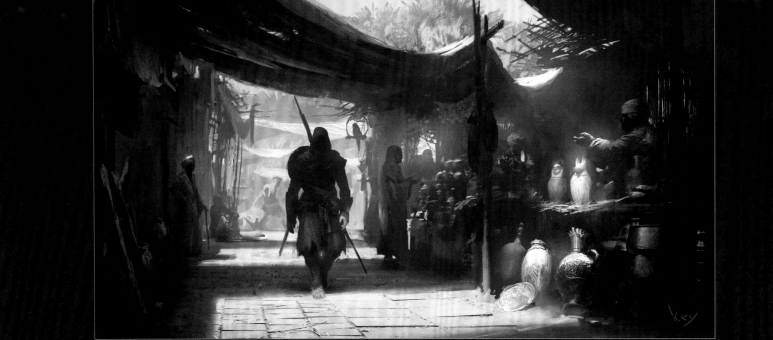

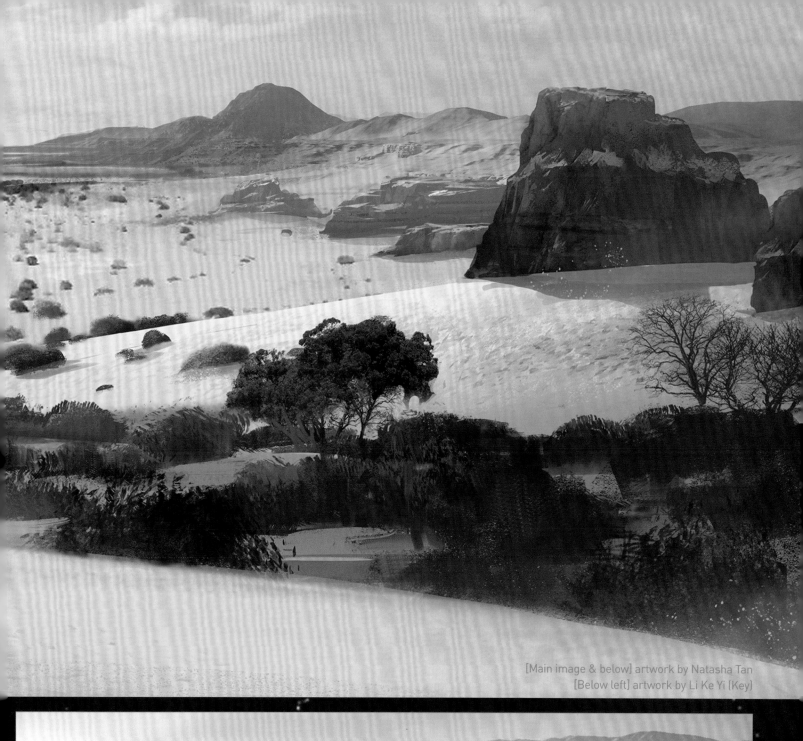

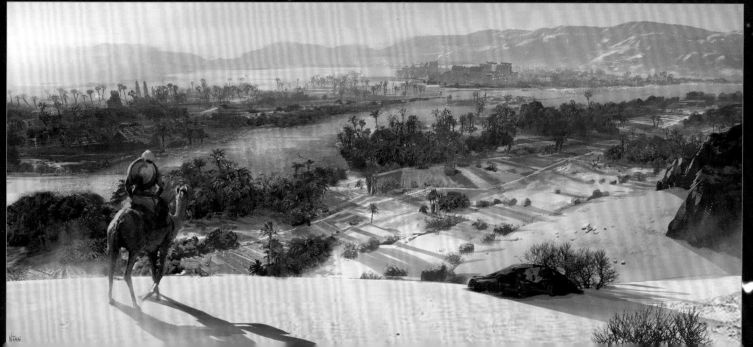

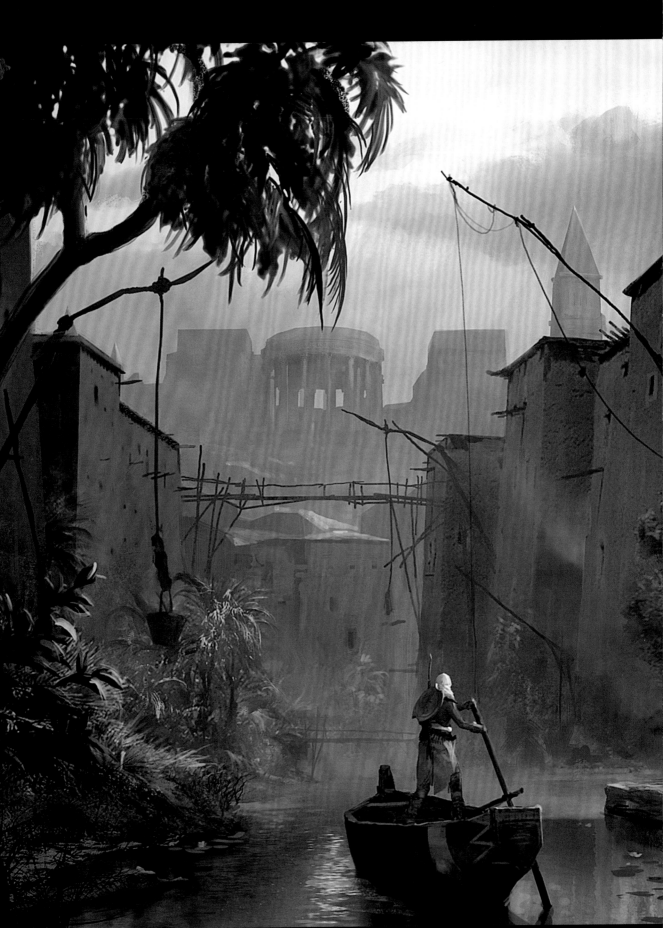

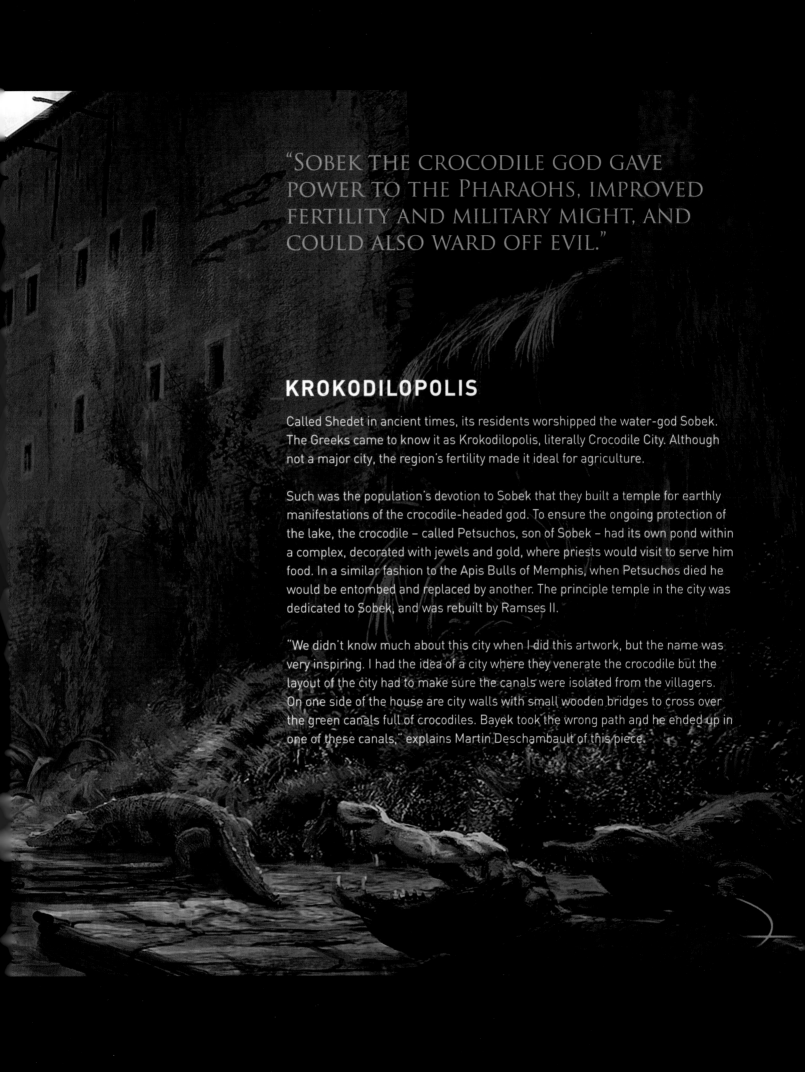

"SOBEK THE CROCODILE GOD GAVE POWER TO THE PHARAOHS, IMPROVED FERTILITY AND MILITARY MIGHT, AND COULD ALSO WARD OFF EVIL."

KROKODILOPOLIS

Called Shedet in ancient times, its residents worshipped the water-god Sobek. The Greeks came to know it as Krokodilopolis, literally Crocodile City. Although not a major city, the region's fertility made it ideal for agriculture.

Such was the population's devotion to Sobek that they built a temple for earthly manifestations of the crocodile-headed god. To ensure the ongoing protection of the lake, the crocodile – called Petsuchos, son of Sobek – had its own pond within a complex, decorated with jewels and gold, where priests would visit to serve him food. In a similar fashion to the Apis Bulls of Memphis, when Petsuchos died he would be entombed and replaced by another. The principle temple in the city was dedicated to Sobek, and was rebuilt by Ramses II.

"We didn't know much about this city when I did this artwork, but the name was very inspiring. I had the idea of a city where they venerate the crocodile but the layout of the city had to make sure the canals were isolated from the villagers. On one side of the house are city walls with small wooden bridges to cross over the green canals full of crocodiles. Bayek took the wrong path and he ended up in one of these canals," explains Martin Deschambault of this piece.

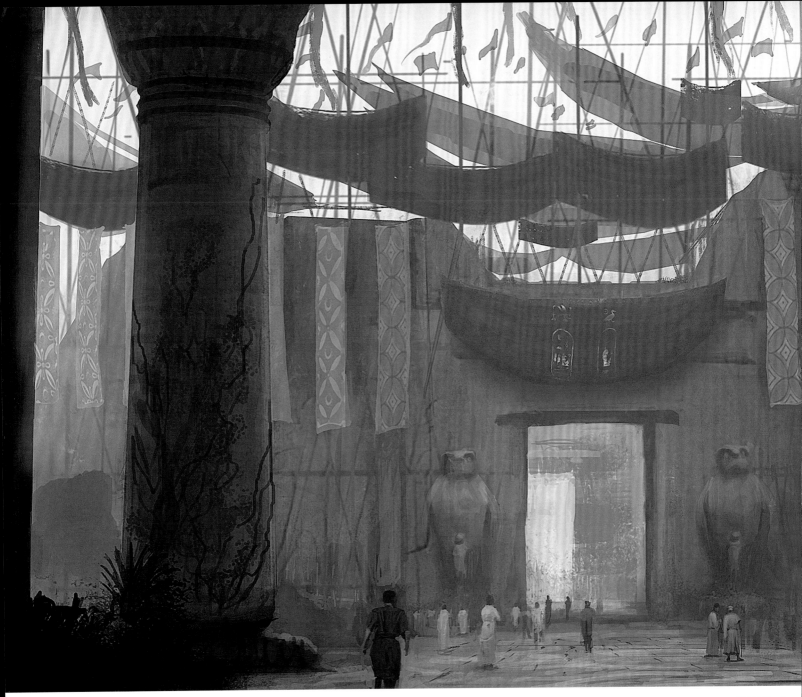

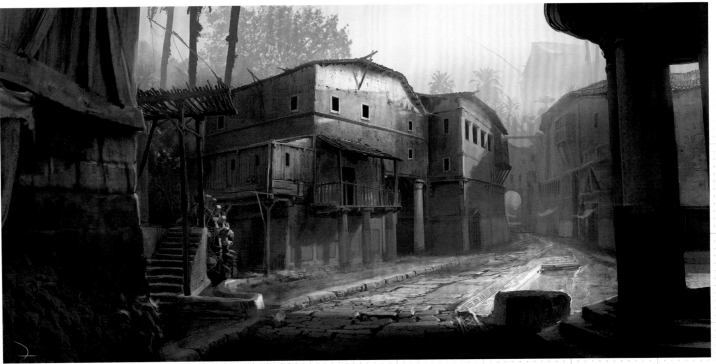

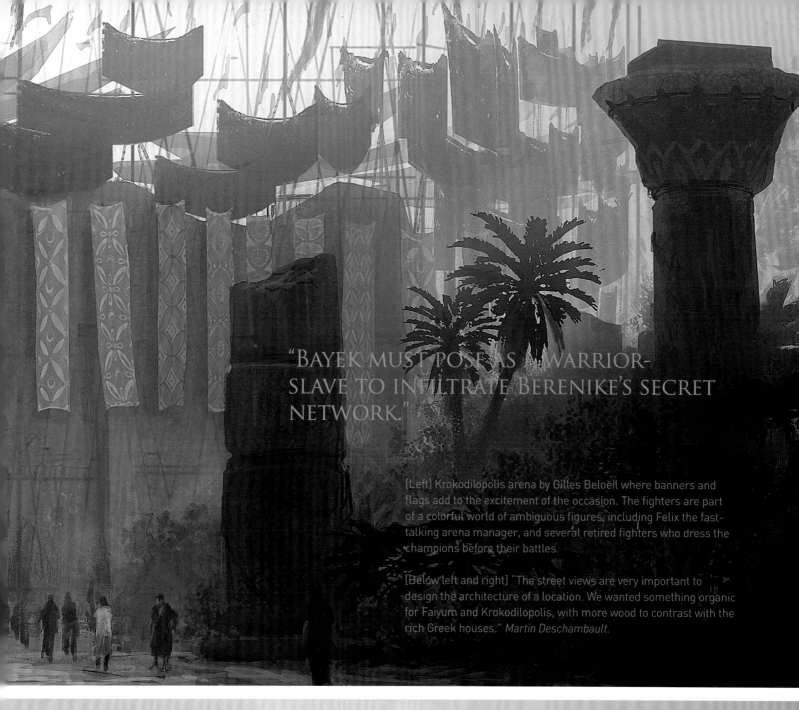

"BAYEK MUST POSE AS A WARRIOR-SLAVE TO INFILTRATE BERENIKE'S SECRET NETWORK."

[Left] Krokodilopolis arena by Gilles Beloeil where banners and flags add to the excitement of the occasion. The fighters are part of a colorful world of ambiguous figures, including Felix the fast-talking arena manager, and several retired fighters who dress the champions before their battles.

[Below left and right] "The street views are very important to design the architecture of a location. We wanted something organic for Faiyum and Krokodilopolis, with more wood to contrast with the rich Greek houses." *Martin Deschambault.*

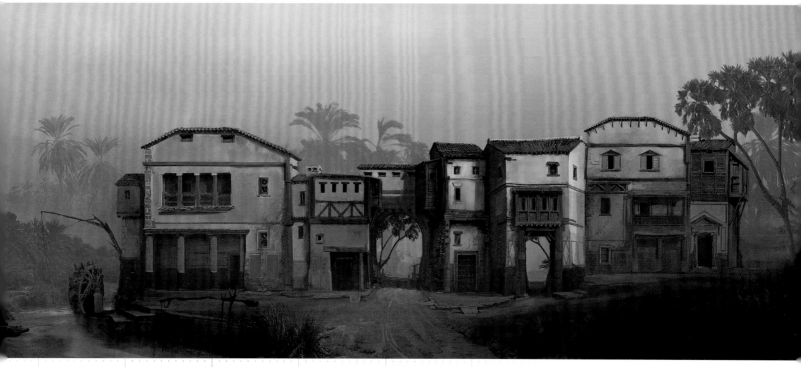

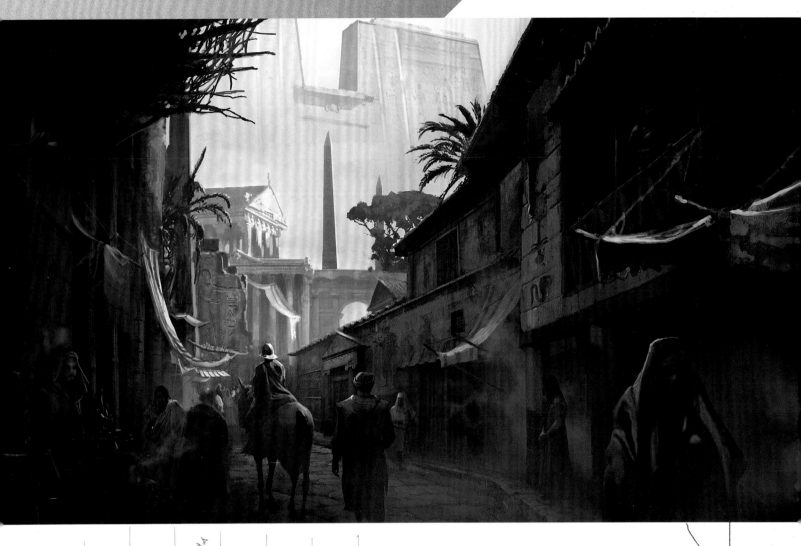

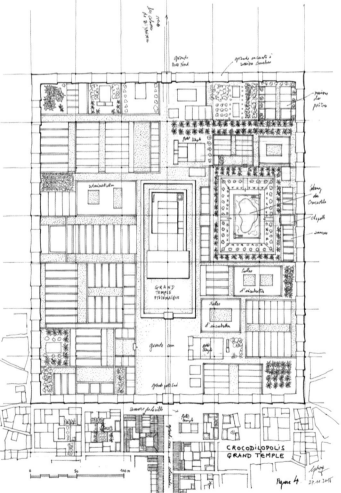

Farmers benefited from the most fertile land in Egypt, and the people were never short of vegetables, corn and olives to sustain them. Flowers were grown here too, decorating the temple complexes and providing another lucrative export to drier locations. Shown above in the concept by Martin Deschambault are examples of Egyptian homesteads. They are well kept and large, indicating the wealth of the area.

[Left & right] plan for the city of Krokodilopolis by Jean-Claude Golvin.

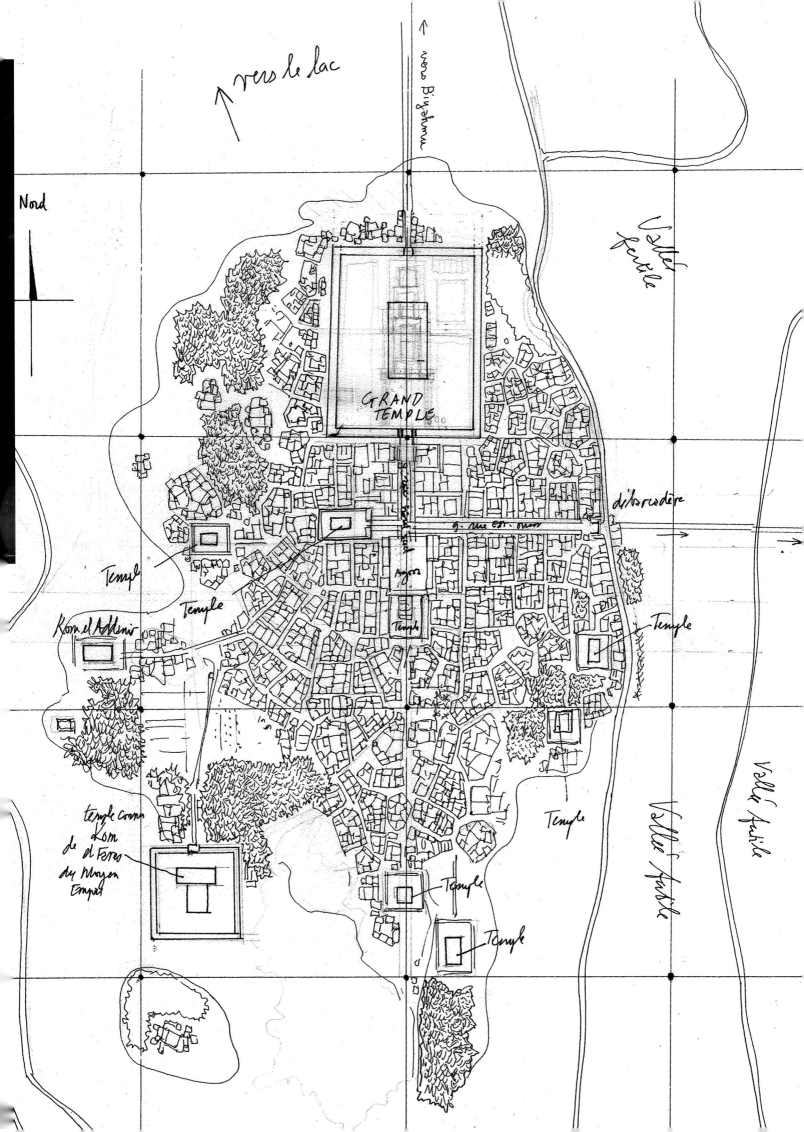

vers le lac

vers Birqohmu

Nord

Vallée fertile

GRAND
TEMPLE

débarcadère

g. rue est-ouest

Agora

Temple

Temple

Temple

Kom el Akhmir

Temple

Temple

Vallée fertile

Temple comme
Kom el Ferco
du Moyen
Empire

Temple

Vallée fertile

Temple

Temple

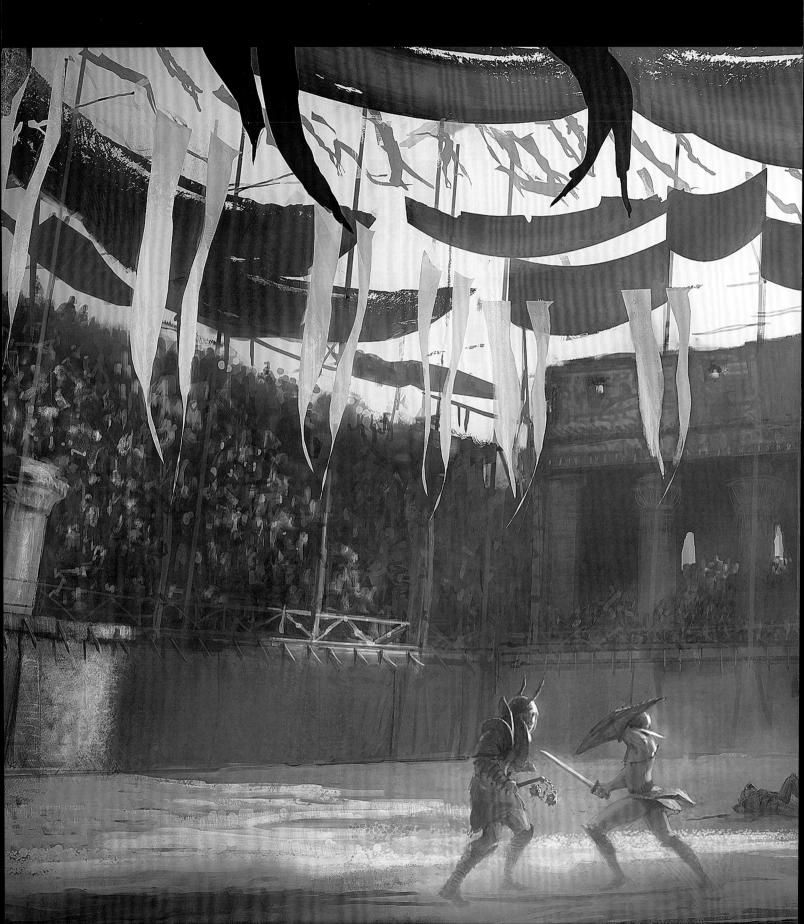

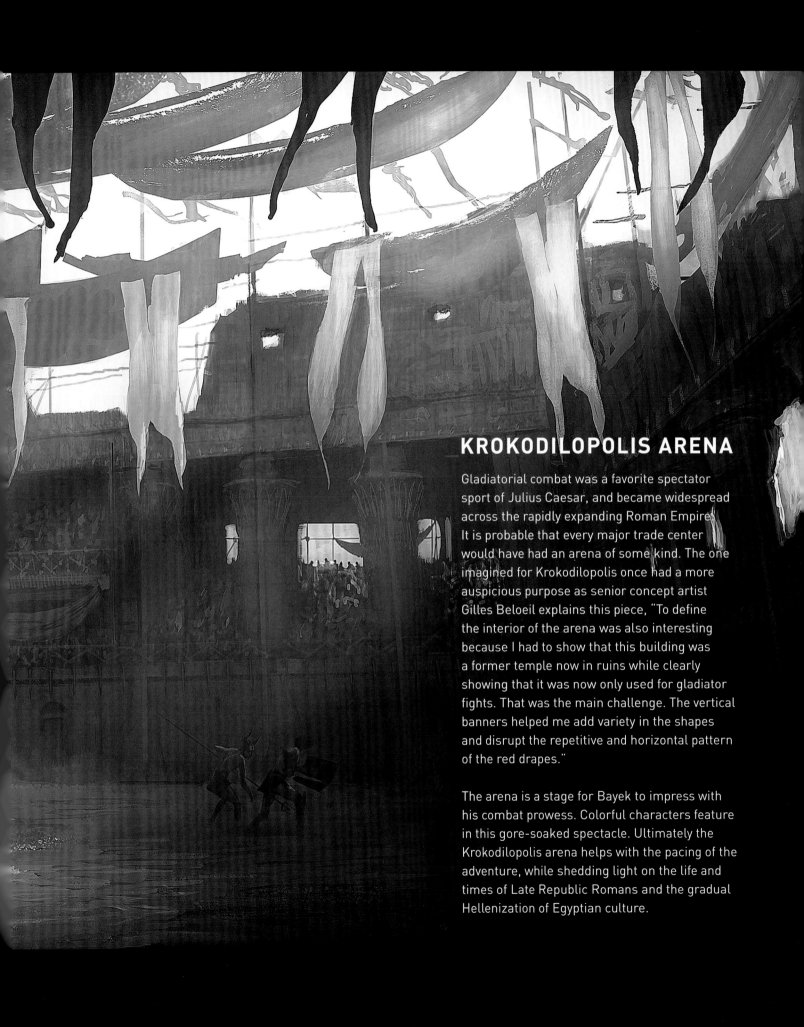

KROKODILOPOLIS ARENA

Gladiatorial combat was a favorite spectator sport of Julius Caesar, and became widespread across the rapidly expanding Roman Empire. It is probable that every major trade center would have had an arena of some kind. The one imagined for Krokodilopolis once had a more auspicious purpose as senior concept artist Gilles Beloeil explains this piece, "To define the interior of the arena was also interesting because I had to show that this building was a former temple now in ruins while clearly showing that it was now only used for gladiator fights. That was the main challenge. The vertical banners helped me add variety in the shapes and disrupt the repetitive and horizontal pattern of the red drapes."

The arena is a stage for Bayek to impress with his combat prowess. Colorful characters feature in this gore-soaked spectacle. Ultimately the Krokodilopolis arena helps with the pacing of the adventure, while shedding light on the life and times of Late Republic Romans and the gradual Hellenization of Egyptian culture.

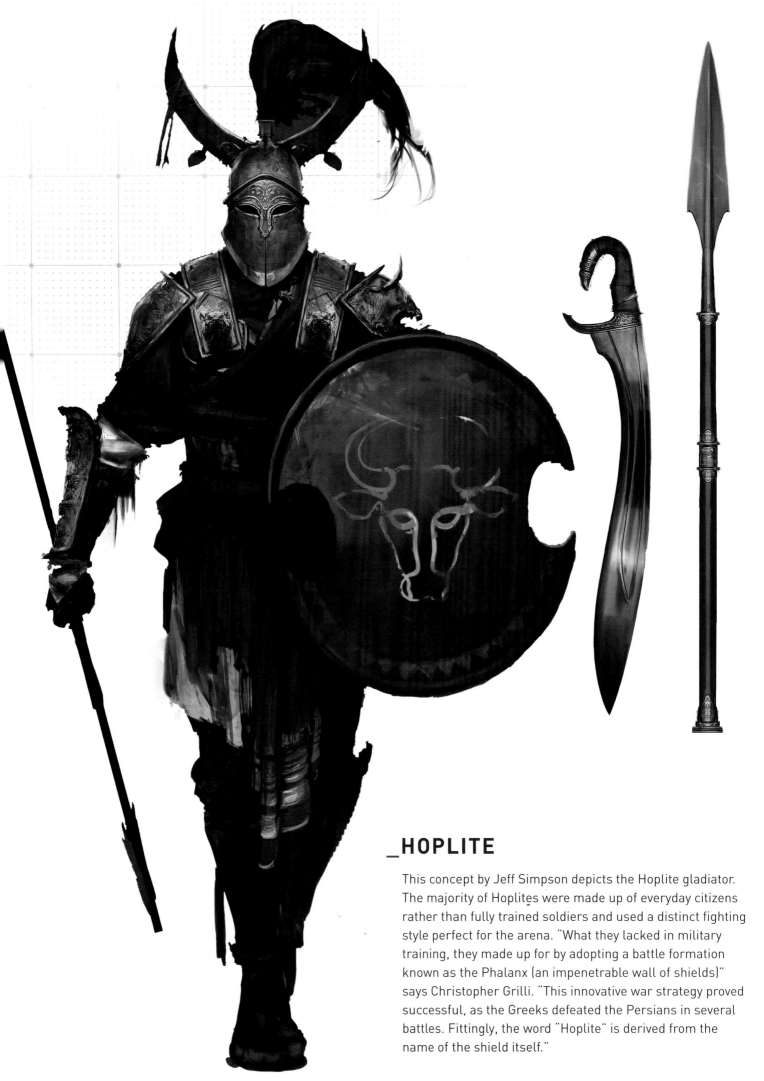

_HOPLITE

This concept by Jeff Simpson depicts the Hoplite gladiator. The majority of Hoplites were made up of everyday citizens rather than fully trained soldiers and used a distinct fighting style perfect for the arena. "What they lacked in military training, they made up for by adopting a battle formation known as the Phalanx (an impenetrable wall of shields)" says Christopher Grilli. "This innovative war strategy proved successful, as the Greeks defeated the Persians in several battles. Fittingly, the word "Hoplite" is derived from the name of the shield itself."

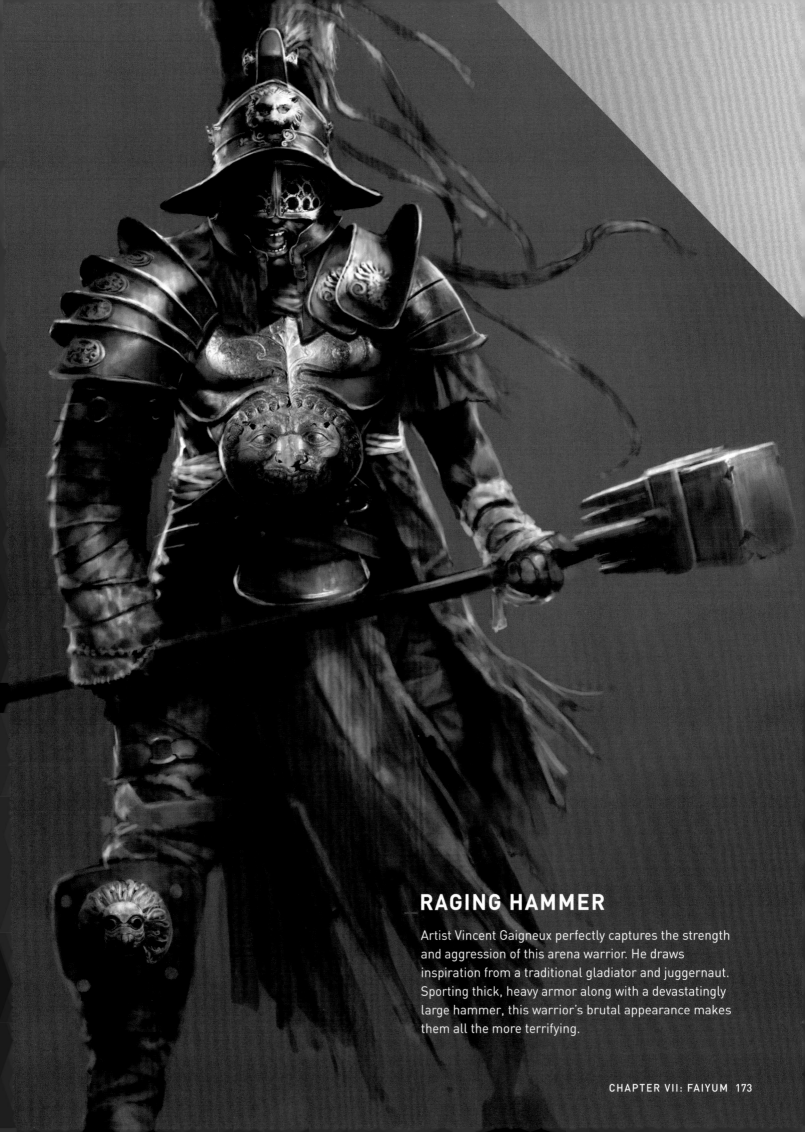

RAGING HAMMER

Artist Vincent Gaigneux perfectly captures the strength
and aggression of this arena warrior. He draws
inspiration from a traditional gladiator and juggernaut.
Sporting thick, heavy armor along with a devastatingly
large hammer, this warrior's brutal appearance makes
them all the more terrifying.

_RAGING AXES

"This arena warrior draws inspiration from the Gaulish tribes who were known to wreak widespread havoc on route to eastward expansion," explains Christopher Grilli. "Many served as mercenaries after their efforts were stifled by more powerful armies; their services reaching as far as Ptolemaic Egypt. They were said to be towering in stature with a reddish complexion, and most had blue eyes." These classic traits are used to full effect in this concept art by Jeff Simpson.

"Gladiators were fun because we could look at other parts of the world for inspirations - people who traveled from far and wide to compete," adds Simpson. "Raging axes would have been from a Germanic tribe or Gaul. The Duelist [right] is from Han dynasty China."

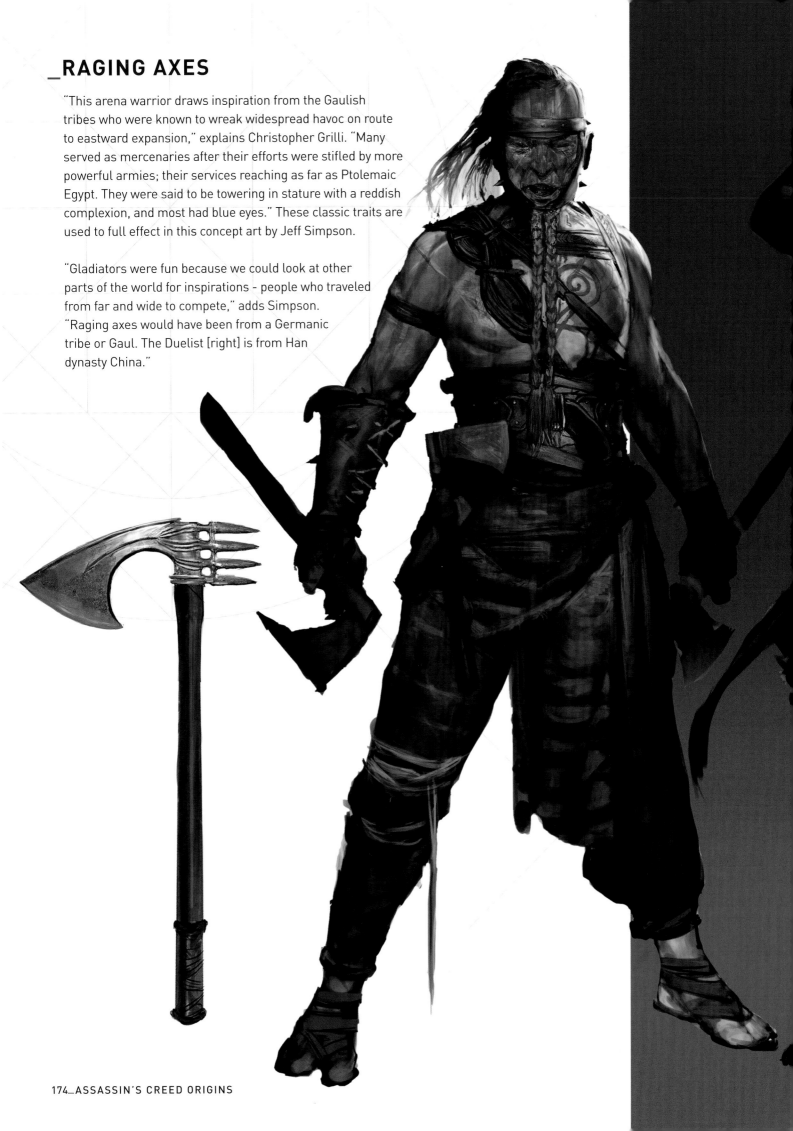

THE SLAVER

The Slaver was a brute both in temperament and appearance as depicted below by artist Vincent Gaigneux. His attire shows wealth made from the backs of his slaves, including a leopard skin indicating its not only people he treats with disdain. Slave-trading was a ruthless world so, as Christopher Grilli points out, "it could be seen as good practice for a slaver to pack on some menacing pounds in order to deter disobedient slaves or low-balling traders. Slavers with a brute appearance like this fellow often got what they wanted with little trouble."

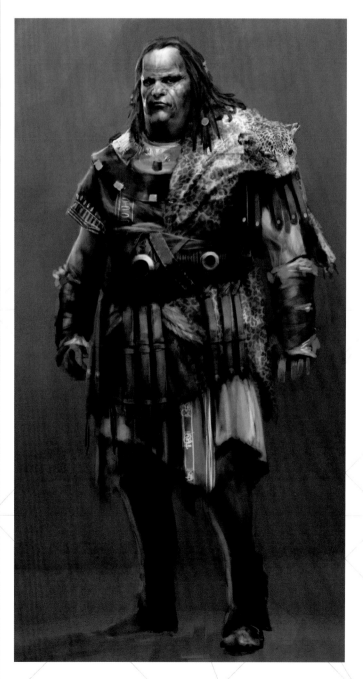

THE DUELIST

The concept for this piece by Jeff Simpson took its inspiration from the protectors of the Han dynasty in China. This arena warrior is adorned with ornaments, silks and armor, reflecting the Asian culture at the time. Christopher Grilli adds, "This warrior uses highly advanced forms of weaponry thanks to improvements in Chinese iron casting."

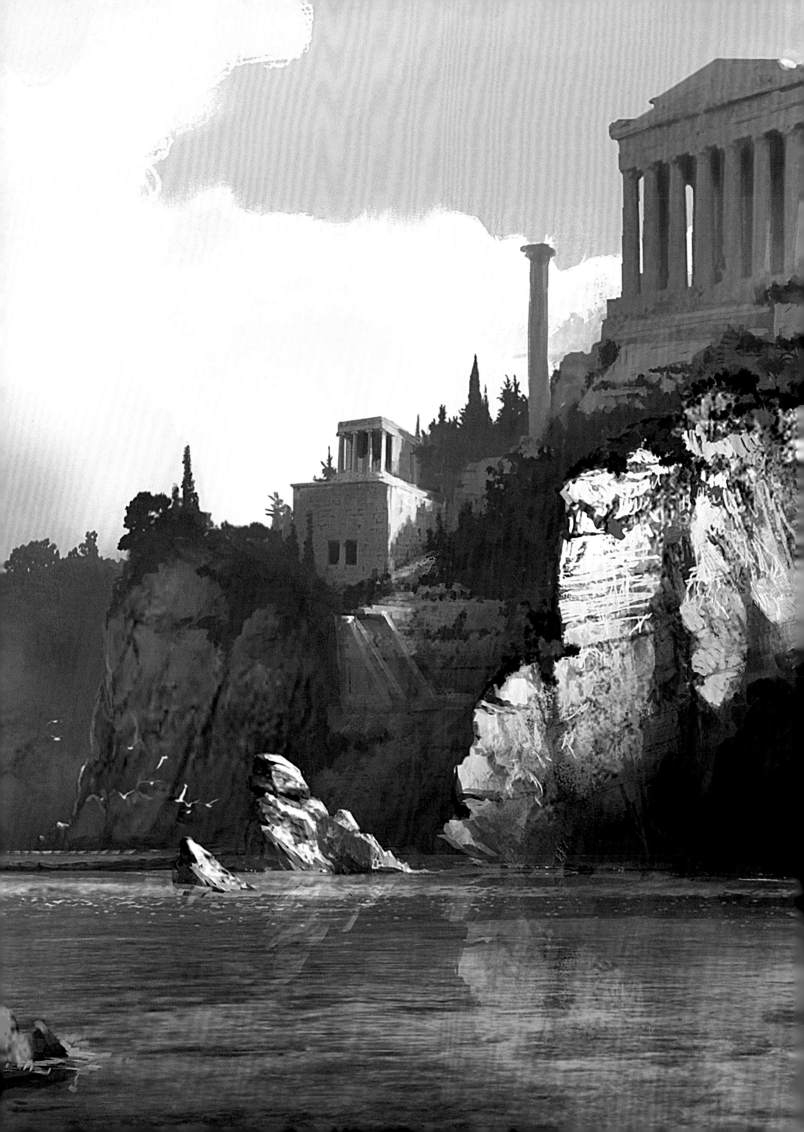

KYRENAIKA

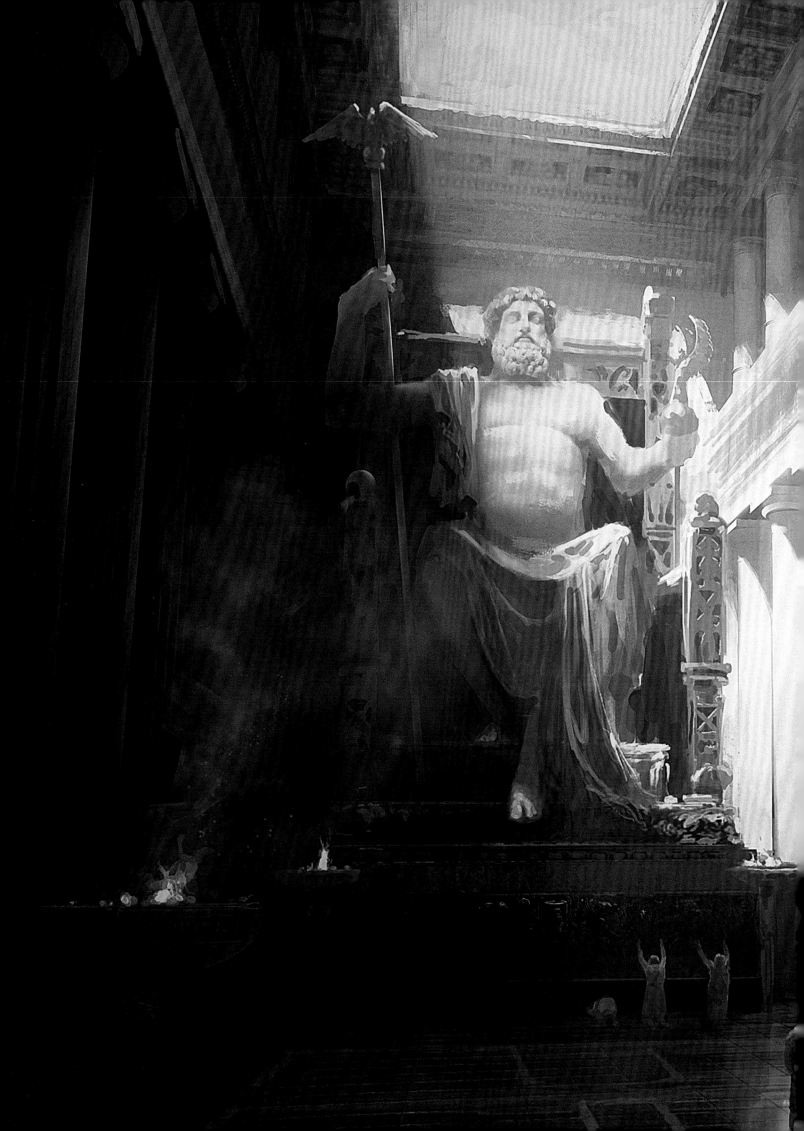

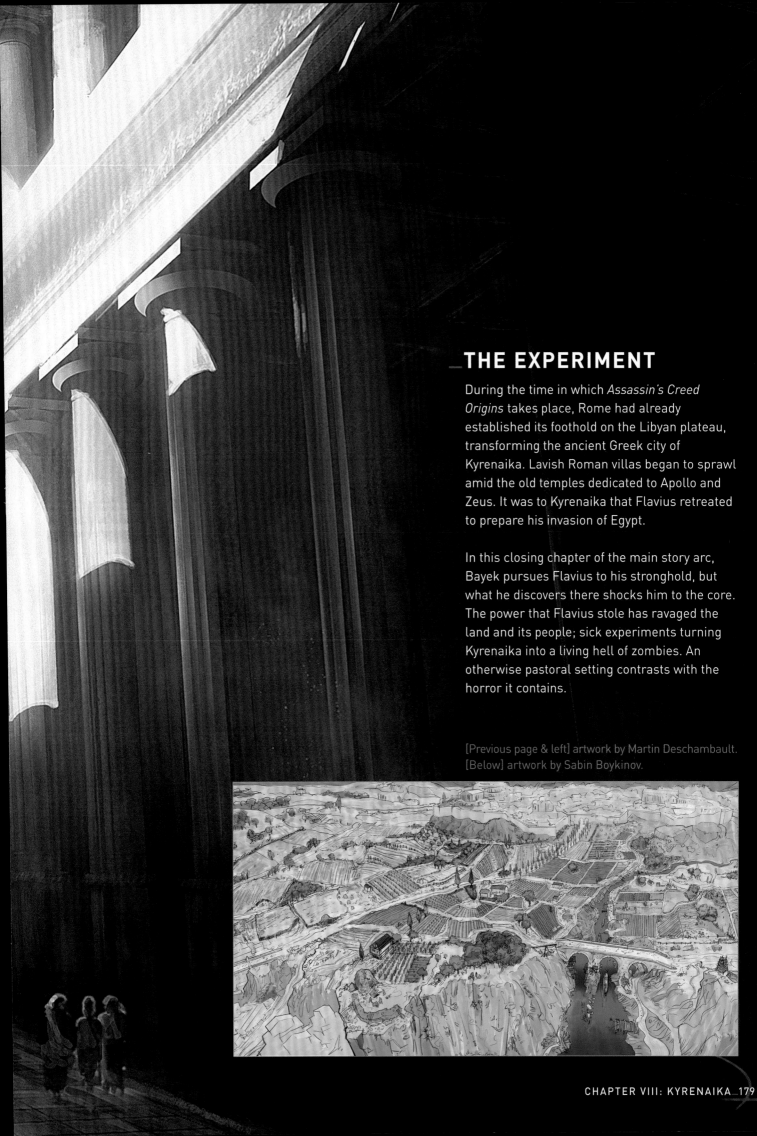

THE EXPERIMENT

During the time in which *Assassin's Creed Origins* takes place, Rome had already established its foothold on the Libyan plateau, transforming the ancient Greek city of Kyrenaika. Lavish Roman villas began to sprawl amid the old temples dedicated to Apollo and Zeus. It was to Kyrenaika that Flavius retreated to prepare his invasion of Egypt.

In this closing chapter of the main story arc, Bayek pursues Flavius to his stronghold, but what he discovers there shocks him to the core. The power that Flavius stole has ravaged the land and its people; sick experiments turning Kyrenaika into a living hell of zombies. An otherwise pastoral setting contrasts with the horror it contains.

[Previous page & left] artwork by Martin Deschambault. [Below] artwork by Sabin Boykinov.

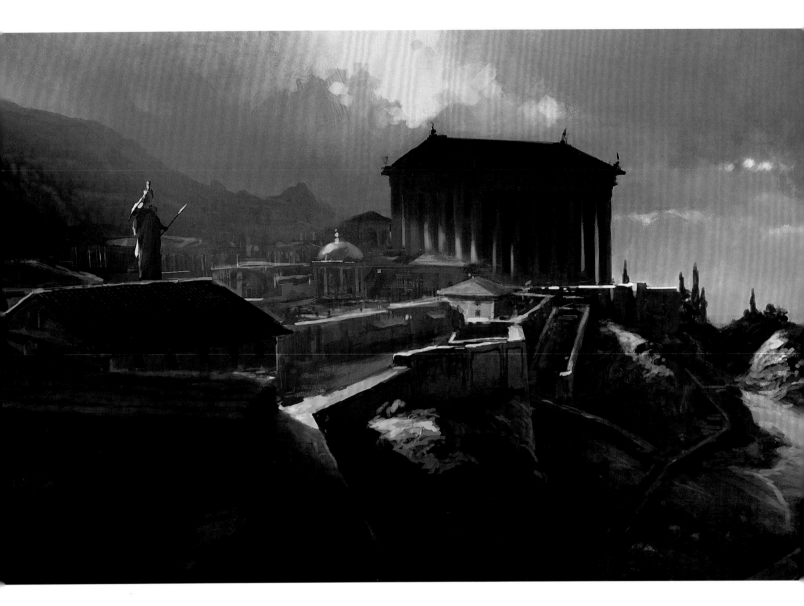

"THE ROMANIZATION OF KYRENAIKA DID NOT DETRACT FROM CENTURIES OF MONUMENTAL GREEK ARTISTRY."

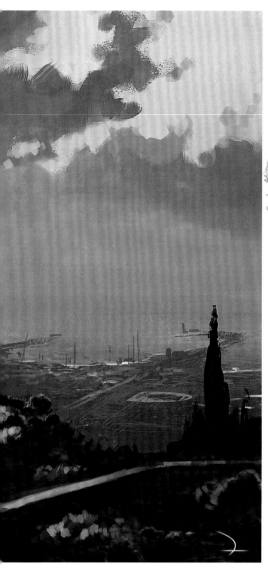

(Left & Below) The Temple of Zeus, which stands larger than the Pantheon at Athens, was built in the 6th century BCE, long before Romanization began after 74 BCE. By that time, Cyrene had become one of the principle cities in the Hellenistic World.

"I was trying to find the best way to make these landmarks more epic and impressive. Even if, just by the size of the architecture, they already are incredible," explains artist Martin Deschambault.

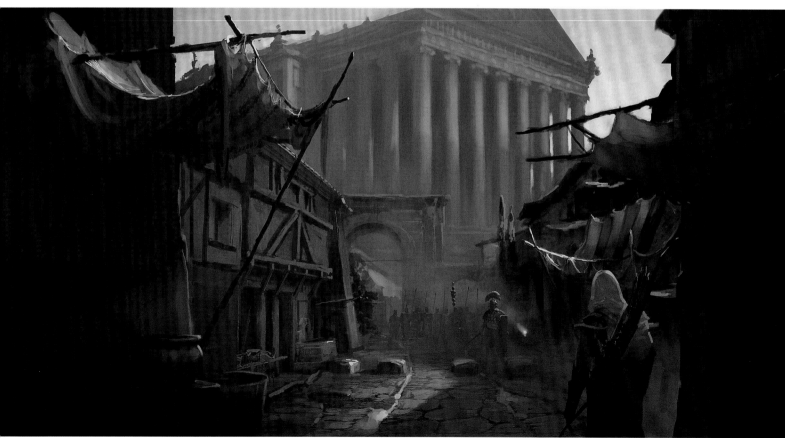

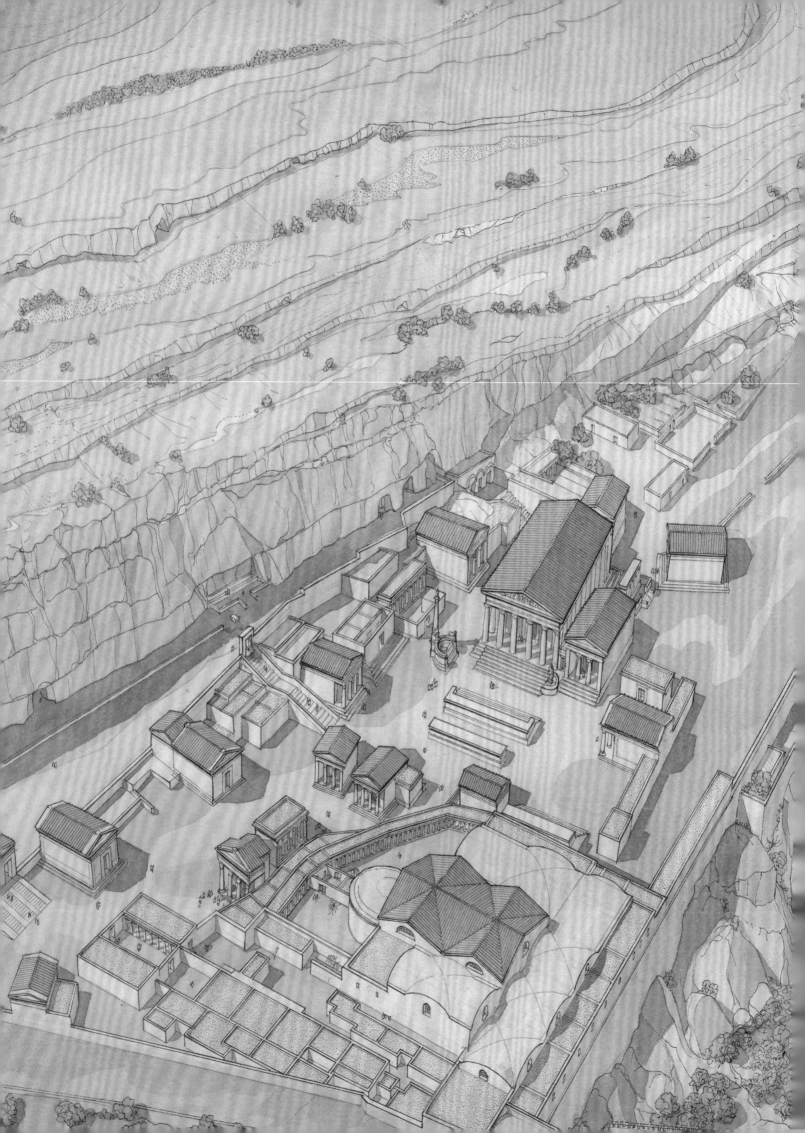

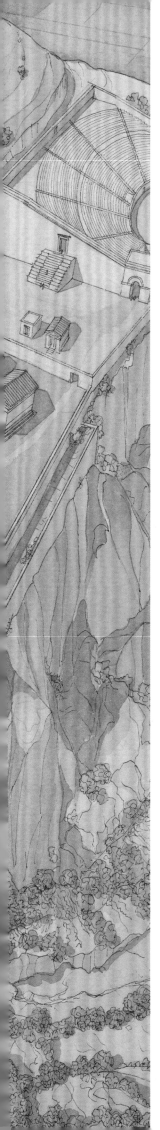

_CYRENE

Kyrenaika, founded in 630 BCE, was named after Kyre, a spring the Greeks consecrated to Apollo. Located in a lush valley, the most important of all Greek cities in the region offers a stark visual contrast to Egypt. Kyrenaika remained relevant after Alexander the Great's death, well into the Ptolemaic era and eventually becoming a Roman province.

On the left, artist and historian Jean-Claude Golvin recreates the city and landscape around Cyrene and in its center stands the Temple of Zeus. Concept artwork by Martin Deschambault [below] and Diana Kalugina [bottom] show the temple's scale and magnificence, which, although now a ruin, is still standing in what is now called Cyrene.

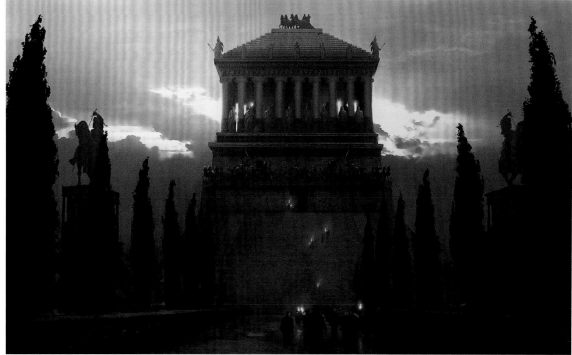

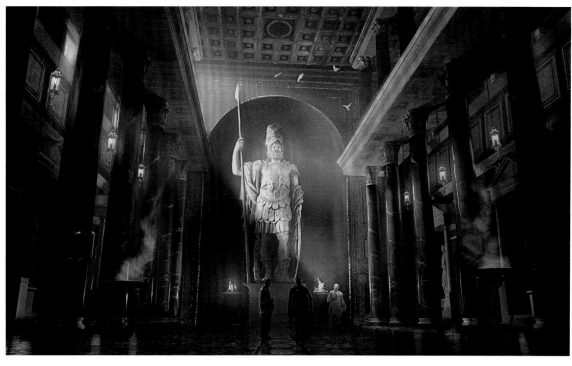

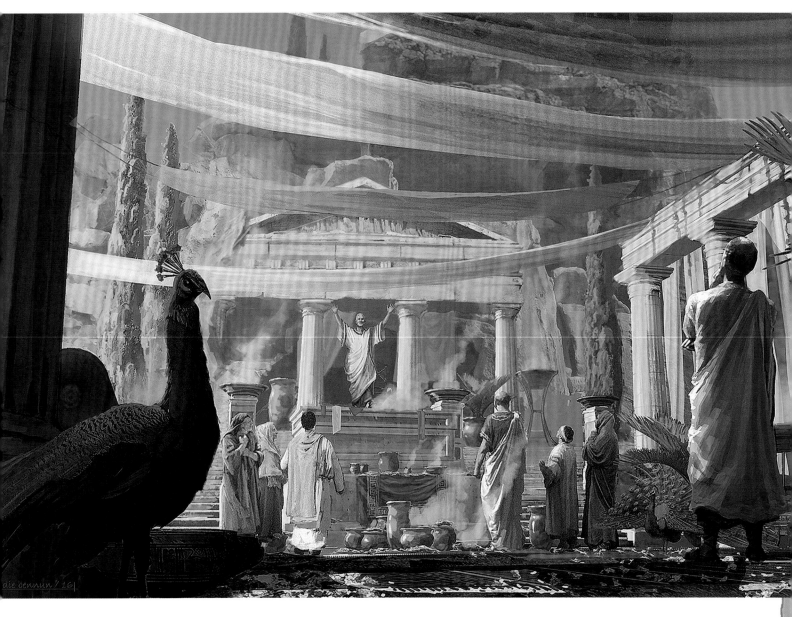

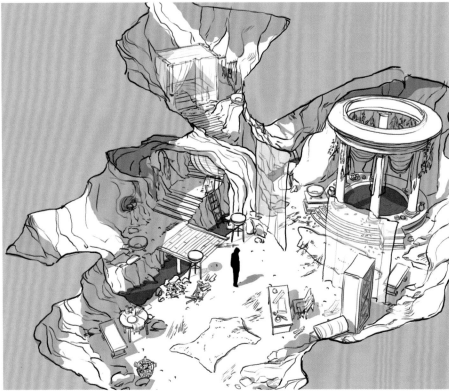

Although oracles lost their importance under Roman rule, the artwork on these pages by Eddie Bennun [above & right] and Diana Kalugina [left] show how important and opulent they once were.

_THE ORACLE

Oracles were sought after for their counsel," explains scriptwriter Christopher Grilli. "Believed to serve as a portal to the gods, those who came with questions took the words of the oracle very seriously. Grinus consulted the oracle at Delphi, who told him to found a new city (what eventually became Kyrenaika). Alexander the Great consulted the oracle at Siwa, a visit that supposedly left him believing he was the son of Amun."

"THE HIDDEN ONE WILL GREET YOU, BUT NOT YET. NOT YET."

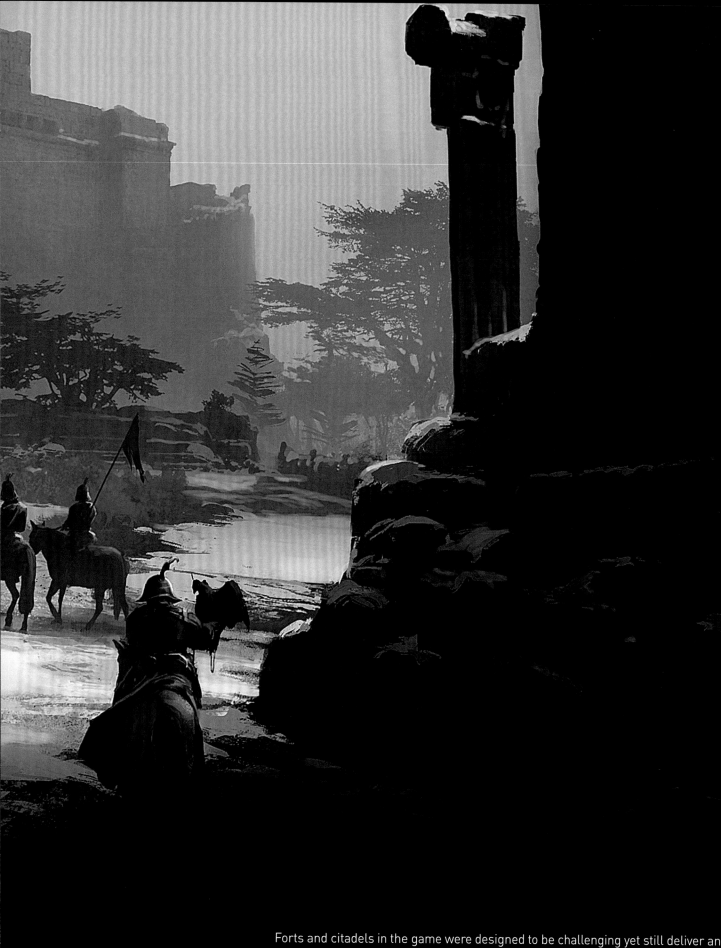

[Left] "Egyptian king Amenemhet I had a wall of fortresses (the Wall of the Prince) constructed along the eastern border of the Nile Delta, favoring the swampy waters as an additional obstacle." Christopher Grilli.

Forts and citadels in the game were designed to be challenging yet still deliver an accurate representation of some of Egypt's most imposing structures, as shown above and left in concept art by Martin Deschambault. Christopher Grilli adds, "These fortresses boasted extremely thick walls, and were built so high up that not even the tallest portable ladder could scale them. Gates were reinforced and often served as the only openings within the walls." But gates, high walls and a lack of ladders are no problem for an Assassin like Bayek of Siwa.

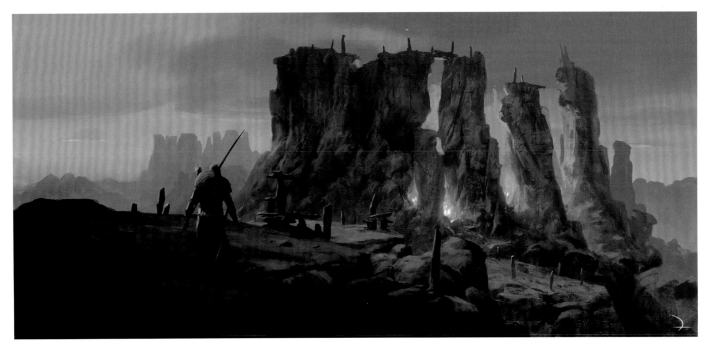

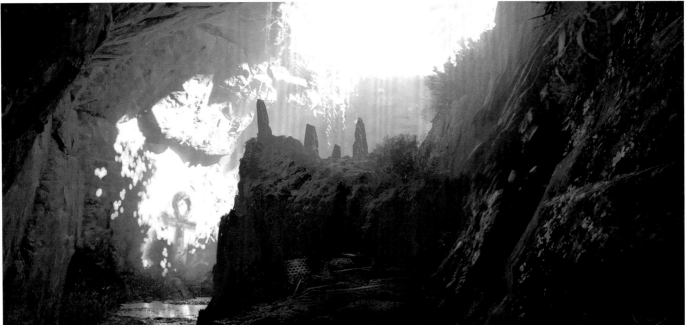

_STONE CIRCLE

Stone circles of varying complexity feature on almost every continent and even now their mysteries are still being decoded. The stone circles Bayek encounters are based on real world monuments that date as far back as 6900 BCE. "The stone circles are said to have some astronomical purpose, perhaps in conjunction with the constellations in the sky," says Christopher Grilli.

Within the game, these stone circles are puzzle games, scattered around Egypt. With the exception of the piece at the top by Martin Deschambault, all artworks on these pages are by Associate Art Director and Concept Artist, Li Ke Yi. They show the stone circles as Bayek sees them and then the result as the puzzle is solved. Classic Egyptian imagery, like the Divine Lion, is used to beautiful effect, alongside the iconic Assassin's Creed eagle.

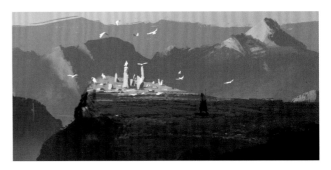

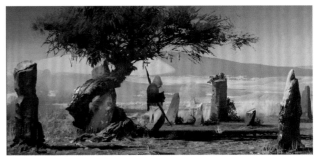

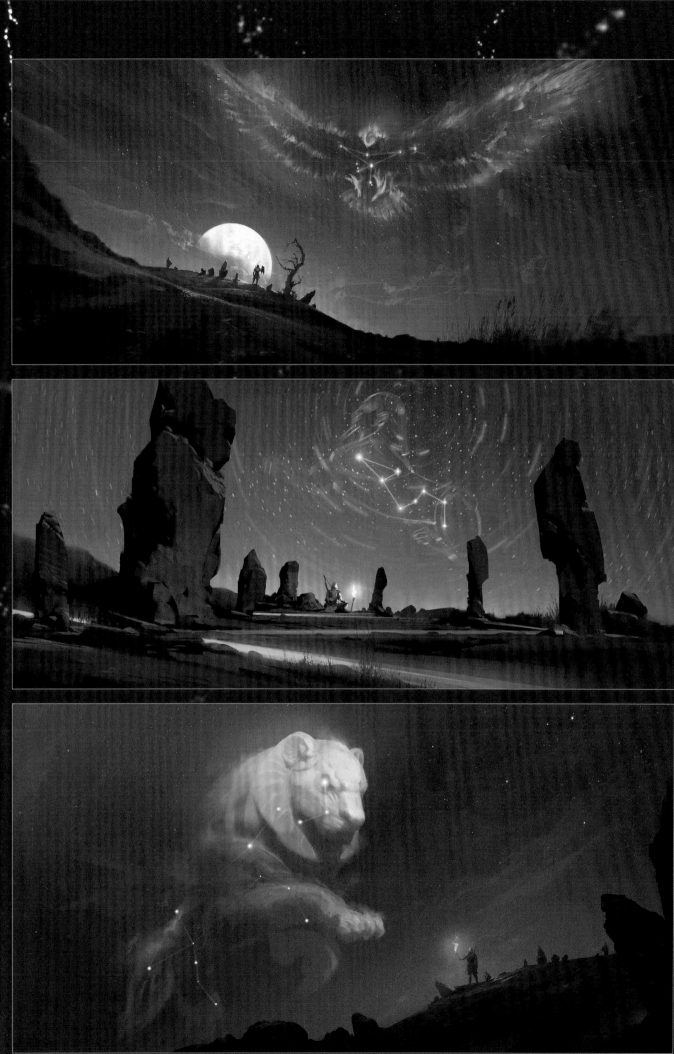

PRESENT DAY

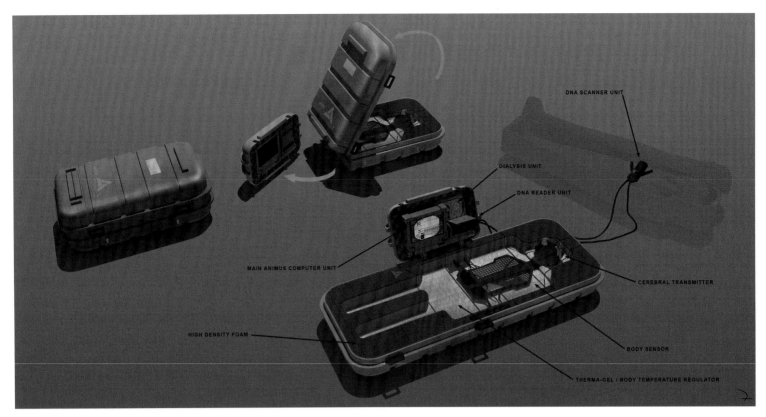

MAIN ANIMUS COMPUTER UNIT

HIGH DENSITY FOAM

DIALYSIS UNIT

DNA READER UNIT

DNA SCANNER UNIT

CEREBRAL TRANSMITTER

BODY SENSOR

THERMA-GEL / BODY TEMPERATURE REGULATOR

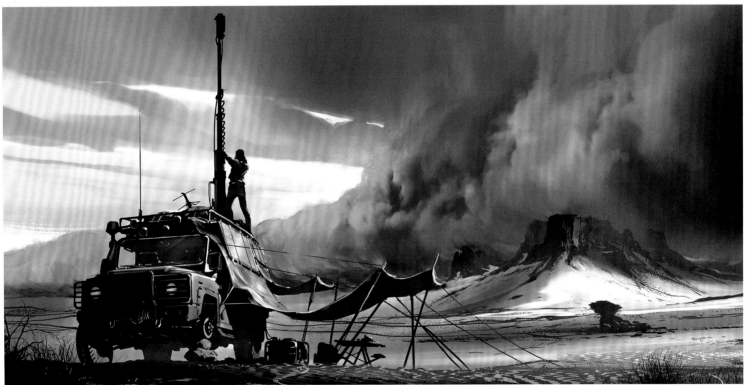

_LAYLA AND ABSTERGO'S SIGMA TEAM

"We often forget that the core of our Assassin's Creed universe is a very cyber high tech one," says Assistant Narrative Director Julie Marchiori. "Bringing an atypical Abstergo scientific prodigy to the mix was our way of acknowledging our true identity, coalescing ten years' worth of lore into a new chapter for our Present Day story.

"Layla is a thirty-three year old electrical engineer. Talented but ultimately bored and rebellious, Layla tends to defy against any system that tries to contain her. Because of who she is, because of what she does, Layla opens up narrative avenues for the future of our brand."

[Top] artwork by Martin Deschambault depicting the new Animus device.
[Above] "This is a scene where Layla tries to protect her camp before the sand storm arrives. I really like to do these kinds of sketches, black and white with strong contrast. I just have to focus on the shape, composition and storytelling." *Martin Deschambault.*
[Previous page] artwork by Martin Deschambault.

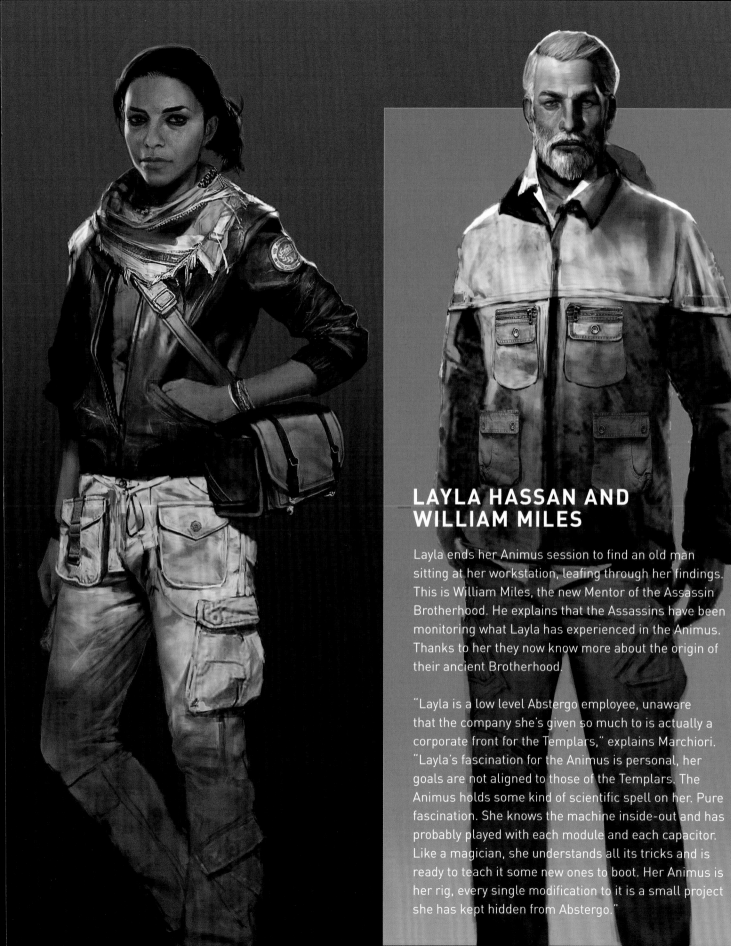

LAYLA HASSAN AND WILLIAM MILES

Layla ends her Animus session to find an old man sitting at her workstation, leafing through her findings. This is William Miles, the new Mentor of the Assassin Brotherhood. He explains that the Assassins have been monitoring what Layla has experienced in the Animus. Thanks to her they now know more about the origin of their ancient Brotherhood.

"Layla is a low level Abstergo employee, unaware that the company she's given so much to is actually a corporate front for the Templars," explains Marchiori. "Layla's fascination for the Animus is personal, her goals are not aligned to those of the Templars. The Animus holds some kind of scientific spell on her. Pure fascination. She knows the machine inside-out and has probably played with each module and each capacitor. Like a magician, she understands all its tricks and is ready to teach it some new ones to boot. Her Animus is her rig, every single modification to it is a small project she has kept hidden from Abstergo."

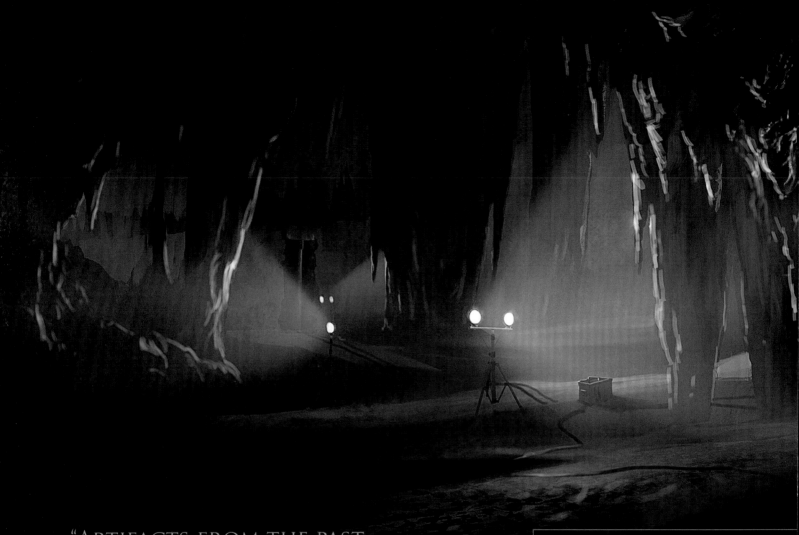

"Artifacts from the past and the present became mirrors of themselves."

JULIE MARCHIORI

Julie Marchiori details the concept behind Present Day, and its impact on the gameplay: "The present world wasn't going to allow us to roam as freely as the player does in the past. So we had to choose wisely what to show and how to show it. It was important for us to use a location that the player could have visited as Bayek in the past.

"The persistence of locations bears some similarity to the persistence of genetic memories in one's blood. They abound with untold stories about the past, just waiting to be discovered. Through environmental storytelling, we had a chance to illustrate the cyclical pattern of history by having artifacts from two different civilizations intertwine - we could show how some are variations on the same theme, and what each says about the civilization they are from.

[Right] "Proposition for the present-day setting, it was very interesting to have this contrast between high tech and the ancient Egyptian Tomb. The cave as well [above] was an interesting location, modeled on the real Djara Cave, I loved the contrast between the stalagmite and the sand and used it as a reference."
Martin Deschambault

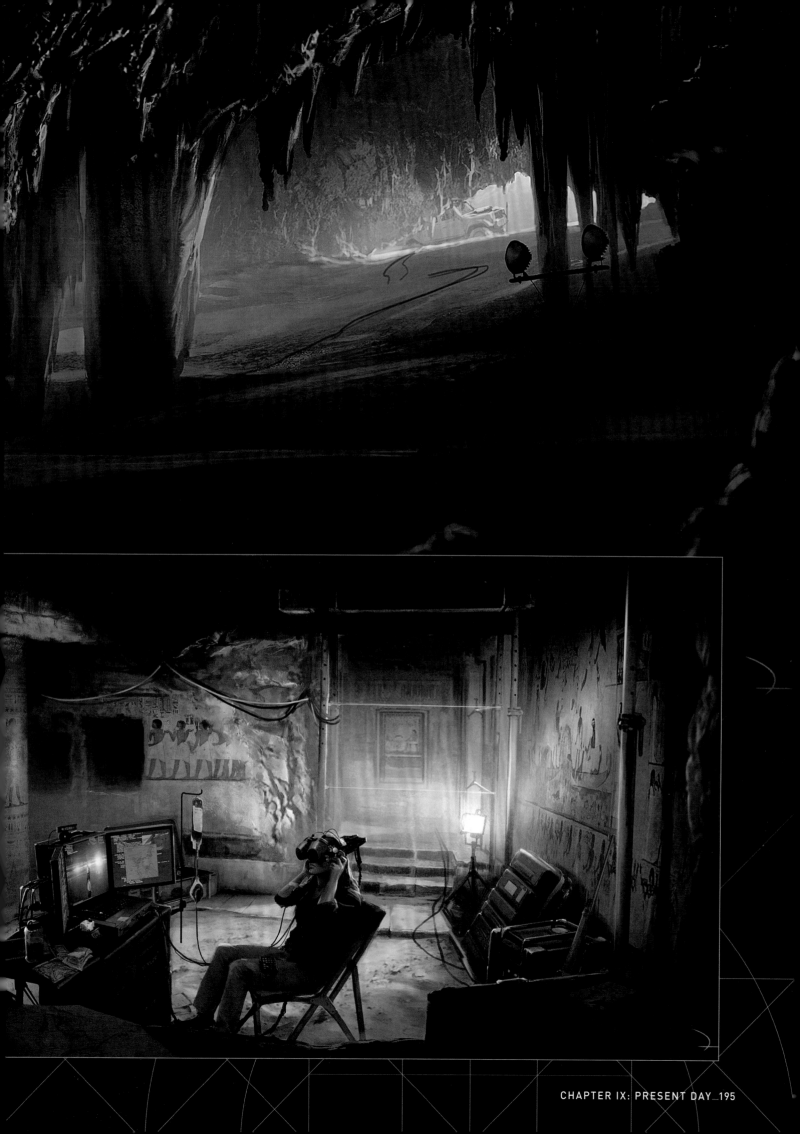

FIRST CIVILIZATION

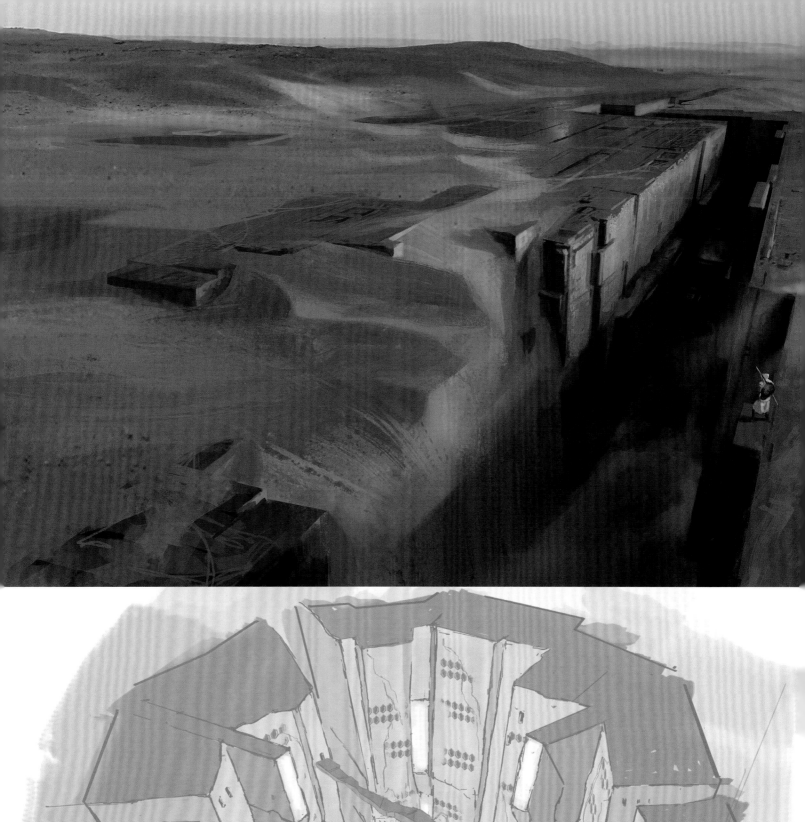
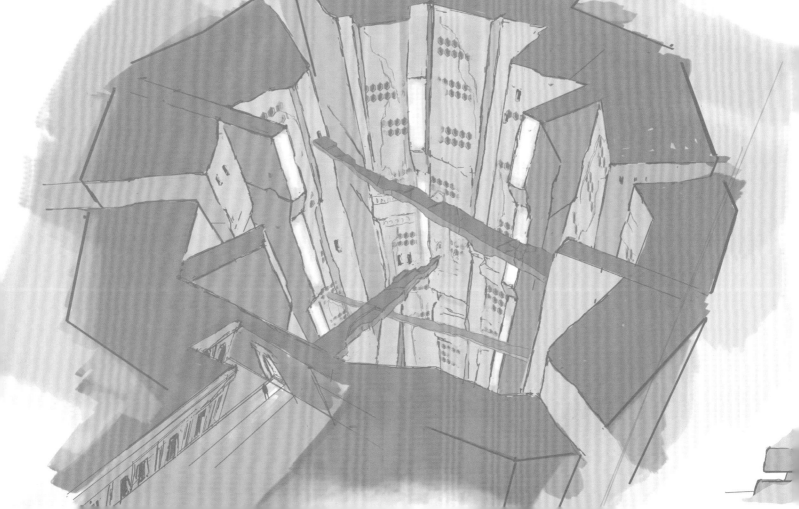

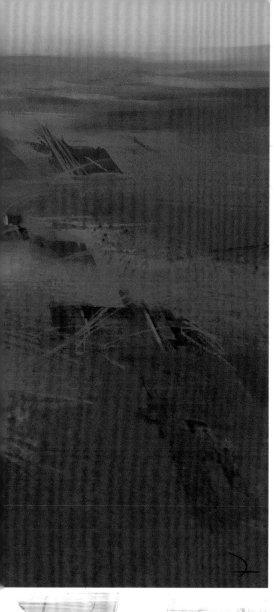

_EXPLORATION

There is a third dimension to the *Assassin's Creed* storyline, a dimension from another world entirely. Humanity has come to know them as the First Civilization, or the Precursors. They refer to themselves as the Isu, and are an advanced humanoid species that Abstergo Industries has scientifically classified *homo sapiens divinus*: godlike.

Bayek stands on the precipice of something very mysterious but entirely real. Many of the myths, legends and religious ideals that shaped Bayek's curious mind while growing up are likely to have had their origin in the First Civilization. And it is the power of these Precursors, capable of manipulating the fabric of mankind's existence, that the Order of the Ancients wished to claim. Even after hearing the truth it all sounds like madness. And yet, Bayek stands on the precipice...

[Left] "I really like to design the First Civilization locations as they are very mysterious. We wanted to refer to the First Civilization room I designed under the Vatican for *Assassin's Creed 2*, so I decided to integrate the monolith sarcophagus on each side of the bridge in the previous spread. The goal with designing First Civilization architecture is to keep it mysterious and intriguing." *Martin Deschambault*.
[Previous page & overleaf] artwork by Martin Deschambault.
[Below] sketches by Eddie Bennun.

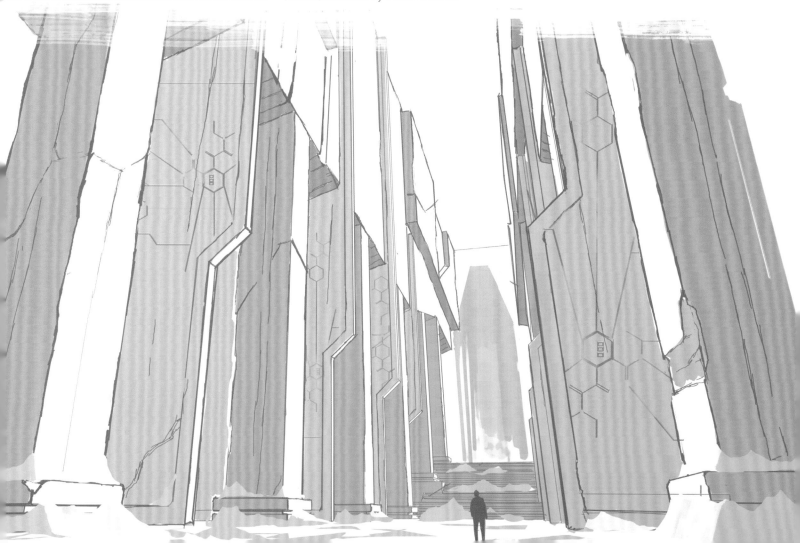

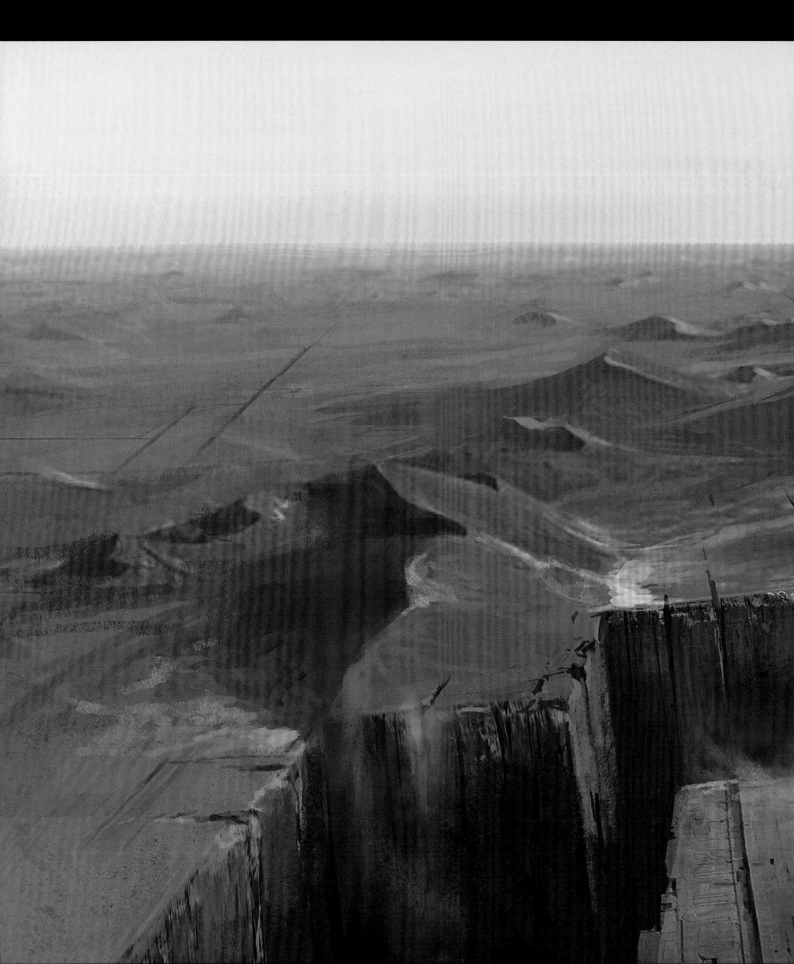

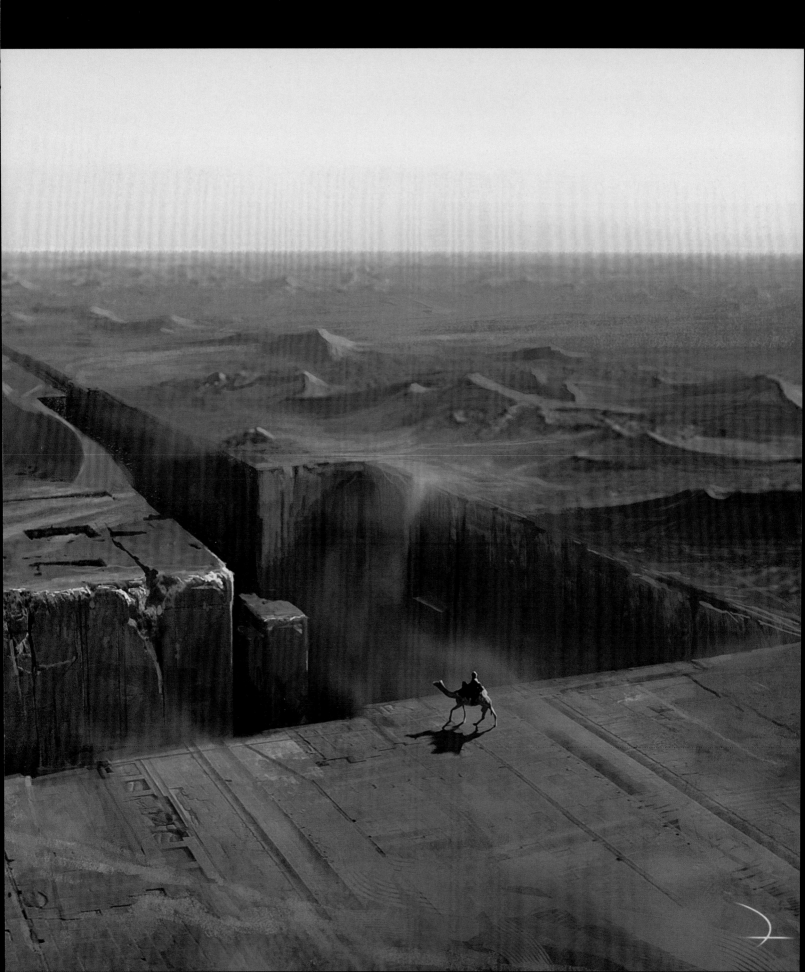

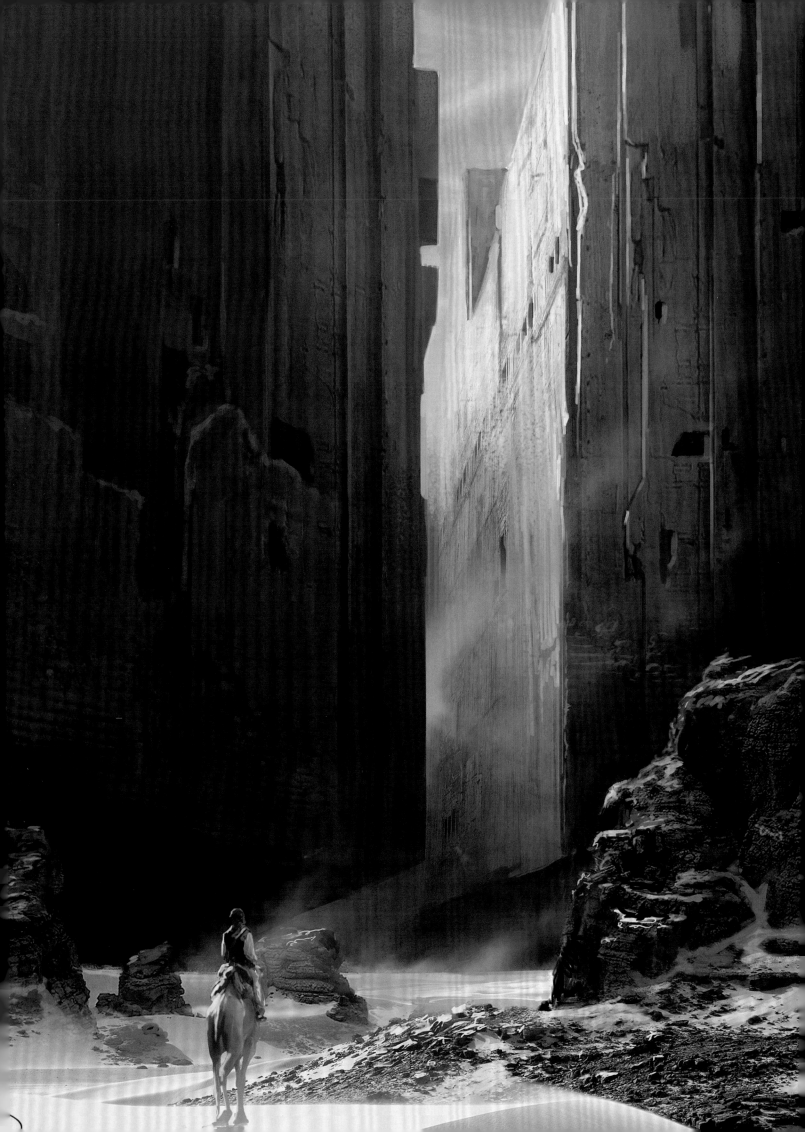

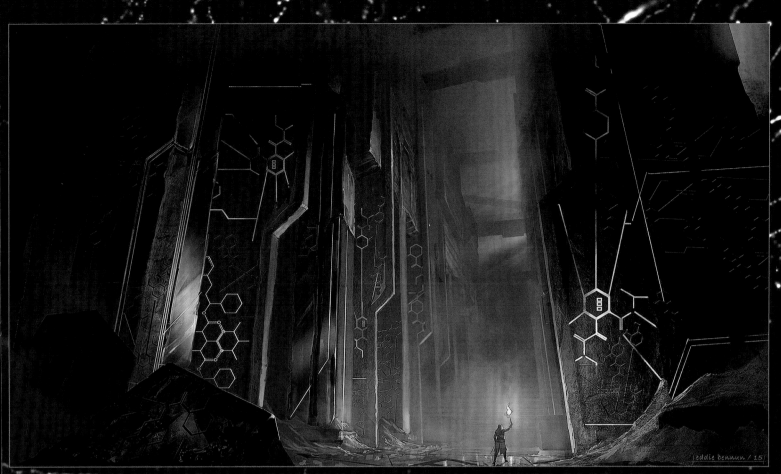

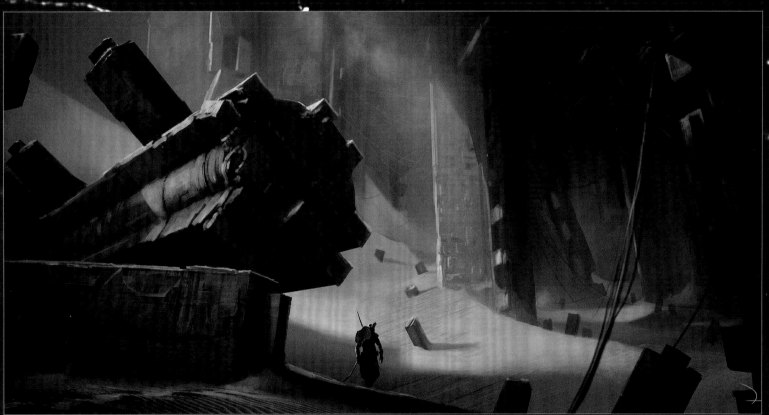

[Top] artwork by Eddie Bennun.
[Above & left] artwork by Martin Deschambault.

"One civilization replaces another and lives with the ruins of the previous inhabitants," explains Julie Marchiori. "These ruins lose their meaning over time but we are still mesmerized by them. We can parallel Bayek's experience of these vaults to our modern lives around the Egyptian ruins of yesteryears. 20th century archaeologists strove to decode structures and languages that had been buried in the sand. The gap is smaller, but the pattern is the same."

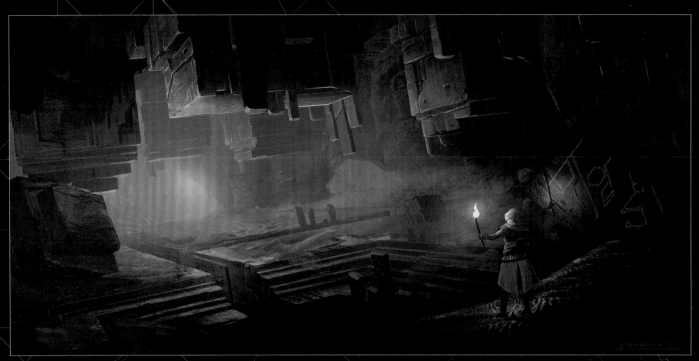

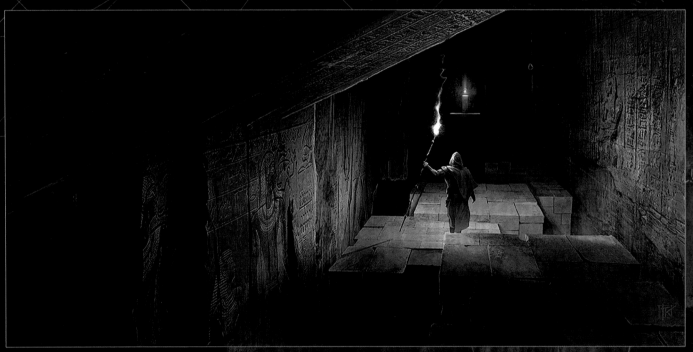

Bayek of Siwa is one of the first *homo sapiens* to set foot inside a Precursor structure for millennia. Others have searched for it. Bayek has been somehow drawn to it. Such is the way that the Isu tend to work. Or, perhaps, they really have no interest at this stage, and played no hand in it. Bayek could just be alone with his thoughts.

Right now, ancient symbols on crooked walls, and mathematical architectural forms that don't add up to anything, are all that Bayek sees. It's all that we have. This is *Assassin's Creed Origins* after all – the big mystery starts here afresh. For the purposes of their newest game, the Ubisoft team posed more questions with the promise of more answers to come. Allow yourself to let go of what you think you know. Gaze upon these mysteries as though for the first time. Experience wonder, joy, fear. Simply allow yourself to see and to feel... and to think.

[Top] artwork by Eddie Bennun.
[Above & right] artwork by Ivan T Koritarev.
[Overleaf] artwork by Martin Deschambault.

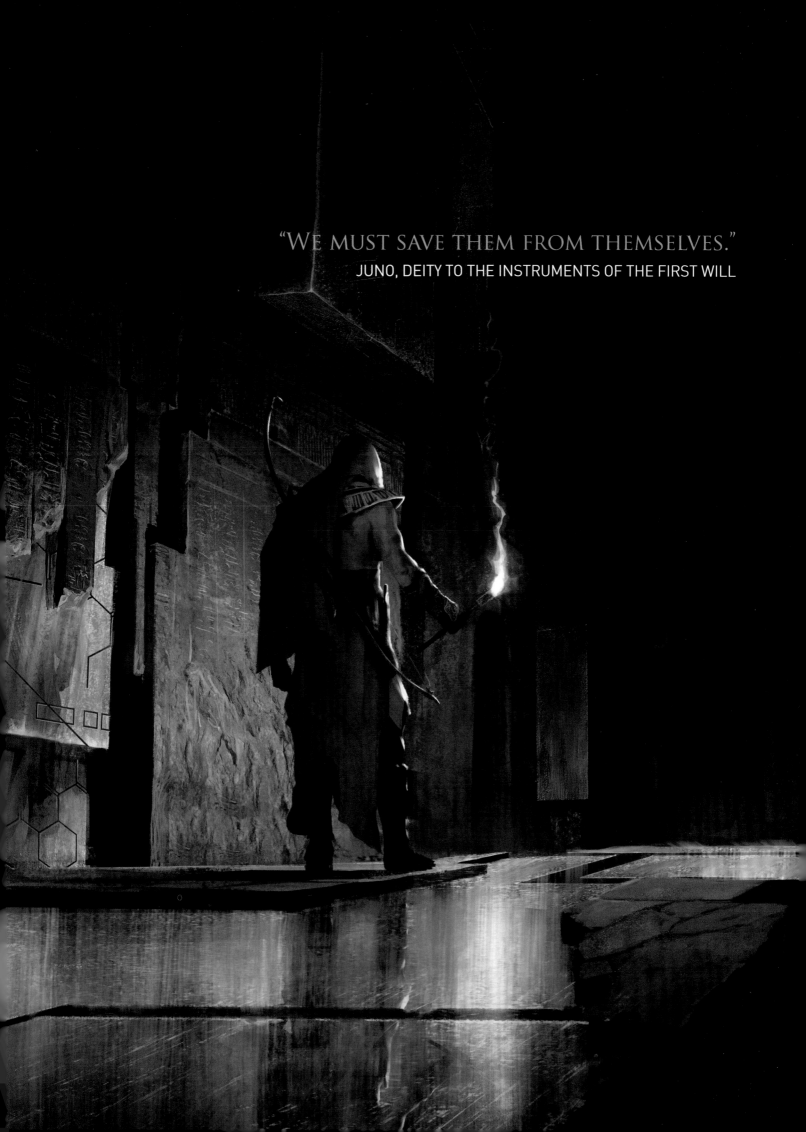

"WE MUST SAVE THEM FROM THEMSELVES."
JUNO, DEITY TO THE INSTRUMENTS OF THE FIRST WILL

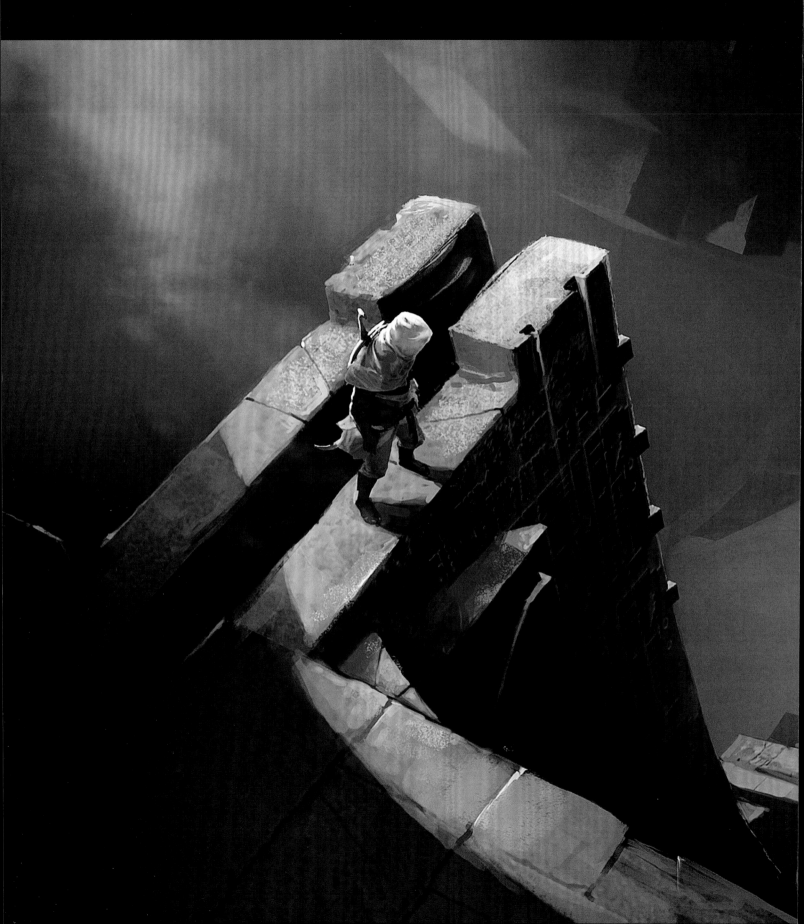

ACKNOWLEDGMENTS

UBISOFT MONTRÉAL
Raphaël Lacoste | Brand Art Director & Concept Artist
Gilles Beloeil | Concept Artist
Raphaëlle Deslandes | Junior Concept Artist
Martin Deschambault | Senior Concept Artist
Richard Forgues | Storyboard Artist
Jose Holder | Storyboard Artist
Vincent Gaigneux | Senior Concept Artist
Jeff Simpson | Concept Artist

UBISOFT SINGAPORE
Mohamed Gambouz | Senior Art Director
Li Ke Yi (KEY) | Associate Art Director & Concept Artist
Kobe Sek | Senior Concept Artist
Jing Cherng-Wong | Concept Artist
Guang Yu Tan | Concept Artist
Natasha Tan | Concept Artist
Nick Tan Chee Eng | Concept Artist
Shamine King | Concept Artist
Tony Zhou Shuo | Concept Artist

UBISOFT SOFIA
Eddie Bennun | Art Director & Senior Concept Artist
Daniel Atanasov | Concept Artist
Sabin Boykinov | Concept Artist
Diana Kalugina | Senior Concept Artist
Ignat Komitov | Concept Artist
Ivan T Koritarev | Concept Artist
Konstantin Kostadinov | Concept Artist
Tsvetelin Krastev | Concept Artist

ASSASSIN'S CREED BRAND TEAM MONTRÉAL
Martin Schelling | Senior Brand Producer
Jean Guesdon | Brand Creative Director
Aymar Azaïzia | Brand Content Director
Étienne Allonier | Brand Director
Antoine Ceszynski | Brand Project Manager
Anouk Bachman | Brand Project Manager
Maxime Durand | Franchise Historian

UBISOFT EMEA
Alain Corre | EMEA Executive Director
Geoffroy Sardin | EMEA Senior Vice President Sales & Marketing
Guillaume Carmona | EMEA Vice President Marketing
Clément Prevosto | EMEA Marketing Director
Justine Toxé | EMEA Brand Manager
Florian Obligis | EMEA Brand & Digital Manager Assistant
François Tallec | Director, Licensing Out & Publishing EMEA
Julien Fabre | EMEA Publishing Manager
Bénédicte Pasquier | Publishing Assistant
Clémence Deleuze | EMEA Publishing Manager

UBISOFT NCSA
Laurent Detoc | President
Mike Breslin | Marketing Director
Caroline Lamache | NCSA Publishing Director
Anthony Marcantonio | Publishing Specialist
Victoria Inel | Publishing Assistant

Special thanks:
Jean-Claude Golvin, Hélix, Alain Mercieca, Matthew Zagurak, Christopher Grilli, Richard Farrèse, Hong Meng Nai, and for their wonderful work: Beth Lewis, Martin Stiff, Matt Ralphs and the team at Titan Books.

Cover image: Eve Berthelette, Hélix; and Martin Deschambault.

This page: artwork by Raphaël Lacoste.